Matthew Brannon, 29.04.06 - 03.06.06, Eröffnung 28.04.06, 18 Uhr

Jan Winkelmann / Berlin, Brunnenstrasse 185 HH, 10119 Berlin, Germany
Telefon + 49 30 28 09 38 99, Telefax + 49 30 28 09 39 08
info@janwinkelmann.com, www.janwinkelmann.com Poster: Carol Bove

Carol Bove and Matthew Brannon

By way of digression... the separate parts of the body suffice to form a solid and artistically constructed whole, and this applies to words and my construction yields in no way to the best examples of construction. What will you say, finally, when you have seen the whole of all the parts as well as the parts of all the parts?... Do you not agree that the reader is able to assimilate only one part at a time? Sometimes he reads two or three passages and never returns; and not, mark you, because he is not interested, but because of some totally extaneous circumstance; and, even if he reads the whole thing, do you suppose for one moment that he has a view of it as a whole, appreciates the constructive harmony of the parts, if no specialist gives him the hint? Is it for this that authors spend years cutting,revising, and rearranging, sweating, straining and suffering? Let us carry the matter further... May not a telephone call, or a fly, distract the reader's attention just at the moment when all the parts, themes, threads, are on the point of converging into a supreme unity? Thus a fly, a telephone call can lay an author's noble work in ruins. Consider, moreover, that that unique and exceptional work of yours on which you have expended so much effort and sweat is just one of the thirty thousand equally unique and exceptional works which will appear during the year. Oh! Terrible and accursed parts! So it is for this that we laboriously construct; so that part of a part of a reader may partially assimilate part of a part of a book. What in reality is a person aiming at nowadays who feels a vocation for the pen, the paint-brush, or the clarionet? Above all, he wants to be an artist... to offer himslf whole to others, ~~to burn on the altar of the sublime in providing humanity with this so desirable manna~~. Moreover, he wants to devote his talent to the service of an idea and perhaps lead ~~mankind~~ towards a better future. ~~What noble aims!~~ What magnificent intentions! Are they not identical with those of S---, G---, B--- or C---? But here you run into trouble. The awkward fact is that you are niether C--- or ~~S~~ ... most a half-S, or a quarter-C (oh! Cursed parts!)

Frances Stark

DJ Olive

Optional questions provided by instructor

1. (A)(B)(C)(D)(E)
2. (A)(B)(C)(D)(E)
3. (A)(B)(C)(D)(E)
4. (A)(B)(C)(D)(E)

5. (A)(B)(C)(D)(E)
6. (A)(B)(C)(D)(E)
7. (A)(B)(C)(D)(E)
8. (A)(B)(C)(D)(E)

9. (A)(B)(C)(D)(E)
10. (A)(B)(C)(D)(E)
11. (A)(B)(C)(D)(E)
12. (A)(B)(C)(D)(E)

13. (A)(B)(C)(D)(E)
14. (A)(B)(C)(D)(E)
15. (A)(B)(C)(D)(E)
16. (A)(B)(C)(D)(E)

17. (A)(B)(C)(D)(E)
18. (A)(B)(C)(D)(E)
19. (A)(B)(C)(D)(E)
20. (A)(B)(C)(D)(E)

Comments

In many ways your written comments can be the most important part of your evaluation of the course and instructor. In the space provided, please indicate what aspects of the course content and instruction were best, how the instructor could improve his or her teaching, and how the content of the course might be improved. The instructor will receive this form after the semester is over.

I was disappointed with the course Mike taught. Instead of criticizing people constructively, he would call their work "crap" or call them an "idiot". I don't agree with this treatment & I felt the course was a waste of my time & money.

Michael Smith

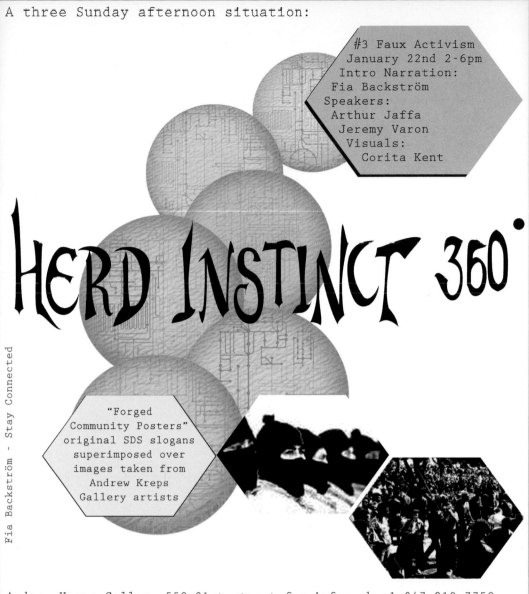

#3 Faux Activism
January 22nd 2-6pm
Intro Narration:
Fia Backström
Speakers:
Arthur Jaffa
Jeremy Varon
Visuals:
Corita Kent

HERD INSTINCT 360°

Fia Backström - Stay Connected

"Forged
Community Posters"
original SDS slogans
superimposed over
images taken from
Andrew Kreps
Gallery artists

Andrew Kreps Gallery 558 21st street for info: ph: 1 347 210 7750
#1: 27th November 2005 #2: 11th December 2005 #3: 22nd January 2006

Cult action, group therapy, corporate brain washed consumer combatants. Together we feel good. Crowd behavior: removing the inhibitions of the individual, no personal responsibility. Yet community is pressure. HERD INSTINCT 360 is an invitation for a group of people to be, see, discuss, and listen to talks about community.

Community—the formerly functional organization of people into pockets of activity, the dead end possibility of the communist collective manifestations in Russia and China, the unspecific and affirming notions of community some works of art rest upon, the increasing sophistication of corporate communal behavior and outreach, the Hippie yearnings for a return to the primal gathering, the exclusive clubs building a 'We-They identity' paving the way for local and global gated communities, the projection of inherent goodness and empowerment from 'productive get-togethers', from the tiniest family unit to the nationalistic one, the pretense of equality. What was to stir action now makes stale.

Let's have negative group expectations? Yet what experience can be outside of it? Community as communication as co-appearance—Stay Connected.

Fia Backström

Fritz Haeg

the normal Harvest of the Apocalypse.

Levinsky Monica.

draped in purple.

—

HER HAND CLUTCHES CONVULSIVELY AT HER THROAT
She is almost naked, in the heat of the dance, the
veils have come undone, the brocaded draperies
have fallen, now she is clad only in the
creations of goldsmiths + silversmiths.
→ in this picture she was truly a whore
As if some great venereal flower that had burgeoned
in a sacrilegious seedbed
with no true forbears, no possible descendants.

(Monoteo - mania ...)

haunted by the symbols of superhuman depravities
+ passions

For the aggrandizement of his solitude

Ian Linker

Every theatre ever invented by religious
→ mania

Claiming that in hell they detected xceptional Assault
-ties of devotious tendencies

These relationship particularly underpinned by their
Silenced existence.

They occupy themselves by sharpening swords ..
Conventions with the nomads is impossible

—

Find out → The exaltation of the dance
of Salome

Dance for Mission.

What moved her?

The subtle mahogany of the murderess
did Afterhand Afterhand
Herod would give
for anything?

What did she want?

With flavors of the Synedrous Vascular of Here Hopes
Barry + Spivi epilogs of Flea things
The dancer do tempters

what would her want?

Naomi Pardon
Leg Dances

the symbolic deity of undestructable

The Goddess of Immortal Hysteria (4)

The Orthetric Paroxysm // Allen of Troy.

William Cordova and Leslie Hewitt (BASE inc.)

Marina Rosenfeld

The Second Sentence of Everything I Read Is You: Mourning Sex, 2005–07

To make this place

A better place for everyone

The second sentence

Of everything I read is you

You're probably the first person to get

Viewers to put part of a work

In their mouths and suck on it

Oral gratification

He had no interest in making

A railway on which no trains run

Somewhere better than this place

This is the soundtrack of your life

Ultimately

It is all the same to the waiter whom he serves

So long as he serves the food

All they need is a given amount of stuff

I want to be invisible

I do guerrilla warfare

I paint my face and travel at night

You don't know it's over until

You are in the body bag

You don't know until election night

We do not remember

It's about the stuff that doesn't let me sleep at night

Next to torture

Art is the greatest persuader

I don't like this idea of having

To undermine your ancestors

Of ridiculing them and making less out of them

Because we're part of a historical process

	Background vocals:
It is a fact	Statesman
	Repetitions
Crazy Eddie's prices are insane	Scholar
	Omissions
Nowhere better than this place	Humanitarian
	Slippages
As if things Felix forgot	Historian
	Metaphors
To tell us are true	Patriot
	Substitutions
Travel promotes change	Ranchman
	Emphases
The bed suggests not only personal	Naturalist
	Repetitions
And social realities	Soldier
	Omissions
But another reality	Statesman
	Slippages
Which is the law	Scholar
	Metaphors
They shouldn't switch too fast	Humanitarian
	Substitutions
From the mournful smile they wear to talk	Historian
	Emphases
About the hostages	Patriot
	Repetitions
To the grin they use for the	Ranchman
	Omissions
Weather forecast	Naturalist
	Slippages
	Soldier

Stephen Prina

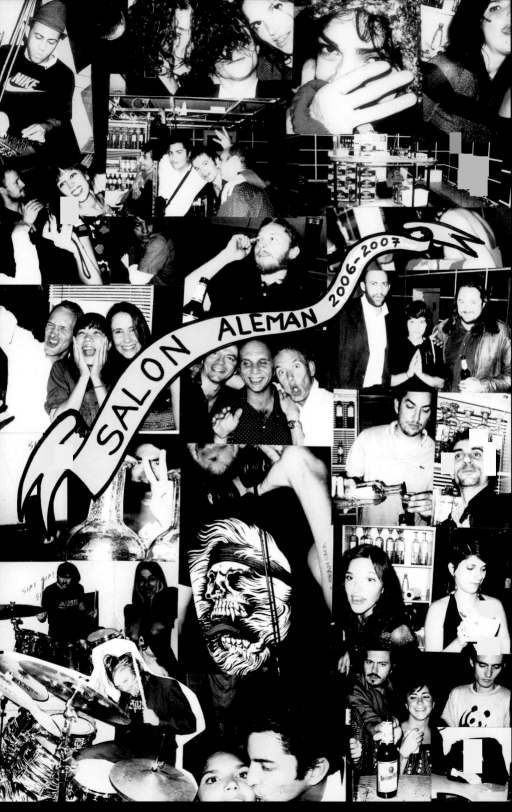

SALON ALEMAN 2006-2007

Eduardo Sarabia

- I HAVE SEEN THE SAME
LIMPING DACHSUND TWO OR 3 TIMES

MY SUNGLASSES HAVE BURNED
A WHITE SHAPE ON MY FACE

- WINE COFFEE CHEESE WINE

A MAN IN ~~PLUM~~ A MAGENTA
CORDUROYS AND PINK SHIRT
TORTISE SHELL SUNGLASSES
A HORSE AND CARRIAGE

CARPETED CHAIR RAIL
SINGULAR SCREENPRINTS

SITE SPECIFIC RUBBINGS

THONG CUTOUTS
POST-EXHIBITION WORK

Amanda Ross-Ho

Coco Fusco

Alice Könitz

Livver

Misty tub in corner, ferns, spray mist
Anal douche in tub (quick short shot, misty, cloudy)
Bomb-making in corner on the table , while bear movie plays on the screen?
Do they make melon heads with rubber masks and dip them in flxi slip, mount
them on spears, chuck them into van or truck?
What are they making? A bomb? A radio? A motor for the hot tub,
Underwear, t-shirts
Stanya lecturing in French in office (write text , translate… text on denial, on
people with lack of self-insight, or …sexual frustration, hots, bien sur, of course I
speak Lithuanian, I minored in lithuanian in school. About travel? Panopticon
architecture in berlin, boxes of potatoes delivered, beets , turnips … Tell stories
too:

Melon heads, Rubber masks, Flexi slip, bloody heads fall into an office

Rock house/Bridewell vacant lot
Skaters on platform by Sal's (Humboldt street)

Cavewoman planting, digging planting trees
Berr skiing and matt snowboarding in costumes : matt witches costume. Ben ice
cream man with hood

Gather wild Mustard at Deb's park, lenny in white and hood too

They get hot tob going
They blow something up> what? Is it burning when we see it? What is it?

Amy is queen? Part white part cavewoman

Or stanya amy and Eileen are cavewomen
They are the gatherers

Is Eileen too recognizable?
Is Amy too shy of an actor?
Matching cavewomen in outfits

Concern: maybe better to be one cavewoman so stands out in a different way?
Or/and stanya wants another role too as standout weirdo so gets to do more
performing. We can figure that out.

Put out corn cob lisiting, start getting guys to do it, Stanya and (who?) are the
women shooting it?

Harry Dodge and Stanya Kahn

2008 BIENNIAL EXHIBITION

HENRIETTE HULDISCH
SHAMIM M. MOMIN

WITH AN ESSAY BY
REBECCA SOLNIT

WHITNEY MUSEUM OF AMERICAN ART, NEW YORK
DISTRIBUTED BY YALE UNIVERSITY PRESS, NEW HAVEN AND LONDON

This catalogue was published on the occasion of the *2008 Biennial Exhibition*, at the Whitney Museum of American Art, New York, March 6–June 1, 2008.

Made possible, in part, by Gap

New and commissioned work is sponsored by Deutsche Bank

Deutsche Bank ▱

Significant funding for the 2008 Biennial is provided by an endowment created by Melva Bucksbaum, Emily Fisher Landau, and Leonard A. Lauder.

Opening events are sponsored by Sotheby's

Sotheby's ⦙

Research for Museum publications is supported by an endowment established by The Andrew W. Mellon Foundation and other generous donors.

"Sometimes Maybe Possibly: Radical Diffidence, or The Shy Downturned Face of Revolution in Our Time" © 2008 Rebecca Solnit

Library of Congress Control Number: 2007942894

ISBN: 978-0-300-13689-0
ISSN: 1043-3260

WHITNEY

Whitney Museum of American Art
945 Madison Avenue at 75th Street
New York, New York 10021
whitney.org

Distributed by:
Yale University Press
302 Temple Street
P.O. Box 209040
New Haven, Connecticut 06520-9040
yalebooks.com

Printed and bound in Italy

CONTENTS

FOREWORD

ADAM D. WEINBERG, ALICE PRATT BROWN DIRECTOR

A biennial is an exercise in imposing temporary order and control onto a situation that is, essentially, out of control. To this end, a curatorial team was set in place to organize the "exercise" of the *2008 Biennial Exhibition*. The show has been curated by Henriette Huldisch, assistant curator at the Whitney Museum of American Art, and Shamim M. Momin, associate curator at the Whitney and branch director and curator of the Whitney Museum of American Art at Altria, and overseen by Donna De Salvo, the Whitney's chief curator and associate director for programs. Three advisers worked with the curatorial team throughout the process: Thelma Golden, director and chief curator of The Studio Museum in Harlem; Bill Horrigan, director of media arts at the Wexner Center for the Arts at The Ohio State University; and Linda Norden, independent curator and writer.

Today there are more artists working in more genres, using more varieties of material and moving among more geographic locations, than ever before. As Huldisch and Momim attest throughout this catalogue, this is a moment—a rather extended one at that—in which art has come to be characterized by heterogeneity, dispersal, and contradiction rather than unity or orthodoxy. It should come as no surprise then that to organize an exhibition of such diverse material is itself an act of origination as well as, to a certain extent, an act of calculated response. It is an act of origination in the sense that no single underlying theme emerged to connect the works of art; instead, the curators put forward ideas based on their experience of recent art, and through an exhaustive process of selection and distillation they arrived at a collage of artistic expressions that resonated to reveal patterns—or, to use the term the curators would prefer, "networks." The 2008 Biennial is thus a by-product of their sensibilities, knowledge, training, and artistic connections, all of it leavened, it should be noted, by chance. Through their concentrated, thoughtful attention the curators have elucidated the links among these seemingly disparate and sometimes ephemeral artistic practices and have made possible their presentation in the form of an exhibition that at the end of the day, however improbably, seeks to characterize the art of the present.

Yet a biennial is also—and always has been—a kind of multivalent response, more so today than ever before. The curators, for their part, would never make any claim to neutrality or objectivity nor would they desire it, and rightly so. In the end they, like all of us, are reacting to what they have had the occasion to see and experience. The highly compressed time frame in which a biennial is organized, moreover, along with the overwhelming amount of art that is viewed, demands no small amount of reflex and response; the nature of the beast is reactive as much as it is proactive. The Biennial is also a response to the physical and conceptual space of the Museum—*this* Museum, Marcel Breuer's Whitney Museum of American Art

in New York City; a biennial organized in another location, even by the same curators at the same time and with the same artists, would be an altogether different affair. Recognizing that many artists in the 2008 Biennial participate in what the curators characterize as "expanded practices," from music performances to guerrilla publishing ventures, Huldisch and Momin have seized on an opportunity to extend both the physical and conceptual "space" of the exhibition by organizing corollary events and installations at the Seventh Regiment Armory Building in conjunction with the Art Production Fund. These range in type and duration from music performances and a dance marathon to a 24-hour film screening and even a bar-cum-sculpture that becomes a site for other artists' projects.

Our fragmented political and social milieu, too, warranted reaction from curators and artists alike. Accordingly, the works of art in this exhibition make reference, more often than not obliquely, to such hot-button issues as the war in Iraq and the global ecological crisis. Perhaps a more subtle influence is how the 2008 Biennial opens in the wake of a trio of influential international exhibitions held in 2007 that occur simultaneously but once a decade—the Münster Sculpture Project (every ten years), Documenta (every five years), and the Venice Biennale—affording the curators the chance to implicitly, if not explicitly, consider and react to their content, structure, and theses. Finally, every Whitney Biennial is to some degree a healthy if occasionally Oedipal response to its predecessor, and the 2008 Biennial is no exception. It has a considerably smaller number of artists (81) than the 2006 Biennial (106), and it posits no metaphoric construct as a framing device.

People come to the Whitney Biennial expecting a great many things: to discover new artists, to experience fresh and important art, to be challenged by experimental ideas and forms, to have a good time, and, perhaps above all, to gain some understanding of the present moment in art. Given that the curators of the 2008 Biennial stand at such a precarious, even chaotic nexus of origination and reaction, not only is it unrealistic to expect them to offer a crystallized overview, it is unwise. They are not so much interpreters or impresarios in this context as *presenters*. Indeed, as I read through the essays in this volume and look at the art in the exhibition, I am mindful of something Susan Sontag wrote almost half a century ago in *Against Interpretation*: "Ours is a culture based on excess, on overproduction; the result is a steady loss of sharpness in our sensory experience. All of the conditions of modern life—its material plenitude, its sheer crowdedness—conjoin to dull our sensory faculties." What Sontag concludes from this state of affairs, at least as it concerns criticism, is a sentiment that I think may also be applied to the role of the Biennial curator: "The function of criticism should be to show *how it is what it is*, even *that it is what it is*, rather than to show *what it means*."

That is a considerable challenge, and I express my deep appreciation to the entire curatorial team and its advisers for meeting it with constancy and skill. The burden, of course, was shouldered in particular by Henriette Huldisch and Shamim M. Momin. I know firsthand that their road was not an easy one. In the end, what sustained them—their passion, energy, and commitment to the artists—has benefited us all.

We gratefully acknowledge the Biennial's corporate sponsors, Gap and Deutsche Bank, for their long-standing commitment to help bridge contemporary artists and public audiences. We are also thankful to Sotheby's for sponsoring the opening events to launch the 2008 Biennial. Finally, we are deeply grateful to Emily Fisher Landau and Leonard A. Lauder for their endowed support of the Whitney's signature exhibition program and to Melva Bucksbaum for her commitment to honoring artistic excellence with the creation of the Bucksbaum Award.

ACKNOWLEDGMENTS

HENRIETTE HULDISCH AND SHAMIM M. MOMIN

In 1931 the Whitney Museum of American Art opened to the public, and the first Whitney Biennial was introduced the following year. From its inception, the Biennial has been a cornerstone of the Whitney Museum of American Art's mission of advocacy and support of living artists. The 2008 Biennial is the seventy-fourth in the series of Whitney Annual and Biennial exhibitions held since 1932, the same year that the Museum established an acquisition fund for purchases from each Biennial exhibition, making the exhibition a foundational aspect of the Museum's permanent collection as well. We thank first and foremost Adam D. Weinberg, Alice Pratt Brown Director, for his trust and encouragement in appointing us to curate the 2008 Biennial, and Donna De Salvo, chief curator and associate director for programs, for helping us guide the exhibition through fruition. A curatorial advisory team graciously lent their in-depth knowledge and insight throughout the process; for their participation we wish to thank Thelma Golden, director and chief curator of The Studio Museum in Harlem; Bill Horrigan, director of media arts at the Wexner Center for the Arts at The Ohio State University; and Linda Norden, independent curator and writer.

We are particularly grateful to the eminently capable biennial coordinator Kim Conaty, whose diligence, diplomacy, and grace under pressure ensured that the exhibition stayed on track at all times. The superior Biennial team was completed by biennial assistant Diana Kamin; Lee Clark, former gallery/curatorial assistant; Stacey Goergen, curatorial assistant; and Elizabeth Lovero, gallery/curatorial assistant: their contributions were invaluable and their commitment, above all, unfailing. The exhibition also benefited greatly from the assistance of interns Alana Corbett, Andrea Gyorody, Maya Jimenez, Rosemary O'Sullivan, Paulina Pobocha, Abbe Schriber, and Peter Sebeckis.

The entire staff of the museum has contributed to the success of the Biennial. We especially single out for their contributions: Jay Abu-Hamda, projectionist; John Balestrieri, director of security; Wendy Barbee-Lowell, manager of visitor services; Jeffrey Bergstrom, audio-visual coordinator; Richard Bloes, senior technician; Melissa Cohen, assistant registrar; Anita Duquette, manager, rights and reproductions; Bridget Elias, chief financial officer; Jessa Farkas, rights and reproduction assistant; Kate Hahm, exhibitions assistant; Matthew Heffernan, registration assistant; Nicholas S. Holmes, legal officer; Abigail Hoover, assistant registrar; Anna Knoell, graphic design; Emily Krell, coordinator of performing arts; Vickie Leung, production manager; Jeffrey Levine, chief marketing and communications officer; David Little, associate director, Helena Rubinstein Chair for Education; Graham Miles, art handler/supervisor; David Miller, art handler; Matt Moon, art handler; Carolyn Padwa, registrar, permanent collection; Kathryn Potts, director of education initiatives; Christy Putnam, associate director for exhibitions and

collections management; Maggie Ress, manager of corporate sponsorships; Joshua Rosenblatt, head preparator; Amy Roth, director of corporate partnerships; G. R. Smith, art handler/supervisor; Stephen Soba, communications officer; Mark Steigelman, manager, design and construction; Emilie Sullivan, associate registrar; Robert Tofolo, assistant director of retail; Limor Tomer, adjunct curator of performing arts; Beth Turk, assistant editor; and Ray Vega, carpenter/supervisor.

Mary DelMonico spearheaded the publication of the catalogue with indefatigable dedication and efficiency. We are indebted to the tireless commitment of Rachel de W. Wixom in her role as head of publications, as well as Richard G. Gallin, Thea Hetzner, Lynn Scrabis, and Dale Tucker for their brilliant editing of the publication's texts. Miko McGinty's original and elegant catalogue design greatly enhanced the exhibition and captured from its beginning the essence of the 2008 Biennial; she was ably assisted by Rita Jules.

We are grateful to Rebecca Solnit, who authored her invaluable catalogue essay under an impossibly short deadline, and to writers Todd Alden, Trinie Dalton, Stacey Goergen, Suzanne Hudson, Jeffrey Kastner, Jason Edward Kaufman, Nathan Lee, and Lisa Turvey for their insightful contributions.

The Art Production Fund (APF) collaborated with the Whitney on a first-ever presentation of Biennial works at the Seventh Regiment Armory Building. Cofounders Yvonne Force Villareal and Doreen Remen, as well as Casey Fremont, director of operations, brought their immense talents and enthusiasm to the project, realizing more than thirty ambitious projects, performances, and installations seemingly without effort and providing the support and confidence necessary to take risks with the program. We are also very grateful to the Park Avenue Armory, who responded to our plans with a shared sense that the moment had come to position the Seventh Regiment Armory Building as a major venue for exhibiting contemporary art. In particular, we are indebted to the determination and hard work of Jack Dobson, director of facilities; Lissa Frenkel, project manager; Peter Gee, CFO and vice president for operations; Wayne Lowery, director of security; Rebecca Robertson, president/CEO; Kirsten Reoch, project director; and Lillian Silver, executive vice president for external affairs.

An exhibition of the scope and scale of the Biennial could never happen without the constant and generous involvement of many galleries, institutions, and individuals. We are delighted to acknowledge the support of: 303 Gallery, New York; Arndt & Partner Berlin and Zürich; Black Dragon Society, Los Angeles; The Blanton Museum of Art, The University of Texas at Austin; Tanya Bonakdar Gallery, New York; Bortolami, New York; Spencer Brownstone Gallery, New York; Christine Burgin Gallery, New York; Galerie Gisela Capitain, Cologne; Cherry and Martin, Los Angeles; China Art Objects

Galleries, Los Angeles; Paula Cooper Gallery, New York; CRG Gallery, New York; D'Amelio Terras, New York; Elizabeth Dee Gallery, New York; Thomas Erben Gallery, New York; Zach Feuer Gallery, New York; Marc Foxx, Los Angeles; James Fuentes LLC, New York; Gladstone Gallery, New York; Marian Goodman Gallery, New York; Greene Naftali, New York; Kavi Gupta Gallery, Chicago; Harris Lieberman, New York; Anna Helwing Gallery, Los Angeles; Daniel Hug, Los Angeles; I-20 Gallery, New York; Ellen Kern; Galerie Peter Kilchmann, Zurich; Nicole Klagsbrun, New York; David Kordansky Gallery, Los Angeles; Andrew Kreps Gallery, New York; Elizabeth Leach Gallery, Portland, Oregon; Margo Leavin Gallery, Los Angeles; Luxe Gallery, New York; Maccarone, New York; Metro Pictures, New York; Paul Monroe; Peres Projects, Los Angeles; Friedrich Petzel Gallery, New York; Postmasters Gallery, New York; The Project, New York; Ratio 3, San Francisco; Andrea Rosen Gallery, New York; Taxter & Spengemann, New York; Frederieke Taylor Gallery, New York; Team Gallery, New York; Susanne Vielmetter Los Angeles Projects; Wallspace, New York; Tracy Williams, Ltd., New York; David Zwirner, New York; and David and Monica Zwirner.

For their help and support throughout the project we thank Domenick Ammirati, senior editor, *Modern Painters*; Lisa Anastos; Liz Armstrong, deputy director for programs and chief curator, Orange County Museum of Art, Newport Beach, California; Sandro Canovas; Bertha Cea, senior adviser to the cultural attaché, United States Embassy in Mexico; Rachel Comer-Greene; Lauren Cornell, executive director, Rhizome, at the New Museum of Contemporary Art, New York; Silvia Karman Cubiñá, director, The Moore Space, Miami; Sue de Beer; Apsara DiQuinzio, assistant curator, painting and sculpture, San Francisco Museum of Modern Art; Sarah Dougher; Caroline and Elizabeth Dowling; Eric Fredericksen, director, Western Bridge, Seattle; Damon Gambuto; Kathy Garcia; Filippo Gentile; Robert Goff; Matthew Higgs, director/chief curator, White Columns, New York; Chrissie Iles; Kerry Inman; Toby Kamps, senior curator, Contemporary Arts Museum Houston; Natas Kaupas; Kristan Kennedy, visual art program director, Portland Institute for Contemporary Art, Oregon; Lila Kanner, director of programs, Artadia, New York; Sara Krajewski, associate curator, Henry Art Gallery at the University of Washington, Seattle; Mary Leclère, associate director, The Core Program, Glassell School of Art at the Museum of Fine Arts, Houston; Jon Lyon; Sarah Macaulay; Cara McCormack, program coordinator, The Core Program, Glassell School of Art at the Museum of Fine Arts, Houston; Cuauhtémoc Medina, associate curator of Latin American art, Tate, London; Dana Miller; Maynard Monrow; John Ryan Moore; Christine Nichols; Serena Naramore; Jenelle Porter, associate curator, Institute of Contemporary Art at the University of Pennsylvania, Philadelphia; David Quadrini; Lawrence R. Rinder,

dean, California College of the Arts, San Francisco; Perry Rubenstein; Bradley Schlei; Itala Schmelz, director, Museo de Arte Carillo Gil, Mexico City; Jeremy Shaw; Debra Singer, executive director and chief curator, The Kitchen, New York; Frank Smigiel, associate curator, public programs, San Francisco Museum of Modern Art; Stephanie Snyder, John and Anne Hauberg Curator and Director, Douglas F. Cooley Memorial Art Gallery at Reed College, Portland, Oregon; Matthew Stadler; Natalia Tkachev; Anton Vidokle, unitednationsplaza, Berlin; Suzanne Weaver, The Nancy and Tim Hanley Associate Curator of Contemporary Art, Dallas Museum of Art; Clint Willour, curator, Galveston Arts Center, Texas; Charles Wylie, The Lupe Murchison Curator of Contemporary Art, Dallas Museum of Art; and Andrea Zittel.

Most important, we thank the artists, whose passion, innovation, and commitment never cease to inspire and illuminate.

INTRODUCTION

HENRIETTE HULDISCH AND SHAMIM M. MOMIN

In a panel discussion preceding the 2006 Biennial, curator Klaus Kertess, responsible for the show's 1995 iteration, noted: "The beauty of this exhibition is its impossibility." Indeed, the Whitney Biennial has historically been hated as fervently as it has been loved and has sustained its share of zealous criticism. Such controversy is a remarkable feat for this earliest showcase for contemporary American art, whose advocacy is rooted in a moment when work being made in this country received little critical attention and few cared about the art that Gertrude Vanderbilt Whitney championed. The beauty of organizing the Biennial, as well as its "impossibility," springs from the fact that now people do care, often passionately.

If taking on the exhibition means shouldering that paradoxical premise, it is one that over the course of our research and myriad studio visits proved in various ways fortuitously resonant. In his foreword Adam D. Weinberg accurately points out that while the nature of a Biennial precludes its being able to encapsulate a uniform or exhaustive picture of contemporary art production, at this point in time that enterprise appears even more daunting. Art in the United States does not reinvent itself in two-year cycles; moreover, embedded in larger international networks of exhibition and artistic interaction, its spirit cannot be neatly compartmentalized by nationality. And yet, while American art is informed by worldwide events and trends, we are also witnessing an inverse and related interest in locally specific contexts, small areas of exchange, and contained arenas of activity, tendencies considered by Henriette Huldisch in her discussion of "lessness" in this catalogue. Shamim M. Momin reflects on a set of similarly simultaneous relationships when locating contemporary art within an understanding of time that has fundamentally reframed contemporary culture: one recursive and coexistent rather than linear and successive, a mode of spatiotemporal thinking fundamentally resistant to a modernist notion of progression. Rebecca Solnit also contributes her take on the broader cultural moment and the shift in what it means to be political in this time, a turning toward smaller, localized gestures and dispersed, nonhegemonic networks.

Within the vast, variously differentiated field that we (perhaps absurdly) continue to yoke under the single term *contemporary art*, certain prevalent, often interrelated practices to us seem particularly germane to the moment. Many of the projects presented in the 2008 exhibition explore fluid communication structures and systems of exchange that index larger social, political, and economic contexts, often aiming to invert the more object-oriented, ends-driven operations of the art market. Recurring concerns involve a nuanced investigation of social, domestic, and public space and its translation into form—primarily sculptural, but also photographic, cinematic, and so forth— which in turn catalyzes social practices extending beyond the exhibition space. There is an evident trend toward creating work of an ephemeral, event-based character. (The front and back sections in this catalogue—a kind of extended endpapers that wrap the body of the book—include supplementary artist material related to these time-based, durational modes.) Such projects do not stand in opposition to the institution; rather, considering each of these multiple platforms equally important, artists show objects in the museum or gallery even as they seek ways to complicate and transcend its parameters.

For the 2008 Biennial, the Seventh Regiment Armory Building serves as a second venue. The Armory's array of period rooms and vast Drill Hall host an extensive program of events, organized by the Whitney and the Art Production Fund in association with the Park Avenue Armory and conceived in a spirit of fluid impermanence—music and other performance, movement workshops, radio broadcasts, publishing projects, community-based activities, film screenings, culinary gatherings, lectures, and more. In several instances these events are related to installations, moving-image works, or objects presented in the Museum's Marcel Breuer building; in some cases the product of a performance or its documentation will be integrated into the work exhibited at the Whitney. Also presented in the Armory are a number of installations that evolve through the duration of the Armory presentation, many created with the participation of various artistic or other communities. These works, like the performative projects, often address the building's architectural or military history.

Across media, much work in the exhibition reflects on a layered exploration of materiality or exploits material properties as a vehicle to articulate social content, for example a frequently manifested interest in questions of gender. Many artists reconcile rigorous formal and conceptual underpinnings with personal narratives or historical references. Numerous works demonstrate an explicit or implicit engagement with art history, particularly the legacy of modernism. Using humble or austere materials, employing calculated messiness or modes of deconstruction, other artists present works distinguished by their poetic sensibility, as they discover pockets of beauty in sometimes unexpected places. And in oblique or allegorical ways, much work reveals political inflections, often contemplating the politics of aesthetics parallel to the aesthetics of politics.

A desire to locate meaning threads through these many modes and practices in what feels like a transitional moment of history. Rather than positing a definitive answer or approach, however, these artists exhibit instead a passion for the search, positioned in the immediate reality of our uncertain sociopolitical times. Drawing Klaus Kertess's cogent recognition of the Biennial's potential in impossibility into a broader statement, we might borrow a favored slogan of the Situationists (whose influence, in turn, resonates throughout the exhibition) to describe this sensibility: "Be realistic. Demand the impossible." It's the least we can do.

LESSNESS: SAMUEL BECKETT IN ECHO PARK, OR AN ART OF SMALLER, SLOWER, AND LESS

HENRIETTE HULDISCH

LESSNESS: SAMUEL BECKETT IN ECHO PARK, OR AN ART OF SMALLER, SLOWER, AND LESS

In Samuel Beckett's 1957 play *Endgame*, four characters cooped up in a seaside cottage spend their days in isolation. The two elders, legless and confined to a couple of garbage cans, look onto the petty bickering of the younger pair and reminisce nostalgically. Hamm and Clov, themselves no longer in their prime, engage in a habitual exchange that circles endlessly around an end that never arrives. The eponymous *partie* among the characters goes on until the play's closing words, uttered by the ornery protagonist Hamm, offer a simple but stark observation: "You . . . remain."[1]

Prefacing an essay surveying the landscape of contemporary American art with this famously bleak scenario admittedly bears a certain amount of risk. If Beckett's work has been attacked for its nihilist outlook and pessimistic depiction of human despair,[2] many critics have also pointed to what might be called a very reluctant *optimism* (an inappropriate yet deliberate Americanizing of this most European of writers is implied in my use of the term) informing his oeuvre.[3] *Endgame*, for example, concludes not with an ending but with a continuation. Similarly, one of the writer's most famous quotations is from the end of his novel *The Unnamable*: "Perhaps it's done already, perhaps they have said me already, perhaps they have carried me to the threshold of my story . . . where I am, I don't know, I'll never know, in the silence you don't know, you must go on, *I can't go on, I'll go on*."[4] The potent resonance of the last two phrases—evoking the inevitability of going on in the face of absurdity, as well as the lack of anywhere to go—provides an apt image for the production of art today, when, as is frequently claimed, everything has already been done, twice. Indeed, art since the late 1960s has been characterized by pervasive and increasing dispersal, decentralization, and heterogeneity. In a description that resonates with the present art landscape, Donna De Salvo writes of that period as having been defined by "the widespread desire among artists . . . to open up the object to the world, [making] works in myriad mediums and, perhaps more important, works whose materials and means are determined less by traditional media than by an effort to realize a concept or idea with whatever means are most effective."[5] The various debates on postmodernism that emerged at that time (and have since fallen out of fashion) attempted to describe the situation not only in terms of specific artistic practices and disciplines, but as a paradigmatic shift in the sociopolitical and cultural landscape. If we were to continue in this line of thinking, we would find ourselves mired in a permanent "post-," perhaps lamenting the loss of forward movement and innovation, or at least unable to ignore the stubborn fact that the contemporary artistic landscape remains distinguished less by overarching trends than by a multitude of heterogeneous practices, far-flung networks, and systemic structures that mobilize both the global and the local. However, as critics such as Noël Carroll have pointed out, postmodernism in the arts not only has taken quite different and occasionally contradictory forms in different disciplines (say, in dance and architecture), but more important, it describes no characteristics that were not already inherent to modernism.[6] Rather than theorizing any dramatic rupture (or so might a new argument hold), we must rethink the definition of modernism in more flexible terms, so that what used to be "post-" is now modern again.

The problem with this reasoning is that it still pursues a linear historical trajectory (tied to an idea of progress), an issue addressed in this catalogue in the essay by Shamim M. Momin, who proposes a different framework for thinking about time and its reflection in much contemporary art. Thomas McEvilley, in *Sculpture in the Age of Doubt*, also critiques such linear thinking, arguing that Western philosophy since antiquity has been marked by a series of pendulum swings between periods of certainty and doubt. In his account, what has been theorized under the header of postmodernism signifies not a dramatic break, but rather a cyclical development in which epistemological certainty makes way for pervasive skepticism and contingency.[7] This arena is where the notion of a Beckettian sensibility resonating within current artistic practice takes hold: an opaque and perhaps comic territory defined by ambiguity and contradiction rather than doctrine and orthodoxy.

Along these lines, what I am pursuing in this essay is not the broader question of historical (dis)continuity, but rather a stocktaking of a number of practices within the current artistic landscape. While it is inherently impossible to present a properly historical account of the present,[8] I argue that the first decade of the new millennium in the United States has been distinguished above all by polarization and by an accompanying sense of anxiety and uncertainty. In social, political, and economic terms, the country is marked by bitter division. The controversial war in Iraq is now in its fifth year and yet remains nearly invisible to vast numbers of Americans; there is broad economic growth in which the majority of citizens do not partake (and which has fueled the art market to vertiginous heights); increasing government interference with civil liberties is coupled with a shrinking public sphere; and an enormous accumulation of private wealth belies a decaying social fabric. Much of the work included in the 2008 Biennial operates within this insecure territory and could be described, to borrow another term from Beckett, as being informed by *lessness*.[9] By this I mean a direction in which artists are working (in diverse modes) that points to constriction, sustainability, nonmonumentality, antispectacle, and ephemerality. In addition, there is an evident tendency toward communal projects and systems of exchange that, while bridging geographically diverse artistic communities, are also deeply invested in local specificity.

These qualities may sound counterintuitive in a period defined by an increasingly international art market with its superexhibitions and megafairs attended by globe-trotting professional and leisure classes, and particularly so in the broader global context defined by multinational corporations and communications networks that presumably make the world smaller. Interconnectedness by way of information technology has without question facilitated an unprecedented exchange among different artistic communities from Los Angeles and Mexico City to Berlin, London, and New York, yet participation in these networks—much like the opportunity to actually go and see the increasing ensemble of international art events—is predicated on what in global terms is enormous socioeconomic privilege. Moreover, it is precisely the existence of such vast, overarching, largely ungraspable, and, to a certain extent, impotence-inducing structures—epitomized by international conglomerates and their economic (and hence political) power—that has precipi-

tated an engagement by many artists with the local and specific, as they stake out smaller pockets of activity in which a sense of agency can be maintained. Contemporary experience is structured by a series of related contradictions, as Jonathan Crary pointed out as early as 1994, in which "the stream of technological breakthroughs and of structural and commercial innovations in communications, biotechnology, and image- and information-processing within certain markets and territories will coexist relatively easily with escalating social barbarism, famine, plague, and fascism." He continues presciently, "Late-capitalist material life comprises immense numbers of ephemeral 'micro-worlds' that are at once seamlessly connected but also piercingly disjointed."[10]

The discussion that follows looks at three broad, often interlocking thematic and formal strands that I interpret as manifestations of a sensibility of less. First, there is the strong current of contemporary work in which artists, in addition to making objects for the gallery or museum, also maintain a set of practices that are collective, embodied, often ephemeral, and time based, and which to a certain extent seek to elude the market even while acknowledging an implication in its mechanisms. Second, the concept of "failure" emerges as a key motif in a range of works. Some of these engage with the disappearance of a grand narrative, be it modernism, the political ideologies of communism and socialism as realized in the former Eastern bloc, or utopian models that grew out of the 1960s counterculture; others, reacting on a more personal level, address failure as a condition profoundly out of key with the principal credos of American culture.[11] Last, there is the penchant for using modest, found, or scavenged materials—often in sculptural works and frequently articulated in formal terms—that exists in opposition to the sheer overabundance of *stuff* in this rampant consumer culture, a mode of working that invokes the waste inherent in the system and references, however subtly, postindustrial landscapes of decay and ecological damage.

SMALL SPACES OF ACTION

It is a commonplace that today traditional object making and post-studio work exist more or less comfortably side by side; project-based, socially invested practice is itself a fairly established category within the vastly scattered field of contemporary art.[12] What is notable, however, is that many artists consider both pursuing an auxiliary set of activities and making traditional objects for the gallery or museum to be equally important aspects of their output. These "expanded practices" take various forms: performances (Adam Putnam's endurance tests, in which he subjects his body to constraining pieces of furniture or architectural spaces); publishing projects and readings (such as those organized by Continuous Project or *Scorched Earth*, in which Seth Price and Cheyney Thompson are involved, respectively); concerts (noise performances by New Humans, or Rita Ackermann and Lizzi Bougatsos's art rock and performance collective Angelblood); and film screenings (William Cordova and Leslie Hewitt's bootleg video library or Walead Beshty's 24-hour presentation of disaster movies from the 1960s, 1970s, and 1980s). The impetus to produce works that are in constant flux or

that exist in the moment is no doubt a reaction to the enormous pressure many artists feel to produce discrete objects in order to sate the ravenous appetite of the market and cater to the increasing number of art fairs. Yet as they move their works out of the white cube of the traditional exhibition space, these artists do not necessarily formulate an antagonistic relationship with the museum or gallery, recognizing instead the complicated ways in which many oppositional practices are dependent on the very thing they examine (Okwui Enwezor has described the "parasitic relationship" between institutional critique and the institution).[13] Many artists' projects incorporate a critical reflection on the efficacy of alternative forms of activity—and express a certain amount of mistrust in perpetuating what might amount to an activist tourism[14]—even as they seek ways to foment communal networks and communication in small-scale settings that will have a certain amount of longevity.

Fia Backström embraces a number of practices beyond traditional object making that defy categorization as collaborations or performances in the conventional sense. Her recent works made under the moniker of "Eco Art"— installations riffing on the language of affordable mass-market design as epitomized, for example, by the international retailer Ikea—were created as "hanging proposals" for work by other artists, among them Roe Ethridge, Adam McEwen, and Kelley Walker, reconfiguring their pieces as playing cards, coasters, or even a Play-Doh version. For the 2005 installation *lesser new york* she gathered ephemera and documentation from artists, writers, curators, and others. Mounted by the artist as a complementary section to P.S.1 Contemporary Art Center's *Greater New York*, a survey of the city's art scene, *lesser new york* replaced the more market-friendly "piece-by-piece" presentation[15] with Backström's hanging strategy, employing "an approach between communist wallpaper and shopping window layout."[16] For *Herd Instinct 360°* (2005–06) at Andrew Kreps Gallery in New York, Backström created installation environments for invited lectures and performances given on three Sundays over the course of two months. The artist opened the events with a slide lecture that engaged with the complexity and possibility of community; reflecting on contexts such as consumer culture, Nazi gatherings, and nostalgia for certain protest movements, she also expressed profound suspicion of purportedly activist art that recoups political movements or images as style. In her narrated script, Backström's skeptical approach becomes apparent as she insists on the importance of art but also acknowledges a measure of absurdity: "Can it be that we are in a post-community state? But how can we be beyond something, which is everything. . . . But we cannot organize, we cannot produce, nor can we define and contain. . . . That's why this meeting is a failure instead of a parody . . . a fictive situation we may call art."[17]

Since 2001, when he started the Sundown Salon, regular gatherings at his geodesic dome house in Los Angeles, architect and educator Fritz Haeg has pursued a set of diverse projects informed by his interest in interdisciplinary exchange and in fostering simple gestures that have potentially large repercussions. His ongoing Edible Estates (2005–), for example, is an attack on the cherished institution of the American lawn, which is essentially a monoculture that wastes inordinate amounts of water and causes ecological

damage through the use of pesticides. Haeg offers his services, often with the help of local art organizations, in transforming ordinary suburban front yards into vegetable gardens; to date, he has created nine Edible Estates. Not simply an environmental project, Edible Estates facilitates community inter-action, carves out a space for agency, and engenders a wider conversation about the environment and our way of life—concerns at the heart of Haeg's practice. "A lot of people feel they have very little to say in the direction the world is going," he notes, "and private property is one of the few things that you have control over. How you use it can demonstrate the way you'd like the world to go, in some small measure."[18]

The artist collective Neighborhood Public Radio (NPR) is similarly invested in being locally specific. A nomadic pirate station broadcasting mainly in the San Francisco Bay Area, NPR points out that, in spite of using the airwaves, the radio is a geographically contained phenomenon with limited reach. Its programming encompasses broadcasts such as *State of Mind Stations*, in which listeners call in to report on their state of mind, and it enlists the help of community groups (for example, the Asian Women's Shelter in the Mission District) to moderate their own programs. The artists also teach workshops on how to make a basic radio transmitter to empower listeners to become broadcasters themselves. In fact, NPR's practice takes its cue from Bertolt Brecht's unfulfilled call that radio serve as an instrument of genuine two-way communication, rather than as mere entertainment listened to passively in isolation.[19] In a media landscape where most commercial stations in the country are owned by a handful of large conglomerates, NPR exploits the democratic potential of a medium that, while seemingly hovering on the brink of obsolescence, is still the only mass-communication device almost anyone can afford and the one we fall back on during times of crisis.

"TRY AGAIN. FAIL AGAIN. FAIL BETTER."[20]

The very idea of failure is in many ways antithetical to American culture, with its underlying tenets of Manifest Destiny, westward expansion, and unerring technological and economic progress. Acknowledgment of failure—even in the face of its most blatant manifestations—is almost taboo, an unmentionable that must be cast in terms of a temporary setback as one sol-diers on, "moving forward": it is permissible only insofar as it represents an obstacle to be overcome in a larger narrative of success. Complete failure, on the other hand—abject failure—is "not an option," as the popular quip goes. This is particularly evident in this time of political polarization in the United States, where the acknowledgment of failure is notably absent from public speechmaking. And yet, perhaps in a kind of return of the repressed, the theme haunts much contemporary artwork in both subtle and more overt ways.

Amie Siegel's *Яɑɑ/DDR* (2008) is an experimental documentary that investigates the former East German state. Tracing the historical German fascination with American Indians, she shows how appropriation of the dress and customs of colonized Native American cultures resonated with East Germans living under the totalitarian regime, who adopted them partly as a

veiled act of resistance. Post-unification, this role-playing has taken on another significance for many participants who perceive the German Democratic Republic as a country that was robbed of its traditions by a Western power. The film integrates scenes of the former secret service head's private office, shots of outmoded Stasi surveillance equipment, and glimpses of the ruinous official radio complex in East Berlin—all symbols of a once formidable apparatus of control that ultimately fell like a house of cards. The East's modernist architecture, signifying a utopian, social reformist project whose promise was never fulfilled, is a theme that informs this film as well as Siegel's earlier video installation *Death Star* (2006). In the latter, which is shown on five flat-screen monitors, long, ominous tracking shots taken in the hallways of five historically fraught German buildings—including Hitler's giant recreational resort for the German people erected by the Baltic Sea—hint at what Siegel calls the "dark side of modernism."[21]

An interest in modernism also informs the work of Corey McCorkle, who mines the intersections of art, architecture, and design—the strict separation of which is a relatively recent phenomenon[22]—by investigating historical movements that sought to implement social transformation. In the video installation *Bestiaire* (2007), shot in an abandoned zoo on the outskirts of Istanbul, the skeletal outlines of futuristic animal abodes stand in for larger misfires in modernist city planning and, perhaps, the drive of the Turkish state toward westernization. Whereas the Istanbul work engages with a municipality, other projects examine groups like the Scottish commune Findhorn (born out of the 1960s counterculture) and the paranormal, as well as the religious ideas of the Oneida Perfectionists (a colony founded in upstate New York in the mid-1800s). In each case McCorkle evidences a sincere appreciation for the reformist ambitions of utopian communities; however, he also addresses their sometimes far-fetched aspirations and practical shortcomings, and tracks moments when progressivism is recast as a marketable lifestyle.

Ellen Harvey's recent project *The Museum of Failure* (2007–) grows out of her assertion that any work of art falls short of the artist's ambitions, being inevitably haunted by a "better version of itself."[23] Part one of the ongoing project, *Collection of Impossible Subjects* (2007), depicts a series of elaborate picture frame engravings in a mirrored wall, portraits of nothing that form, Harvey writes, "a tribute to my sense of inadequacy when faced with the burning issues of the day."[24] Through a single cutout in the wall, the viewer looks onto a large painting behind it titled *Invisible Self-Portrait in My Studio* (2008). Against a red background, Harvey reproduces an identical salon-style hanging of framed photographs of the artist taking a picture of herself in the mirror; in each, the image is erased by the painted reflection of the flash in the glass. Harvey's futile self-portraits are a testimony to her interest in the difficulty of adequate self-representation while they also, paradoxically and gleefully, reassert painting, acknowledging at once the medium's often-postulated impossibility as well as the almost comic redundancy of its defense.

Since the 1970s Michael Smith's videos and performances have featured his alter ego "Mike," a bumbling antihero whose indefatigable enthusiasm and earnest embrace of the American dream stand in inverse relationship to his achievements. In the short video *Portal Excursion*

(2005–07), Mike's ambitions are invigorated by technological progress in the form of educational shareware published by MIT for "self-learners around the world," signifying his renewed hopes of fashioning, against the odds, personal success. Harry Dodge and Stanya Kahn's collaborative videos have featured a comparably hapless character in Lois, a needy stoner played by Kahn. In their recent *Can't Swallow It, Can't Spit It Out* (2006), Kahn performs as another, Valkyrie-like protagonist sporting a Viking helmet replete with fake braids and a green polka-dot dress. She is trailed around Los Angeles by an invisible videographer (Dodge) in search of "action" à la the Rodney King police brutality incident, leading her to a series of desolate, unremarkable public or corporate spaces devoid of people and human interaction. Although scathingly funny, the piece is marked by an underlying sense of dread as the woman delivers rambling monologues suffused with violent fantasies, dreams, and fears, all the while pointing toward eerie and banal scenes in her futile quest for an ennui-busting event. For all its loquacity, *Can't Swallow It,* like Dodge and Kahn's earlier videos, is concerned foremost with failures of communication and the inability to express oneself literally, interpersonally, and publicly. The video, they write, is "basically a portrait of civilian anxiety in a time of war. We tried to capture or translate the feedback loop of grief and paralysis that people are feeling . . . trying to establish a sense of agency as a citizen."[25]

Dodge and Kahn's metaphoric engagement with the unraveling of the American social fabric is as subtle as Spike Lee's is incendiary. His 4-hour documentary *When the Levees Broke: A Requiem in Four Acts* (2006) presents a scathing indictment of the government's response to Hurricane Katrina in 2005. Originally shown on cable television a year after the tragedy in New Orleans, through a series of interviews with scientists, activists, and residents Lee's film documents how the disaster was preventable. He argues that the slow and inadequate emergency relief effort was tinged by racial prejudice and class bias, bearing witness to a callous indifference toward a seemingly expendable part of the citizenry, predominantly black and poor, left behind in a drowning city.

As Lee's images linger on remnants of Katrina's destruction—such as heaps of splintered wood strewn with defunct household appliances—they convey the eerie, apocalyptic overtones of nature's revenge wrought on an out-of-control consumer culture. Gretchen Skogerson's video *DRIVE THRU* (2006) takes a more elegiac stock of the damage inflicted upon the Florida coast by Hurricane Ivan in 2004. In a series of nocturnal scenes, she films broken neon lights flickering futilely above shuttered construction sites and unremarkable commercial settings, forming a landscape of empty signs.

MODESTY OF MATERIALS

Beyond ecological disaster, the contemporary American landscape also bears the scars of overconsumption and disposability, epitomized by endless strip malls, rampant suburban sprawl, undistinguished corporate box architecture, and the rusty ruins of industries that have moved operations elsewhere. Rebecca Solnit has portrayed how nature is incrementally taking back the

empty spaces in the decaying inner city of Detroit, once the proud center of American industrial might and now a barren shell thrown into stark relief against its affluent suburbs.[26] Her account of the newly "pastoral" Motor City also illustrates the rapidly widening gap between the haves and the have-nots in the United States. The accelerated amassing of wealth at the top socioeconomic levels plays out against the backdrop of a service economy flooded with mountains of *stuff* largely manufactured abroad but still exacting a considerable environmental toll at home. These entropic, postindustrial settings and starkly contrasting landscapes provide fertile ground for many contemporary artists whose work is distinguished by a certain modesty of materials and scale and relies on scavenged, recycled, or cheap mass-market goods. Working within a tradition that encompasses both California funk art and Arte Povera, these artists, many of whom reside on the West Coast, wrest a wallflower beauty from detritus and debris while simultaneously wrestling with formalist concerns in sculptural practice.

Alice Könitz's recent sculptures draw on the vocabulary of the ubiquitous mid-century architecture in Los Angeles, the artist's adopted city. Making meticulous use of cheap materials such as melamine, plastic, and Mylar, her works hover between sharp-angled elegance and flimsy materiality, echoing the built-in obsolescence of boxy corporate architecture. At the same time, they clearly manifest Könitz's appreciation for the tarnished glamour of modernism's project. A group of 2006 pieces exhibited together under the title *Public Sculpture* present themselves as models for outdoor structures; they were inspired in part by Century City, an LA business and commercial district that was once a Twentieth Century Fox backlot. One of the works, *Mall Sculpture*, referencing the essentially paradoxical construction of a commercial public space, comprises four long, hexagonal shapes in brown felt and columns that are covered in gold construction paper and propped on the floor. Könitz's investigation into the interstices of public and commercial space is carried further in her *Public Sculpture* (2006), consisting of a performative intervention and a structure of gold discs affixed to three poles of varying height. Installed outside a twenty-four-hour doughnut shop near downtown LA, the piece blends almost seamlessly with the business's 1970s decor. Northern Californian Mitzi Pederson has a similar knack for employing mundane, workhorse materials to precariously beautiful effect. Her formal investigation of tension, suspension, and balance results in works such as *untitled (ten years later or maybe just one)* (2005), a stack of broken cinder blocks whose rough edges are covered with bluish glitter, and *untitled* (2006), in which sheets of bent plywood and stacked cinder blocks are complemented by almost tacky iridescent cellophane.

Charles Long has recently taken inspiration from a part of the LA topography very different from that mined by Könitz, namely, the Los Angeles River. In some places no more than a trickle sheathed in concrete and infamously polluted by garbage and urban runoff, the river water has collected in an area near the artist's house, forming an urban biotope replete with fish and wildlife as well as trash washed up with the winter floods. "It is an apocalyptic, surreal jungle," says the artist.[27] In an untitled series of sculptures, Long has fashioned tall, slender forms from this flotsam—plaster and trash,

cigarette packets and butts, feathers, scraps of plastic, and foil wrappers—to emulate accumulations of bird droppings. Despite their scatological overtones, these sylphlike pieces perched on gridded structures are poetic and elegant, their underpinnings of ecological damage and renewal reconciled with such classical sculptural concerns as volume, line, and balance.

Ry Rocklen's sculptures consist almost entirely of materials scavenged from the street or found in the trash and then altered by the artist in subtle but profound ways. In *Refuge* (2007), for example, the metal holes in a stripped mattress box spring have been meticulously filled with nails, forming a smooth, shiny surface that bristles underneath with a stratum of protruding spikes; in *Hideaway* (2006), five long acrylic fingernails painted with a flower pattern and inlaid with tiny rhinestones adorn a skeletal lawn chair. Like Long's sculptures, these compositions—poetic, wry, slightly surreal, and treading the line of the readymade—employ humble materials to engage in a formal exploration of sculptural properties.

The same is true of the works of Jedediah Caesar, who makes sculptural blocks by encasing scraps of wood, metal, plastic, and desiccated household trash in clear or pigmented resins. The artist pours the bonding material into cardboard boxes filled with his sundry materials and then cuts smaller gemstonelike or geometric blocks from these large pieces, which he stacks and assembles on the floor. *Dry Stock* (2007), made for the 2008 Biennial, consists of a series of thin slabs in opaque white mounted along the wall. From its ossified cross sections emerge beautifully veined, involuntary mosaics that seem to defy their origins in debris and yet retain the tension between an industrial logic of machine-made lines and the messier economy of thrift and recycling.

If Caesar's structures evidence traces of external systems of manufacture, assembly, distribution, and dispersal, Phoebe Washburn's large-scale installations create their own absurdist ecosystem of production and decay. *Regulated Fool's Milk Meadow*, an enormous "grass factory" that in 2007 filled Berlin's Deutsche Guggenheim gallery, is a functional—if notably inefficient—system for growing small plots of sod. Like many of Washburn's structures, the factory is made from pieces of found and recycled material, in this case scraps of wood clamped and screwed together. The grass plots are grown and then placed on the factory's roof, where they dry out and decompose over the course of the exhibition. The New York–based artist takes inspiration from what she calls "minor architecture": street vending carts, construction sites, and the city's towering garbage piles.[28] While her work thus touches on ecological issues of overproduction and waste, she emphasizes that her scavenging is primarily a matter of convenience. Indeed, the effort and resources involved in shipping, dismantling, and reshipping massive amounts of used wood render the frugality of its acquisition absurd, and yet ironically this contradiction may present an even more potent comment on the logic of consumption.

Recently, Anne Ellegood has made an argument for a direction in sculpture distinguished by its freewheeling use of materials and unabashed engagement with formal concerns. In a description germane to many of the pieces discussed above, she writes that "works successfully shuttle between these two positions and exist formally as autonomous objects while at the

same time remaining tethered to social content through the artists' very particular material choices and cultural signifiers, and, in the process, embrace an uncertainty of meaning, multiple meanings, and meanings in flux."[29] Indeed, if any collective description can be applied to the multitude of practices in contemporary art (and presented in the 2008 Biennial), it is a post-doctrinaire, anti-ideological, and nonorthodox stance. Many objects and projects are conceived in a conceptual framework but filled with narrative, anecdotal, or historical content. And while often visually restrained or made using humble materials, many works are also invested in an austere beauty. There is a sense of weariness of grand proclamations and braggadocio—a preference for the historical footnote, perhaps, rather than the totalizing story—that is unsurprising in an environment where, as of very recently, contemporary art no longer appears to have any enemies,[30] and the oppositional gesture itself runs the risk of amounting to little more than a self-congratulatory pat on the back. This is why, I would argue, much recent art reflects on movements that signify a bygone era of utopian aspiration while at the same time engaging critically with the efficacy of an art put into the service of any such doctrine (perhaps wary of the baby boom generation's triumphant reconciliation of revolution and selling out). To pursue the Beckettian metaphor, if we find ourselves in a scenario marked by the experience of loss, by doubt, or by a fundamental absence of certainty or meaning, it is not pessimism, detachment, or irony that defines the moment but persistence and belief—belief in staking out small areas of meaning and agency, however futile or absurd it may seem at times, and going on, for better rather than for worse.

NOTES

1. Samuel Beckett, *Endgame* (1957), in *Samuel Beckett: The Grove Centenary Edition*, vol. 3 (New York: Grove Press, 2006), 154.

2. György Lukács condemned Beckett's work for depicting "an idiot's vegetative existence" and "the utmost pathological human degradation" endemic to capitalism. Lukács, *The Meaning of Contemporary Realism*, trans. John and Necke Mander (London: Merlin Press, 1963).

3. See for example Wolfgang Iser, "When Is the End Not the End? The Idea of Fiction in Beckett," in S. E. Gontarski, ed., *On Beckett: Essays and Criticism* (New York: Grove Press, 1986), 46–64.

4. Beckett, *The Unnamable* (1949–50), in *Samuel Beckett*, vol. 2, 407. My italics.

5. Donna De Salvo, "Where We Begin: Opening the System, c. 1970," in De Salvo, ed., *Open Systems: Rethinking Art c. 1970*, exh. cat. (London: Tate Publishing, 2005), 13.

6. Noël Carroll, "Periodizing Postmodernism?" *Clio* 26, no. 2 (Winter 1997): 143–65.

7. Thomas McEvilley, "The Art of Doubting," in McEvilley, *Sculpture in the Age of Doubt* (New York: Allsworth Press, 1999), 3–30.

8. See Carroll, "Periodizing Postmodernism?" 160. See also Peter Gay, *Modernism: The Lure of Heresy* (New York: W. W. Norton, 2008).

9. Beckett, "Lessness" (1969), in *Samuel Beckett*, vol. 4, 375–79. I use the term here for its evocative connotations rather than for its significance to Beckett's story, which comprises 120 reshuffled sentences arranged in purportedly random order.

10. Jonathan Crary, "Critical Reflections," *Artforum* 32, no. 6 (February 1994): 59.

11. Scott A. Sandage traces how the notion of "failure" in the United States has transformed from being a term used exclusively in connection with business to an attribute describing a deficiency in one's very identity. Sandage, *Born Losers: A History of Failure in America* (Cambridge, Massachusetts, and London: Harvard University Press, 2005).

12. California College of the Arts (CCA) in San Francisco offers a social practice track within its MFA program; Portland State University added this orientation to its MFA course in the fall of 2007.

13. Okwui Enwezor, "The Postcolonial Constellation: Contemporary Art in a State of Permanent Transition," *Research in African Literatures* 34, no. 4 (Winter 2003): 76.

14. Hal Foster has criticized the ostensibly collaborative relationship in community-based projects that do not question the artist's role of authority. See "The Artist as Ethnographer," in Foster, *The Return of the Real: The Avant-Garde at the End of the Century* (Cambridge, Massachusetts, and London: MIT Press, 1996), 171–203. For an overview of critical assessments of art as social practice, see Miwon Kwon's "The (Un)Sitings of Community," in Kwon, *One Place after Another: Site-Specific Art and Locational Identity* (Cambridge, Massachusetts, and London: MIT Press, 2002), 138–55.

15. Conversation with the artist, Berlin, June 21, 2007.

16. Email correspondence with artist, November 11, 2007.

17. *Herd Instinct 360°*, exh. flyer, Andrew Kreps Gallery, New York, November 27, 2005, December 11, 2005, and January 22, 2006.

18. Lottie Moggach, "Art That You Eat," *London Paper*, June 20, 2007, http://www.thelondonpaper.com/cs/Satellite/london/videos/article/1157147976607?packedargs=suffix=ArticleController.

19. Bertolt Brecht, "The Radio as an Apparatus of Communication" (1932), in John Hanhardt, ed., *Video Culture: A Critical Investigation* (New York: Visual Studies Workshop, 1986), 53–55. Brecht's invocation of the radio's utopian potential has been repeated in similar ways with the advent of new forms of mass media, from television and video to the internet.

20. Beckett, *Worstward Ho* (1983), in *Samuel Beckett*, vol. 4, 471.

21. Conversation with the artist, Berlin, June 22, 2007.

22. See Helmut Draxler, "Letting Loos(e): Institutional Critique and Design," in Alexander Alberro and Sabeth Buchmann, eds., *Art after Conceptual Art* (Cambridge, Massachusetts, and London: MIT Press; Vienna: Generali Foundation, 2006), 154.

23. Ellen Harvey, 2008 Whitney Biennial artist's statement, November 2007.

24. Ibid.

25. Harry Dodge and Stanya Kahn, "Harry Dodge and Stanya Kahn on Making Comedy in a Time of War," *Modern Painters* 21 (November 2006): 83.

26. Rebecca Solnit, "Detroit Arcadia," *Harper's Magazine* 315, no. 1886 (July 2007): 65–73.

27. Vesela Sretenovic, "Charles Long in Conversation with Vesela Sretenovic," in Charles Long, *More Like a Dream Than a Scheme*, exh. cat. (Providence, Rhode Island: Brown University, 2005), 21.

28. Kimberly Davenport and Phoebe Washburn, "Excerpts from Conversations between Phoebe Washburn and Kimberly Davenport," in *Phoebe Washburn: True, False, and Slightly Better*, exh. cat. (Houston: Rice University Art Gallery, 2003), 24.

29. Anne Ellegood, "The Uncertainty of Objects and Ideas," in Ellegood, *The Uncertainty of Objects and Ideas: Recent Sculpture* (Washington, DC: Hirshhorn Museum and Sculpture Garden, Smithsonian Institution, 2006), 22.

30. See Martin Gayford, "Hugging the New," *Apollo* (May 2007): 80–81.

TIME CHANGE

SHAMIM M. MOMIN

Time is Fast, Space is Slow.

—Vito Acconci[1]

Time to get you know what. Time to get you know what. Time to get you know what. What, what, what. What. Time to get you know what. Time to get you know what. Time to get you know what . . . So are we there yet? No. So are we there yet? No. So are we there yet? No. So are we there yet? I have No way. No.

—Matt Mullican, *Zurich Performance 2003*[2]

Nearly a century ago, Albert Einstein proposed that the mass-energy and momentum of celestial bodies—a black hole, for example—produce a distortion of the space-time continuum. The prediction was one part of Einstein's general theory of relativity, which, as many might recall from high-school science, initiated revolutionary changes in the way we think about the world. In recent years, astrophysicists have observed a number of gravitational effects around neutron stars that have provided unprecedented evidence of Einstein's predicted distortion, which had initially been considered too slight to measure and thus true primarily in a mathematical sense. Einsteinian thought has long held poetic appeal, and this discovery has stoked the fires of its potential ramifications. If space-time warps, can it also bend back on itself? Are all time spans lapidary, overlapping cycles of intersection and convergence? In thinking about the present, will we have to accept in due course that everything already always was, forever—or something to that overwhelming and terrifying effect?

A similarly transformative reconfiguration of time and space is one of the central points connecting many of the works in the 2008 Whitney Biennial, and there is no more pressing moment than the present to address why this concept illuminates, and troubles, so much contemporary art. Although a thorough historical contextualization of this phenomenon is impossible here, I would argue that this reconfiguration stems from a set of conditions that emerged from the post–World War II period and which significantly changed not only how our society is structured but also how it informs, and is informed by, visual culture. As a broadly illustrative example, Robert Smithson, in his 1966 treatise "Quasi-Infinities and the Waning of Space," created a complex, fluid system of images and text as a visual analogue to his analysis of spatio-temporal decentering in the visual arts and culture of the period.[3] Though typically (and perhaps excessively) referenced in recent writing and artwork for his ideas about entropy, Smithson is arguably more significant for his prescient recognition of the obsession with time that pervaded 1960s culture. Emblematic of the artist's thinking, "Quasi-Infinities" describes a world that was reconceiving notions of the temporal on multiple fronts, the most important of which, in critical terms, was the revision of absolutes in scientific discourse that since the 1930s had filtered broadly into the popular imagination.[4] As in the artist's other writings, many of the metaphors in "Quasi-Infinities" derive from the physical rather than the biological sciences, which rely on life span, human or animal, as a standard measure. As a result Smithson's idea of "quasi-infinities" reflects a different temporal shape, one that privileges

complex, networked motion and possibility (which can be described as rhizomatic, or weblike) rather than a standard evolutionary timeline.

Although Smithson's choice of the metaphor of entropy—broadly defined as a trend to disorder within a closed system—ultimately proved too neat to encapsulate the full extent of these philosophical shifts, he was otherwise on the right track. The investigation of static ideas of space and time represented in his writings and art was, in the decades that followed, paralleled by transformative technological developments, most significantly the birth of the Information Age. The transition to a computer-based, networked world—and the resulting impact of cyberspace on social and economic structures—literalized a fractured, open-systems thinking (simply put, a feedback system that continuously interacts with its environment to produce newly "informed" output) and brought about major changes in our understanding of space and time. These momentous ideas echoed throughout subsequent philosophical and theoretical writings and became over successive decades a significant literary conceit spanning various genres,[5] reflecting both the possibilities as well as the anxiety that continues to shape the critical framework for the present world and how that world is reflected in contemporary art.

The Newtonian characterization of time and space as absolutes—in truth, something hypothetical to begin with and discarded decades ago in science—retained currency much longer in cultural interpretation, including in the visual arts. By the mid-twentieth century, however, philosophical inquiry had mostly dismantled a purely causal temporal logic, proposing instead that multiple interpretative modes are at play in our engagements with the past, and in the relationship of the past to the present and the future.[6] Art historian George Kubler, with unusual analytical distance, described an ensuing temporal anxiety so prevalent in the sixties as to be largely invisible to the cultural producers so affected by it. In the arts, Kubler suggested (as did Smithson, who often cited him), the crucial effect of destabilizing a singular, causal progression was that it defied the logic of the modernist project, with its viselike grip on interpretive thought and production. "At any past moment," wrote Kubler, "what was then present may be regarded as consisting mainly of latent possibilities. Equally truthful, it may be regarded as consisting mainly of explicit actualities."[7]

The philosophical conceit of "simultaneous potentialities" was doubtless influenced by earlier developments in scientific theory, such as those related to the superposition of states, the notion of indeterminacy, and the observer effect. Although the complexities of these scientific investigations are often lost in pop-cultural translation, their symbolic and metaphoric potencies lent themselves to temporal rethinking at a postwar moment primed to receive it. Thought experiments such as the increasingly popularly invoked Schrödinger's cat (part of a 1935 thought experiment questioning a paradox of quantum mechanics) were coeval with burgeoning technological developments that likewise were reflected in visual culture.[8] This emerging language of "simultaneous potential," "complexity," and "reflexive systems" evinced a profound recalibration of notions of temporal progress; the idea that the act of viewing may have not just a critical but a *determinate* effect on an outcome, for example—vis-à-vis a slight misreading of Werner Karl Heisenberg's

uncertainty principle and the observer effect, which introduced the concept of "temporal paradox"—was an important influence on the fundamental shifts in art that began at that moment. Susan Sontag acknowledged this influence, describing in her essay "One Culture and the New Sensibility" (1965) a cultural field recognizing and appreciating anew the relationship between scientific innovation and art, particularly through the writings of engineers, artists, and theorists such as Buckminster Fuller, John Cage, Marshall McLuhan, and Roland Barthes, among others.[9] Smithson, for instance, made frequent reference to Fuller's concepts: his "vectoral" geometry; his models of form that integrated natural and scientific systems into plastic arts; his proposition of fluid mapping (rather than mapping fixed points).[10] In Fuller's words, "Humans still think in terms of an entirely superficial game of static things—solids, surfaces, or straight lines—despite that . . . Science has found no 'things'; only events. Universe has no nouns; only verbs."[11] And as influential as Fuller might have been in the sixties, he is perhaps even more so today; such language and concepts can be used to characterize a large segment of current artistic practice, and, indeed, Fuller is frequently referenced, implicitly and explicitly, by many artists in the 2008 Whitney Biennial specifically.

From a current vantage point that proffers a clearer view of the changes in these various fields, recent scholarship has reframed the foremost concern of art in the sixties as a reimagined sense of time. It has been proposed that the idea of the spatiotemporal shift was more formative than the commonly accepted, linear narrative of the mute, industrialized object posed against the expressive abstraction of the preceding practice. Taking a broader view, moreover, some scholars have tracked this paradigm shift against the political and cultural conditions of the era, both the uncertainty of that transitional historical moment and the beginnings of the globally transformative technological evolution.[12] Although here I use "the sixties" to reflect on certain aspects of contemporary artistic practice, the emphasis is on the idea of temporal transformation inherent in the period's art, not specific artistic forms. References to Minimalism in recent artwork, for example, have been misinterpreted by some observers as a purely formal reinvestigation of, say, Donald Judd's "specific object," when in fact they are part of a general orientation in contemporary art that seeks a better grasp of the disquiet of that moment and, in turn, of the present as well.

To that end, the recent invocation of Minimalism has evolved into a wide-ranging investigation of modernist forms, turning the rethinking of the nature of time toward the goal of unpacking that larger, decaying project. Contemporary artists, acutely aware of the Gordian knot that is the modernist monolith—the trope of its own making—have accordingly refined and reframed their projects as investigations of the conditions of modernity, ongoing negotiations rather than static sets of progressive events (Fuller's "verbs" instead of "nouns").[13] This is revealed in part through an increasing number of references to the architecture and sculpture of the 1950s, as many artists locate the source of our temporal anxiety in the immediate post-World War II period, when the failures of modernism's causal systems were first beginning to be felt. Current art resists the teleological dimension of modernism,

which ultimately proved unsatisfactory to grasp the complex, unstable nature of the world despite all authoritarian efforts to the contrary. Yet dismantling modernism's progressive intent has also uncovered instabilities of meaning, lingering questions that require constant negotiation but often stubbornly resist resolution. In the wake of the troubling of faith in grand causal models (God, Civil Society, Revolution, Progress), a kind of crisis of meaning has unfolded. Where does one locate, or how should we define, contemporaneity? Anxiety about a world situation fraught with uncertainty and threatened by catastrophic events supervenes in current art; for example, the fragility and sense of vulnerability within much of the work in the 2008 Biennial reflect this temporal tenuousness—the sense many artists feel of being in transition. From a contemporary perspective, one can see how this still-developing context continues to inform our situation and concurrent artistic practice. Suffering from a similar obsession with time, our networked, digital culture at once celebrates and laments the potential of the expanded experience of time (fractured, rhizomatic, nonteleological) to (re)structure our lives. One important distinction in the present era, however, is awareness. As Pamela Lee has observed, whereas in the 1960s "this structure [was] registered at the level of reception rather than production, consumption rather than intention, and organization, rather than representation," contemporary artistic practice is deliberate at all levels.[14]

That the reconception of time has profoundly shaped much of the art being made today is most evident in sculpture and installation—both in the works in this exhibition as well as that made in general in the past decade— but it is also reflected across media, genres, and content. It is inextricably linked to—in fact, it has arguably helped produce—the particular ways we define space in our world. In this regard, two closely related categories of work can be distinguished, both predicated on the concept of simultaneous modes in form and function. In the first category are those artists who use sculptural form to construct a kind of "theater of the moment," in which the lexicon of formal artistic practice is reintegrated into an investigation of time and process. The theatrical provides a framing structure, not in the sense of dramatics but in the staging of time through props and backdrops typical of that framework; the idea of temporal activity and movement is initiated within a static construct, but the objects used are a model for, not an actual translation of, the content of the work. This staging often references vernacular architecture and urban landscape through a literal, topographical presence as well as a psychogeographical tracking, which incorporates concepts of duration and movement rather than fixed forms. Another way to think of this staging is as "spatialized time": not a fixed state of form, but a mode of working that is necessarily fluid, fragmented, and unresolved.

The second category includes artists who follow a more general trend toward nonlinear paradigms of seriality: a systems-based versus a medium-specific production, as illustrated, for example, by numerous references to the temporal dimensions of Minimalism (such as endlessness, duration, repetition). In this line of thinking, artists are creating open systems that shape both form and content in a manner not unlike (or perhaps analogous to) many of today's rampant new communications technologies. This

includes both internalized networked systems that direct the production and content of the work, and, in a kind of inverse of that scheme, networks that extend into the world through external, collaborative practices. At times a recursive mode emerges that synthesizes the two strands into a "do-over" approach, both strategies discussed in greater detail later in the essay.[15]

STAGING TIME

Actuality is . . . the interchronic pause when nothing is happening. It is the void between events.
—George Kubler, *The Shape of Time: Remarks on the History of Things*[16]

Michael Fried's famous text "Art and Objecthood" (1967) is a seminal illustration of the spatiotemporal anxieties of the sixties. A denunciation of the phenomenological staging of Minimalist sculpture, Fried's frankly hostile view of the "temporal" was based on the idea that art must have purity of presence: read, timelessness. In its proper state, according to Fried, art would test only the limits of its discrete medium and, thus, retain what he called "presentness." This achievement Fried construed as a redemptive one: a moral stance that framed time as the culprit behind all of Minimalism's ills—the theatricality of the objects, the endlessness inherent in industrial production, the notion that meaning exists in the space around an object and is activated by the viewer's presence rather than held autonomously within the object itself.[17]

From our vantage today, the tidy opposition of Postminimal work to Minimalism, and even of Minimalism to modernist abstraction, hews to an idea of progressive evolution (what Smithson called "ideological" time)[18] when in fact these practices are linked by common concerns and a fluid dialogue, albeit a slippery and at times rather tense one. In their often durational, performative works, for example, artists and groups as varied as John Cage, Vito Acconci, Eva Hesse, Bruce Nauman, and the Situationists have embraced an enhanced form (or nonform) of the precise quality in the Minimalist object maligned by Fried, who claimed that "art degenerates as it approaches the condition of theater" and, presumably, thereby ingratiates itself with the viewer.[19] The very aspect Fried defined pejoratively as what lies between the discrete arts is exactly what these artists sought to capture: a perverse, interstitial place where form constructs meaning beyond itself, and where a slippage between the arts becomes the ultimate corruption of its autonomous purity. For many contemporary artists, too, it is this "pollution" of form by idea that defines their work, and the "gap" between them where their work gains greatest purchase.

While much contemporary art structurally reflects Smithson's so-called non-Sites—constructions or installations that "activated" a dead object with static forms, visually mimicking the possibilities of a larger, external system—it does so in almost the opposite way, by making performance static. That is to say, an artist captures a transient moment within a set of specific forms, proposing the idea of that moment as the work itself, both in terms of its

creation and its interpretation. This mode parallels the evolution of art "installation" from its earlier function as a noun to that of a verb; rather than a single compendium of objects in an immersive environment, the new characterization of installation comprises a set of works, assembled in various ways, that generates a discourse and is activated by the viewer's presence. This is the strategy employed by Carol Bove in her staged collections of historically referential and personally meaningful objects, which she arranges on platforms or shelves in spare, delicate balance. Through the historical resonance of the objects—for example, used cult books (primarily from the 1960s and 1970s) or bits of driftwood, plexiglass, and found concrete blocks arranged to evoke modernist sculptural styles (from Constantin Brancusi to Donald Judd)—the collections assume a patina of accumulated identities, desires, and ideals, plumbing the depths and power of collective memory. In this way the objects function in concert as props from a rehearsal of a life we know, knew, or, perhaps, desire.

In Bove's *Driscoll Garden* (2006), a planklike platform presents a carefully arranged set of simple objects: stacked concrete and plexiglass cubes adorned with feathers; a magazine photograph of Mia Farrow propped against the wall, suggesting the presence or influence of some individual identity; a reference book of lunar phases open to a gently sensual image of the curving moon, elegantly evoking the passage of cosmological time. Calling to mind the grand proposition of the modernist "sculpture garden," this domestically scaled collection of knickknacks wittily subverts that monumentality, implying a kind of rehearsal for a larger event but remaining a model of itself—what Bove calls a "scaled-up small thing."[20] Similarly, the installation of *The Night Sky over Berlin, March 2, 2006, at 19.00* (2006) uses long, vertically hung bronze rods to construct a mathematically precise schematic of the stellar constellation at a particular moment. Set above a diorama of objects at eye level, the installation's unnervingly direct visual relationship calls attention to complementary shifts in temporal scale: the immediacy of the viewer's interaction before it, the histories (typically of recent, familiar decades) that the objects suggest, and the infinity of cosmic time. The artist has noted that "the sixties and the millennium . . . share a fascination with each other for me. We're the objects of their fantasies. I think about completing transactions that were initiated then . . . in a way that addresses them but doesn't explain them or put them to rest."[21] Rather than defining a linear evolution of events, Bove investigates how desires recur in the mass unconscious of the cultural field, creating revolutions of time that reflect back on reflecting back. The sound piece *The Future of Ecstasy* (2004), for example, includes a text by Alan Watts, known for his popularizing exegeses on Zen Buddhism; written in the past (the 1960s), it imagines a future narrative (in the 1990s) that is itself now part of our past. The work thus becomes a malleable, living archaeology of recent cultural and art history that is less a commentary on past events and aspirations than a means of collapsing, condensing, and displacing temporal elements in the service of renewed examination.

Bove strives for what she calls an "imperiled quality,"[22] a vulnerability that maintains a temporal tension. In *Utopia or Oblivion* (2002) stacked Knoll tables recall Buckminster Fuller's concept of "tensegrity," defined as the qual-

ity of being stable only through extension.[23] As Bove describes it, the work branches out in space and time as "part of a three-dimensional grid that exists everywhere but is only apparent in this one place."[24] Thus, the world is the system, and time is all around us, not just ahead or behind. Bove engages books in an analogous but perhaps inverted manner. As an individual object, the book can be seen as part of an infinite system—a work such as *Conversations with Jorge Luis Borges* (2002) evokes that writer's similar obsession with both books and infinite systems, among other things; yet Bove also suggests that while books point endlessly backward and forward in time (in terms of the personal collector whose world they map), they are also discrete entities whose "world" can belong to, or be grasped by, no single reader.

This "in-between" subjectivity is also central to the oeuvre of Matt Mullican, who has been searching for the liminal space "where one thinks" for more than thirty years.[25] Mullican's work brings together his cosmology sculptures, drawings, architectural installations, and performances, both his own and those of an alternate personality he calls "That Person." These disparate media are linked via the idea of the model, as in Bove's work, a mode of working that recurs throughout the 2008 Biennial. According to Mullican, a model is not a static object but a "metaphoric thing, like a language."[26] "My cosmology," he continues, "is a model for a cosmology; it is not a cosmology [in and of itself]."[27] In other words, for Mullican this strategy is a discursive system more akin to scientific modeling (a mathematical construct used to compare processes) than to a finite, architectural form. The artist constructs these orchestrated belief systems using both the talismanic power of objects and images as well as the influence of the networked digital environment, what he describes as the "hypnotic world."[28] The cosmology sculptures, variously formed in glass, metal, and concrete, employ a rich system of symbols to create a map of that world, which he then converts into three dimensions—objects, drawings, models, and architecture—to "[allow] you to . . . revolve it, and walk into it."[29]

Throughout Mullican's oeuvre, memory and language serve as sources for topological as well as temporal metaphors. He cites the idea of the memory palace, for example, referring to the long-standing place of architecture as a favorite metaphor within modernist metaphysics, but expands on the concept, which for him symbolizes not a fixed spatial form but rather transition and motion through space. In *Five Suitcases of Love, Truth, Work, and Beauty* (2006), bedsheets—which form what the artist calls a "skin" when hung horizontally, or a "wall" when hung vertically—constitute a maze in which the viewer is both guided and walled in by language. It pleasurably recalls an oversize version of the bedsheet forts made by children until one notices that the walls are literally built from the writings of Mullican's other personality, suggesting an uncomfortable intrusion into another's private space: That Person's thoughts staged as a spatial reality. Further, Mullican's hypnosis performances are a literal version of this alternate world, one in which—to reference the artist's manic quotation that introduces this essay—That Person tends to be obsessed with mobility and time.

Since the 1970s architecture has emerged as an increasingly significant component of art, although, like Mullican, most artists are more interested in

the social forms it represents than its physical manifestations. Among the works in a recent installation by William Cordova was a skeletal structure (titled *The House that Frank Lloyd Wright built 4 Fred Hampton and Mark Clark* [2006]) modeled on the architectural footprint of Fred Hampton's house (Hampton, an Illinois chairman of the Black Panther Party, was murdered in 1969), or at least the *memory* of Hampton's house, as recalled by the FBI agent involved in the case, suggesting the subjective interpretation of history. The piece uses architecture to frame layered histories among which the viewer wanders, looking through the unfinished walls to drawings and sculptural elements that evoke other shameful moments in our cultural memory. Like Mullican's cosmologies or Bove's platforms, Cordova's constructions, particularly in their evocation of the overlooked and forgotten, evince a critical moment by modeling conditions and effects rather than the thing itself. The 2007 exhibition at Arndt & Partner Zürich featuring the Hampton house piece was titled *Pachacuti (Stand up next to a Mountain)*, a Quechuan word (and the name of an early Inca conqueror) meaning "world-turner" or "cataclysm": implying a total destabilization of time, place, and scale that Cordova suggests, however parenthetically, might allow for a new strength.

While object and form remain deeply important to many artists, the same work can often exist in different incarnations, part of a widespread "antimasterpiece" stance that seeks to underscore the permeability of art's underlying structures. Sampling and remixing as cultural processes—wherein one makes many masters, each still the real work but differently distributed—have been widely discussed in terms of their effects on contemporary art. As Greg Tate has written, this influence can be understood as the spatial counterpart to the temporal fracture of the digital world: "We can now enslave little nuggets of time as we will, even as we ourselves are enslaved to perform the labors of Hercules to Hyper-Capital . . . yet the breakbeat, the tag, and the signifying impulse in hip-hop also have made for a reordering of space as well—for a new taxonomy of cultural materials."[30]

The remixing of cultural material in order to question and, possibly, produce systems is an idea that unifies the installations of Gardar Eide Einarsson. His ongoing investigation of the concept of the outlaw as it relates to movements of oppression and transgression probes the (im)possibilities of an alternative, parallel existence. Art "operates with its own kind of attention span," according to Einarsson, creating "an immediate (and sometimes maybe even bodily) effect, perhaps similar to music, and a longer-term analytical effect, which is perhaps more akin to textual production."[31] In his mise-en-scènes, the artist strives to short-circuit expectations so that at times one effect feels like the other, forcing the viewer into an awareness of this spatiotemporal destablization. Using texts and images appropriated from such varied sources as comic books, political manifestos, and the literary efforts of Ted Kaczynski (the Unabomber) into paintings, sculptures, wall drawings, even performances, Einarsson choreographs the destabilized familiar into a Minimalist theater staged with the viewer's interaction in mind. What he refers to as his "prop paintings" are at times literally leaned against walls to emphasize their function as backdrops, not as "actors" per se,

and he often leaves paintings unfinished in order to question the meaning behind the act of making them, exploring the parameters of medium in a way that parallels his investigation of content. Though politically engaged, Einarsson avoids the self-righteous redemption proposed by some so-called political art of the 1990s by keeping his (and our) moral positions unfixed; we function as a "failed interpreter," according to the artist.[32] Politics, like time, becomes inbuilt into Einarsson's work, which no longer performs (or is performed) from a superior, detached, or omniscient position but, in a subtly but radically altered perspective, questions its own systems of production.[33] Significantly, the artist cites Dan Graham and Vito Acconci as influences, and indeed his work often combines Graham's staged structures with Acconci's invocation of "architecture . . . that includes public space, but that also makes room for the psycho-killer."[34] The opacity of Einarsson's references allows him to make the object the locus of an expanded work: a system of footnotes that seem as infinitely connected as Bove's tensegrity forms.

Staging time from an entirely different perspective, Jedediah Caesar creates sculptures out of the collected detritus of his house and studio, which he preserves in blocks of colored resin and slices into units using an industrial process and shows at times on the floor, leaning against walls, or mounted as grid. The individual pieces, which constitute a material archive of time and space, are simultaneously micro and macro: at one moment seeming to be a personal, or even a cellular, image, in another suggesting a landscape or a lunar surface. They function variously as reflections of the past, cross sections of the ephemeral present, and ghostly suggestions of future forms. The work *0,000,000* (2006), a translation of one of Caesar's earlier sculptures, was cast from molds based on the schematic diameter of a previously made, geodelike form, *1,000,000 AD* (2005), and then encrusted with salt crystals and plaster forms that cover its surface like barnacles. In describing the work, Caesar uses the metaphor of spatial collapse, an idea common in deep-space physics: "It [*0,000,000*] started as a reflection of *1,000,000 AD*, as if [the latter] had been crushed into a denser form of itself—closer to a material than an object."[35] In the 2007 installation *City of Industry*, the constructions recalled Minimalist forms, though impregnated with their own archaeology, but also schematic industrial landscapes. A coarse plywood floor acted as a stage for the sculptures and also made reference to the shipping pallets the artist incorporated into the work. The suggestion of transit and exchange (what the artist calls "negotiated cargo") is an important subtext in Caesar's recent work, part of an interest in the transitional spaces of production and dispersal shared by other artists in the 2008 Biennial (and discussed in more detail later in the essay).[36]

A recent installation, *Three Views from Space* (2007) tracks what Caesar refers to as "sculpture time,"[37] in which the information embedded in the sliced cross sections—mounted on the wall in a contiguous grid—serves as an extrapolated document of itself. In this process, no information is hidden; the back of one panel is the front of the next, and both sides are given parity as part of a holistic composition that, at the same time, suggests an almost cinematic motion. The delicately balanced reconstruction of the box that originally contained the resin block is a nod to Richard Serra's prop objects,

but it is as much a statement about the dispersal of the material formerly inside the box as it is recognition of Serra's tenuous balancing act. As the container of its expanded self, the box suggests its own phases of being and extension. Although the formal system Caesar invokes is one of abstraction and modular production, he enlivens these modernist paradigms by channeling the ambiguous space between (and the movement around) objects and ideas within the modernist system.

Such moments of transition also inform the sculptural practice of Patrick Hill, who describes his work as "perverting the sterility of modernism" while still exploring abstraction as a viable project.[38] Ironically, in evoking that formal language Hill finds more meaning in modernism's failures than in its achievements.[39] Combining sheets of glass, painted geometric wood forms, stained and draped fabric, and, recently, metal and concrete constructions, Hill explores how material affects interaction with the work. Forms dissolve and resolve as the viewer navigates around the structures, looking on as transitions of light—across the transparent or mirrored surfaces, and over the balanced or propped elements—foreground the very act of viewing-in-motion. Elegance vies with aggression as planes slice across or pierce through one another; weight strains against gravity; limp cloth forms further "corrupt" modernism's quintessential erect vertical objects with suggestions of sexuality or bodily processes. Like Caesar, Hill delves into the potential for abstract forms to exist at multiple scales within a single object; to that end, at times his work functions as a schematic model of urban architecture, but also as a physical counterpart to the body. Other constructions evoke the spiritual and the transformative, suggesting altars (*Heavy Rising* [2005]) or crosses (*Jesus was a Cross Maker (for Judee Sill)* [2006]); some pieces incorporate as a paint organic materials that are believed to have healing power. Hill's latest works expand both in scale and physiological interaction: cast concrete pedestals are staked by tilted, embedded crosses of stained fabric, described by the artist as tombstones to a "dead modernism";[40] dense concrete blocks and steel sheets hang as a mobile from slim rods bent by their weight, pushing a moment of tension almost to the point of collapse. The precariously balanced steel, granite, and glass structure *Forming* (2007) slips from intimidating monumentality to delicacy of line upon circumnavigation; like all of Hill's recent work, it bridges the oppressively physical and the magically insubstantial through a combination of transformation, transition, and motion.

Other artists, such as Ry Rocklen, find tenuousness in form by dint of ritual enactments that suggest revised formats for belief and agency. *Rollin' on 23's* (2007), for instance, can be seen as a stalled, mobile altar. It comprises a beam stretched between two concrete wheels 23 inches in diameter (the number is a personal talisman for the artist); carefully balanced glasses of water are arrayed along the beam's length. Prevented from rolling by tiny stones wedged beside the wheels as chocks, the sculpture, like Hill's hanging works, suggests a frozen moment fraught with anxiety. As the water in the glasses evaporates over the course of the exhibition, the work becomes yet another avatar of time, but one of duration rather than imminent break. Indeed, Rocklen's delicate gestures demand from the viewer a certain slowness. In *Refuge* (2007), it takes a moment to notice the thousands of nails

dropped into the mesh top of a discarded bedspring, which endow it with a shimmering, snakelike skin. He compares his time-consuming, easily overlooked process to a personal ritual, "like counting prayer beads . . . a minimally teased-out magic."[41] Rocklen also attributes a somewhat aggressive quality in his work to the idea of extended attention; *Rollin' on 23's* nearly blocks the viewer's entry, forcing immediate interaction with the potential disaster implied in the title. As he puts it, the work is an invocation to "be present."[42] Here Fried's injunction to "presentness" becomes an imperative for the *viewer*, not the *object*—a distinction that locates the temporal in the space around, rather than within, the work of art.

IF ON A WINTER'S NIGHT A TRAVELER

Five hours' New York jet lag and Cayce Pollard wakes in Camden Town to the dire and ever-circling wolves of disrupted circadian rhythm. It is that flat and spectral non-hour. . . . She knows, now, absolutely . . . that Damien's theory of jet lag is correct: that her mortal soul is leagues behind her, being reeled in on some ghostly umbilical down the vanished wake of the plane that brought her here, hundreds of thousands of feet above the Atlantic. Souls can't move that quickly, and are left behind, and must be awaited, upon arrival, like lost luggage.

—William Gibson, *Pattern Recognition*[43]

In his characteristically prescient novels, cyberpunk author William Gibson has long recognized how patterns of movement and communication are mutually dependent, and how they help construct our sense of the world. In the passage quoted above, "jet lag" proves the perfect metaphor to convey the anxieties of a contemporary reality obsessed with time and mobility. As a transitional, subjective condition, jet lag is both liberating and yet strangely terrifying: it is the physical sense of being connected across distant spaces and to multiple places simultaneously, but at the same time it is a symptom of being "placeless." In a historical moment characterized by fear and impotence in the face of overwhelming international events, conflicted opinions on globalization, and the potential loss of a psychogeographic sense of place, Gibson's metaphor captures both the emptiness and the infinite potential of our transitional state. This current mode of nomadic thinking is further troubled; it has been used, arguably, to support the logic of capitalist expansion, yet it can also be construed as a defiance of commodification. As such it is informed and afflicted by some of the same problems inherent to the concept of globalism: the expediency of markets, an implicit imperialism, the conflicting cultures of immigration and tourism, and the leveling of specificity in place and culture. Although nomadic globalism has facilitated unprecedented networks of communication, it has also allowed for an expansion of cultural hegemony in the name of idealism.

Olaf Breuning's video *Home 2* (2007) (a sequel to his multinarrative work *Home* [2004]) employs an absurdist and frequently uncomfortable, culturally insensitive tone to illuminate these conflicts of unprecedented mobility. His

bumbling, awkward, and familiar tourist (whose different avatars are all played by the same actor) searches for some "pure" place that either no longer exists or never actually did. Riffing mercilessly on self-congratulatory, bourgeois notions of how indigenous peoples embody the "real," Breuning believes that the exploited environments his tourist stumbles through are what constitute our contemporary reality and that the idea of a "true" world is mere myth. His traveler is aware of his hierarchal privilege even as he disavows it, and the film collapses time and specificity of place with the same glibness exhibited in mass-media representations of global travel. Breuning's sculptural work also employs the tropes of tourism; in a 2007 exhibition at Zurich's Migros Museum für Gegenwartskunst for example, faux souvenir photographs were propped on crates and tables and displayed so that they peeked out of packing boxes, implying that the exhibition itself was a temporary arrangement designed to be moved at a moment's notice.

Breuning's send-up of the misguided search for the real (always anywhere but here) can be linked to the strong specificity of location manifested in other current artwork, from the San Francisco radio collective Neighborhood Public Radio (NPR) to Mario Ybarra Jr.'s New Chinatown Barbershop, a hybrid art gallery-cum-social club in a functional former hair salon. This type of practice resists the leveling of place that is the focus of Breuning's satire, but it also defies categorization as provincial, expressing instead what Kenneth Frampton has termed "double mediation," a concept, as applied by Miwon Kwon, that "might mean finding a terrain between mobilization and specificity—to be *out* of place with punctuality and precision."[44] Other artists in the Biennial express a similar preoccupation with mobility by creating works that are meant to be experienced transitively, and which they imbue with a deep sense of specific topology. Here the topographical impulse refers less to an *image* of landscape than to the experience of its forms, such as moving through the spaces of an urban, postindustrial context. In this type of careful mapping, speed—a function of time and movement—becomes a key concern. Like Rocklen, many artists profess a desire to slow the pace of thought and experience, to heighten "presentness." In this sense, duration in space becomes a defense against the endlessly mediated onslaught of information; slowness denies excess. (In her essay in this catalogue, Henriette Huldisch addresses a related manifestation in contemporary practice described as "lessness": an economy of means, locality of gesture, and the embrace of failure as possibility.)

Harry Dodge and Stanya Kahn's video *Can't Swallow It, Can't Spit It Out* (2006) uses the Los Angeles urban landscape to inhabit the "in-between" terrain proposed by Kwon.[45] The on-camera character, inexplicably dressed as a Valkyrie and suffering the aftermath of some unexplained violent conflict, wanders through the city on an unfulfilled quest. Her continuous monologue is alternately absurd, hilarious, and horrifying—intimate and yet anonymous. Just as the urban environment around her proffers only blank, institutional walls and the social alienation of empty public spaces, her exchange with the off-camera videographer is similarly thwarted; he or she is never revealed, the connection between them is never truly made. Described by the artists as "a portrait of civilian anxiety in a time of war," the video taps

into what they see as a pervasive sense of personal impotence.[46] The viewer, playing the part of the unseen cameraperson, is complicit in the work's narrative of desire and loss, accompanying the woman on her futile search and, like her, becoming placed in restless motion without apparent destination.

In the work of Miami-based Adler Guerrier, the wandering observer is on neither a journey nor an aimless stroll, but instead maps the psychogeographic space of a city. Guerrier invokes the nineteenth-century flaneur in his photo-installation *untitled (flaneur nyc/mia)* (1999–2001), but the Situationist notion of the *dérive* is equally applicable. According to Situationist provocateur Guy Debord, "From a *dérive* point of view cities have psychogeographical contours, with constant currents, fixed points, and vortexes that strongly discourage entry into or exit from certain zones."[47] Guerrier's observer, like Dodge and Kahn's Valkyrie, is less a subject or protagonist than a tool that activates space in time, as his shadowy figure endows largely empty, often banal urban scenes with a sense of poetic mystery and looming alienation. *Green is the color of my quotidian space, but i hear brown* (2003), part of a series of photographs Guerrier took in a backyard, exhaustively documents the moment-to-moment changes within the confines of the space, creating a real-time continuum of trivial events that embraces the specific and temporal. This effect can be compared to how the camera assumes the place of the viewer's body in Guerrier's video works, similarly absorbing the minute details of an unpeopled domestic interior; its languorous movement through such everyday, familiar spaces encourages our heightened attention to *attention* itself, whereas the nearly empty rooms construct a prolonged moment of anticipation. Space becomes a metaphor for that which is about to happen, but, as in the unfulfilled quest of the Valkyrie/videographer, there is no progressive build toward climax.

Charles Long describes his current project, based on the Los Angeles River, as creating "spaces of presentness with residue of where things were."[48] If the topographical impulse discussed above seeks out the restive, in-between space of our contemporary moment, the Los Angeles River, where nature's structure has been replaced by a failed human infrastructure, might be its most profound manifestation. At times a teeming density of flowing water, vegetation, and animal life, more frequently the river is a viscous dump crammed with urban detritus. Deposited along its sloping concrete banks, this trash offers scattered, intimate glimpses of anonymous lives, yet the empty, damp spaces also exude a vague apprehension of some illicit activity or untoward mutation. Rather than a representation of the natural sublime, the river is a product of compounded cultural, industrial, economic, and historical processes: a destroyed space reaching toward replenishment and cleansing but constantly fluxing back into filth.

From this rich source Long fashions magical and tragic hybrids, sculptural installations that hold within their material bodies both their original life in the river and the process of transubstantiation to which the artist has subjected them. In his *knowirds* installation (2007), he transforms elegant tracings of egret scat into delicately balanced sculptural groups using trash pulled from the river. The laden air around the sculptural groups carves absence into the gallery; silence becomes a material. The viewer's movement

among the sculptures seemingly reprises some ritual motion aimed at embracing an ever-mutable moment.[49] Documenting the project, Long's hundreds of photographs of the river and of his interactions with it (occasionally they incorporate the artist's ghostly, fleeting silhouette) follow his navigation through an artery of abasement and transcendence that literally links a city to its inhabitants, whether they are cognizant of it or not. Long's project also highlights the insistent return of the wild and chaotic to modernist authoritarian control and reduced complexity; however, rather than representing an apocalyptic state—something often attributed to Long's images—his hybrid objects celebrate the adaptability of human and natural forms, their potential futures versus their end of days.[50]

The social dimensions of boundary and movement embedded in Long's topologies figure clearly in the work of Ruben Ochoa: literally, as in *CLASS: C* (2001–05), for which he retrofitted his family's tortilla delivery van as a traveling art gallery, and more figuratively, as in his recent freeway project. In *Extracted* (2006), for example, Ochoa transferred what appeared to be a section of the freeway boundary wall to a gallery space and then seemingly replaced that same segment on the road with wallpaper simulations of the natural world obscured behind the concrete barrier. Visitors to the gallery soon discovered the massive, Serra-esque form was an elaborate fake; as one moved "backstage," it revealed its own construction, as did certain viewpoints of the wallpaper "replacements" from passing cars. Process, once again, is made part of the object. Ochoa's work, whether referencing the freeway boundary walls or the more conceptual barriers between neighborhoods and communities, refocuses attention on the socioeconomic underpinnings of spatial flow and control.

The number of artists mining American urban sprawl (Los Angeles in particular, but also Miami, Seattle, Houston, and other decentralized cities) speaks to the metaphorical power of that subject. The restless motion, alienating corporate-modern vernacular, and lack of true communal space inherent to sprawl are common ground for many artists, as is an insistence on finding interstitial spaces of transformation and resistance. In this way, the topographical impulse touches upon ongoing discussions of (and revisions to) the idea of site specificity, in which site has become a discursive space.[51] As Kwon elaborates, "site is now structured (inter)textually rather than spatially, and its model is not a map but an itinerary, a fragmentary sequence of events and actions *through* spaces, that is, a nomadic narrative."[52]

This is an arena that the LA-based artist Stephen Prina has been exploring critically for several decades. The subjects of his investigations—intertextual and media relations as exercised through varied content—are linked by a tension between moments of historical change and spatial arrangement, or as one critic has explained succinctly, they are "a way of thinking about information without getting pushed around by medium and circumstance."[53] A recent installation, *The Second Sentence of Everything I Read Is You: Mourning Sex* (2005–07), exemplifies Prina's ideas about temporal spectacle, history, transit, and the transitory. He refers to the piece as a "mini-Broadway musical on the road,"[54] a traveling spectacle that is also a fluid, elegiac monument to Felix Gonzalez-Torres. As in Breuning's

installation, the objects double as their own modes of transit. Crates-cum-seating units upholstered in saccharine Martha Stewart interior colors are assembled into a listening room for Prina's audio track, whose lyrics are texts sampled from a recent Gonzalez-Torres monograph. The viewer moves through the installation looking for the subject of the theater, eventually realizing that the viewer *is* the subject. In another installation in this series, subtitled *The Queen Mary* (1979–2006), a single spotlighted speaker and a backlit, blurred photograph of the ship, seen either docking or pulling away, enhance a mood of bated anticipation: a moment before or after a performance, which might be either the viewer's (a forgotten debut) or someone else's (into which one has thus intruded).

This aspect of stalled transition informs Walead Beshty's multipronged project, which investigates photography as both a temporal medium and one that shapes our understanding of history. Although his installations and series of pictorial and abstract photographs occupy visually discrete realms, they are bound by the idea of translation, both in the sense of "moving laterally" as well as "the transformation of coded symbols." Beshty rejects reading an image as a static icon; doing so, he believes, turns history into the mere transformation of ideology into monument, by which metamorphosis history loses the power to adapt. Indeterminacy is thus a guiding principle for Beshty, drawing him to such subjects as failed housing projects, highway medians, defunct shopping malls, and, in a recent work, the abandoned Iraqi diplomatic mission in Berlin. The latter territory, ceded in perpetuity to Iraq by the German Democratic Republic, remains standing, though denuded of purpose, nearly eighteen years after reunification. In Beshty's work we glimpse within the building's largely destroyed, inaccessible interior vestiges of its former function: a landscape of fax machines, desks, scattered papers, and filing cabinets. The idea of "territory" here becomes an object, as the gap in the mission's use has created a perpetual ruin. Beshty's images of the building in its circadian transitions were then mutated in transport by an X-ray machine, an accident that suggested the idea of deliberately using that mutated film stock in developing those and later images. The resulting mackled *Travel Pictures* (2006–08) capture a sense of their own movement by virtue of the formal language of the medium, a succinct visual evocation of the perpetual transition the mission represents.

Throughout these diverse practices, a vectored and discursive notion of place is at work, not a literal, phenomenological one. Art becomes a function, not a thing: a fluid relay point that can enact its own mobility while reflecting on its unstable parameters. A revised concept of site specificity, now proposed as a function of memory or absence, is used to subvert the concretizing of place, while the failed "anti-commodity" idealism of earlier site-specific work is newly addressed by artists investigating systems of dispersal and production. It is worth pointing out, as Édouard Glissant has done, that this relay model has long been one of critical import in the "pre-modern" world: "To live in the world-totality from the place that is one's own means to establish a relation, not consecrate exclusion . . . the great books that found and root communities are in fact books of wandering . . . these books are 'complete' because while their vocation is one of rooting, they also and immediately

propose the vocation of wandering."[55] Indeed, the metaphor of "rooting"—which combines a grounding that then flows out in fractured extension—is an apt one to describe the transformations in communication systems that in recent years have so fundamentally restructured our sense of "presentness."

REVISING THE SPACE-TIME CONTINUUM: WHERE AND WHEN IS THE NEW WORLD?

In societies not possessed of a founding myth, the idea of identity is verified less by reference to a great na(rra)tion or a territory than by the weave of relations between subjects. Needless to say, we cannot understand the poetics of relation without taking into account the idea of place. Place, however, is not understood here as territory, but as relation.

—Édouard Glissant[56]

The large degree to which technological changes have helped shape contemporary reality is no longer simply evidence of a superficial fascination with "things digital" (primarily an aesthetic concern), but rather shows the transformative effect of technology on the structural operations of space and time. Manuel Castells has attributed this temporal dissolution to what he characterizes as the "space of flows," in which information and distribution networks disorder "the sequence of events and [make] them simultaneous, thus installing society into an eternal ephemerality."[57] In other words, technology has brought about a rhizomatic, fragmented simultaneity in the world that has produced a sea of possibility and yet, at the same time, reflects a more general crisis of meaning that is manifested in much of the work in the 2008 Biennial.

In the past science and technology have been understood, both by their practitioners and within the culture at large, as fixed, rigid systems (the aesthetics of modernity), but in recent decades this view has evolved toward a greater recognition of relational flow. Theories of complexity and chaos proposing similar approaches to the study of systems have filtered into the cultural imagination, although often in an interpolated form, much like those of quantum mechanics nearly a century ago. Understanding that the following are greatly simplified summations, "chaos theory" can be defined as a means of looking at how simple things can generate complex outcomes that cannot be predicted by examining the parts alone (e.g., a flock of birds); by comparison, "complexity theory" considers how complex systems can generate simple outcomes (e.g., the single unit of the human body). These theoretical constructs have enriched the reductionist method that has historically guided scientific examination—breaking things down into their constituent parts—by providing for greater reciprocity among the elements of a given system. This translates into a greater holistic approach: studying individual parts in tandem with the relational effect of an accumulation of parts. The aim here is not to iterate any literal applications for these theories but, through these definitions, to point out their metaphorical application to concerns in contemporary culture. Uncertainty, responsive contingency, and systemic

subversion resonate consistently throughout the language of post-World War II technologies, as well as in the literature and popular culture those ideas largely inspired, from the writings of Thomas Pynchon, Philip K. Dick, and many cyberpunk authors to movies, television shows, and sophisticated video games that have internalized these developments, to cite but a few examples.

Rosalind Krauss's concept of "recursion" is instructive here.[58] Derived from the Latin for "a return," it implies a temporal process of moving back, although not in the sense of an escapist retreat. Rather, recursion refers to the feedback system on which most computer programming is based and which is applied in various ways to mathematics, linguistics, and the like: defining or testing a situation or idea by repeatedly applying a set of rules or conditions.[59] As a pattern for growth and self-correction, recursion forms the basis of many types of culturally potent communications: websites such as Wikipedia, so successful it is often more accurate than encyclopedic print publications; social networking and production spaces like YouTube or MySpace; even crowdsourcing, a term recently coined to describe a peer-production model of problem solving and task fulfillment. (In contrast to the specific hire implied by outsourcing, crowdsourcing makes a problem available to the networked masses, producing competitive quality, low prices, and innovative applications.[60]) Ironically, some art historical arguments employ Krauss's idea of recusion to reinterpret Fried's "essentializing" stance as the very means to "deemphasiz[e] content, theme, and expression for structure, pattern, and organization."[61] In artistic practice, what has emerged along these lines is work that is concerned not with content but with ways of behaving *as* content. The ideas behind these strategies inform a wide swath of work in the exhibition, although certain practices employ them more explicitly than others. Mullican's imagined world, for example, builds a fragmentary order in which a model gives rise to a language of ciphers; these are used to construct a physical space in which material has a reciprocal effect on meaning. A reflexive but expanding network, it is both systemic and infinite.

Another application of this strategy in contemporary art takes the expansive systems of production and dispersal integral to network and commodity structures but channels them in differently vectored, frequently off-kilter ways in order to expose them. Artists such as Seth Price, for instance, make distribution, compression, and reproduction foundational conceits of their practice, exploring both the space produced by those processes as well as the temporal destabilization they induce. Using a medium or mode to question itself is what makes explicit Krauss's recursive gesture, as the work flips back on its own patterns over and over again in order to move forward. In *Freelance Stenographer* (2007), Price and fellow artist Kelley Walker created a performance based on the ideal of the archival, in a takeoff of Conceptual art's dependence on documentation. Combining the intangible boundaries of multiple events with varied, simultaneous means of recording, the piece queries which part of its reproducible forms—photocopies, videos, a stenographer's report—is "the work." The answer, in essence, is all of it and none; the process of archiving is both content and material. Like Price's earlier music compilation work, *Title Variable* (2001–), the performance exists in diverse styles and formats in order to destabilize its specificity. The artist

states that "all the parts are self-sufficient but also point elsewhere . . . a piece without a singular location or a particular medium, without an identifiable position,"[62] recalling the Heisenbergian principle that speed and position cannot be measured simultaneously. Price's work thus reflects the unfixed state of technological and historical change. His well-known essay *Dispersion* (2002–) likewise exists in variegated published iterations, the embodiment of its eponymous content.

In his latest series of works, *Untitled* (2007), Price also finds common ground with other Biennial artists who address the topographical impulse and micro/macro temporal shifts. Beginning with small, digitally compressed internet image grabs of people interacting in intimate ways, such as feeding one another, telling secrets, or holding hands, he enlarges the negative spaces from the images and uses those "absences" as templates for panels of plastic-encased wood veneer, a material frequently employed to frame images but which in this case gives shape to the image itself. Grouped on the wall, the pieces create negative-positive optical fluctuations that at one moment suggest a macrocosmic cartography (e.g., not-quite-identifiable world maps) and in the next reveal themselves as portrayals of individual, private interactions. Gold metal plaques arrayed nearby, titled *Gold Keys* (2007), are initially presumed to be an interpretive key to the images, but instead offer an opaque lexicon that resists translation.

Disassociate (2007), a collaborative installation by Mika Tajima/New Humans, engages the slippage between sculpture and performative process and—drawing on Dan Graham's ideas about the materiality of sound—addresses how at times one can embody the other. The presentation was divided into two parts: the first a place of "constant production, before the final thing is made," and the second of "post-destruction," the aftermath of the object itself.[63] Throughout the show, a series of silkscreened movable units took on multiple arrangements, morphing into, for example, architectonic investigations, a recording studio, or a chaotic landscape environment. Within these arrangements, whose true medium was space itself, the unit "objects" were never quite fixed: at times they served as a physical support for the work of other artists, but at other moments they became an autonomous image, sculpture, or sign. Sound events that took place within the installation—collaborations between violinist C. Spencer Yeh and Vito Acconci, for example—turned the audience into what Tajima calls an "architecture of isolation" by using their bodies as sound baffles. In an ongoing sonic element, the Rolling Stones' song "Sympathy for the Devil" was condensed into a single tone, an aural analogue to the questions of compression and translation inherent within the installation's constituent objects (i.e., the flatness of silkscreening transformed into a three-dimensional, mobile construction).

Often characterized as "noise," the music of Tajima/New Humans is more importantly defined by the use of sonic elements in a modular format, much like the sculptural components. The installation *Appearance (Against Type)* in the Biennial employs flat forms and supports, similar to those of *Disassociate*, as well as hinged A-frame panels that recall mobile announcement placards. Video clips of the New Humans' past performances play

behind louvered panels, which evoke both Bauhaus display design as well as a type of predigital advertising signage that used large grids of panels which toggle between different images. As with other objects in the installation, the video's structure disrupts itself, in this case with credit lines or layering patterns reminiscent of the silkscreens. By preventing unmitigated viewing, these obstacles and interruptions allow the video—again, like the rest of the installation—to avoid becoming a singular totality. As stand-ins for performance and production, the installations exemplify the spatialization of time discussed throughout this essay, as well as the evolution of static artistic frameworks into systems that rely on constant feedback. A related project by Tajima/New Humans for the Biennial, staged at the Seventh Regiment Armory Building, is a film of the making of their performance, which, much like Price's *Freelance Stenographer*, performs the idea of itself, incorporating its own processes as part of the work rather than the culmination of it. In perpetuating a serial format to disrupt the idea of performance as a singular, contained event, Tajima/New Humans embrace what they've referred to as the logic of the "endless remake," a concept discussed in the next section.

The collaborations that New Humans embed in their work are representative of the second manifestation of fractured networks mentioned above, which for the purposes of this exhibition are being termed "expanded practices." Often ephemeral in character and interventionist and renegade in sensibility, these varied activities—music performances or concerts, radio broadcasts, publishing projects, culinary gatherings, readings, lectures, and symposia, all typically in collaboration with other artists—address an issue aptly summarized by Price: "The problem is that situating the work at a singular point in place and time turns it, a priori, into a monument. . . . We should recognize that collective experience is now based on simultaneous private experiences, distributed across the field of media culture. . . . Publicness today has as much to do with sites of production and reproduction as it does with any supposed physical commons."[64] These collaborations are notably distinct from similar concepts of the past, idealized, shared efforts in which the individual and authorial voice was intentionally dissolved. Today they are not *collectives* but *collective activities*, and they retain the authorial mark. A better model for this is a rhizomatic network, where cells or nodes come together to form constellations of connection; in this system, as in the ubiquitous social networking websites, individual identity is not just retained, it is celebrated through a transformative reciprocity. Each member is both the star and the audience, part of a unifying force functional only within that constellated form. The interactive relationships (among people, work, or processes) that emerge from these networks are not quid pro quo, however—the "warm and fuzzy" so characteristic of earlier efforts—but instead are frequently antagonistic, awkward, and strange: a realization of those social spaces that still "makes room for the psycho-killer."[65]

The network-distribution logic of many expanded practices saves them from falling into the trap of smug condescension, whereby the audience becomes material for an unsustained "drop-in" community. Fritz Haeg's multiple projects are emblematic of this; mobile and yet site specific (as well as self-sustaining), his works employ an intimate or specific locus to affect a

larger system. In the ongoing project Edible Estates, begun in 2005, Haeg transforms suburban front lawns from useless, resource-consuming "carpets of conformity"[66] to productive gardens. To quote the artist, "just the act of spending an extended period of time outside with your hands in the dirt is a profoundly 'deviant' act today."[67] Haeg's position—shifting awareness from a final static result to that of an overall process—resembles that of Buckminster Fuller, who regarded specialization as a means to enslave the world by obscuring a view of the big picture, something Fuller believed would enable people to question power structures. The artist's mobile, translatable projects, like those of critical predecessors such as Andrea Zittel, seek to create modest but sustainable pockets of autonomy: what Zittel termed "small liberties," individually subversive or resistant gestures that slip through the cracks of the overarching system. Also rejecting the grand gesture, Haeg acknowledges the powerfully alienating nature of the urban environment as well as the impotence many people feel in the face of multiple global crises by focusing on what he views as the most local (and sometimes the only) area under one's control: private property. Both his Sundown Schoolhouse project (which began in 2006 as informal events held in his geodesic dome house in Los Angeles and evolved into intensive twelve-week courses with teachers and students from all over the world) and his architectural practice are accordingly small in scale, seemingly "modest and benevolent," he says, "until you think of the implications if they were replicated."[68] Indeed, even the character of Haeg's descriptions often promotes this subversive, systemic intervention, which today in his as in other politically informed practice is less about "think global/act local" than "think viral, act viral."

Nothing if not viral in form and effect, the sprawling, eclectic, and rigorously exploratory art of the late Jason Rhoades—whose cited influences included modernist abstraction, Fuller's tensegrity constructions, Marcel Duchamp's wry, backstage *Étant donnés* (1946–66) and utopian architectural fantasies—touched on many of the key concerns evident in the work of the younger artists in the exhibition. These include a projected, dispersed composition (and thus practice) that defies a complete understanding of the whole; a constant shifting of viewpoints (overhead to ground, micro to macro, and the like); and a tension between immersive, spatiotemporal experience and near-formalist arrangement within a single installation. Rhoades's proposed but never-realized plan to mark all the parts of an installation with barcodes trackable by GPS— making them dissociated but forever linked—elegantly captures the systemic dispersal and infinite connection of his approach. Perhaps his most meaningful stance, however, was to insist that his work incorporate *within itself* "the anticipation and preparation of a form, the form itself, and the interaction with the form."[69] His 1999 installation *Perfect World* (which one critic has described as a "three-dimensional mathematical formula laid out flat")[70] offered some of the fluid and extreme viewpoints seen, for example, in Phoebe Washburn's grass factory project (discussed further in Henriette Huldisch's essay). Similarly, Mika Rottenberg's rambling, Chaplinesque spoof of industrial production and bodily spectatorship (discussed below) recalls Rhoades's elaborately staged *PeaRoeFoam, My Special Purpose* (2002), which over the course of three

separate installations turned the exhibition spaces into evolving iterations of a production-line factory that created the eponymous product; each stage of the process was both a sculptural installation and a functional site.

Rhoades's last endeavor, *Black Pussy* (2005–07), is the most elaborate example of his participatory, expanded practice. Although visual and formal concerns were a significant component of the artist's work, paramount in this project were the reticulate social groups attached to it through its dispersed parts and activities "If you know anything about my work," the artist said, "you know that it is never finished."[71] Staged in his enormous Los Angeles studio, the project morphed and evolved throughout its life there. The installation's fragmented, decentralized architecture created intimate social spaces but at the same time prevented viewers from seeing the project in full; stations spread throughout the site produced neon text sculptures, frozen yogurt, souvenir knickknacks, macramé dreamcatchers, and other consumer wares that were then added to the display units. Rhoades's provocative project—whether through the infinite world implied through the "pussy" database designed to collect every variation of slang for female genitalia or through its performance-based, salon-style programming that focused attention on physical interactions within the ebullient tapestry of his sculptural forms—insisted on challenging the space between viewer and object.

THE ORIGINAL REMAKE: THE FUTURE IS A DO-OVER

There is a particular kind of reflective nostalgia that is not retrospective but prospective. In my understanding, nostalgia is not merely antimodern, but coeval with the modern project itself. Like modernity, nostalgia has a utopian element, but it is no longer directed toward the future. Sometimes it is not directed toward the past either, but rather sideways. The nostalgic feels stifled within the conventional confines of time and space.

—Svetlana Boym[72]

Cultural theorist Svetlana Boym, whose revision of nostalgia fundamentally resists the dream of progress, distinguishes between two types of nostalgia, restorative and reflective. The former is the more common understanding of the word: an attempt to recapture perceived absolutes (an idea of nationhood, for example, steeped in notions of truth and tradition). The latter type acknowledges the impermanence of place and thus celebrates absences, fragments, and ruins. Akin to the revision of the idea of site specific discussed above, in reflective nostalgia "place" is a concept, as are its characteristic forms. Typically more intimate than restorative nostalgia, reflective nostalgia is also less suited to collective mythologies. Boym has spoken about this as the "off-modern" (versus pre- or post-), which she says "doesn't follow the logic of progress but rather involves exploration of the side alleys and lateral potentialities of the project of critical modernity."[73] This definition, which recalls how the continually evolving formats utilized by Tajima/New Humans deny fixity (the endless remake), is useful in understanding the increasing frequency in art of what might be called a "do-over" mode: a type

of work, or a method of working, that seeks to release historical time from a fixed state of events and capture alternate (or failed) time lines.[74]

The frequent renegotiation of modernist or utopian paradigms in contemporary art, for example, is not the result of any idealized notion of 1960s counterculture (many of whose myths were debunked long ago but nonetheless persist in the greater American culture); rather, as noted earlier, it is a reflection of the sense of displacement, spatiotemporal anxiety, fearsome political structures, and (failed) attempt toward progressive uniformity that evolved out of conditions at mid-century, and which in many ways persist in today's world.

That the do-over mode creates an unfixed arena of past possibilities (often harboring, ironically, many of the anxieties suffusing the present) is perhaps most clearly addressed in the work of filmmaker Amie Siegel. *Berlin Remake* (2005), for example, incorporates scenes from the films of Deutsche Film Aktiengesellschaft (DEFA), the state-run East German studio, alongside Siegel's reconstructions of those scenes set in the same locations. Not perfect reenactments (itself a contradiction in terms), the scenes are matched shot-to-shot rather than according to content. The same pan sometimes includes actors replicating the DEFA script, but not always—an absence that underscores how the camera is itself an actor. Siegel has likened her approach to using a musical score (here, the original film) that she then performs, applying a spatiotemporal language to these collapsed (or constructed and eviscerated) sites of histories.

Like other artists in the 2008 Biennial, Siegel has come to regard certain architectural forms as symbolic of failed ideological programs. In *Death Star* (2006), she selected five spaces in Germany built just before, during, or immediately after the Third Reich, undermining the familiar aesthetic of the modernist style by focusing on buildings that represent some of its bleaker aspects: for example, a Volkswagen factory, Hitler's workers' resort on the Baltic Sea, a defunct radio station. These buildings represent what Siegel calls "labor modernism," a reference to their underlying power constructs. Further enhancing the lifeless, hermetic feeling of the piece, the programmatic architectural systems are tracked by a slowly moving camera, which slides through their hallways accompanied by music from the film *Star Wars* (1977) that played during scenes of the space station Death Star's interior. Here again it is the *motion through* that is significant: the endless roaming within the overlooked and seemingly abandoned corridors, which project their failed ambitions back on the viewer.

Siegel's most recent work, *ЯGG/DDR* (2008), a feature-length film focusing on East Germany, weaves together the do-over mode with some of the other temporal strategies employed in various works in the exhibition, such as those that focus on transition and translation. For Siegel, as for Beshty, the German Democratic Republic provides a powerful metaphor of a no longer extant territory that nonetheless remains a contested site of memory and history. Among other encounters, the film combines actual and remade video surveillance from the Stasi archives, participatory scenes from East German reenactments of Native American cultural practices (which even today remain oddly popular), and psychoanalytic interviews exploring the notion

of the "wall malady," a nostalgia for the former East Berlin aesthetics and society. Like the rest of Siegel's oeuvre, the film, she says, "considers its own behavior"[75] as a tool for reflecting on the invasiveness and cultural confusion of its content.

"The causal search," Kubler wrote, to return to his reconsideration of the temporal, "is one that imposes an excessively simple pattern of explanation upon events. Since every event, however minute, may be infinitely complex, the causal interpretation always betrays the haste of practical urgency. More flexible and expressive is the statement of conditions for any event. The conditional search is necessarily tentative, and it frays into many strands of doubt."[76] Kubler's idea of "frayed strands" is particularly applicable to the work of Omer Fast, for whom the conditional becomes material. Approaching history as cultural storytelling rather than a fixed state, Fast often presents his videos on double-sided screens, so that the viewer is physically reminded of the multiple versions possible within any narrative. In *Godville* (2005), he splices together interviews with performers from a colonial reenactment village, who speak both in and out of character. Fast's contribution to the Biennial, *The Casting* (2007), addresses more recent histories; it intertwines two different stories told by a young U.S. Army sergeant before his second deployment to Iraq. On one side of the screen are intercut segments from interviews with him—one telling of a romance with a troubled German girl, the second of the accidental shooting of an Iraqi soldier—while on the other side we see the script of the edited stories being performed by actors in silent tableaux. Fast's reconstructed narratives blur time and truth, and question the intelligibility of historical return, whether to a distant or a more recent past.

The video installations of Mika Rottenberg offer a potent investigatory mix of beauty rites, sexuality and intimacy, and assembly-line labor, as she images the female body as a site of production, transformation, and creation. The artist often selects subjects with extraordinary physical qualities that foreground her interest in how feminine identity is typically defined and confined. In *Cheese* (2007), her latest and most ambitious project to date, the narrative centers on the Sutherland sisters, real late nineteenth-century siblings whose radically long hair prompted development of a "hair fertilizer" that brought them great acclaim. For the film, Rottenberg constructed a fantastic factory for the sisters' product, a sprawling three acres on which they would produce cheese, tend animals, and tend themselves, conflating modes of food production and *toilette* into an alchemical enterprise. The film is projected across five screens and viewed from within a displaced, somewhat claustrophobic section of the fantasy factory set, placing the viewer literally and metaphorically inside the imagined history. Together, the segments produce a sense of a networked movement, or a system of controlled navigation through the cycle of days.

Adler Guerrier's installation for the Biennial, *untitled (BLCK—We wear the mask)* (2007–08), also posits a remake, in this case of a fantasy artists' group politically positioned in the sixties as a counterpart to the Black Power movement. His faux interviews with the group's members, along with their drawings and photographs, are shown alongside film clips of actual events from the period (riots and protests, mostly) in a poetic exploration

of ideology and power relations. Like Einarsson's embedded politics or Haeg's "viral" projects, Guerrier's take on the do-over reveals a subtle investigation of the possibilities of resistance and reshaping. Indeed, by revisiting failed or abortive social systems—whether those that once held power or those that sought to seize it—the do-over is a working strategy that actively seeks out, in the manner of Boym's reflective return, the side alleys and lateral possibilities of history.

Ad Reinhardt, in his revisionist prescription "Twelve Rules for a New Academy," stated that "the present is the future of the past, not the past of the future."[77] The constant negotiation across multiple spaces and times implicit in Reinhardt's phrase captures a sensibility that links much of the diverse work in the 2008 Whitney Biennial. One might hypothesize that ultimately this sensibility is indicative of a true temporal pivot between the modernist project (which includes the postmodern) and "what comes next," a metaphorical version of the bifurcation point of scientific theory, when a system fluctuates and evolves toward a more complex organization. Yet the question remains of how we will "stage time" in the future, so that the dangers and possibilities of our increasing temporal flux—the dilemma of time itself—can be played out. How do we find a space—perhaps one more psychological than literal—that can accommodate dispersed, viral resistance, and where individual collectivity (or collective individuality) is located via communication and mobility; where the tension of rapid, endless searching coexists with moments of duration and silence that can hold their own time, softly but certainly?

NOTES

1. Vito Acconci, from the work *World in Your Bones* (1998); see also *Vito Hannibal Acconci Studio*, exh. cat. (Barcelona: Museu d'Art Contemporani de Barcelona, 2004–05), 408–09.

2. Matt Mullican, "Zurich Performance 2003: Transcript," in *DC: Matt Mullican: Learning from That Person's Work*, exh. cat. (Cologne: Museum Ludwig; Verlag der Buchhandlung Walther König, 2005), 26, 28.

3. Robert Smithson, "Quasi-Infinities and the Waning of Space," in *Robert Smithson: The Collected Writings*, ed. Jack Flam (Berkeley and Los Angeles: University of California Press, 1996), 34–37.

4. Thomas S. Kuhn, *The Structure of Scientific Revolutions*, 3rd ed. (Chicago and London: University of Chicago Press, 1996). This seminal 1962 paper on the nature of scientific paradigm shifts parallels these ideas. Kuhn argues that science is not a steady, cumulative acquisition of knowledge building toward a conclusion, but rather a set of interludes punctuated by intellectually violent revolutions. These occur around "crises" triggered by instances of anomalous fit between existing theory and a physical event, where the failure to resolve those problems is the result of inadequate tools or the desire to retain "normal" science. When pushed forward to resolution, however, these crises can help lead to paradigm shifts that reshape conceptual worldviews. While from a certain perspective Kuhn's ideas run counter to a notion of progress, he was careful to define them as part of an overall ideological concept of progress (one I call modernist in this essay), since scientific advancements (such as penicillin, cancer treatment, and the like) do provide human benefits that should be considered progress.

5. Included in this illustrious lineage are Jorge Luis Borges, Philip K. Dick, Umberto Eco, and Thomas Pynchon, to name but a few highly influential temporal rethinkers.

6. William Fleming, "The Newer Concepts of Time and Their Relation to the Temporal Arts," *The Journal of Aesthetics and Art Criticism* 4, no. 2 (December 1945): 101–06.

7. George Kubler, "Style and Representation of Historical Time," in section 3 "Three Essays," *Aspen* 5/6 (Fall/Winter 1967): n.p.

8. In this famous thought experiment (which was posed to seem deliberately ridiculous), a cat is confined in a steel box along with a particle of a radioactive substance so tiny that one atom might decay within the hour but, with equal probability, might not. A Geiger counter is poised to record the decay, if it occurs, and then shatter a capsule of cyanide, killing the cat. (If there is no decay, then nothing happens and the cat lives.) The paradox is that in the absence of observation the system contains both outcomes simultaneously: the cat is both alive and dead (or, technically speaking, half-alive and half-dead, if following probability terms). While Schrödinger's paradox has since been resolved by science, the idea of "superposition"—being in multiple possible states at once—retains metaphorical power.

9. Susan Sontag, "One Culture and the New Sensibility," in *Against Interpretation and Other Essays* (New York: Noonday Press, 1966), 298.

10. Smithson, "Entropy and the New Monuments," in *Robert Smithson: The Collected Writings*, 21.

11. Dana Miller, in a forthcoming essay on Buckminster Fuller, has succinctly summarized this critical transition and Fuller's integral role in facilitating it within the plastic arts. Buckminster Fuller, quoted in Miller, "Thought Patterns: Buckminster Fuller the Scientist-Artist," in *Buckminster Fuller: Starting with the Universe*, exh. cat. (New York: Whitney Museum of American Art; New Haven, Connecticut: Yale University Press, forthcoming).

12. Pamela Lee, *Chronophobia: On Time in the Art of the 1960s* (Cambridge, Massachusetts, and London: MIT Press, 2004). Lee's rigorous analysis defines a rupture in the experience of time during the 1960s and analyzes it in relation to art and technology in post–World War II culture. She argues that this rereading of the effect of 1960s cultural anxiety over temporality is necessary in order to situate and contextualize our current relationship to technology and time.

13. T. J. Clark, *Farewell to an Idea: Episodes from a History of Modernism* (New Haven, Connecticut: Yale University Press, 1999).

14. Lee, *Chronophobia,* xx.

15. An ironic consequence of trying to clarify these sensibilities in contemporary art is that to do so relies on the traditional essay format and its linearity of argument. Although innovative fictive formats created by many writers (such as Borges, Pynchon, and Eco) have translated these concepts into written form, they have not yet found adequate rendering in art writing even as they remain seminal concepts in art itself.

16. Kubler, *The Shape of Time: Remarks on the History of Things* (New Haven, Connecticut: Yale University Press, 1962), 17.

17. Michael Fried, "Art and Objecthood," in *Art and Objecthood: Essays and Reviews* (Chicago: University of Chicago Press, 1998), 148–72.

18. Smithson, "Quasi-Infinities and the Waning of Space," 37.

19. Fried, "Art and Objecthood," 164.

20. Carol Bove, interview by Beatrix Ruf, *Below Your Mind* (Frankfurt: Revolver, 2004): 168–74. *Ice Cream: Contemporary Art in Culture* (London: Phaidon, 2007), 57.

21. Bove, interview by Ruf, 170.

22. Carol Bove, conversation with the author, October 11, 2007.

23. Fuller invented this word—a contraction of "tension" and "integrity" to refer to sculpture and, sometimes, engineering whose structure is based on discontinuous compression. For Fuller it generally involved some form of suspension—which better translates a notion of balance and extended system (usually in triangular modular units, not cubes or squares)—though he also used the term more loosely as a conceptual type. Its application by many artists in conceptualizing their work is significant to the temporal tension and to the idea of extended systems articulated throughout the 2008 Biennial. See, e.g., Bove, *Below Your Mind,* 170.

24. Ibid., 171.

25. Matt Mullican, conversation with the author, September 11, 2007. In an earlier interview with the author, Mullican told a story that poetically details his approach. As a child, he would find a word in the dictionary and then look up a synonymous word in its definition; from that word he would repeat the same process until he returned to the original word. He came to see the unmooring of language from its absolute definitions as a release, and this led him to investigate what lies between words, and between thoughts and images, to find "the real space of subjectivity," as he puts it.

26. Matt Mullican, "Matt Mullican in Discussion with Allan McCollum," in *Matt Mullican: Model Architecture,* exh. cat. (Ostfildern, Germany: Hatje Cantz Verlag, 2006), 17.

27. Mullican, "Interview: Matt Mullican and Michael Tarantino," in Matt Mullican, *Matt Mullican: The MIT Project,* exh. cat. (Cambridge, Massachusetts: MIT List Visual Arts Center, 1990), 18.

28. Martha Schwendener, "Matt Mullican: Tracy Williams, Ltd," *Artforum* 43, no. 4 (December 2004): 196.

29. Mullican, "Matt Mullican in Discussion with Allan McCollum," 21.

30. Greg Tate, "Cord Diva Mic Check One," in *Scratch: Artists-in-Residence 2004–5* (New York: The Studio Museum in Harlem, 2005), 5.

31. Gardar Eide Einarsson, interview by Ana Finel Honigman, "Gardar Eide Einarsson," *Tema Celeste* 22, no. 111 (September–October 2005): 46.

32. "I see great political potential in these different ways of acting and living on the side of and under the radar of patterns and behaviors that are imposed. With the current hegemony seemingly being so total these different everyday reinterpretations of life and public participation to me radiate an interesting form of resistance." Einarsson, "Andre Helter," interview by Marianne Heier, trans. Einarsson, *Billedkunst,* June 2, 2004, http://billedkunstmag.no/Content.aspx?contentId=906. The language of resistance used here links a broad array of seemingly dissimilar work in the exhibition. This comment is strikingly similar, for example, to the ideas articulated by Fritz Haeg about his community-based garden projects.

33. Einarsson, interview by Bob Nickas, "Remember Kids," *Purple Fashion* 3, no. 6 (Fall/Winter 2006–07, 138–44. See also the essay by Rebecca Solnit in this volume. The dualism of "resist or play the game" as the choices for revolution are no longer valid in contemporary culture. The "outside" subversive space (a sixties/seventies

notion of removing oneself from the institutional/hegemonic space as a means of critique) is likewise no longer possible. In the same way that expanded practices in contemporary art exist in multiple arenas (gallery-based object, ephemeral activity, performative practice, and the like), so too is protest networked and dispersed, fragmented, and rhizomatic.

34. Einarsson, "Remember Kids," 144.

35. Jedediah Caesar, email to the author, July 21, 2006.

36. Ibid.

37. Caesar, conversation with the author, September 6, 2007.

38. Patrick Hill, conversation with the author, May 25, 2007.

39. Hill, telephone conversation with the author, August 20, 2007.

40. Ibid.

41. Ry Rocklen, conversation with the author, May 23, 2007.

42. Ibid.

43. William Gibson, *Pattern Recognition* (New York: Berkley Books, 2003), 1.

44. Miwon Kwon, *One Place after Another: Site-Specific Art and Locational Identity* (Cambridge, Massachusetts, and London: MIT Press, 2002), 166.

45. Kwon, *One Place after Another*, 156–66.

46. Harry Dodge and Stanya Kahn, "Harry Dodge and Stanya Kahn on Making Comedy in a Time of War," *Modern Painters* 21 (November 2006): 83.

47. Guy Debord, "Theory of the *Dérive*," in *Situationist International Anthology*, ed. Ken Knabb (Berkeley: Bureau of Public Secrets, 2006), 62.

See also Rebecca Solnit (*A Field Guide to Getting Lost* [New York: Penguin, 2006]) for a detailed exploration of the pleasures and terrors of wandering, the advantages of being lost as both a release of directed movement and an awareness that one's path is not arbitrary, and the usefulness of the unknown.

48. Charles Long, conversation with the author, May 24, 2007.

49. Like many of the younger artists in the exhibition, Long came to these object forms via performance, interactive installation, and an interest in music. The undeniable temporality and spatial sculpting inherent to music make it a natural influence or counterpart to this category of work; it is defined by its experience in time. (As Van Meter Ames put it, "like life, music is always nine-tenths memory or premonition." Quoted in Fleming, "The Newer Concepts of Time and Their Relation to the Temporal Arts," 105.) Indeed, the artist's description of his river projects as "spaces of presentness and the residue of where things were simultaneously" is a particularly apt characterization of listening to music. Music as a component of art—whether literally or in its more conceptual or linguistic manifestations (a film that is "performed" like a musical score, for example)—is a significant contemporary development, explored most recently in the 2007 exhibition *Sympathy for the Devil: Art and Rock and Roll Since 1967* at the Museum of Contemporary Art, Chicago. (Dominic Molon et al. *Sympathy for the Devil: Art and Rock and Roll Since 1967*, exh. cat. [Chicago: Museum of Contemporary Art; New Haven, Connecticut: Yale University Press, 2007]).

50. Rebecca Solnit, "Detroit Arcadia: Exploring the Post-American Landscape," *Harper's Magazine* 315, no. 1886 (July 2007): 65–73.

51. James Meyer, "The Functional Site; or, The Transformation of Site-Specificity," in *Space, Site, Intervention: Situating Installation Art*, ed. Erika Suderburg (Minneapolis: University of Minnesota Press, 2000), 23–37.

52. Kwon, *One Place after Another*, 29.

53. Edward Leffingwell, "Stephen Prina at Friedrich Petzel," *Art in America* 89, no. 9 (September 2001): 151.

54. Astrid Wege, "Cologne: Stephen Prina: Galerie Gisela Capitain," *Artforum* 45, no. 10 (Summer 2007): 513.

55. Édouard Glissant, " Introduction to a Poetics of the Diverse," *boundary 2* 26, no. 1 (Spring 1999): 120.

56. Glissant, email with the author, November 28, 2007, in reference to his *Poetics of Relation*, (available in English, trans. Betsy Wing; Ann Arbor: The University of Michigan Press, 1997).

57. Manuel Castells, *The Information Age: Economy, Society, and Culture*, vol. 1, *The Rise of the Network Society* (Cambridge, Massachusetts; Oxford, UK: Blackwell, 1996), 467.

58. Rosalind E. Krauss, *A Voyage on the North Sea: Art in the Age of the Post-Medium Condition* (New York : Thames & Hudson, 2000).

59. Discussed at length in Lee, *Chronophobia*, 60–68.

60. Jeff Howe, "The Rise of Crowdsourcing," *Wired* 14.06, June 2006, http://www.wired.com/wired/archive/14.06/crowds.html.

61. Lee, *Chronophobia*, 74.

62. Seth Price, interview by Gwen Allen, "Interview with Seth Price," *Art Journal* 66, no. 1 (Spring 2007): 81.

63. Mika Tajima, interview by Richard Goldstein, "Maximum Capacity: An Interview with Mika Tajima of New Humans," *Whitehot Magazine of Contemporary Art* 2 (April 7, 2007), http://whitehotmagazine.com/whitehot_articles.cfm?id=332.

64. Seth Price, *Dispersion* (Ljubljana: International Centre of Graphic Arts, 2003), n.p.

65. Einarsson, "Remember Kids," 144.

66. Fritz Haeg, *Edible Estates* (Salina, Kansas: Salina Art Center, 2005).

67. Fritz Haeg, interview by Nato Thompson, "Interrogating Public Space: Fritz Haeg" *Creative Time* (July 2007), http://www.creativetime.org/programs/archive/publicspace/haeg.html.

68. Haeg, interview by Amy Seek, "Fritz Haeg: Small Revolutions," *Archinect*, (January 29, 2007), http://archinect.com/features/article.php?id=50581_0_23_24_M.

69. Linda Norden, "Constructed Reality" *Artforum* 45 no. 2 (October 2006): 61.

70. Roberto Ohrt, "The Soluble Fish Is Better Off on the Beach," *Parkett* 58 (May 2000): 154–60.

71. Jason Rhoades, *Perfect World* (Cologne: Octagon, 2000), 11.

72. Svetlana Boym, quoted in "Michael Elmgreen & Ingar Dragset," in Brigitte Franzen, Kasper König, and Carina Plath, eds., *Sculpture Projects Münster 07*, exh. cat. (Cologne: Verlag der Buchhandlung Walther König, 2007), 83.

73. Ibid.

74. This term stems from one commonly used by children: typically when playing a game or such, if an error was made but it was either not a full try or a kind of stupid mistake (dropping the ball or tripping, for example) one would call, plaintively, for a "do-over." Thus the action is subtly distinct from a reenactment, passing through the motion again always knowing the error of the first, yet making the second better. The do-over was always an exception to the rules as well, thus additionally apt in this application.

75. Amie Siegel, correspondence with the author, June 22, 2007.

76. Kubler, "Style and the Representation of Historical Time," n.p. The taxonomic application of style, Kubler believed, is incapable of containing within it an idea of time and thus can be used to describe synchronous situations only, not diachronic duration, which is defined by unceasing motion and flow. He proposed that "the idea of style is better suited to extension than duration. When we are dealing with large durations, words describing time work better than extensional words like style." Ibid. The difficulty of his proposition is that it virtually precludes the logic of periodization, which in turn might be seen as the primary characteristic of contemporary work.

77. Ad Reinhardt, "Twelve Rules for a New Academy" in *Art as Art: The Selected Writings of Ad Reinhardt*, ed. Barbara Rose (New York: Viking Press, 1975), 206.

SOMETIMES MAYBE POSSIBLY: RADICAL DIFFIDENCE, OR THE SHY DOWNTURNED FACE OF REVOLUTION IN OUR TIME

REBECCA SOLNIT

For Ann Chamberlain, artist, friend,
world-changer on the quiet

THE SEVEN DEADLY VIRTUES OF CONTEMPORARY ART:
ORIGINALITY
SPONTANEITY
SIMPLICITY
INTENSITY
IMMEDIACY
IMPENETRABILITY
SHOCK

—cardboard sign hand-lettered in pastel by the artist Jess (1923–2004)
and installed in his studio[1]

Lately I've been arguing about the state of American youth with baby boomers who want to believe that subsequent generations have dropped the banner of idealism that they themselves once carried so high. I hasten to point out to these boomers the antisweatshop and the justice-for-janitors campus solidarity movements of recent years and the significant minority of young people involved in other direct-action campaigns, but most of all I argue that the very tenor of these young American lives is an act of resistance to, among other things, becoming like such boomers themselves and passing summary judgment on strangers. Of course, this combativeness is a sign of my own boomer-cusp status. The young: I often admire their lovely diffidence, the modesty that manifests as a refusal to tell other people what to do, a careful avoidance of all soapboxes and pulpits. Or I admire it up to a point, perhaps defined as a pinnacle of moral refinement beyond which lies a slippery slope. Small is beautiful, but too willfully small can become ineffectual, evasive, or trivial.

In a way, though, "the small" is the politics of our time, and it can be a powerful antidote to the big. Small is the opposite, for example, of corporate globalization. All those heroic battles of recent years—from the protests against the World Trade Organization in Seattle (1999) and Cancún (2003) and Hong Kong (2005) to the current struggles against the spread of Wal-Mart and other big-box stores in the American (and Mexican and European) landscape—were and are about protecting the small, the local, the particular against a steamroller of homogenization and economic strip-mining. (A local business, the protesters would tell you, keeps most of the money in the community, a chain pumps out profit to someplace far away; the local is accountable, the transnational is not; local economies breed diversity and support cultural memory; and so forth.) In the world of food politics, for example, the local means community-supported agriculture, farmers' markets (which have proliferated astoundingly in the last decade, one of the small revolutions of our time), and thinking about things like "food miles" (how far your food traveled to your plate). And growing your own.

The cumulative effect of all these localizing gestures is laudable, but it doesn't necessarily put a dent in Monsanto's campaign to privatize seed stock and genetically alter major crops. To do that requires the kind of confrontational, collective action that, for example, North Dakota farmers took to undermine that corporation's attempts to promulgate genetically modified wheat. This begets a big question: can the small be defended with small gestures alone, or are boldness and confrontation sometimes required—the things these kids

in their radical diffidence shy away from. Other sectors of the contemporary world manage to do both, none more breathtakingly or brilliantly than the Zapatista Army of National Liberation of Chiapas, Mexico, who rose up on January 1, 1994, the day that the North American Free Trade Agreement (NAFTA) went into effect. They did so to protest what transnational corporate capital would do to the indigenous, the deep-rooted, the small, the fragile, the local—and has since done to the traditional corn farmers of Mexico, among others. Their revolution was carried out to a small degree with weapons, but as they say, "our word is our weapon," and their ideas are enormously powerful and profoundly influential.[2]

Among the principles the Zapatistas enunciated were *mandar obedeciendo* (lead by obeying), *para todos todo, nada para nosotros* (everything for everyone, nothing for ourselves), and *preguntando caminamos* (walking we ask questions). These mottos articulate a flexible, modest, hopeful, quixotic grasp of how to step forward without stepping on anyone. "Walking we ask questions" is one of their ways of insisting that they do not have answers—"our specialty is proposing problems," they say, not solutions—and that questions can carry you forward. The Zapatistas made it clear that the old Left—domineering, centrist, convinced that if it ran the state then the state would set us free, ready to pass judgment, fond of one-size-fits-all answers, full of its own globalizing tendencies—was dead. They were too polite to put it quite that way, but there it was, and a hazy yet often luminous new political-cultural era has arrived. I see the insurrectionary diffidence of the privileged young around me as inspired by this, up to a point. It is as though they have vowed never to be bullies again, but in so doing find it hard to stand up for (and to) things. I like the humility, the gentleness, but I want those who come after me to dream big dreams and try to change the world—to feel powerful, with all the burden and opportunity that goes with that power. "Engaged withdrawal," the term for the creation of alternatives and the refusal to participate in what is seen as corrupt, can be an effective mode of social and political change, but sometimes engagement is necessary.

Not that withdrawal is as easy as it used to be, either. As my friend Heather Smith, a San Francisco journalist in her early thirties, puts it, the days of easy utopias are over:

Not many 20-year-olds in this day and age have the money or free time to dream up a mescaline-fueled utopian vision of life off the grid. Land is expensive. Everything is expensive. Most people who finish even undergraduate-level college these days have $30,000 to $50,000 in government-subsidized student loans—and the interest rates on those loans have climbed from about 3% to 8% in the last ten years. So, you find people planting vegetable gardens, or keeping a hen in their backyard, so they can feel slightly opted-out from the agricultural-industrial complex (which seems to be everyone's favorite Great Satan these days). The goal isn't to, say, stand around Whole Foods or Safeway holding signs, or blow up chain stores until they agree to support local farmers. It's more an extension of the punk DIY 'Book Your Own Fuckin' Life' culture.[3]

That is, economics has forced many of the young into smaller-scale gestures—something I first saw in the art world when the dot-com boom era of gentrification forced emerging artists to work at their kitchen tables instead of in studios (an interesting corollary, I believe, to how the grand scale of art from the sixties to the eighties was born of the availability of industrial spaces as zones like SoHo deindustrialized in an earlier round of global economic mutation). Of course, these are arenas for young people who believe that their acts matter or, as articulated by the famous former tree-sitter Julia Butterfly Hill, that "one makes the difference."[4] Hill's gesture was both grand—defiance of a big corporation's logging plans—and modest, since it took the form of occupying a very small, remote, and unsafe space for a very long time. One makes the difference, or at least one enjoys the backyard eggs and tomatoes. For the rest, even such a basic level of belief is a struggle, and yet what I see rising out of this is not amorality but ethical doubt, or an ethic *of* doubt.

The world is large, and within it, coexisting with the soft-spoken gesture of the one, is the ferocity of hip-hop, which is and always has been fine with power—with speaking truth to power, loudly, profanely, and directly. This may be the most significant other expressive strain in contemporary American culture: the margins standing up as the heirs to the center sit-down. Beyond that, though, the mix is infinitely complex. Take, for example, the transnational collective of kids—beginning with one freshly minted high school graduate from Toronto—who used Facebook to organize support for the September 2007 Buddhist monk–led uprising in Myanmar and within a few weeks had 400,000 members on their site.[5] No doubt the internet is enormously effective as an organizing tool, but it poses the immediate problem of whether it propagates and links direct actions or leads to a miasma of indirectness. It is, nonetheless, effective enough that Myanmar's ruling military junta has tried to shut it out of that country. And the monks and nuns who rebelled—by walking on city streets—were, many of them, very young, as have been many of the people at the demonstrations in support of them worldwide. Idealism lives, but the nature of power is an open question now, in the sense that "walking we ask questions."

My editor at Tomdispatch.com, Tom Engelhardt, about as conscientious a baby boomer as can be imagined, writes, at sixty-three, "When people look back on the Vietnam era, few comment on how connected the size and vigor of demonstrations were to a conception of government in Washington as responsible to the American people. . . . Though they may not have known it, they were still believers, after a fashion. By and large, the demonstrators of that moment not only believed that Washington should listen, but when, for instance, they chanted angrily, 'Hey, hey, LBJ, how many kids did you kill today?' that President Lyndon Baines Johnson would be listening. (And, in fact, he was. He called it 'that horrible song.') Which young people today would believe that in their gut?"[6] What Tom is noting is that the radical actions of 1960s youth were shaped in part by their confidence in their own power and their own government's accountability. I'm not sure the sense of futility and powerlessness felt by many kids of this generation is truly new—corrupt politics can't be too much worse than the looming nuclear Armageddon of the 1950s or life behind the Iron Curtain—but I can say that their low-power

personas aren't always defeatist. They're chosen, and chosen for a reason. For the affluent and privileged kids, it's about being careful not to be dominant or hegemonic or any of the other evils decried by, among other movements, the multiculturalism of the 1980s. Their carefulness is a just response to those charges and to the deep suspicion of power in our time. It's a victory. But it can also become a defeat: a strategy of disavowing the power to act by imagining or depicting one's hegemonic, white, first-world self as an aging innocent, a would-be Joseph Cornell or Henry Darger tinkering away in the childhood bedroom with the tiny materials and lite-Pop subjects that speak to one's own ineffectuality or marginality. The marginal are the antiheroes of an era that eschews power, and pretending to not have any, or believing you don't, gets you off all kinds of hooks.

Toward the end of Sam Green and Bill Siegel's 2003 documentary film *The Weather Underground*, Brian Flanagan, a rueful survivor of that tumultuous organization, says, "If you think that you have the moral high ground, that's a really dangerous position and you can do some really dreadful things." That's not something many on the extreme left could have said in the late sixties and early seventies, when the Weather Underground and other radical groups were orchestrating their domestic bombing campaigns, but it is now. Politics have changed profoundly in the decades since "the sixties," the much-mythologized, much-misrepresented era of about 1966–74. Watching Green's film, it is the hubris of the young then that is most startling—and the violence some of them wrought was a consequence of that, for the great sin of hubris is assuming the privilege of making life-and-death decisions for others.

But maybe it's wrong to focus on the sixties as the object of young resistance. After all, there is plenty from the 1980s worth repulsing or resisting, too. When I ponder arrogance in the art world, I see the art of the eighties, or at least that sector of it I used to call "political flavored": the stuff that functioned within the conventional art economy but featured confrontational slogans and denunciations and dramatic imagery. It didn't seem to do anything more than serve as a billboard for the moral qualifications of the artist. The antithesis of that would be a lot of the work nowadays that goes quietly down other avenues to engage with various communities, possibilities, economies, and alternatives, often examining the means of its own making, an art of microcosms rather than manifestos, or as manifestos. For example, in my own town, San Francisco, Amy Franceschini and Futurefarmers started a series of victory gardens modeled after the wildly successful World War II Victory garden campaign that made everyone, even city-dwellers, agrarian and involved. You no longer denounce industrial agriculture and have your cadre make a ten-point plan for global reform, or speak for "the people." You plant a garden, or you work with a community to plant a garden. Fritz Haeg's Edible Estates is a full-fledged assault on the front lawn and, by implication, suburbia, replacing lawns one at a time with produce gardens, often in defiance of neighborhood norms. On vacant inner-city lots groups such as City Slicker Farms in West Oakland, California, or Greening of Detroit are similarly working to benefit local economies and promote healthful diets and healthier communities. One part of the revolution needs to confront Monsanto, but another front can be the front yard or the vacant lot.

I grew up hearing about the revolution that never happened. The familiar refrain "after the revolution" meant that through some miracle everything would become different, suddenly and pervasively. "After the revolution you'll be in a forced reeducation camp," one of my friends used to tease his right-wing uncle, but joking aside, the model then was an overthrow of the current government *of them* and its replacement by a government that, at least in theory, was *of us*, if ever a government is. History has since lurched onward, though some people got there early. Last year I had the pleasure and honor of meeting Grace Lee Boggs in Detroit, where she has lived and organized radical politics since the 1950s. Grace was born to Chinese immigrant parents in 1915, earned a PhD in philosophy in 1940, married the African-American labor organizer Jimmy Boggs in the early 1950s, and has lived long enough to see the whole idea of revolution change. She said to me, "In the first half of this century people never thought that revolution involved transforming ourselves, that it required a two-sided transformation. They thought that all we had to do was transform the system, that all the problems were on the other side."[7] The Boggses grew disillusioned by what Black Power turned into when it became the African-American government of the city of Detroit, and they began looking further and deeper for where change comes from and where it needed to go. They came to revalue the contributions of Martin Luther King, Jr., and the utility of nonviolence and love as tools of social change.

It seems odd now to believe that the state can give us freedom, happiness, solidarity, vision—our biggest hope for the state today is that it won't take any of those things away from us and waterboard us in the process. The Mexico-based political theorist John Holloway has tried to articulate another role or guise for revolution in an era when state power strikes many as something to reduce as much as possible, not to seize. As he noted in a conversation with activist scholar Marina Sitrin, "Why are more and more people turning their back on the state now? . . . It is . . . the experience of activists that building for taking state power involves us in a bureaucratic, hierarchical, alienating sort of politics that is a long way from the sort of society that we want to create."[8] That is, the quest today is not for power, or at least not power over others. And that is where the modesty and doubt of the project come in. Holloway adds, "I think we have to start by admitting that we don't have the answers. The fact that we think that taking state power is the wrong way to go does not mean that we know the right way. Probably we have to think of advancing through experiments and questions: '*preguntando caminamos*,' . . . as the Zapatistas put it. To think of moving forward through questions rather than answers means a different sort of politics, a different sort of organization. If nobody has the answers, then we have to think not of hierarchical structures of leadership, but horizontal structures that involve everyone as much as possible." This is a conscious political ideology of the disavowal of power—power over others, not power to act. It is the politics of the small.

Boggs in Detroit agrees with Holloway in Puebla, Mexico, and though my subject is the young, their ideas are far from the property of a generation (and the idea of generational revolution is itself antiquated). Theirs are ideas that have come in quietly through the back door to clean the house and open the windows, and I think they are gradually taking over most of the rooms.

"In revolutionary struggles throughout the twentieth century," Boggs says, "we've seen that state power, viewed as a way to empower workers, ends up disempowering them. So we have to begin thinking differently. The old concept used to be: first we make the political revolution and then the cultural revolution. Now we have to think about how the cultural revolution can empower people differently. . . . There's a new power emerging that already has new values, that is already participatory. It is a very different scenario."[9] Or, as the political theorists David Graeber and Andrej Grubacic write in their own inquiry about what revolution in our time might look like, "Everywhere one finds the same core principles: decentralization, voluntary association, mutual aid, the network model, and above all, the rejection of any idea that the end justifies the means, let alone that the business of a revolutionary is to seize state power and then begin imposing one's vision at the point of a gun."[10] The strategy and goal, they say, is "less about seizing state power than about exposing, de-legitimizing, and dismantling mechanisms of rule while winning ever-larger spaces of autonomy and participatory management within it."[11] I think that in a small, inchoate way, many of the young, in what they do and what they refrain from doing, embody this.

As Boggs, Holloway, Graeber, Grubacic, and others make clear, the revolution is not about taking over the state, and so it won't manifest as one heroic or violent confrontation. It involves myriad acts and choices, small and large, at every moment, and it is already going on in gender, race, economic, social, and ecological ideas and arrangements as well as in the transformation of power structures and daily practices. This is the idealism of the small—writ large, the revolution of everyday life. For example, how did the status of gays and lesbians change in the modern world? You can point to legislation and historic moments, but in the end those simply acknowledged and ratified a sea change in the culture—ultimately in much of global culture—begun earlier by millions of people coming out of the closet and by a host of smaller shifts in representation, in schools, in workplaces. That is to say, countless individual gestures of courage and truth accumulated slowly and incrementally to remake the social landscape and collective imagination, a process of change in which culture and media played pivotal roles. The industrial revolution and other radical transformations of our society took place by degrees, and change in our own time is likewise incremental, and just as profound. The revolution is already here, imperfect and incomplete, but well under way. If overthrowing the government is not the goal, then it won't take the form of some spectacular, military-style confrontation, and there will be no watershed at all if the movement is committed to changing almost everything. The revolution can be, must be, will be in each of our gestures all the time. And how do you change almost everything? Step by step.

NOTES

1. Rebecca Solnit, *Secret Exhibition: Six California Artists of the Cold War Era* (San Francisco: City Lights Books, 1990), 111–12.

2. For a list of Zapatista aphorisms, see Manuel Callahan, "Zapatismo beyond Chiapas," in David Solnit, ed., *Globalize Liberation: How to Uproot the System and Build a Better World* (San Francisco: City Lights Books, 2004), 217–18, 226.

3. Heather Smith, email to the author, October 8, 2007. *Book Your Own Fuckin' Life* began as a book published by the punk zine collective behind *Maximumrocknroll* and is now a website for social networking, event listing, band booking, and more, accessible at: http://www.byofl.org.

4. See Julia Butterfly Hill and Jessica Hurley, *One Makes the Difference: Inspiring Actions That Change Our World* (San Francisco: HarperSanFrancisco, 2002).

5. Facebook's profile for Support the Monks' Protest in Burma, accessible at: http://www.facebook.com/group.php?gid=24957770200.

6. "Thoughts on Getting to the March," October 28, 2007, accessible at: http://www.tomdispatch.com/post/174855/thoughts_on_getting_to_the_march.

7. Grace Lee Boggs, conversation with the author, September 2006.

8. John Holloway, "Walking We Ask Questions: An Interview with John Holloway," interview by Marina Sitrin, *Perspectives on Anarchist Theory* (Fall 2004); also accessible at: http://info.interactivist.net/analysis/05/03/02/1545238.shtml?tid=22.

9. Grace Lee Boggs, "'Revolution as a New Beginning': An Interview with Grace Lee Boggs," interview by Adrian Harewood and Tom Keefer, *Upping the Anti* 1 (2003); also accessible at: www.belovedcommunitiesnet.org/Readings%20PDFs/Grace%20Lee%20Boggs/REVOLU_NEW_BEGNG.pdf.

10. David Graeber and Andrej Grubacic, "Anarchism, or the Revolutionary Moment of the Twenty-First Century" (2004), published on multiple websites; accessible at: http://www.zmag.org/content/showarticle.cfm?ItemID=4796.

11. Ibid.

ARTISTS IN THE EXHIBITION

ARTISTS IN THE EXHIBITION

WHITNEY BIENNIAL 2008

RITA ACKERMANN

NATALIA ALMADA

EDGAR ARCENEAUX

FIA BACKSTRÖM

JOHN BALDESSARI

ROBERT BECHTLE

WALEAD BESHTY

CAROL BOVE

JOE BRADLEY

MATTHEW BRANNON

BOZIDAR BRAZDA

OLAF BREUNING

JEDEDIAH CAESAR

WILLIAM CORDOVA

DEXTER SINISTER

HARRY DODGE AND STANYA KAHN

SHANNON EBNER

GARDAR EIDE EINARSSON

ROE ETHRIDGE

KEVIN JEROME EVERSON

OMER FAST

ROBERT FENZ

COCO FUSCO

GANG GANG DANCE

AMY GRANAT AND DREW HEITZLER

RASHAWN GRIFFIN

ADLER GUERRIER

MK GUTH

FRITZ HAEG

RACHEL HARRISON

ELLEN HARVEY

MARY HEILMANN

LESLIE HEWITT

PATRICK HILL

WILLIAM E. JONES

KAREN KILIMNIK

ALICE KÖNITZ

LOUISE LAWLER

SPIKE LEE

SHERRIE LEVINE

CHARLES LONG

LUCKY DRAGONS

DANIEL JOSEPH MARTINEZ

COREY McCORKLE

RODNEY McMILLIAN

JULIA MELTZER AND DAVID THORNE

JENNIFER MONTGOMERY

OLIVIER MOSSET

MATT MULLICAN

NEIGHBORHOOD PUBLIC RADIO (NPR)

RUBEN OCHOA

DJ OLIVE

MITZI PEDERSON

KEMBRA PFAHLER / THE VOLUPTUOUS
 HORROR OF KAREN BLACK

SETH PRICE

STEPHEN PRINA

ADAM PUTNAM

MICHAEL QUEENLAND

JASON RHOADES

RY ROCKLEN

BERT RODRIGUEZ

MARINA ROSENFELD

AMANDA ROSS-HO

MIKA ROTTENBERG

HEATHER ROWE

EDUARDO SARABIA

MELANIE SCHIFF

AMIE SIEGEL

LISA SIGAL

GRETCHEN SKOGERSON

MICHAEL SMITH

AGATHE SNOW

FRANCES STARK

MIKA TAJIMA / NEW HUMANS

JAVIER TÉLLEZ

CHEYNEY THOMPSON

MUNGO THOMSON

LESLIE THORNTON

PHOEBE WASHBURN

JAMES WELLING

MARIO YBARRA JR.

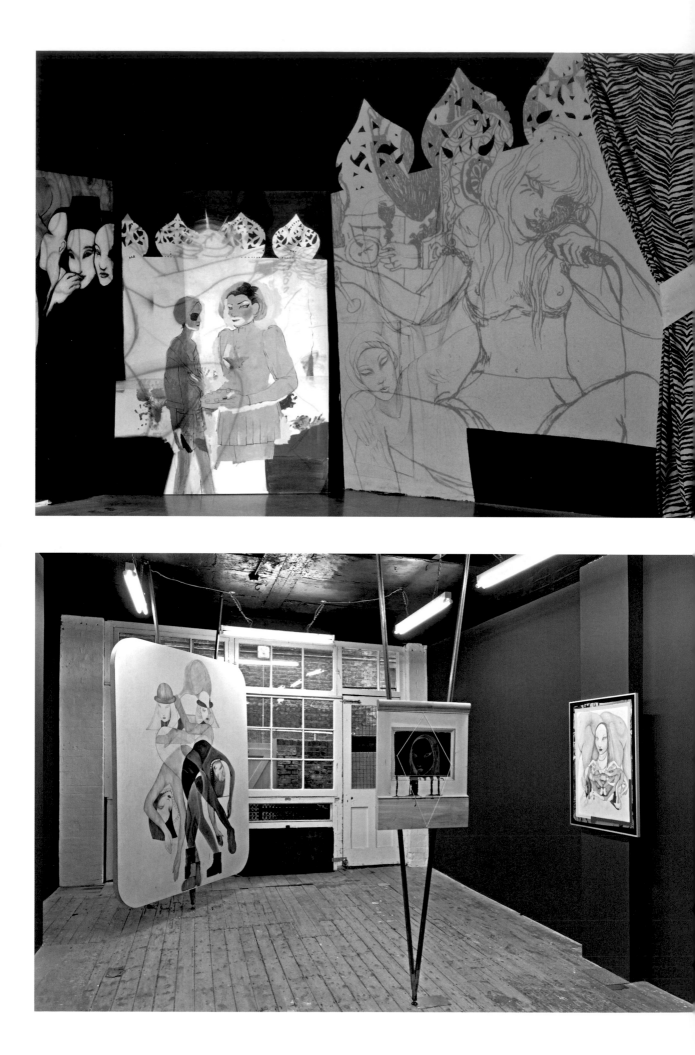

RITA ACKERMANN

Born 1968 in Budapest, Hungary; lives in New York, New York For the past decade, Rita Ackermann has pushed the boundaries of a painting-based practice that embraces a plethora of social roles and an equally catholic range of artistic media, from stained glass to the red ballpoint pen she's applied to runway models' faces in lieu of makeup. She has realized multiform shadow puppet theaters like *The Deer Slayer* (1997), performed as a band member of the art collaborative Angelblood, and curated exhibitions including *The Perfect Man* (2007) and *The Kate Moss Show* (2006, with Olivier Zahm).

An aesthetic magpie, she gained cultish recognition for her seductive, complicative renderings of pubescent girls idling in various states of undress. This all-female alternate reality of syringes and telephones refracted the gritty self-image of 1990s downtown New York City through an otherwordly veneer, prefiguring the complexities of postidentity politics and cyberpunk virtual worlds such as Second Life. Since she first executed paintings of gothic, cat-eyed nymphs on the windows of a downtown squatter bar more than a decade ago, Ackermann has continued to question traditional notions of painting and support, creating oneiric mixed-media murals and large-scale freestanding collages that alight on similar themes of seduction and violence, such as the phantasmagoric, zebra-curtain-framed *Toast for No Fear! (Los Angeles)* (2007).

In both her drawings and collages Ackermann juxtaposes characters and narratives, as in *Scorpionun (Man on My Breast/Man, Man between My Legs)* (2006), which draws on the semiotics of fertility charms and pornography to create an anthropomorphic woman-man-child. The superimposed images composing this life-size freestanding collage on plexiglass come from the artist's own sketches—a row of her lithe women, wearing bowler hats and holding tennis rackets—as well as other sources, such as an illustration of the Madonna and Child positioned over the figure's heart.

As *Scorpionun*'s content suggests, Ackermann's interest in constructions of gender and the fantasies that subtend and are sustained by them has survived her transformation of scale and material. Indeed, the oversize cruciform *Nun/Skeleton/Cross* (2006) and comparably large-scale *Nun/Mother/Whore* (2006) revolve around the bifurcated, simultaneously present identities of these objects of desire. The aggregation in these collages' listlike titles is mirrored in the conspicuous overlay of their images: Ackermann does not negate tropes of womanhood but stages them as acts and processes of becoming to be set into dizzying and conflicting relief with and within one another. Few clear plots emerge despite her utilizations of fairy-tale themes, and irrespective of the ingratiatingly beautiful protagonists who inhabit them, neither are there storybook endings. **S.H.**

Nun/Mother/Whore, 2006. Collage on plexiglass, double-sided, 83 x 43 in. (210.8 x 109.2 cm). Collection of the artist
opposite top: *Toast for No Fear! (Los Angeles)*, 2007. Fabric, synthetic polymer on wall, graphite on wall, oil on canvas, two projectors, transparencies, and adhesive tape, 132 x 288 in. (335.3 x 731.5 cm). Collection of the artist
opposite bottom: Installation view, *Gentlemen, I Need Air*, HOTEL, London, 2007

NATALIA ALMADA

Born 1974 in Mexico; lives in Mexico City, Mexico, and New York, New York Acknowledging six generations of family history in her homeland of Sinaloa, Mexico, filmmaker Natalia Almada honors her heritage by making cross-cultural films that connect the past to the present. As a Mexican-American artist who reflects, as she notes in her director's statement, on how "free trade with our wealthy neighbor [the U.S.] changed our economy and culture," Almada is compelled to make portraits of those most affected by poverty, not to simply elicit sympathy but to examine the complex nature of decision making under financial duress. Like the ethnographic films of Mongolian writer-director Byambasuren Davaa, Almada's films expose a culture whose intricacies are largely unknown to their audience, though Almada's work is purely nonfictional. Her most recent feature, *Al Otro Lado (To the Other Side)* (2005), describes corrido music as the artistic imperative that has for two hundred years preserved Mexican tradition, serving as the primary narrative channel through which news of underground culture is spread.

Al Otro Lado juxtaposes three stories by allowing corrido music to serve as narration, replacing the voice-overs typically employed in documentary films. Lyrically, corrido—structurally rooted in medieval troubadour balladry—recounts tales of larger-than-life heroes and outlaws; in recent decades narcocorridos, about drug traffickers, and songs about undocumented immigrants have become popular. *Al Otro Lado* introduces the story of fourth-generation fisherman Magdiel,

a twenty-three-year-old corrido composer who dreams of escaping Sinaloa to the United States in search of musical fame and fortune. Counterbalancing this saga is performance and interview footage of Los Tigres del Norte, an internationally renowned corrido band whose members provide a success model to youth yearning to leave the poverty of Mexico. Interspersed with footage of corrido hero Chalino Sánchez and other corridistas, *Al Otro Lado* functions in part as music documentary. Scenes shot in Los Angeles and Arizona show how corrido has inspired American fans, as it offers a new generation a symbol both of Mexican pride and of an attempt to live the American dream—prefacing Almada's emphasis on border politics as the story's underpinning.

One striking aspect of *Al Otro Lado* is the wealth of candid interview footage Almada captured among drug traffickers, farmers growing marijuana and poppies, "coyotes" who for a fee smuggle Mexicans across the border, members of the U.S. Border Patrol, and Minuteman Civil Defense Corps cofounder Chris Simcox, who finds and detains a group of immigrants hiding in bushes while Almada's camera is rolling. The film ends as Almada follows a coyote-escorted group, including Magdiel, hoping to make it over the border as night falls. Exploring a world rife with desperation and dreams, Almada's camera functions as a cinematic corrido, a portrayal of an overarchingly disastrous situation made artistically relevant by her journalistic dedication to its cause. **T.D.**

Stills from *Al Otro Lado (To the Other Side)*, 2005. Digital video, color, sound; 66 min. Collection of the artist

EDGAR ARCENEAUX

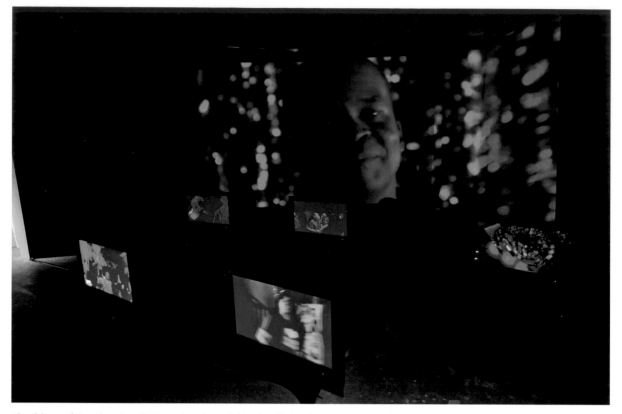

The Alchemy of Comedy . . . Stupid, 2006. Nine-channel video installation: four projections and five 36-in. (91.4-cm) flat-screen monitors, cardboard, and wood, dimensions variable. Collection of the artist

Born 1972 in Los Angeles, California; lives in Los Angeles, California Probing strikingly incongruent sets of data for patterns of affinity, Edgar Arceneaux's conceptual program uncovers meaning in unexpected adjacencies and sees beauty in tangential leaps. The artist's practice takes advantage not only of his intellectual restlessness but also his wide-ranging technical adroitness, a mix of multidisciplinary skills—including drawing, photography, sculpture, and filmmaking—that figure into the unorthodox installation scenarios he has developed and refined over the last decade.

Arceneaux's early work often grew first and foremost from the act of rendering—his *Drawings of Removal,* an ongoing multivenue performance/production project begun in 1999 and first seen in New York in 2002 at the Studio Museum in Harlem, filled the different galleries where it was executed with dozens upon dozens of drawings directly on the walls of the gallery. Working in the exhibition space as a live studio, he repeatedly made, erased, redrew, scored, cut up, and reassembled the pencil on paper and velum images in a process designed to both mimic and provoke the mechanics of recollection. From early projects like this, Arceneaux's explorations have only increased in breadth and complexity. Cosmologies, both arcenal and scientific, are often woven into each other: in 2004's *Borrowed Sun,* for example, Arceneaux created an intertwined medita-

tion on three major cultural figures—astronomer Galileo, musician Sun Ra, and artist Sol LeWitt—that read the trio's respective astronomical/religious, musical/racial, and conceptual/perceptual systems against one another, teasing out surprising consonances between them via gorgeous charcoal drawings, sculptural elements like glass disks and a Minimalist wall of cinder blocks, and both 35mm slide and 16mm film projections.

Another of Arceneaux's recent large-scale projects is similarly representative of his exploration of the potential relationships between what at first might seem to be unlikely topics. His 2006 installation piece *The Alchemy of Comedy . . . Stupid* features the actor David Alan Grier working out an introspective and frequently awkward comedy routine before a number of different audiences in a variety of venues. Shot under various lighting and compositional conditions, the resulting videos are presented on separate screens in the gallery (amid drawings and works on paper) in a complex geometrical array whose arrangement and palette turn out to be based on classic alchemical processes. The alchemists, Arceneaux recently noted, believed that their practice brought about changes not just in the objects of their experiments, but in the experimenters themselves; it is an observation that lies at the heart of both the work of the comedian and, in Arceneaux's transfigurative practice, the artist as well. **J.K.**

5 spirits, 2006 (detail)

5 spirits, 2006. Oil and oil pencil on metallic paper under glass, six parts, 22 x 17½ in. (55.9 x 44.5 cm) each.
Collection of the artist

ART POLITIQUEMENT ENGAGÉ—POLITISCH ENGAGIERTE KUNST, 2007. Wall paint, publications, ephemera, wallpaper, screenprint and inkjet prints, lights, clay, and photographs by Eileen Quinlan and Roe Ethridge, dimensions variable

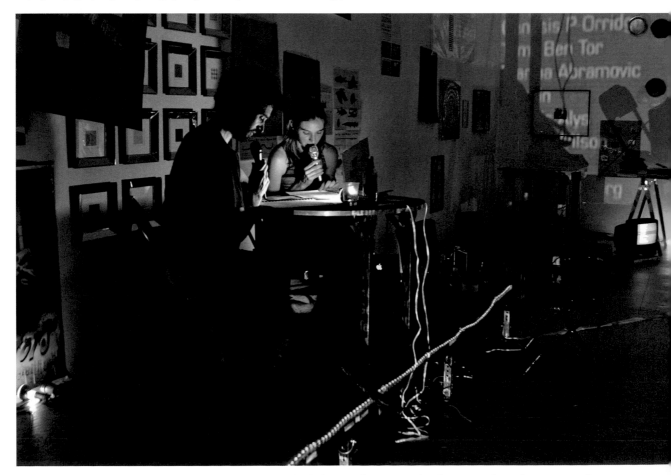

Domestic Affairs, 2006. Reading of extended exhibition checklist, Elizabeth Dee Gallery, New York, July 27, 2006. Pictured: Dan Torop and Jessica Hutchins

A New Order for a New Economy—to Form and Content (A proposal to re-arrange the ads of Artforum), 2006–07. Magazine, wooden shelf, and glass, dimensions variable

Born 1970 in Stockholm, Sweden; lives in New York, New York Undermining assumptions about what constitutes an exhibition—its institutional context, discursive network, audience, or even the artwork shown—Fia Backström's work explores the parameters of format and the logic of display. Her work refuses fixity of images or categories; virtually impossible to characterize, her practice encompasses producing printed matter and merchandise-based items, arrangements and displays, creating objects, writing texts, and initiating gatherings and events. Working within a system that favors the branding of individual identity and style as an artistic signature, Backström acknowledges the elusiveness of her practice in a conversation with Wade Guyton for *North Drive Press*: "There is this great movie title for a film with Leonardo DiCaprio called *Catch Me If You Can* . . . about a con artist who always manages to escape. All artists are sort of like con artists."

In recent installations, Backström has appropriated the work of other artists. For *Forged Community Posters* (2006), she superimposed SDS (Students for a Democratic Society) slogans over images consigned by artists represented by Andrew Kreps Gallery, turning a language of radicality into a marketing spoof. *A New Order for a New Economy—to Form and Content (A proposal to re-arrange the ads of Artforum)* (2006–07), a friezelike ribbon of magazine advertisements encircling the gallery, follows the directive of its own title. By unmooring the images from their original matrix and sorting them according to color, subject (nudes, portraits, animals, crying men), and composition, Backström flattens the formal differences—jarring colors, odd croppings, and the like—so carefully designed to ensure maximum visual impact in *Artforum*'s cluttered pages, transforming the commercial backbone of the magazine into its content.

In highlighting the mercantile underpinnings of the art world in the space of a commercial gallery, Backström renders its operations visibly reflexive. A similar strategy manifested in the performative work *Herd Instinct 360°* (2005–06), a series of gatherings staged as feedback-producing images of themselves—somewhat like Dan Graham's seminal *Performer/Audience/Mirror* (1975), in which the audience confronted its own reflection in a mirror. Conceived to be similarly disruptive, Backström's 2007 gathering *Eco Day* offered participants a series of conspicuously useless, waste-producing activities including interpretive dancing with toilet paper and a scattered "carrying around" of placards in Stockholm's Marabou Park, where a protest march and a lifestyle commercial seemed indistinguishable. Considering us all guilty of collusion, Backström refuses narcissistic melancholy and didactic activism alike as she reworks the signs for engagement—including those of the art context—as they resurface in contemporary image culture. Instead, she offers frameworks for strategic positioning that are there and then are gone. **S.H.**

top: *Arms & Legs (Specif. Elbows & Knees), Etc.: Blue Torso and Pink Arm*, 2007. Interior flat enamel and three-dimensional digital archival print on UV-coated canvas mounted on shaped form with synthetic polymer on wall, 78 x 105½ in. (198.1 x 268 cm). Private collection
bottom: *Arms & Legs (Specif. Elbows & Knees), Etc.: Arm and Plaid Jacket (Green)*, 2007. Three-dimensional digital archival print with polycarbonate resin and synthetic polymer, mounted, 59¾ x 90 in. (151.8 x 228.6 cm). Private collection

Arms & Legs (Specif. Elbows & Knees), Etc.: Elbow (Blue) with Desk, 2007. Three-dimensional digital archival print with polycarbonate resin and synthetic polymer, mounted, 59¾ x 98¾ in. (151.8 x 250.8 cm). Private collection

Born 1931 in National City, California; lives in Santa Monica, California For the last five decades, John Baldessari has constantly reinvented himself, working in a variety of media and forms including painting, photography, books, sculpture, and exhibition design. Although typically associated with Conceptual art, the only consistent aspect of the artist's work—aside from his commitment to mining the archives of art history and the mass media—is his defiance of expectations.

So it was again in 2006 when Baldessari aimed his disruptive sensibility toward museum interventions. Notable was his installation at the Los Angeles County Museum of Art of *Magritte and Contemporary Art: The Treachery of Images* (2006–07), a gathering of works by René Magritte and contemporary artists. Through a dramatic installation gambit, the artist transformed the neutrality of the white cube into a surprising exhibition environment, essentially structuring the show's dialogue between past and present. Viewers walked on carpeting printed with images of Magritte's white clouds against a blue sky while the ceiling was papered with images of Los Angeles freeways. In a characteristically playful turn of the screw, the artist even arranged for museum guards to wear bowler hats similar to those famously populating Magritte's paintings. Baldessari's juxtapositions, displacements, and spatial interventions resonated

with Magritte's uncanny aesthetics but also with the disjunctive poetics very much at the dyslexic heart of his own work. This was further achieved through the deployment of elective affinities, primarily by displacing the familiar—and familiar narratives—with the unexpected or with other elements of disruption, including surprising spacing or gaps.

Baldessari's recent wall-bound works—including *Arms & Legs (Specif. Elbows & Knees), Etc.: Arm and Plaid Jacket (Green)* (2007) and *Arms & Legs (Specif. Elbows & Knees), Etc.: Elbow (Blue) with Desk* (2007)—continue in this manner, furthering a dialogue with Surrealist invention by juxtaposing fragmented body parts and creating more unexpected pairings. Expanding on his *Noses & Ears, Etc.* series (2006–07) also recombining fragments of body parts, the multimedia works from *Arms & Legs (Specif. Elbows & Knees), Etc.* (2007–) bring together photographic, painted, and three-dimensional elements. *Arms & Legs (Specif. Elbows & Knees), Etc.: Blue Torso and Pink Arm* (2007), for example, joins a flat yellow ground painted directly on the wall, a collaged pink-painted photographic arm, and a sculptural torso painted blue. Eliding body fragments into colorful, gap-filled, elliptical tableaux, "these works," the artist notes, "can be seen not as painting, photography, or sculpture, but as a melding of all three." **T.A.**

ROBERT BECHTLE

Born 1932 in San Francisco, California; lives in San Francisco, California For the last forty years, Robert Bechtle has painted portraits, genre scenes, and landscapes as notable for their willfully prosaic leisure-class iconography—replete with suburban bungalows, manicured lawns, patios, and, most frequently, cars—as for their technical facility. As the apocryphal story goes, having returned from a trip to Europe in 1962, Bechtle drove cross-country from New York; near to home, he noticed an overpass dotted with palm trees. "All of a sudden, this stuff that I'd grown up with in California, but hadn't paid much attention to as having anything to do with art," Bechtle later recalled in an interview for SFGate.com, "came into focus." This last turn of phrase is apt since Bechtle has long used 35-millimeter color slides projected onto his supports as the basis of his images, which he then develops through layers of underdrawings and washes. (Indeed, initially exhibiting his works alongside those of Richard Estes, Philip Pearlstein, and Alex Katz, he is often considered the first Photorealist.)

Bechtle's early works mined autobiography and locality, as in the iconic *'61 Pontiac* (1968–69), an oil painting of the artist and his young family with their station wagon; *Fosters Freeze, Alameda* (1970) captures his first wife and children eating ice cream in an all-too-familiar suburban scene. Quotidian mainstays—and their uncanny, desolate placidity—persist in recent work. Cars are still omnipresent if often shrouded: the small water-color *Covered Car—High Street* (2004) gives over the entirety of its frame to its titular focus. Likewise consistent is Bechtle's interest in figuration, although his latest series of self-portraits (2004–06) reveals an unprecedented sobriety of the aging subject facing mortality.

One could suggest that however representational Bechtle's compositions are, his subject is the mediation of vision and even light itself: how it bounces off a chrome bumper, is flattened in a midday blaze, seeps into rooms, or radiates from an incandescent source. Edward Hopper once described his enigmatic *Second Story Sunlight* (1960) as "an attempt to paint sunlight as white with almost no . . . yellow pigment in the white. Any psychological idea will have to be supplied by the viewer." In this tradition, Bechtle's paintings produce an anticipatory stillness, a fact made only more poignant as they become harbingers of something more tangible—an apparition seen as though for the first and last time. **S.H.**

Six Cars on 20th Street, 2007. Watercolor on paper, 22⅜ x 30 in. (56.8 x 76.2 cm). Collection of the artist
opposite top: *Six Houses on Mound Street*, 2006. Oil on canvas, 36 x 66 in. (91.4 x 167.6 cm). Private collection
opposite bottom: *20th and Mississippi—Night*, 2005. Oil on canvas, 37¼ x 67¼ in. (94.6 x 170.8 cm). Private collection

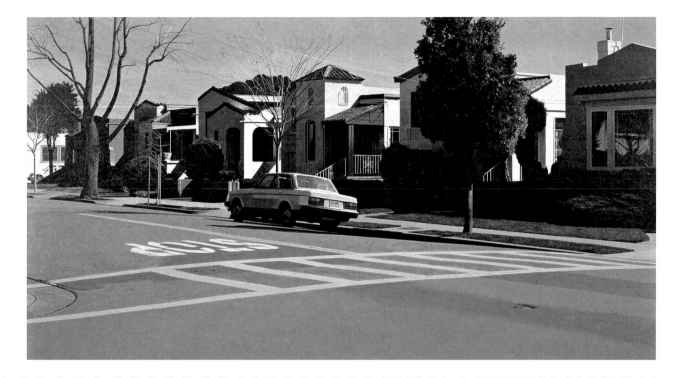

WALEAD BESHTY

Installation view, *Hammer Projects: Walead Beshty*, The Hammer Museum, Los Angeles, 2006; from left: *Travel Picture Granite [Tschaikowskistrasse 17 in multiple exposures* (LAXFRATHF/TXLCPHSEALAX) March 27–April 3, 2006]*, 2006; *Travel Picture Sunset [Tschaikowskistrasse 17 in multiple exposures* (LAXFRATHF/TXLCPHSEALAX) March 27–April 3, 2006]*, 2006; *Dismal Science Reading Area with Direct Dial Embassy Phone*, 2006

Born 1976 in London, England; lives in Los Angeles, California Walead Beshty has long used photography as a tool to explore the social and political conditions of our material culture. More recently, the material conditions of photography itself have spurred his continuing investigations of the gap between the physical world and the image world, and the way this rupture is instrumentalized by ideologies that seek to infiltrate the processes through which we produce meaning.

From his early projects, like those in *The Phenomenology of Shopping and Dead Malls*, a 2004 exhibition of the artist's work at P.S.1 Contemporary Art Center in Long Island City, New York, Beshty has frequently experimented with photography's deadpan recording ability, using the mechanics of its preservation of information about objects and places in specific moments of time—especially subjects with limited native content, like the forlorn precincts of derelict shopping centers— to expose the kinds of projection and fictionalization that affect even the most superficially stable types of "factual" images.

In his more recent projects, the artist has explored other, more politically complex kinds of ruins, most notably in a series of works flowing from a string of visits he made between 2001 and 2006 to the defunct Iraqi Diplomatic Mission in the former East Berlin. The abandoned building—a piece of a sovereign nation then undergoing radical social and political deconstruction, unmoored within the territory of another nation that had ceased to exist—was, Beshty later wrote, "a relic of two bygone regimes, unclaimable by any nation; a physical location marooned between symbolic shifts in global politics and a displaced representation of the turmoil of the nation to which it is abstractly linked." During his trips to and from Berlin, Beshty found echoes of this zone of radical indeterminacy in the transitional spaces of modern travel—the airport, the customs station, the security checkpoint. It was an unexpected encounter with the last of these that provided the proximate inspiration for the newest phase in Beshty's ever-evolving practice. Using a batch of film damaged by the airport security X-ray machine, the artist literally added a whole new set of traces of form and meaning to his already layered images, initiating another step in his ongoing examination of what he has called a "core dialectic of his work," namely, the operative tension between the material and the optical in the photographic artifact. **J.K.**

opposite: *Travel Picture Sunset [Tschaikowskistrasse 17 in multiple exposures* (LAXFRATHF/TXLCPHSEALAX) March 27–April 3, 2006]*, 2006–08. Chromogenic print, 87 x 49 in. (221 x 124.5 cm). Collection of the artist

**Contax G-2, L-3 Communications eXaminer 3DX 6000, and InVision Technologies CTX 5000*

CAROL BOVE

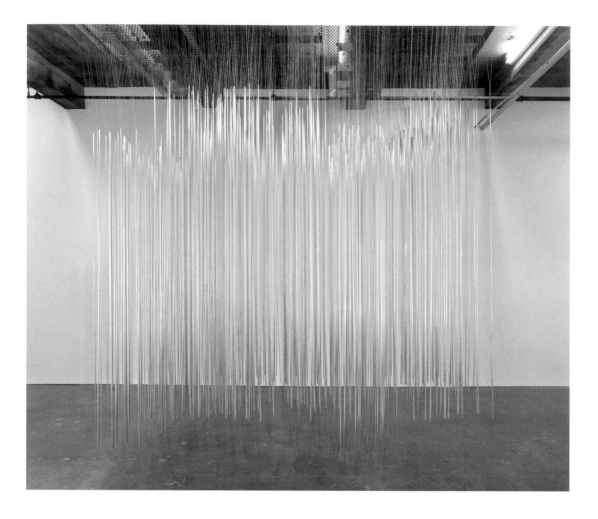

Born 1971 in Geneva, Switzerland; lives in New York, New York "I have a sense of history being contained by objects," Carol Bove recently told Swiss curator Beatrix Ruf, an observation that might well serve as a motto for her nuanced combinatory practice. The particular history with which her work usually has been concerned—namely, that charged, quasi-chronological, sociopolitical moment known as the sixties—is obliquely but convincingly instantiated in her pieces, both the modest shelf-based and the increasingly room-sized displays of carefully chosen found and made objects. Bove's "settings" draw on the style, and substance, of certain time-specific materials to resuscitate their referential possibilities, to pull them out of historical stasis and return them to active symbolic duty, where new adjacencies might reactivate latent meanings. Whether plucked from the archives of culture or couture, from the spheres of entertainment or the academy, the raw materials of Bove's evocative assemblages pulse with the affinities and contradictions of their age, fine-tuned within the artist's categorical systems.

Bove's earliest pieces were typically Minimalist wooden shelves or tables on which she placed simple arrangements of books and images culled from pop culture sources. The array deployed in *At Home in the*

Universe (2001) is representative, capturing the ambitions and ambivalences of the era's revolutionary movements (social, political, and sexual) with a pair of shelves holding *Soul on Ice, Walden*, and books by Aldous Huxley and Buckminster Fuller; *The Writings of Robert Smithson* and *Our Bodies Ourselves*; and a nostalgically modest spread from a nudist book. Bove's recent work has grown physically—outboard installation elements now accompany larger presentational environments that incorporate their own constellations of shelves, tables, and plinths—and broadened its focus to evoke even more ambiguous conditions of history and memory. Bove's 2006 installation at Georg Kargl BOX gallery in Vienna, for example, included a low table set like a diorama-sized sociological sculpture garden of small plexiglass and concrete cubes, peacock feathers, compositionally symmetrical photographs from a fashion magazine, and a lunar atlas; wall drawings made with thread and nails; and a shimmering beaded curtain. The precise allusions of such expanded arrays are perhaps more elusive than in Bove's previous projects, but the "ambience cues," a phrase Bove has used to describe the delicate mechanics of her environments, are as evocative as ever. **J.K.**

The Night Sky over New York, October 21, 2007, 9 p.m., 2007. Bronze rods, wire, and expanded metal, 146 x 192 x 96 in. (370.8 x 487.7 x 243.8 cm). Collection of the artist
opposite: Installation view, *Carol Bove*, Georg Kargl BOX, Vienna, 2006; from left: *Golden Hair*, 2006; *Driscoll Garden*, 2006; *Silver Compass*, 2005

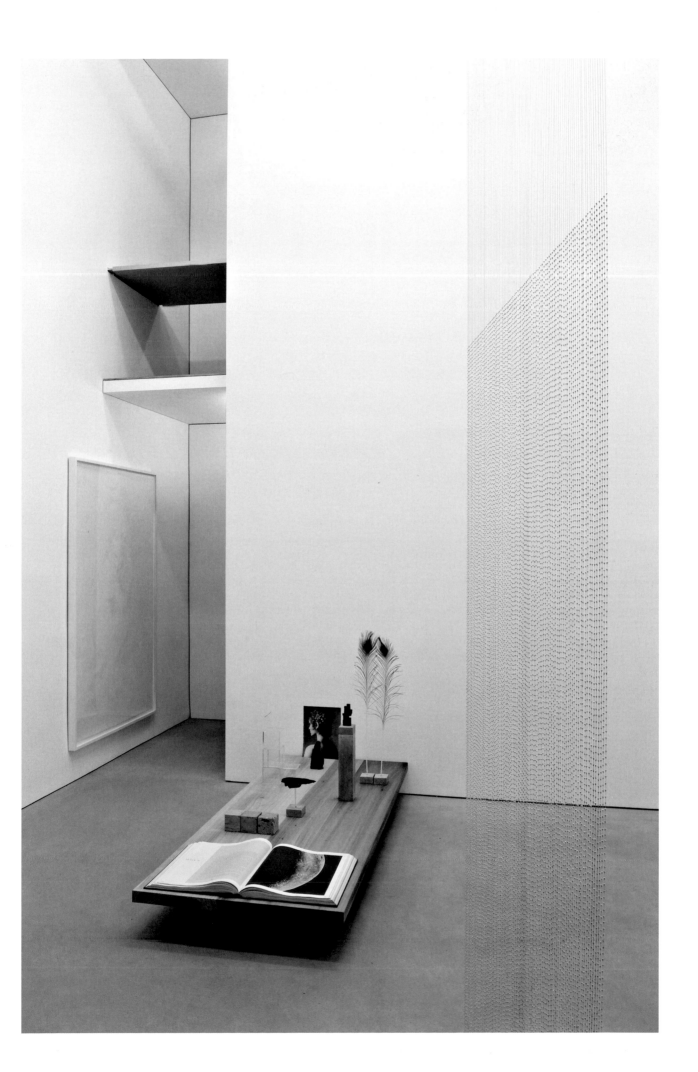

JOE BRADLEY

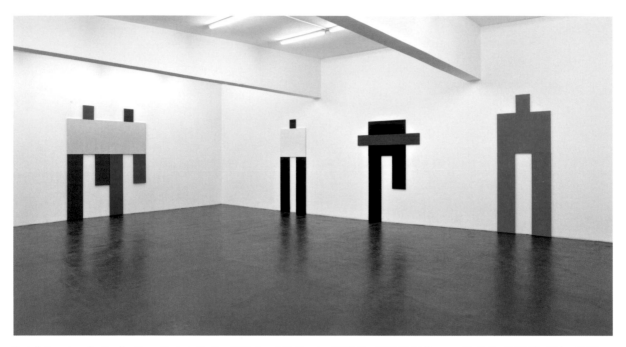

Installation view, *Joe Bradley*, Peres Projects Berlin, 2007; from left: *Cavalry*, 2007; *Itz*, 2007; *Night Runner with Strike*, 2007; *The Thing*, 2007

Born 1975 in Old Orchard Beach, Maine; lives in New York, New York At first glance, Joe Bradley's abstract, monochromatic canvases look like experiments in Minimalism; longer viewing, however, reveals surprising levels of figuration and what Bradley calls an "intentional shoddiness" that points to a dissatisfaction with the narrative of twentieth-century painting. His depictions of people, animals, places, and objects are visually distilled rectangles of color and blocky forms that, hung in sets on the wall, communicate an overall sense of theater and movement. Described by the artist as expressively "pathetic" takes on heroic, large-scale Color Field works, they have the primitive feel of ancient totemic sculptures. At the same time, subtle color variations and surface texturing on the flimsy, store-bought canvases belie the fetishized perfection the paintings allude to. By grouping his works as installations, Bradley injects additional character into each piece, letting them interact as families of energized entities.

Bradley's works refer to multiple modern art movements while exposing the absurdities of the critical systems they borrow from. Though his paintings draw visually from Ellsworth Kelly, Joel Shapiro, and Barry Le Va, the humorous narratives they create lend them an enlightened Pop sensibility: *Animal* (2007) consists of four variously sized, rectangular brown canvases arranged to look like the head, torso, and legs of a 9-foot-tall creature rearing up before the viewer. The four canvases that make up *The Thing* (2007) are placed in the same configuration as *Animal*, painted a vivid orange that suggests the eponymous comic-book character. In a 2007 solo show at Peres Projects Berlin, these two pieces were shown in separate rooms to emphasize their individuality. Installed diagonally across from *The Thing* in the Berlin exhibition, *Cavalry* (2007) is a seven-part acrylic painting composed of a yellow horizontal rectangle and vertical blue and red rectangles positioned to connote the heads and legs of two soldiers the artist envisions as "marching to the rescue." Together the paintings engaged in a dialogue that anthropomorphized the works to challenge definitions of abstract painting as a philosophically hard-line, self-referential process.

While operating in a lightheartedly slapdash mode, Bradley's paintings also reflect a thoughtful attention to the study of color and the visual range achievable through presenting colors alone or juxtaposing them in infinite combinations. In particular, his work harks back to Josef Albers's color theories about the physical versus psychic effects of color. Though his installations have a certain geometric precision, Bradley hopes his paintings' visual economy will give the viewer a psychological charge that is as oddball as it is formally engineered. **T.D.**

opposite: *Animal*, 2007. Synthetic polymer on canvas, four parts, 108½ x 36 in. (275.6 x 91.4 cm) overall. Private collection

Steak Dinner

• THIS YEAR TELL HER YOU LOVE HER ALL OVER AGAIN •
• WITH A GRAB BAG OF DIAMONDS • WITH MOUTHFULS OF CAVIAR • WITH YOUR RENT IN CLOTHES • A CREDIT CARD OF HOTEL ROOMS •
• STOCKINGS • CHAMPAGNE • PLANE TICKETS • AND A SOFT SLAP ON HER BARE ASS •

Steak Dinner, 2007. Letterpress print on paper, 24 x 18 in. (61 x 45.7 cm). Collection of the artist

opposite: *Stage (We're writing a play. It starts with an orgy. With animals tearing each other's guts out. With sound. Of breaking glass. Then it's tedious, without direction. More boring than uncomfortable. For like another hour. There's no satisfaction. No closure. No reward. You can leave after fifteen minutes. It's called "HYENA."),* 2007. Wood, metal, leather, screenprint on canvas, and screenprint on paper, 192 x 96 x 48 in. (487.7 x 243.8 x 121.9 cm). Rennie Collection, Vancouver, Canada

Born 1971 in Saint Maries, Idaho; lives in New York, New York Matthew Brannon's work turns on the opposition—and ever-mounting imbrication—of art and design. After an early stint as a painter, he began to draw his inspiration from those printed materials that mediate everyday life in late-capitalist, early twenty-first-century America, from posters and advertisements to promotional flyers and take-out menus. But if Brannon's iconography conjures mass-produced, throwaway sources, his methods are laboriously handcrafted, even old-fashioned: screenprint, letterpress, and lithograph works, often executed in a limited palette and consistent in their graphic rigor. His art seems on first glance disarmingly direct. But as one turns to the text paired with his images for explication or illumination, disorder intervenes. An early series recalls the conventions of posters for horror films: in *Sick Decisions* (2004), the driveway leading to a stately house is cloaked by shadows cast by bare, looming trees. In place of what look to be credits in the lower part of the work, however, is a string of pithy non sequiturs: this film is "A Desperate Appeal Release," starring, among others, "Abuse of Education" and "Misplaced Trust," with a screenplay by "101 Unanswered Phone Calls."

In recent work Brannon pictures signifiers of contemporary metropolitan life ranging from the quotidian (an alarm clock, a tube of toothpaste, a banana peel) to the more rarefied (oysters, sushi, champagne). Here again, the straightforward quality of each depiction is offset by bewildering, quasi-poetic phrases running below it, what the artist has called a "salad of language."

One line of text under the silhouette of a lobster reads, "this is how it ends" (*The Price of Admission*, 2007); another, below the rendering of a showerhead and bar of soap, "And when he's home at night trying to sleep/He sees himself as a gross pig that everyone hates" (*Alarm Clock*, 2007). Behind the veneer of convenience, plenty, and success implied by the content and format of his images, Brannon seems to suggest, reside darker imperatives—abuse, excess, careerism, insecurity, and failure.

Previous installations of Brannon's work have suggested environments such as a corporate lobby or an airport lounge, and his contribution to the 2008 Biennial evokes a similar example of anonymous urban architecture. In a setting that could be a high-rise apartment, a hotel room, or even a conference area, swaths of elegant drapery frame a faux window and painted graphic of the New York City skyline; domestic accoutrements fill the space. As is often the case with the artist's work, these items initially appear innocuous and then grow more puzzling: small sound-canceling devices, typically found in psychoanalysts' offices, create subtle white noise that aurally isolates the viewer and bolsters a sense of privacy, and the contents of a bookshelf are just out of reach. These volumes, penned by the artist yet devoid of any identifying markings on spine or cover, evade legibility to become instead enigmatically sculptural. Negotiating this theatrical space underscores viewers' sense of self-consciousness and throws into relief a constant of Brannon's work—our own complicity in deciphering and completing meaning. **L.T.**

Radio Pressburg: The I Don't Need Society, 2004. Acetate record of performance, 10 in. (25.4 cm) diameter. Collection of the artist

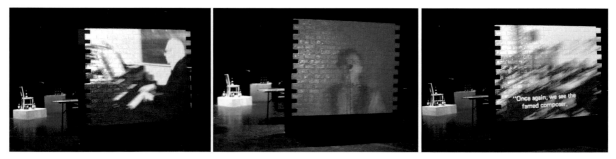

Installation view, *Bread*, The Kitchen, New York, 2007

Mogensen Zine, 2007 (detail, front sheet). Unique offset print on newsprint, 23 x 14 in. (58.4 x 35.6 cm). Collection of Cristina Delgado, Stephen F. Olsen, and F. August Olsen

Born 1972 in Cambridge, Canada; lives in New York, New York Bozidar Brazda designs his multimedia installations as performances to be "pulled apart" into individual elements, activating viewers' participation as they navigate the spaces between his objects. Incorporating sculpture, painting, music, and video, Brazda's aesthetically Postminimal, rough-hewn exhibitions center around partially autobiographical narratives that contextualize his tangible works not as evidence but as charmed arrangements which, through the stories embedded within them, impose a logic on the installation. These stories, conflating issues including past relationships with an unspecified Eastern European country, punk rock history, space travel, drug culture, and Communist or Socialist politics, are unified by a witty desire to represent "objective" history as art—something mutable, subjective, timeless, and poetic. While punk flyers and other remnant underground ephemera imply revolutionary politics, his installations also include off-kilter objects, such as loaves of bread, to undermine any perceived political stance with mystery and ambiguity. This obscurity negates potential nostalgia for the times and places Brazda's works conjure, instead creating what he describes as a present-tense "meeting point" for viewers to reexperience those histories.

Brazda sometimes uses the gallery's press release as a vehicle for narratives substantiating an exhibition's actions and visuals. A story about an imprisoned journalist freed by Hegel-curious teen rebels served as the premise for *The Journalist* (2004) at New York's Haswellediger & Co., for which flyers promoting a Danish punk band called Beret Cola were distributed as if for a concert. In lieu of a live show, Brazda passed out Beret Cola T-shirts and offered sandwiches on a handmade banquet-style table that also displayed two baguettes and a Persian rug draped around the stereo system serving as the band's stand-in. By establishing a narrative of nonsensical connections in his exhibitions, Brazda creates a space in which the shattering of that narrative pushes it further toward absurdity.

Brazda's 2008 Whitney Biennial contribution, *Our Hour/Radioff* (2008), is related to two previous audio installations, *Radio Prussia* (2004) and *Radio Pressburg* (2004). Fake radio programming plays in the gallery: spliced sequences of songs, interviews, recordings of friends and family, and scripted narration alternate with advertisements for fictive goods and services. Stacks of commercially packaged CDs of the recording provide a nonprecious, takeaway sculptural element. Like *Radio Pressburg*, which features punk music, sped-up classic rock, and stories told by a narrator described as "the pan-morph and occasional time hobo," *Our Hour/Radioff*'s humor is built of outlandish moments at odds with each other. Brazda's interest in what he calls "radio's structure" operates on several levels, which, woven together, both actualize and destroy what he has presented to the viewer as art. **T.D.**

Stills from *Home 2*, 2007. High-definition video, color, sound; 30 min. Collection of the artist

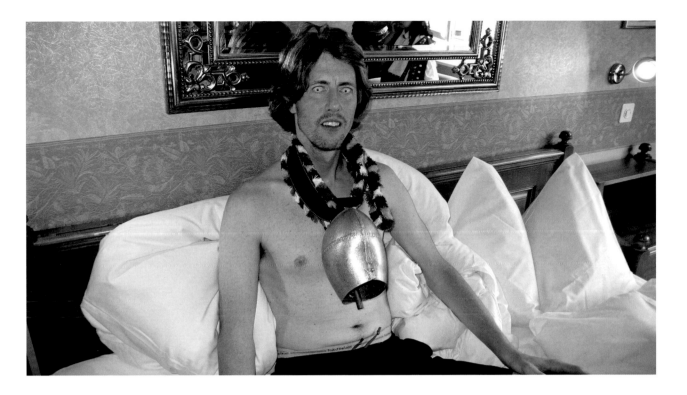

Born 1970 in Schaffhausen, Switzerland; lives in New York, New York Commingling reality and illusion, authenticity and artifice, barbarism and civility, Olaf Breuning creates photographs, films, sculptures, and installations that draw heavily from popular culture and a collective visual iconography. He combines these contemporary aesthetics with more primal shared drives: violence, sexuality, ritual, and companionship. The divergent impulses collide, often with absurd and hilarious results, as Breuning exploits the thin line between humor and pain.

In his 2007 exhibition at Zurich's Migros Museum für Gegenwartskunst, Breuning employed art transport boxes as supports for his photographs, drawings, and sculptures. The crates and packing material, which also frame the exhibition's architecture, take on multiple connotations as vehicles of transport and change. Arranged in a plexiglass showcase, dozens of small ceramic pieces, each incongruously fitted with a pair of large cartoonish eyes, comprise *The Collectors* (2007). These comical figures, mounted on the side of a carton and staring into the exhibition space, conjure comparisons to the collectors who roam international art fairs, frenziedly purchasing and packaging works. In the chromogenic print *20 Dollars* (2007), five young African boys, slightly bemused but smiling broadly, present to the camera $20 bills given to them by the photographer. The detritus of a smoldering garbage heap is strewn around their feet. Mounted on and framed by an over-size shipping crate balanced on a smaller box, the glossy photograph appears broadcast from a large-screen entertainment center, underlining the distance between subject and viewer. The disparities illustrated by the image, especially between the entrenched poverty and easily gained currency, suggest the futility—and perhaps offensiveness—of looking to tourism and globalization as effective vehicles for change in this impoverished scene.

At the center of the Migros exhibition is *Home 2* (2007), a video in which Breuning expands on themes of dislocation, homelessness, and cultural identity explored in his 2004 video *Home*. Here the original narrator, again played by actor Brian Kerstetter, joins a tourist group traveling through Papua New Guinea. He stumbles his way through assorted villages and tribes, variously charming or insulting his fellow tourists and the "natives" he encounters. In this foreign environment his mind is transported to locations of previous travel or fantasy as he sifts through notions of identity and belonging. Home is a universal, but also a specific, construct. "Each has a home they want to go to, like me," the narrator opines as his journey comes to an end. The viewer is left with the distinct notion that neither the traveler nor the world he has left is enriched by the experience. Contextualizing the helplessness of today's global citizen, Breuning examines a basic human quest for commonality in an increasingly global, but ever more fragmented, world. **S.G.**

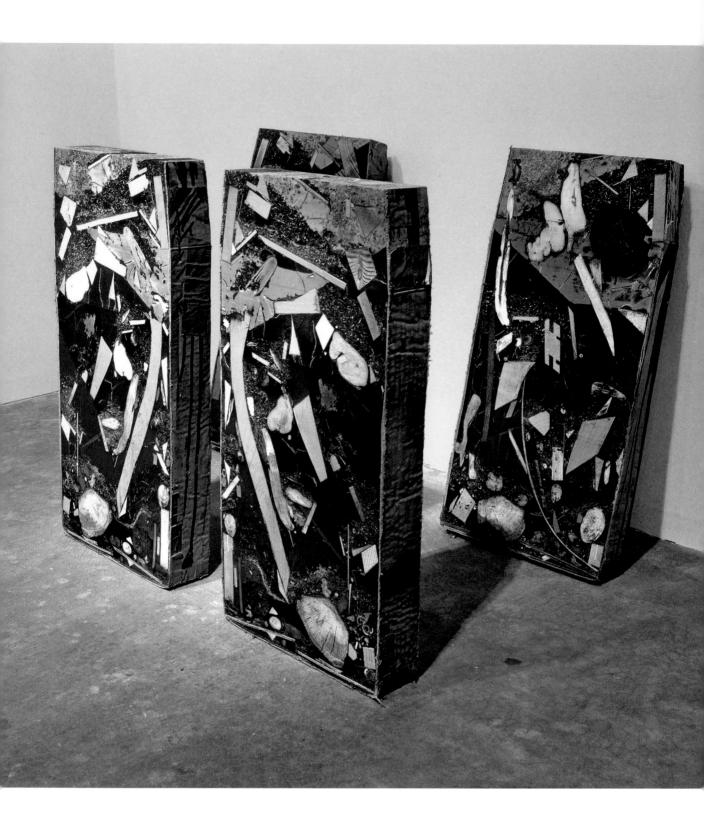

Untitled, 2006 (detail). Resin, pigment, wood, and cardboard, five parts, dimensions variable. Collection of the artist

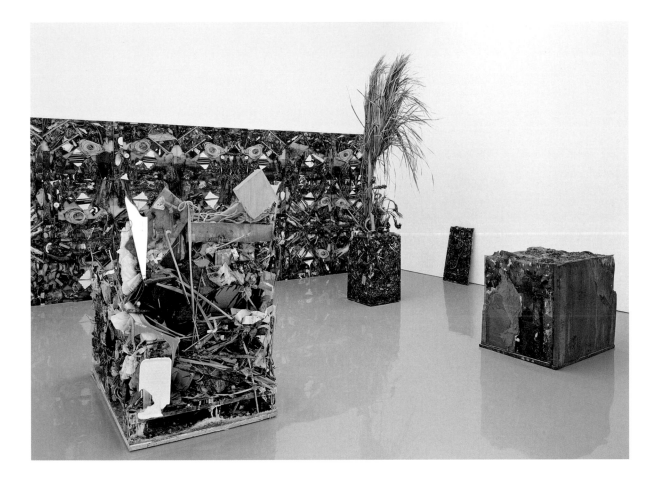

Born 1973 in Oakland, California; lives in Los Angeles, California The sculptor Jedediah Caesar's invented medium is an amalgam of found objects encased in clear or colored resin, which he began creating in late 2003, when it occurred to him that he was more interested in materials themselves than in constructing sculptures with them. In an act of metaphorical rebirth, he filled buckets and other containers with leftover scraps of plywood, along with paper, pieces of cloth, and other assorted studio debris. He poured in liquid resin, and when it hardened he removed solid masses of an essentially new kind of material. He later went on to fill cardboard boxes with bottles, cups, sponges, socks, and other objects that he fused together with resin, and then took the resulting blocks of material to a factory outside Los Angeles where he had them cut with band saws, finally polishing the surfaces to reveal the embedded components trapped like flies in translucent amber.

The faceted cut-resin blocks, which he exhibits alone or in stacked groupings, have been likened to geodes and marbled agate. Their variegated compositions allude to the "allover" abstraction of certain Abstract Expressionists, and when cut into cubes and rectilinear forms they replace the pristine geometry of Minimalism with a chaos of matter in space. "Encasing everything in resin puts things at the same material level, but reveals a pre-functional object materiality," the artist notes. "It's like destroying the meaning of a thing and reengaging with another meaning of it at the same time." Recently, he has sliced his resin blocks into rectangular panels and mounted them in rows on the wall, allowing the viewer to follow the embedded objects from one cross-sectioned tile to the next, like the frames of a film. An untitled 2007 piece includes a full-size lounge chair elevated on a wooden platform and rendered useless by an accumulation of debris on the seat and around it; another untitled work from 2007 incorporates various natural materials encased in resin to form a freestanding block, its sides cut smooth, with palm branches, flowers, and wood sprouting from the top like plants from a core sample of earth.

"I am trying to physicalize concepts," the artist says of his work, "like the sense of material as vibrating elements subdivided into tinier and tinier particles—the closeness of one thing to another." Sensual and intellectually stimulating, Caesar's singular works seduce us with their beauty while inviting us to question the nature of materials, objects, and space. **J.E.K.**

Installation view, *Three Views from Space*, D'Amelio Terras, New York, 2007

WILLIAM CORDOVA

Born 1971 in Lima, Peru; lives in Houston, Texas, Miami, Florida, and New York, New York William Cordova's work is tied to an urban ecology of obsolescence, disparity, and displacement. Busted cars, trashed tires, discarded shoes, machetes, speakers, and books yellowed with age provide the material support and iconographic program for his drawings, collages, and installations. For the artist, these material choices reference the reality of lived experience, as opposed to the spectacle of culture, mass-produced for constant consumption. The fluency with which Cordova traverses media and remixes cultural signifiers confirms his visual multilinguism, as barbed as it is lived-in.

The range of Cordova's sources is strikingly evident in the titles of works like *Medgar Evers* (2005), *daniel boone, pat boone & mary boone (y los Olmec's?)* (2006), and *Arrow of god (4-chinua achebe)* (2006). His rapaciousness shows as well in his frequent use of color symbols, as in the red and black in *O. T. atsinadnas* (2007), at once referring to the colors of the Sandinista flag, a politically charged image for some viewers, and existing purely as formal composition. As an extension of his individual artistic practice, Cordova has collaborated with fellow artist/writer Leslie Hewitt through their BASE collective on projects such as *I Wish It Were True* (for more information about this project, please see the artist's entry for Hewitt in this catalogue). Another project, *From the Root* (2006–), utilizes existing billboards to activate dialogue within their respective communities by listing names of activists in an antichronological and antihierarchical fashion.

Cordova has been preoccupied with issues of transformation and interpretation since his youth, owing partly to his own transitions between countries, economies, and languages. Having moved as a six-year-old from Lima to Miami, Cordova found comfort in the sight of what he thought were familiar Peruvian *cajón* drums scattered on the streets, but which were in fact discarded speaker boxes. The hulking *Badussy (or Machu Picchu after dark)* (2004–05) dominates the gallery with some two hundred old speakers stacked to suggest a pre-Columbian monolith. Similarly addressing the fragility of history through an ephemeral environment, *The House that Frank Lloyd Wright built 4 Fred Hampton and Mark Clark* (2006), shown at Arndt & Partner Berlin in 2006, is a dizzying room-scale labyrinth of wooden beams based on the footprint of the house where Black Panthers Fred Hampton and Mark Clark were killed by Chicago police in a predawn raid in 1969. Much of Cordova's work induces similarly uncanny interpretive spirals, abetted not by arbitrary Surrealist juxtapositions but the all-too-common strangeness of our own detritus and the too-often repressed histories they conceal. **S.H.**

Installation view, *Pálante*, Arndt & Partner Berlin, 2006

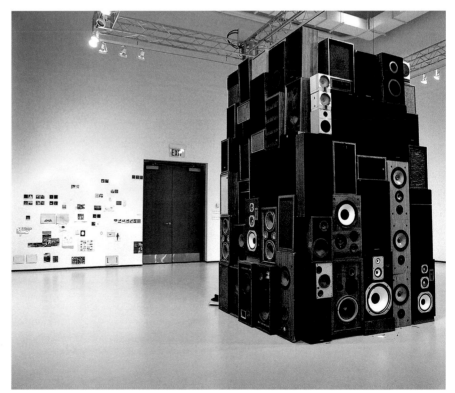

top: *Shit, Damn, Motherfucker*, from *World-Famo Paintings*, suite of one hundred drawings, 2004–05. Ink, graphite, and collage on paper, 8 x 10 in. (20.3 x 25.4 cm). Burger Collection, Switzerland/Hong Kong
bottom: *Badussy (or Machu Picchu after dark)*, 2004–05. Two hundred found speakers, candy, pennies, record jackets, and candles, 96 x 180 x 96 in. (243.8 x 457.2 x 243.8 cm). Colección INELCOM, Madrid-Xàtiva, Spain

DS051007, 2007. Offset, laser, and mimeograph prints, 39⅜ x 27¾ in. (100 x 70.5 cm)

DEXTER SINISTER

Stuart Bailey: Born 1973 in York, England; lives in New York, New York. David Reinfurt: Born 1971 in Chapel Hill, North Carolina; lives in New York, New York Opened by David Reinfurt and Stuart Bailey in 2006 as a "Just-in-Time Workshop & Occasional Bookstore" in a Ludlow Street basement in New York, the design and publishing collaborative Dexter Sinister collapses categories, functions, and roles. Joined by Sarah Crowner, Dexter Sinister combines the characteristically distinct identities of designer, producer, publisher, and distributor. They propose a heteroclite counterpart to the dominant one-size-fits-all, Fordist assembly-line style of print production and distribution. In contrast to the juggernaut of contemporary publishing and its economies of scale, the workshop, according to the artists, "involves avoiding waste by working on demand, utilizing local cheap machinery, considering alternate distribution strategies, and collapsing distinctions of editing, design, production, and distribution into one efficient activity."

Evolving out of a proposal to contribute a print workshop to *Manifesta 6*—the 2006 biennial in Cyprus that was to take the form of an art school—Dexter Sinister's gadfly practice is located in specific projects, but also in pedagogy. Prior to the show's cancellation, in January 2006 they produced the first part of the Manifesta project, an anthology titled *Notes for an Art School*, comprising essays on the future of the art school by artists, curators, theorists, and educators designed to

"rethink the goals and structure of an art school, its ideological contexts" and to "interrogate the appropriateness and validity of existing school models." Significantly, Dexter Sinister's practice continues to combine both the local and metaphorical precepts of their *Manifesta 6* gambit.

The name and form of Dexter Sinister refer to a heraldic device, or the announcement of something to come: a plain shield with a single diagonal line running from the top right corner to the bottom left edge— in Latin, "dexter" and "sinister," respectively. Tellingly, the insignia mirrors the heraldic device in the title of Vladimir Nabokov's 1947 novel, *Bend Sinister*, which announces the coming of a totalitarian, conformist society that discourages individuality and celebrates the state.

Dexter Sinister's proposal for the Whitney takes the form of an extended poem titled *True Mirror*, a composite of excerpts from writings and artworks derived from a variety of artists and authors. Loosely based on ideas of reflecting and shadowing, the manifestations of this abstract proposal remain necessarily open until the Biennial begins. Dexter Sinister will occupy a former colonel's dressing room at New York's uptown Armory, from which they will explore various channels of distribution alongside the rest of the show. These activities are prefaced by a typically oblique double motto: "Quality is merely the distribution aspect of Quantity" (or vice versa). **T.A.**

(Party) per bend sinister, 2005. Materials variable, dimensions variable

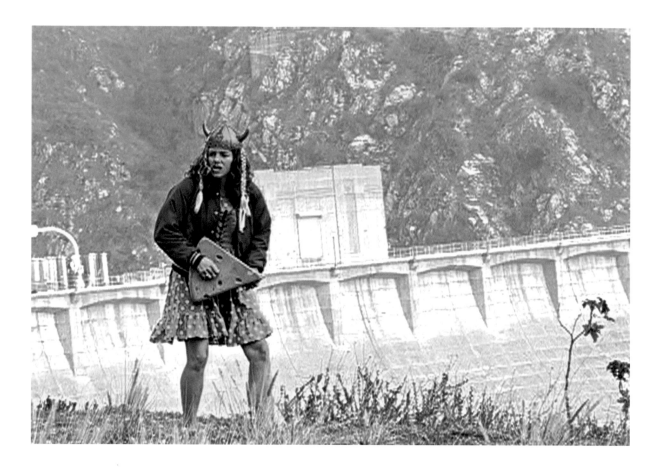

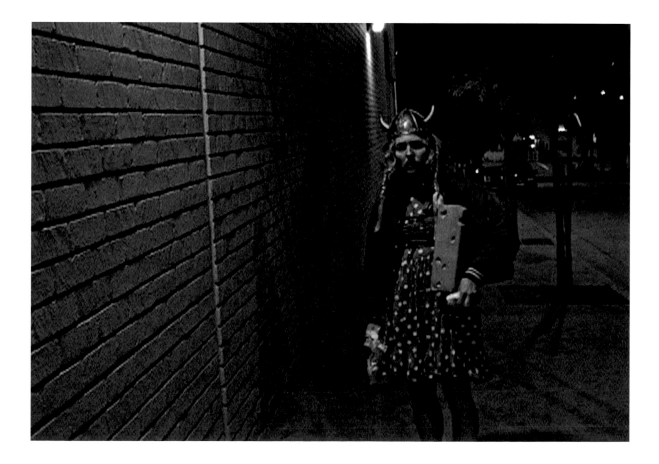

HARRY DODGE AND STANYA KAHN

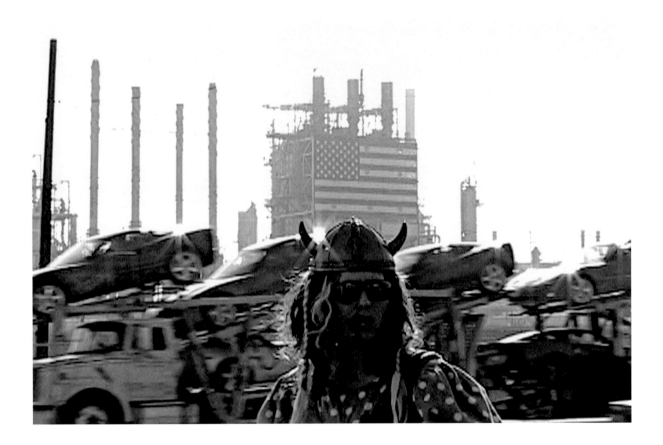

Harry (Harriet) Dodge: Born 1966 in San Francisco, California; lives in Los Angeles, California. Stanya Kahn: Born 1968 in San Francisco, California; lives in Los Angeles, California A woman in a sundress takes a weed whacker to an overgrown lot; a gentle stoner meets a man with a camera in the desert as they both wait in vain for a rock concert shuttle that never comes; a voyeur lurking in a patch of shrubbery is surprised by a loquacious woman wearing a plastic Viking hat, carrying a wedge of foam-rubber cheese, and daubing an unexplained nosebleed. At first glance the films of Harry Dodge and Stanya Kahn seem like lo-fi screwball sketches, thanks to their improvisational skills, Kahn's magnetic performances, and Dodge's keen directorial hand. Their characters have a wistful air and a penchant for stringing anecdotal non sequiturs into unexpectedly poignant narratives. Dodge, who directs and typically shoots the films, is more than a silent partner in the pair's enterprise. Dodge and Kahn imbue the camera's gaze with an improbably vivid sense of personality, at once baring the formal artifice of the cinematic process and translating what might otherwise read like soliloquies by Kahn into revealing dialogues. The more one watches the pair's pieces, the more their subver-

sions of not just the sketch form but also filmmaking itself—and the larger conceptual reasons for these deformations—make themselves apparent.

Dodge and Kahn employ video as a tool to dramatize the longing that underpins interpersonal expression (both functional and dysfunctional), the desire for contact and some sense of personal agency. What at first might seem like random decisions in the works— unorthodox choices for location, wardrobe, and editing—are carefully poised to produce scenarios that flirt with slapstick without diluting their characters' basic humanity. This balancing act is particularly vivid in the pair's *Can't Swallow It, Can't Spit It Out* (2006), which charts the relationship that develops between that logorrheic Valkyrie and her voyeur-cum-documentarian as the two move from confrontation to empathy during the course of an off-kilter *dérive* through Los Angeles. Wandering a largely depopulated city, the woman regales her newfound companion with tales that run from personal reminiscences to insane ramblings (more than a few begin "When I was in hell . . . "), occasionally pausing in their fruitless search for "action" to lament, "You should have been there for that!" By the end, both the cameraperson and the viewer know they have. **J.K.**

Stills from *Can't Swallow It, Can't Spit It Out*, 2006. Digital video, color, sound; 26 min. Collection of the artists

SHANNON EBNER

Study for *STRIKE*, 2007

Born 1971 in Englewood, New Jersey; lives in Los Angeles, California Shannon Ebner's work centers on a do-it-yourself alphabet of handmade letters and signs temporarily placed—and strategically displaced—in public contexts. The artist sets language in the service of photography, her cryptic messages captured and fixed in black-and-white photographs. Populating actual yet uncertain landscapes or mise-en-scènes including California real estate sites, the La Brea Tar Pits, and the Washington Monument, these ephemeral signs spell out such darkly ambiguous phrases as "Landscape Incarceration," "The Doom," and "The Day—Sob—Dies."

In *On the Way to Paradise* (2004) ten photographs of individuals wearing T-shirts that bear a single screen-printed letter spell out the phrase "SELF IGNITE." Like her other publicly directed, language-and-photography-based works, this one reshuffles the shifting alphabet of language with the also fugitive—and frequently ominous—languages of resistance. Ebner's works almost always also point toward fluctuating semantic contexts and to the uses and abuses of language.

All of these works belong to the *Dead Democracy Letters* series (2002–06), as what the artist has described in *North Drive Press* as a "direct response to the 'war on terror' and . . . the way that political ebvents and language were constructed after the terrorist attacks."

Ebner's ongoing *The Sun & the Sign* series, begun in 2006, continues to mine language's porous and indefinite topography. *Sculptures Involuntaires* (2006) pictures a makeshift wooden crate set in an anonymous, nonspecific site and containing—though hidden from view—all twenty-six characters that had comprised the *Dead Democracy Letters*. The spray-painted phrase "SCULPTURES INVOLUNTAIRES" [*sic*] suggests Brassaï's photographs of graffiti and other ephemera in particular and more generally the Surrealists' interest in the concrete irrational. Conjuring language's opaque and mordant qualities and the limitations these impose, Ebner's entombment of a particular alphabet simultaneously evokes its liberating potential, which once promised a language of infinite possibilities, the ever-expanding syntax that dreamed of Stéphane Mallarmé's *Un Coup de Des . . .* and Jorge Luis Borges's "The Library of Babel."

Ebner has noted that she draws on a photographic tradition spanning "from Atget to Ruscha," a history of photographic practice that privileges photographs of signs as a record of facts and an index of truth—however fleeting. By embracing photography's fundamental contradictions as well, however, her most recent work also unearths its fictions, "exploring the way the camera misunderstands what it is seeing." Ultimately, Ebner's photographic and semantic landscapes excavate the residue of language's ephemeral materiality, leaving the viewer to make sense of what is lost and what is found. **T.A.**

opposite top: *Landscape Incarceration*, 2003. Chromogenic print, 32 x 40½ in. (81.3 x 102.9 cm). Collection of the artist
opposite bottom: *Sculptures Involuntaires*, 2006. Chromogenic print, 49¹/₁₆ x 62⅝ in. (124.6 x 159.1 cm). Collection of the artist

GARDAR EIDE EINARSSON

Installation view, *Judge*, Team Gallery, New York, 2007

Born 1976 in Oslo, Norway; lives in New York, New York Investigations into various forms of social transgression and arguments for political subversion, Gardar Eide Einarsson's text-based works provoke the critical analysis associated with reading to augment the immediate visceral experience of viewing his art. To this end, his choice of media is determined by his current discourse on communities in relation to their outsiders. Visual imagery borrowed from underground subcultures including the criminal world and left-wing militias, portrayed in a primarily black-and-white palette, gives Einarsson's work a stylish punk sheen that evokes rebellion through its cold, hard-edged rejection of sentiment. His installations often combine paintings leaned against walls as "props," explicit messages printed on flags or illuminated on light boxes, images co-opted from graffiti, skateboarding graphics, or punk music flyers screenprinted or painted directly onto gallery walls, videos screened on televisions, photography, and sculpture such as austere furniture centered in the exhibition space.

Mining his understanding of how graphic design and advertising methods manipulate public beliefs, Einarsson appropriates logos, symbols, phrases, and slogans to recontextualize meaning, creating a tension between imagery and the action it compels the viewer to take. For his 2006 show *Population One* at Standard (Oslo), Einarsson referenced Russian prison tattoos, comic-book character Judge Dredd's villainous narratives, and a confiscated forged driver's license to consider the renegade value in aberrant society members' ideologies. One wall panel shaped like a comic-book

blurb quotes Dredd: "Odious though it was to turn myself into a tawdry attraction, I had greater goals to consider." Hung beside it was a painting of two white triangles pointed together on a black background; though based on a prison tattoo, *I'll Never Give My Hand to the Police* (2007) evades any obvious visual associations. Einarsson purposely problematizes his own work to avoid didactic, facile expressions of negativity or controversy. His use of text allows for a directness that both recalls and critiques artworks decrying political injustices made during the 1990s by artists like Barbara Kruger. By staging textual works alongside abstract objects, images, and props, Einarsson embeds his politics more deeply in his search for answers, and through Minimalist formalism he offers opaque or ambivalent translations of his skepticism toward established power structures.

In *South of Heaven*, a 2007 installation at Frankfurter Kunstverein, the artist again applied text to underscore ideas of authority and rebellion. What looks like ad hoc graffiti scrawled on one wall by an angry teenager declaring "You just don't get it dad, so fuck off" is contextually inverted not only by a flag emblazoned with "American Liberty" hanging from the ceiling nearby but by the fact that the "graffiti" was premeditated, designed on a computer, then carefully placed on the wall as a formal painting. As a native Norwegian relocated to the United States, Einarsson creates work increasingly opposed to what can be seen as the hypocrisies of our current government by highlighting our national preoccupation with individual freedoms. **T.D.**

left to right: *The Law The Law The Law The Law The Law*, 2007. Screenprint on aluminum, 24 x 53 in. (61 x 134.6 cm). Private collection
What Are You Supposed to Fight Them With, 2007. Screenprint on aluminum, 10¾ x 40 in. (27.3 x 101.6 cm). Collection of the artist

left to right: *Untitled (bomb checklist)*, 2007. Vinyl on wall, dimensions variable. Private collection
. . . And I'll Give Em Hell, 2007. Inkjet on wood panel, 78¾ x 47¼ in. (200 x 120 cm). Collection of Mark Fletcher and Tobias Meyer

Born 1969 in Miami, Florida; lives in New York, New York Roe Ethridge arranges his large-format photographs into series whose precise meaning remains elusive. His gallery installations and book projects mix fine-art photographs and commercial images, including outtakes from his illustrational magazine work. A polished studio portrait may be juxtaposed with a grainy still-life drawn from a retail catalogue or a cropped shot of signage in a strip mall. At first glance the groupings may seem like selections from a stock-photography archive, but they are infused with an element of nostalgia and the uncanny. Images that feel familiar begin to take on an eerie sense of mystery when juxtaposed in the artist's seemingly random arrays.

Though not immediately apparent, Ethridge organizes his series around certain themes. His recent book *Rockaway, NY* (2007) plays with a "coastal" theme, but the imagery ranges from a frozen marina on the Columbia River to the port of Mumbai and surfers in Cornwall, England, as well as scenes of Rockaway Beach, Queens, where he and his wife rent an apartment. Ethridge describes his process as both improvised and system-

atic: "The idea is not to render a perfect illustration of a coastal-themed photo project, but something more like a fugue form with multiple voices that pull the threads through this coastal thematic." A boat appears in one image, echoed by a different vessel in the next; portraits of individuals are followed by misty streetscapes. "There could be any kind of counterpoint—formal, conceptual to content. It's like a plate spinner. You want to keep all of them going at one time," he says.

Not surprisingly, Ethridge has been influenced by the work of Thomas Ruff, Michael Schmidt, Christopher Williams, and other artists who combine photographs that veer from the biographical to a metanarrative conceptual mode. "I'm not making individual conceptual images, but a conceptual aspect comes about in the juxtapositions and groupings," he says. By arranging his work in various sequences, contexts, and installations, Ethridge reveals the mutability of his images, the possibility that the original intention with which a picture was created might fall away over time, allowing it to take on new meaning. We are encouraged each time to examine these images and their interrelations anew. **J.E.K.**

KEVIN JEROME EVERSON

Born 1965 in Mansfield, Ohio; lives in Charlottesville, Virginia In 1997, filmmaker Kevin Jerome Everson made a 16-millimeter, black-and-white short about a correctional officer discussing his work (*Eleven Eighty-Two*). In 2007, he made another black-and-white short, this time on high-definition video, about the perilous beauty of light as narrated by a Pandorus Sphinx moth (*Nectar*, in collaboration with William Wylie). Over the ten years separating these two disparate projects, Everson has created numerous shorts and features, using both film and video, alternating color and black and white, on a bewildering variety of topics: picnics, poems, Renaissance painters, African-American drag racers, the chemistry of busing, cleaning collard greens, *The Wizard of Oz*, immigration, luck, his hometown of Charlottesville, Pompeii, eighteenth-century beekeepers, 1971 black beauty pageants, factory workers, bank tellers, taxi drivers, and a founding member of the legendary Motown group The Temptations. Despite this wild eclecticism, Everson professes an overarching motivation: "My artworks and films are about responding to daily materials, conditions, tasks, and/or gestures of people of African descent." Frequently basing a work on archival or found footage, Everson repositions these materials "through a variety of mediums such as photography, film, sculpture, artist books, and paintings. The results usually have a formal reference to art history and resemble objects or images seen in working-class culture."

The material for *Emergency Needs* (2007) derives from a news conference held by the first African-American mayor of a large city, Carl B. Stokes of Cleveland, in response to a violent outbreak of civil unrest in the summer of 1968. Known as the Glenville Shootout after the African-American working-class neighborhood where the incident took place, the crisis began the night of July 23 when a firefight broke out between the Cleveland police and a radical black nationalist group under surveillance, leaving seven dead and many more wounded. Riots and looting ensued. Stokes promptly called in the National Guard to restore order, and the following day ordered all white officers out of Glenville, to be replaced by African-American ones. Everson presents archival footage from the Stokes press conference alongside a reenactment performed by a woman, cutting between the two or arranging them in split screen. Inspired by Robert Rauschenberg's "identical" 1957 paintings *Factum I* and *Factum II*, where the unity of content inspires reflection on the difference of technique, *Emergency Needs* invites close consideration of gesture and performance at the Stokes press conference. By means of this duplication, and the imposition of new rhythmic patterns, Everson enlivens a historical document, resurrecting the conditions, tasks, and gestures of a vital moment in time by repositioning them in the present. **N.L.**

Stills from *Emergency Needs*, 2007. 16mm film, color, sound; 7 min. Collection of the artist

OMER FAST

Born 1972 in Jerusalem, Israel; lives in Berlin, Germany Omer Fast works with film, video, and television footage to examine how individuals and histories interact with each other in narrative. He mixes sound and image into stories that often veer between the personal and the media's account of current events and history.

For *Spielberg's List* (2003), a 65-minute, two-channel color video installation, the artist visited Cracow, the Polish city that served as the setting for Steven Spielberg's film *Schindler's List* (1993), and interviewed Poles who worked as extras in the film. Their memories are presented as the dry, authentic accounts of a historical event—in most cases, the 1990s Hollywood production, but in some cases the 1940s German occupation. The artist juxtaposes these accounts with shots of the surviving film set, built near the remains of the actual German labor camp and never fully dismantled. Much like the two sites, which appear increasingly indistinguishable with the passage of time, the work reveals the production of history through the merger of re-creation and relic.

In *Godville* (2005), a 51-minute, two-channel color video, historical reenactors at the Colonial Williamsburg living-history museum in Virginia describe their eighteenth-century characters' lives and their personal lives in ways that seem interchangeable. Fast splices the reenacted and real biographies together, often word-by-word, into a rambling narrative that is as aurally fluent as it is temporally dissonant. The work tells the story of a town in America whose residents are unmoored, floating somewhere between the past and the present, between revolution and reenactment, between fiction and life.

Fast's recent work *The Casting* (2007), a shorter four-channel video projection, addresses current events. A U.S. Army sergeant recounts two incidents: a romantic liaison with a young German woman who mutilates herself and the accidental shooting of an Iraqi. The two tales are seamlessly woven together into a script that was given to actors to perform in silent tableaux. While the actors try hard to keep still, the narrator's recollections slip between setting and story, trying to find relief if not redemption in the act of recalling. **J.E.K.**

Production still from *The Casting*, 2007. Four-channel video installation, color, sound; 14 min. Collection of the artist

Born 1969 in Ann Arbor, Michigan; lives in Cambridge, Massachusetts While Robert Fenz's 16-millimeter films document place and time, they also serve as emotive simulacra reminding the viewer of cinema's historical subjectivity. Editing together footage of daily life from countries in political upheaval, he illustrates human characteristics that transcend borders in semihypnotic odes to the lands he portrays. Fenz's self-proclaimed "moving pictures"—silent or presented with recorded natural sound—offer glimpses into cultural diversity while experimenting with in-camera editing and a variety of formal cinematic techniques. Inspired by Structuralist filmmakers such as Michael Snow and James Benning, Fenz sometimes builds his films along predetermined guidelines. His methods, however, are improvised and lyrical, closer to the work of Chantal Akerman, with whom he has recently worked. "My need to think or feel something through film," he notes, "is not reactionary against video, but a concern for film's disappearance as a material."

Fenz traveled to Brazil, Cuba, Mexico, and around the United States to capture footage of the poverty and political strife that precede and encourage revolution for his five-part series *Meditations on Revolution*, each segment offering a new set of experimental platforms. For the 2002 Whitney Biennial, Fenz screened *Part III: Soledad* (2001), a black-and-white silent film alternating footage of masked insurgents in Chiapas with urban scenes and sequences of two men making tortillas in Mexico City. In *Part V: Foreign City* (2003), a black-and-white film with sound about immigrant New York, Fenz pushes the grain quality to "accelerate the randomness of the film," distinguishing it from video as a medium able to, as he describes, "vibrate." The artist's overarching formal concern in *Meditations* centers on black-and-white film's capacity to trigger memory by referring to previously recorded events as well as the history of cinema.

In *Crossings* (2006–07), made for the 2008 Whitney Biennial, Fenz switches to color film to convey more sensate information about the United States–Mexico border wall. Ten minutes of film features *Crossings* played twice—first silently, next with ambient sound—allowing the viewer to imagine a soundtrack before the imposed audio begins. Presented as quick, single-frame snapshots are a pair of frames shot looking to the left and right from each side of the wall followed by upward and downward views on both sides, creating a strobelike effect that recalls the psychedelic experiments of James Whitney or Harry Smith. The length of each shot is of primary importance to Fenz, for whom each frame is a captured moment in time. These moments build, highlighting the surprising formal beauty of the wall while evoking the frenetic, fearful energy one might feel if trapped by it. By visually simulating what the wall symbolizes, Fenz depicts terror and awe as impossibly intertwined. **T.D.**

Stills from *Crossings*, 2006–07. 16mm film, color, sound and silent; 10 min. Collection of the artist

COCO FUSCO

Born 1960 in New York, New York; lives in New York, New York Coco Fusco is an interdisciplinary artist, writer, and curator whose practice includes video, performance, and lectures. Born to Cuban and Italian parents, she often explores the dialogue between identity, globalization, technology, gender, and race. In the quasi-documentary film *a/k/a Mrs. George Gilbert* (2004), she navigates the racial politics dictating the FBI's intense 1970 hunt for African-American activist Angela Davis. Fusco focused on the subtleties of hierarchy and power as co-curator of *Only Skin Deep: Changing Visions of the American Self*, a photography exhibition organized by New York's International Center of Photography in 2003 illustrating how images construct and perpetuate racialized vision.

In her video *Operation Atropos* (2006), Fusco examines the mechanics of the interrogation process. She invited six women to participate with her in the Prisoner of War Interrogation Resistance Program, a course designed by former members of the United States military to prepare private clients for the "psychology of capture." The immersive program is structured to replicate a military interrogation as "captors" attempt to force confession of a prearranged shared secret from "prisoners." The group is driven into the woods, ambushed by hooded men, strip-searched, and subjected to verbal and psychological abuse. While the instructors do not use physical violence, they threaten and insinuate it. Exploiting gender and racial differences functions to isolate prisoners, but most effective is the suggestion of retaliation on others in the group, as interrogators lead resistant captives to believe that nearby screams of pain are coming from fellow prisoners. Fusco notes that this tactic is particularly useful against women. As the scenario unfolds, the line between reality and playacting blurs. The women are prodded and pushed until four of the seven reveal their secret. Afterward, the former prisoners are instructed in the art of interrogation: they are taught to do to others what has been done to them.

The power of the interrogation process is evident—as prisoners, one of the women is reduced to tears, another to fury. The implicit undertone—the near-certain conclusion in an environment where the threat of death or violence is real—is compelling, and the possibility that any non–trained professional could withstand the pressure seems minimal. Titling the work *Operation Atropos*, after the Greek Fate who determined how each mortal would die, the artist refers to the similarly inevitable results of these operations. Fusco's timely video suggests a corollary in contemporary political dynamics, alluding that confessions forced under duress within the bounds of military guidelines seem equally predetermined and inescapable. **S.G.**

Stills from *Operation Atropos*, 2006. Video, color, sound; 59 min. Collection of the artist

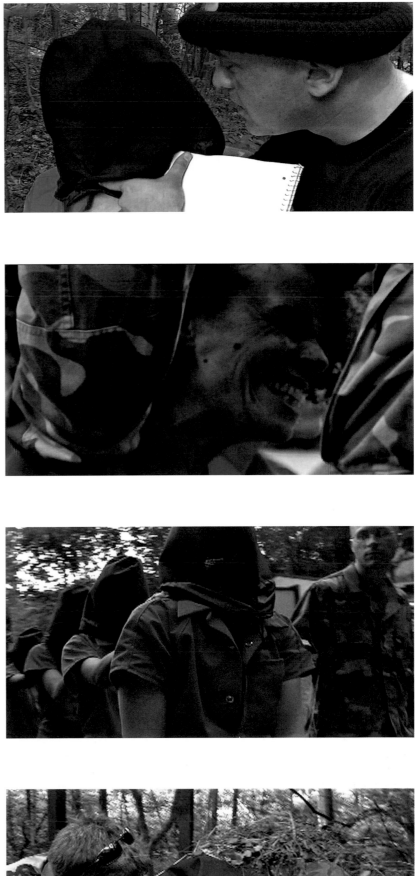

Brian DeGraw, *No Critique in the Kingdom(s) of Mars*, 2007–22. Collage on paper, 9¾ x 8⅜ in. (24.8 x 21.3 cm). Collection of Gang Gang Dance

Founded 2001–02 in New York, New York, by Lizzi Bougatsos, Brian DeGraw, Tim DeWit, Josh Diamond, and Nathan Maddox Engaging primarily as a rock group, Gang Gang Dance's interdisciplinary practice challenges expectations implicit to the music genre, reconfiguring the typical notion of a band into what they call a "band of outsiders." With interests collectively encompassing dance, performance art, theater, DJing, film, and visual art, they play gigs as often in galleries, museums, and art fairs as they do at nightclubs and music festivals. Besides rejecting industry limitations, Gang Gang Dance subject their musical practice to stringent laws of free-spiritedness, assimilating a wide array of international sounds into their new breed of world music. Beats and melodies from every continent are sampled, processed through synthesizers and computers, and looped into pulsating rhythms that pull from ancient traditions while offering a contemporary, foreign sound. Their ability to reinvigorate potentially repetitive 4/4 rock beats with an ear toward global syncretism links them to experimental bands like Sun City Girls, who collected field samples from radio and live performance around the planet, though Gang Gang Dance are more groove oriented. Having shared studio spaces with Animal Collective and Black Dice, Gang Gang Dance also share a futuristic noise aesthetic inspired by New York's recent musical history, from 1970s avant-garde musicians like Yoko Ono to the 1980s no wave scene.

Gang Gang Dance's attempts to control the sonic chaos they create results in dense tonal collages overlapped by luscious, echoing vocals. Drummer and singer Lizzi Bougatsos, frequently compared to Kate Bush for her slightly goth, birdlike trill, keyboardist and electronic percussionist Brian DeGraw, drummer Tim DeWit, and guitarist Josh Diamond describe their music as somewhat "devotional" in commemoration of member Nathan Maddox, killed by lightning strike in 2002. Their recent records *God's Money* (2005) and *RAWWAR* (2007) express a joie de vivre inspired by Maddox's life and death; *Retina Riddim* (2007), a visual project by DeGraw, particularly harnesses this impassioned energy.

Retina Riddim is a 30-minute DVD project combining video and sound into an abstract documentary of Gang Gang Dance's rich history. Found and live footage and interview clips pieced together alongside shots of friends and fans are accompanied by a mixed soundtrack of live recordings, field recordings, practice tapes, and previously released work. Though the film opens with trance-inducing, mellow sequences, other moments barrage the viewer into a pleasant state of sensory overload. A loose, painterly narrative unfolding through a multiplicity of short clips reveals a sense of the band's interactions with their audience and among themselves. By evolving Gang Gang Dance's visual aesthetic, *Rettina Riddim* embodies their belief that music is integral to all art forms. **T.D.**

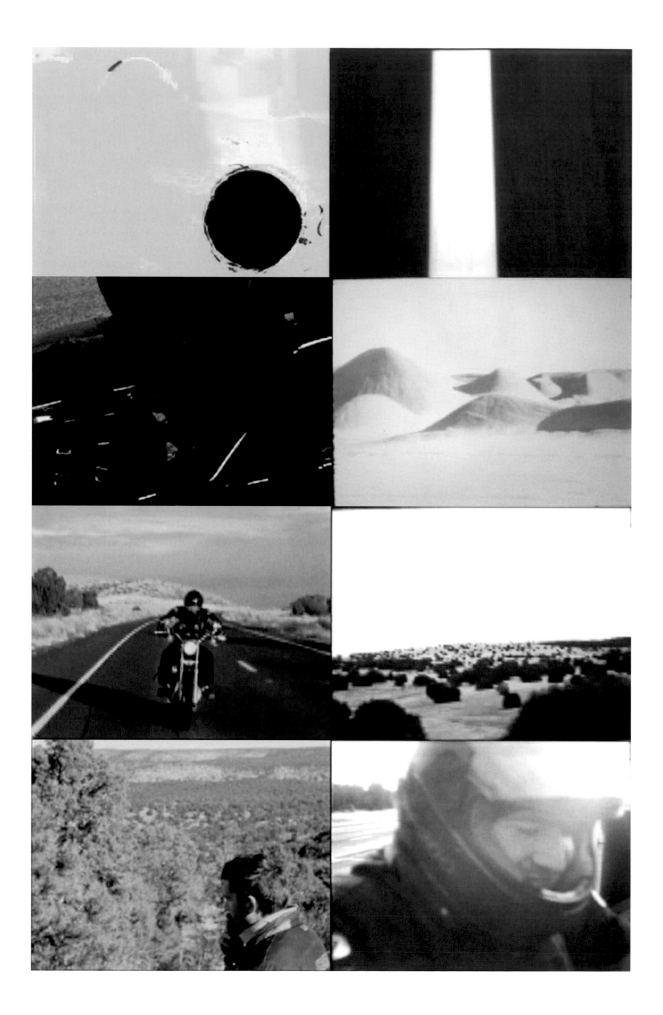

AMY GRANAT AND DREW HEITZLER

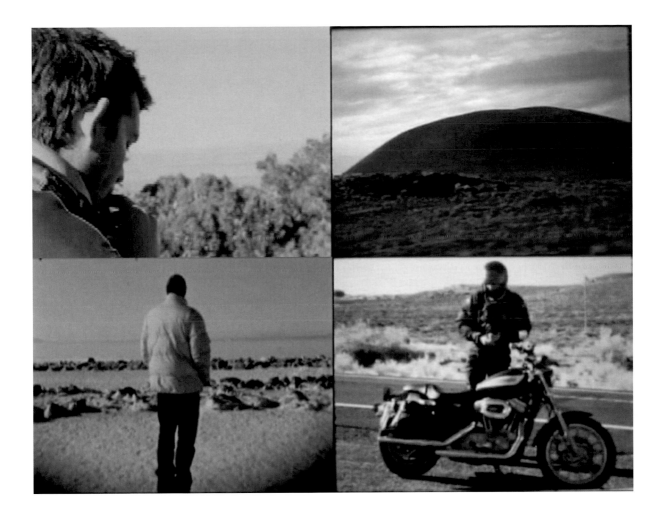

Amy Granat: Born 1976 in Saint Louis, Missouri; lives in New York, New York. Drew Heitzler: Born 1972 in Charleston, South Carolina; lives in Los Angeles, California For their first film collaboration, Amy Granat and Drew Heitzler bring unique aesthetic contributions to *T.S.O.Y.W.* (2007). Amy Granat works with film stock as raw material to make abstract films and photograms that are minimal and site specific. Though some of Drew Heitzler's films, such as *Subway Sessions* (2002), have employed traditional narrative, his films more often operate within the context of installations. In his 2007 exhibition at Los Angeles's Trudi Gallery, Heitzler showed *Untitled (Ladera Heights)* (2007), a short, silent black-and-white film of a single image of a Los Angeles oil dike interrupted by a color shot of palm trees; concurrently, a few miles away at Angstrom Gallery, he laid stills of every third frame (two hundred in all) from the film on the gallery's floor. This gestural, tangible approach to manipulating film stock is the common ground underlying Granat and Heitzler's recent team effort.

T.S.O.Y.W., whose protagonist derives from Johann Wolfgang von Goethe's Werther, developed from Granat and Heitzler's discussions with artists Olivier Mosset and Steven Parrino about writer Jean Genet's suggestion in his autobiography of replacing Werther's unattainable love, Charlotte, with a motorcycle. Presented as a dual screen projection, this film concurrently features each artist's rendition of this idea, based on 16-millimeter footage they shot simultaneously on shared sets with Bolex cameras. A pining Werther, portrayed by artist Skylar Haskard, searches in vain for meaning in his desert home, eventually enacting the quintessential American road trip. After stealing his friend's Harley from his Airstream trailer, Werther rides it to Robert Smithson's *Spiral Jetty* and Joshua Tree. On what Heitzler calls Werther's "journey to nowhere," he finally wanders away into the distance, mirroring the lost temporality and melancholic feeling noted by the artists in both Goethe's epistolary novel and in America's current wartime malaise. A subtle political statement, the film functions metaphorically as what Heitzler calls a "romanticized death."

Structurally, Granat has made her most narrative film to date, editing in-camera to tell Werther's story through varying light and scene length. While filming, she explored numerous effects, such as changing aperture to achieve a strobelike vibration in certain sequences. Heitzler's wide-angle shots flatten out the already flat desert horizon, and his exploitation of the telephoto lens lends his edit a grainy nostalgia. A soundtrack composed by Granat and artist Jutta Koether adds discordant sonic ambience to the film's sense of emotional disconnect. In this portrait of a modern-day Werther, the only consolation that remains is the symbolic freedom of the open road. **T.D.**

Stills from *T.S.O.Y.W.*, 2007. Two-channel projection, 16mm film transferred to digital video, color, sound; 200 min. Collection of the artists

RASHAWN GRIFFIN

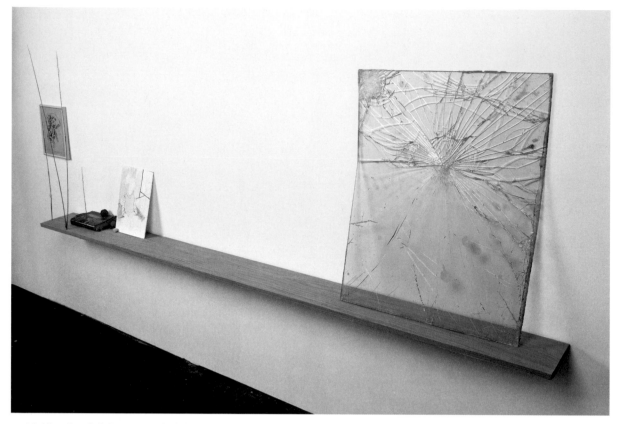

Untitled (nat, love, baby!), 2006. Cracked glass, wood, book, ink on paper, framed, collage and colored pencil on mat board, grass, and debris, 31 x 82 x 7½ in. (78.7 x 208.3 x 19.1 cm) overall. Collection of the artist

Born 1980 in Los Angeles, California; lives in New York, New York Drawing from his training in sculpture and painting, Rashawn Griffin's nostalgic assemblages use the architecture of the gallery space to reveal social landscapes and personal narratives. In the tradition of artists such as David Hammons and Bruce Conner, his diverse practice employs found objects and personal effects that introduce evocative hints of place and character. The dialogues Griffin creates between organic, transient materials including grasses and food and larger, architectural concerns engage the viewer as an active participant through fluctuations in scale and viewpoint.

Untitled (nat, love, baby!) (2006), exhibited in the 2006 artist-in-residence show Quid Pro Quo at the Studio Museum in Harlem, New York, includes a shattered pane of glass and reeds collected near the museum, a drawing and colorful pom-poms from his residency studio, a colored-pencil portrait with an indistinguishable face, and the artist's copy of Marcel Proust's Swann's Way. Displayed on a shelf, this piece functions formally as a landscape, yet the individual elements hold strong personal and geographic resonance. The work also reads as a social panorama of Harlem, incorporating physical pieces from the environment into a specific narrative parallel to that of the artist. Like Proust, Griffin explores identity as a construct of objects, memories, and relationships—an idea perhaps echoed by the ambiguous portrait whose features, meaningless in isolation, recover meaning in the context of materials surrounding it.

In the 2005 exhibition Early February at Yale University's Green Hall Gallery in New Haven, Connecticut, Griffin installed large canvases hung from the ceiling at eye level on the gallery's entry floor. The monumental banners act as paintings, the environment of the public space lending them an official air. But the surfaces, covered with worn sheets and other fabrics, crudely hand stitched and stained, are imperfect, imbuing the works with an intimacy that belies their immediate impression of authority. Building on such antithetical notions, other banners incorporate newly purchased denim, a material with universal associations encompassing both high fashion and manual labor. Seen from below as the viewer descended into the gallery space, the panels shifted scale and dimension to become more sculptural. In the center of the gallery, what at first appeared to be a Minimalist brick box revealed itself as a framework covered with rows of Fig Newtons exuding a heavy, sweet fragrance. The handcrafted quality of the sculpture is emphasized by variations in the color and shape of the mass-produced biscuits. Inevitably the work will rot and disintegrate, a failure that mirrors the deliberate imperfection of his monumental banners. Employing quiet reserve, this and other powerful works by Griffin reflect on the social landscape through personal gestures that translate to universally important concerns. **S.G.**

opposite top: Untitled (room), 2005 (installation view, Green Hall Gallery at Yale University, New Haven, Connecticut, 2005). Fig Newtons, wood, sheet, fabric, and blanket, dimensions variable. Collection of the artist
opposite bottom: Untitled (Boo Radley), 2006. Pockets, blanket, fabric, wool, foam, artificial flower, cotton, and wood, 84¾ x 82 x 10¼ in. (215.3 x 208.3 x 26 cm). Private collection

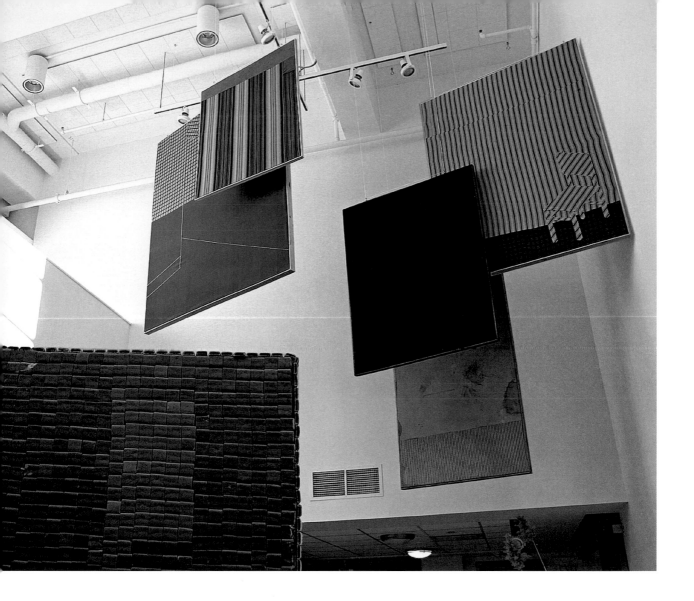

untitled (flaneur nyc/mia), 1999–2001 (detail). Twelve chromogenic prints, 8 x 10 in. (20.3 x 25.4 cm) each. Collection of the artist

Born 1975 in Port-au-Prince, Haiti; lives in Miami, Florida Deploying a variety of media including photography, drawing, and video, Adler Guerrier explores the effects of particular geographical, political, and historical environments on identity formation. Combining the techniques of photographic observation with a studio art practice and urban wanderings, the artist maps the places of everyday life with lyrical resonance. Considering walking to be "a political and poetic act," Guerrier takes to the streets, capturing images of desolate urban spaces washed in a nocturnal glow and taking pictures of private backyards saturated with vernal colors; he also makes cryptic drawings of himself frequently accompanied by poetic texts such as "playing scratchy records" and "concerted action." Relating his work— typically arranged in groupings—to the fleeting observations of a contemporary wandering flaneur, the artist notes, "My work has to do with movement, narrative, and is also concerned with the perceived and fictional portrayal of places."

Guerrier's gambit in *untitled (BLCK—We wear the mask)* (2007–08) is to present an installation by "BLCK," a fictional Miami-based artist collaborative from 1968 (all the works are actually by Guerrier). Pointedly local in time, place, and scope, Guerrier takes up the social,

political, and aesthetic dialogue of these nameless artists from the once-vital Liberty City, a mostly black neighborhood of Miami that suffered in the aftermath of riots coinciding with the 1968 Republican National Convention in nearby Miami Beach. Deploying an array of materials—curtains, drawings, spurious "documentary" photographs, and video—he explores the imagined imagery and imaged imaginary of fictional artists whose work was grounded in realities of social protest. Signaling themes of political resistance, a hand-painted sign reads "Welcome to Liberty City in this year of 1968," while a projected film takes up the themes of a then-contemporary short story by LeRoi Jones (later known as Amiri Baraka), the influential African-American poet arrested in Newark, New Jersey, in April that year during riots following the assassination of Martin Luther King, Jr.

Finding messages for the present in the scars of the past, this installation, according to the artist, "does not pay homage to great 1960s heroes, but rather to anonymous artists who were aware of the civil rights movement and politics of the time and contributed positively." Blurring distinctions between fiction and fact, past and present, Guerrier's psychogeography of a distant Miami neighborhood is strikingly near and contemporary. **T.A.**

opposite top: *Untitled (Liberty City)*, 2007 (detail). Six chromogenic prints, 11 x 14 in. (27.9 x 35.6 cm) each. Collection of the artist
opposite center: *Untitled (Liberty City)*, 2007 (detail)
opposite bottom: *Untitled (Red Street)*, 2007. Chromogenic print, 11 x 14 in. (27.9 x 35.6 cm). Collection of the artist

MK GUTH

Our Rapunzel, 2006. Performance, Miller Fine Arts Center at Linfield College, McMinnville, Oregon, November 24, 2006

Born 1963 in Stevens Point, Wisconsin; lives in Portland, Oregon Through video, photography, and social sculpture, MK Guth reimagines traditional fables and popular fantasies, inserting new, hybrid mythologies into the public realm as vehicles for agency, empathy, and social engagement. In her often humorous narratives Guth collides art and life in performative orchestrations of practical magic, confounding discrimination between fantasy and verity. Her method is especially poignant given popular culture's obsession with reality television and other forms of mass mediation. Indeed, Guth's practice takes as axiomatic that "what ifs" are destined to become real despite their hypothetical premises.

Red Shoe Delivery Service (RSDS) (2003–) began with one such transformative hypothesis, inspired by *The Wizard of Oz*: "What if Dorothy's ruby slippers did not just take you to Kansas?" To find out, Guth, Molly Dilworth, and Cris Moss formed an art collective dedicated to realizing the inherent promise of Dorothy's magical shoes. Creating, as they put it, "art that moves you," their van picks up willing passengers randomly chosen on the street and ferries them wherever they wish to be taken. The travelers don red glitter-encrusted footwear—chosen from a so-dubbed "cornucopia of tastes" including athletic shoes, slides, and

pumps—and pronounce their destinations on camera in documentations that become part of an expanding archive and fodder for future projects. Adapting its configuration to each city and venue, the site-specific *RSDS* remains part transit service, part mobile gallery, and, literally and otherwise, part vehicle of wish fulfillment.

Guth's interactive *Our Rapunzel* (2006), as well as *the way I see you the way you see me* (2007), similarly creates space for the articulation of intention. Transforming the fairy tale into an open-source story, Guth invites participants to write a desire or regret (or, in the most recent iteration of the project, their opinions of Americans) on colorful ribbons to be braided, often communally, with artificial hair into long, thick locks. Although the active performances are temporary, the results linger: room-scale installations intersected with multicolored plaits cascading from the ceiling and pooling on the ground. Like *RSDS*, Guth's braid installations cross make-believe with all-too-real social and political disappointments; they are shot with the same potential born of disillusionment evident in *The Wizard of Oz*, which moved Salman Rushdie to note of the film, "[its] driving force is the inadequacy of adults, even of good adults . . . [whose] weaknesses . . . force a child to take control of her own destiny." **s.h.**

opposite top: *Our Rapunzel*, 2006 (installation view, Miller Fine Arts Center at Linfield College, McMinnville, Oregon, 2006). Braided fabric and artificial hair, 700 ft. (213.4 m) long, configuration variable. Collection of the artist
opposite bottom: *the way I see you the way you see me*, 2007 (installation view, A Gentil Carioca, Rio de Janeiro, 2007). Braided fabric and artificial hair, 450 ft. (137.2 m) long, configuration variable. Collection of the artist

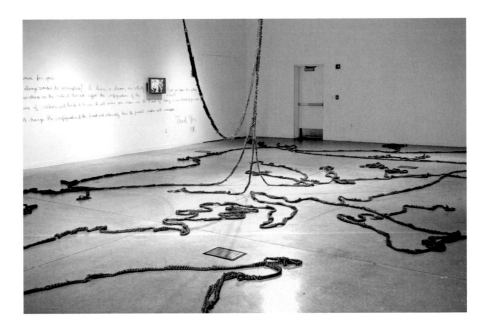

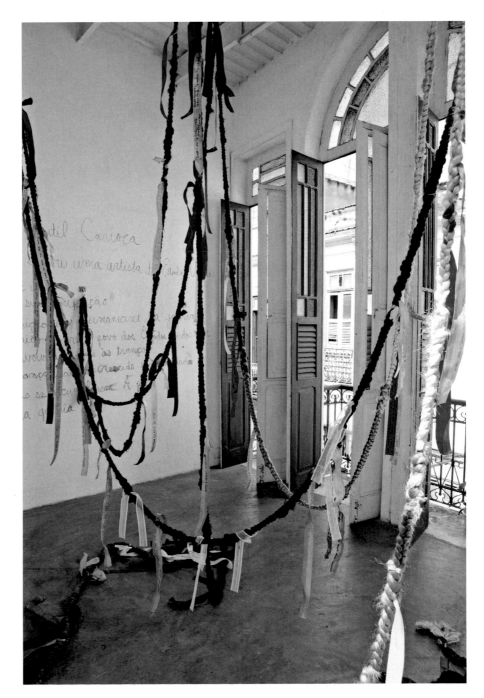

Sundown Schoolhouse: Fall Session 2006, 2006. Tour of Los Angeles in capes designed with Andrea Zittel, December 10, 2006

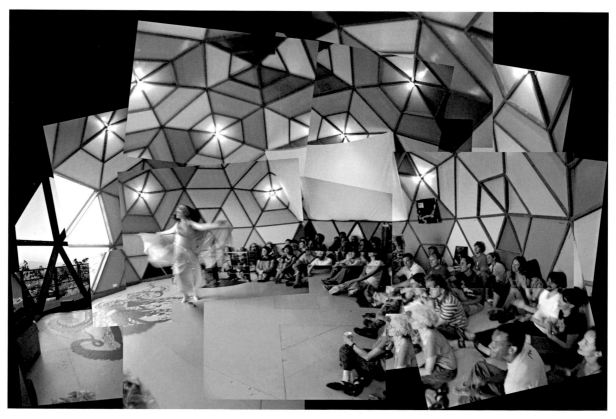

Sundown Salon #29: Dancing Convention, 2006. Event, Los Angeles, July 9, 2006

Edible Estates Regional Prototype Garden #02, 2006– . Multimedia project, Lakewood, California

Born 1969 in Saint Cloud, Minnesota; lives in Los Angeles, California Fritz Haeg applies his skills as an architect to diverse artistic and curatorial practices that include designing houses, leading a peripatetic educational center, facilitating grassroots political activism, and experimenting in radical gardening. Rejecting categorization and specialization, Haeg is attracted to multidisciplinary projects that manifest as social opportunities, benevolent gestures, or inspirational models. Like fellow artist/designer Joep van Lieshout, Haeg takes a collective approach to his work, viewing its outcomes as organic culminations of multiple individual inputs rather than the result of directorial cues. His philosophical disinterest in materialism and the manufacturing of goods, however, more closely recall Buckminster Fuller's practical approach to architecture. Haeg's projects may also be seen as an extension of Ant Farm's performance-based, often nomadic interpretations of architect R. M. Schindler's notion of a modern dwelling as a flexible setting for harmonious living.

Haeg's practices have recently focused on two main programs, one that reclaims private property as a site for activism, the second occurring in the public arena as community outreach. Sundown Schoolhouse is a continuation of his Sundown Salons, which began in 2001 as gatherings for knitting, reading literature, dancing, wrestling, drawing, or conversing on a given topic. Following a more politically active mission, the School-house empowers individuals in the private realm by disseminating radical information through social engage-ment. Classes are often based in Haeg's home, a geodesic dome perched on a Los Angeles hillside, though they have been hosted by art institutions across the country and abroad. After yoga and a wholesome breakfast, the 12-hour days feature guest lecturer–led discussions on matters from the practical—how to navigate the LA mass transit system—to loftier personal strategies such as ecstatic resistance and creating personal manifestos.

Spearheaded by Haeg, Edible Estates (2005–) is a horticultural experiment that transforms suburban front lawns into plots teeming with edible plants. Though the "reclaimed" land is private property, local volunteers create each garden, and the results can be appreciated by the entire community. The Estates are reminiscent of World War II Victory gardens while acknowledging a tie to more recent landscape interventions: on the second completed Edible Estate, in Lakewood, California, a spiral path among the vegetables recalls Robert Smithson's *Spiral Jetty* as an homage to Land art. Through his participation in the manual labor of tilling and planting, Haeg reminds spectators that gardening for food can represent an act of rebellion against the monoculture emblematized by the American lawn.

As political actions, Haeg's initiatives subvert the idea that humans are the earth's apex species by alleviating our alienation from our environment, our food, and each other. Artistically, they challenge viewers and participants to diversify their own daily routines in favor of poeticism and positive interaction in all regards. **T.D.**

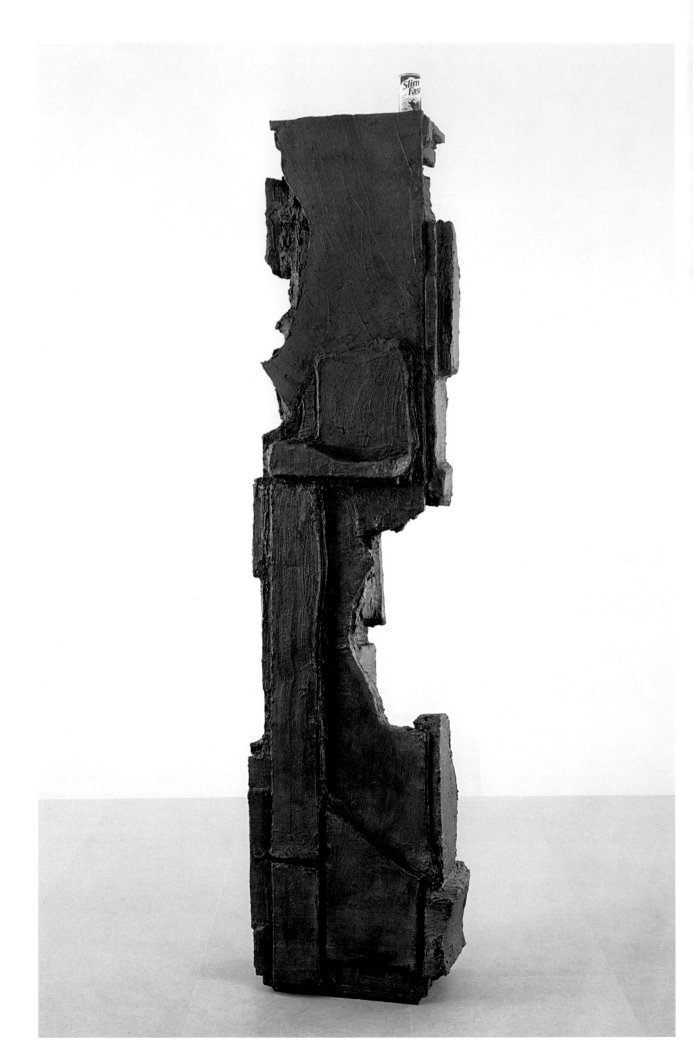

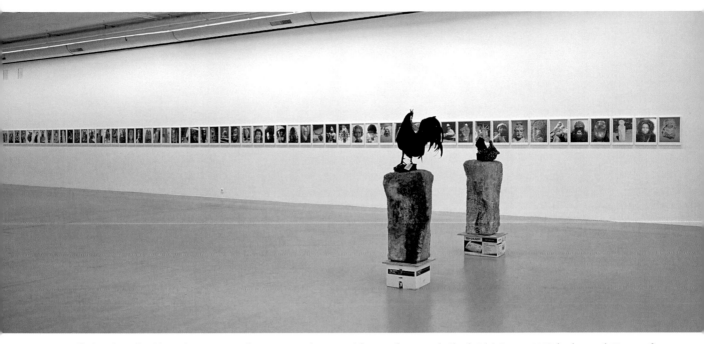

Installation view, *If I Did It*, Migros Museum für Gegenwartskunst, Zurich, 2007; foreground: *Claude Lévi-Strauss*, 2007; background: *Voyage of the Beagle*, 2007

Born 1966 in New York, New York; lives in New York, New York Rachel Harrison's sculptures populate a space of interpretation that at one moment encourages critical discourse and at another draws on its own enigmatic, intuitive logic. With a deluge of cultural debris including canned goods, celebrity magazines, fake fruit, wigs, mannequins, soft drinks, and taxidermied animals placed on forms of often monolithic scale, Harrison conflates the art historically scripted media of painting, installation, sculpture, and photography. She recombines abstraction with the figurative, the biomorphic with the architectural, and the readymade with the handmade. The sculptures are often painted in a variety of ways ranging from monochromes to multicolored palettes that veer from Rococo painting to amusement park decor. Such surface detail at once informs and undermines their simultaneously flamboyant and totemic presence.

In the 2007 solo exhibition *If I Did It* at New York's Greene Naftali, Harrison exhibited nine sculptures alongside fifty-seven portraits hung in a row. *The Voyage of the Beagle*, Charles Darwin's field journal from the survey expedition that led to his theory of evolution, is the source for the title of the eponymous photographic series. While Darwin's explorations served as a radical new foundation on which the representation of the human subject could be formed, Harrison's photographic "expedition" casts a wholly different base on which representation can be figured. These photographs show human and anthropomorphized animal forms in various cultural depictions, including Corsican menhirs dating from 3000 BCE, a public sculpture of Gertrude Stein, a stuffed porcupine, and a drag-queen mannequin.

The nine sculptures in the exhibition are titled after famous men: Alexander the Great, Johnny Depp, Fats Domino, Rainer Werner Fassbinder, Al Gore, John Locke, Pasquale Paoli, Claude Lévi-Strauss, Amerigo Vespucci, and Tiger Woods. The two-part *Claude Lévi-Strauss* (2007), stacked on U.S. postal and fax machine boxes, comprises a pair of rectangular orange-red and green bases on which perch a stuffed hen and rooster facing each other, communicating through the viewer's presence. A female mannequin dressed in aerobic exercise clothing, the Janus-like *Rainer Werner Fassbinder* (2007) sports voguish glasses and a backward-facing rubber Dick Cheney mask as a trail of packing peanuts covers the floor behind this sculptural she/he.

The sculptures and photographs function as "complexes," combinations of seemingly incongruous formal or symbolic elements that obliquely mirror the human subject. These poses and masks, mannequins and menhirs that people Harrison's sculptural universe garner their real power by revealing themselves as part of a conceptual system, one that catalogues this mirrored subjectivity as it walks upright through the morass of cultural and political history. **T.D.**

opposite: *Fats Domino*, 2006. Wood, polystyrene, cement, synthetic coating, synthetic polymer, and Slim-Fast chocolate meal option, 105 x 25 x 22 in. (266.7 x 63.5 x 55.9 cm). Collection of Martin and Rebecca Eisenberg

ELLEN HARVEY

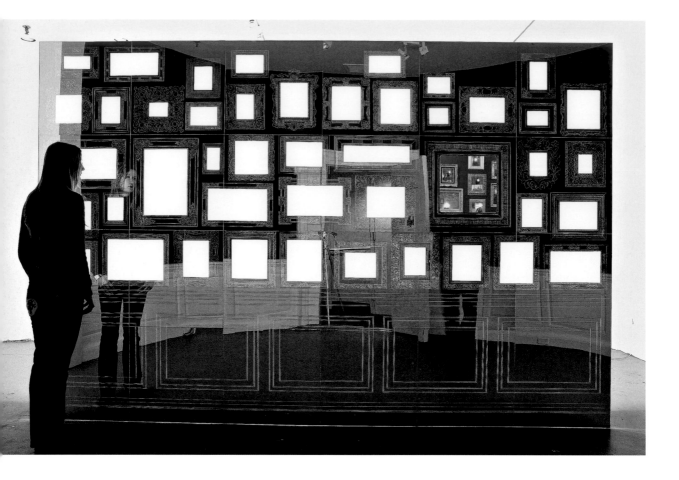

Born 1967 in Kent, England; lives in New York, New York An artist with a keen sense of both art's potential and its limitations, Ellen Harvey was trained not only as a painter but also as an attorney, and fittingly her work balances an auteur's faith with a lawyer's skepticism. From her works for public spaces to her gallery-based practice, Harvey's belief in the communicative power of art is leavened by a commendable awareness—and even explicit acknowledgment—of the potential for failure, missed connections, and misunderstandings. Her willingness to contend with the possibility of malfunction in her own process strengthens rather than weakens it, opening up the mechanisms of inspiration and execution to productive interrogation.

After completing the Whitney's Independent Study Program in 1999, Harvey spent two years working in anonymity on her *New York Beautification Project* (1999–2001), a brilliantly simple guerrilla intervention into public space. She "tagged" various unloved bits of city real estate with small Hudson River–style landscape vignettes, challenging accepted notions of vandalism by asking, in a disarmingly modest way, how certain artistic modes (and contexts) contribute to the calculus through which forms of expression are officially valued or scorned. Her projects in the following years tracked similarly thorny aesthetic questions. *A Whitney for the Whitney* (2003), for example, featured painted reproductions of each work in the Museum's then-recent catalogue, exactingly recapitulated in scale and displayed

in alphabetical order, re-creating a purposefully inadequate stand-in for the Museum's collection. Meanwhile, her interests in larger interventions continued apace; her work *Mirror* (2005) was an architecturally scaled project in which she engraved an uncannily beautiful, fine-lined doppelgänger of the grand staircase hall at Philadelphia's Pennsylvania Academy of the Fine Arts onto a wall of mirrors she installed there, but she altered the "mirror image" to suggest an advanced state of ruin, projecting the latent dysfunction of individual works of art onto the edifice that contained them.

Harvey's latest major work combines the interests and forms of her recent projects. The ongoing *Museum of Failure* (2007–)—a new elaboration of which is part of the Biennial—includes *Collection of Impossible Subjects*, a rear-illuminated plexiglass mirror wall hand-engraved with a salon-style exhibition of ornately framed, sanded-out rectangles. Visible through an opening in one of them is *Invisible Self-Portrait in My Studio*, a painting of an identical collection of frames, except that these hold paintings based on photographs the artist took of herself in a mirror where the image is obliterated by the camera's flash. It is a nuanced twin bill that probes conventional wisdom about the artist and the museum, about making and seeing.

Harvey will also be performing *100 Biennial Visitors Immortalized* at the Armory, providing one hundred people with a free fifteen-minute portrait in exchange for their evaluation of the portrait's success. **J.K.**

Museum of Failure: Collection of Impossible Subjects & Invisible Self-Portraits, 2007 (installation views, Luxe Gallery, New York, 2007). Rear-illuminated hand-engraved plexiglass and aluminum frame, fluorescent lights, wall paint, and oil on canvas, twelve parts, in secondhand frames, 96 x 120 in. (243.9 x 304.8 cm). Collection of the artist

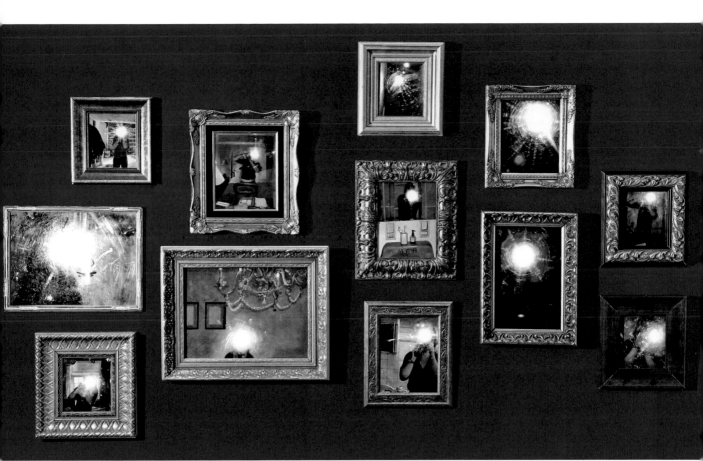

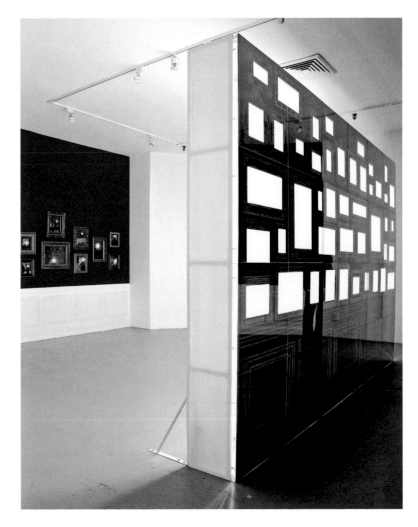

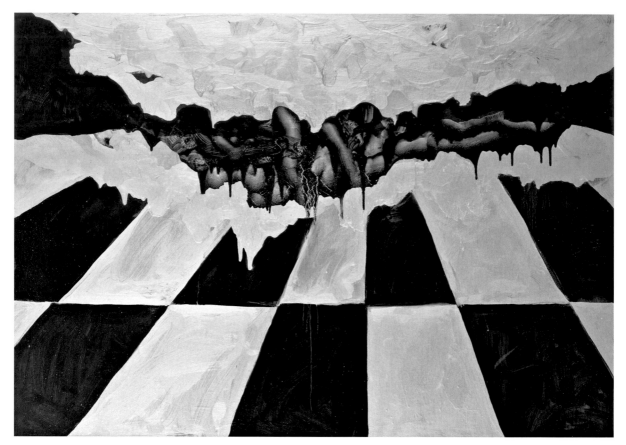

Stevie's Rip, 2007. Oil on canvas, 40 x 56 in. (101.6 x 142.2 cm). Private collection

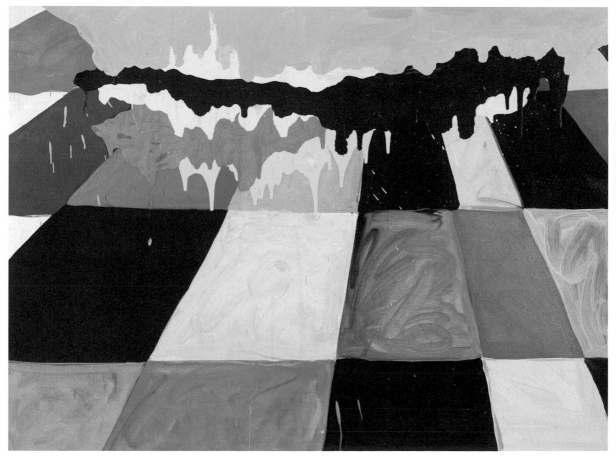

Go Ask Alice, 2006. Oil on canvas, 36 x 48 in. (91.4 x 121.9 cm). Collection of Phil Schrager

Thin Blue Line, 1990. Oil on canvas, two parts, 54 x 60 in. (137.2 x 152.4 cm). Collection of the artist

Born 1940 in San Francisco, California; lives in New York, New York For the past thirty years Mary Heilmann has been championed as the consummate artist's artist: Her unfussy approach—born of the Southern California surf culture of her childhood and paradoxically refined by a lifetime's practice—is as notable for the unremitting intimacy it admits as the quixotic sociability it invites. One of the few women abstract painters of her generation, Heilmann actually trained as a sculptor and ceramist and continues to make pottery, design lighting, and even produce furniture, such as the rolling painted-wood and polypropylene-webbed *Clubchairs* (2002–) that offer viewers a comfortable place to linger. Indeed, Dave Hickey notes in the catalogue for her 2007 retrospective at the Orange County Museum of Art that "Heilmann began painting canvases as if they were ceramic objects, as if, more specifically, they were *pots*, informal domestic accoutrements with no specific shape and no lateral edge."

Perhaps this is why "casual" is one of the most common words describing Heilmann's paintings, which so gracefully traverse craft traditions, popular culture, and the fine arts. Owing in part to her works' messy assurance, by turns glib and erudite, Heilmann also confounds irony and sincerity. With their visceral convolutions of color, runny streaks of paint, and riotous compositions, her recent paintings wear their pleasures on their sleeves. As if the title and nestling biomorphic forms of *Sea of Joy* (2006) were not enough to inspire an answering elation in the viewer, take *Heaven* (2004), a lush turquoise and white froth, or *Surfing on Acid* (2005) and *Winter Surf, San Francisco* (2006), two striated works that conjure the wall-like force of water, effortlessly if voraciously subsuming everything in their paths.

A different appropriative strategy obtains in works influenced by music (e.g., new wave, acid house)—a mainstay in Heilmann's body of work. *Save the Last Dance for Me* (1979), *The Blues for Miles* (1991), *Billy Preston* (2002), and *Go Ask Alice* (2006) mine song lyrics or reference musicians, while the title of the Los Angeles Orange County Museum of Art exhibition, *To Be Someone*, summons a 1970s rock ballad with equal parts ambition and poignancy. Although the influence of her oeuvre on artists including Laura Owens, Elizabeth Peyton, Monique Prieto, and Jessica Stockholder has been widely noted, in a recent conversation with Dodie Kazanjian, Heilmann puts it differently: "I just think that in the midst of all the digital stuff, people sort of crave seeing something that's still and quiet and on the wall." **S.H.**

LESLIE HEWITT

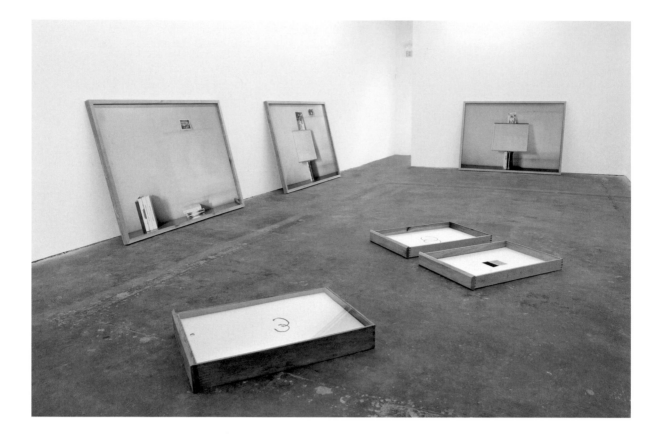

Born 1977 in New York, New York; lives in New York, New York, and Houston, Texas Leslie Hewitt is inspired by "the everyday and the transformative power of circumstance or situation," as she notes in *Modern Painters*, taking on the forsaken documents of our past—brittle pictures, forgotten books, repressed films, and ephemera—to repurpose them in the present. Influenced by the ethics of Third Cinema and the potential and limits of the photographic as a tool for discourse, Hewitt renders the aesthetic and the conceptual inextricable. Her photosculptural works not only retrieve memory but question the very basis of our access to it: how it is mediated, reframed, and changed through the contingencies of space and the exigencies of time.

For her series of ten chromogenic prints *Riffs on Real Time* (2002–05), Hewitt rephotographed intimate family pictures she had collaged on grounds of handwritten letters, magazines, and vocabulary primers, which were in turn placed on wooden planks, shag carpets, and other fundamentally domestic grounds. In their reorientation from floor-bound assemblages to wall-mounted photographs and as the layers of history accumulate, these objects accrue personal and collective significance, yet the pictures also pointedly reflect on the camera's role—and limitations—in constructing meaning.

The objectlike materiality of images—their texture, heft, and scale—is further examined in the two series shown in her 2006 exhibition at LAXART in Los Angeles. Propped almost sculpturally against the wall,

the billboard-size photographs constituting *Make It Plain* (2006) depict old snapshots and books including the 1968 Kerner Report on urban riots and, published the same year, Joanne Grant's *Black Protest* arranged around an empty, flattened rectangular structure. In *Ready to Battle* (2006), large black-and-white ink drawings of objects of adornment (earrings, a hair pick, pomade) are pinned to the gallery wall alongside related drawings nestled in wooden drawers on the floor. Here Hewitt insists that even these most personal artifacts are not exclusive in significance, but open for public debate.

Hewitt's collaboration with William Cordova, *I Wish It Were True* (2004–), gains meaning as an act of collaboration between artists and community (see Cordova entry). Earlier, as students at Yale, they had sought to redress a deficiency in the institution's collection of revolutionary-themed films by amassing what they describe in *Houston Review* as "an evolving archive of our collection of bootleg independent/ alternative films central to representing Black and Latino consciousness within the canon of cinema." They developed this concept for Houston's Project Row Houses, reconstructing a monolith-inspired phalanx of some eight hundred VHS tapes and a rudimentary screening room—a social sculpture attuned to its context and audience. As Hewitt suggests in this and other works, these are not just images to be looked at: in their mobility and allowance for agency, their ideas can be put to critical use. **S.H.**

Make It Plain, 2006 (installation view, LAXART, Los Angeles, 2006). Three digital chromogenic prints in custom ash-wood frames, unglazed, ink on paper, three parts, three custom sycamore-wood boxes, and glass, dimensions variable. Collection of the artist

Make It Plain (2 of 5), 2006. Digital chromogenic print in custom ash-wood frame, unglazed, 60 x 84 in. (152.4 x 213.4 cm). Collection of the artist

Riffs on Real Time (7 of 10), 2002–05. Chromogenic print, 30 x 24 in. (76.2 x 61 cm). Collection of the artist

Riffs on Real Time (4 of 10), 2002–05. Chromogenic print, 30 x 24 in. (76.2 x 61 cm). Collection of the artist

Forming, 2007 (installation views, Bortolami, New York, 2007). Glass, steel, granite, canvas, dye, paint, and glue, 108 x 120 x 84 in. (274.3 x 304.8 x 213.4 cm). Collection of the artist

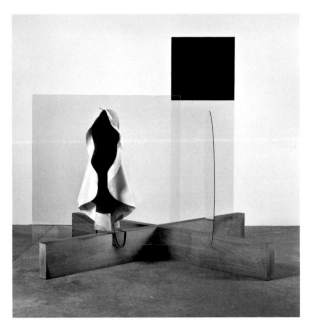

Valley, 2006. Wood, glass, brass, canvas, dye, oil, glue, syrup, and bleach, 79¼ x 76 x 73 in. (201.3 x 193 x 185.4 cm). Private collection

Born 1972 in Royal Oak, Michigan; lives in Los Angeles, California Employing the language of abstract sculpture, Patrick Hill creates highly referential, narrative constructions in the tradition of Anthony Caro and Barry Le Va. Hill opposes hard, architectural elements (stone, glass, brass, wood) with soft, supple materials (ribbon, canvas, wool), combining Minimalist forms with a more feminine tradition. Often alluding to unpleasant or distasteful aspects of the physicality of the human body, Hill is interested in the phenomenology of his work, inviting the viewer into difficult dialogues.

In *Sex and Violence* (2006), Hill addresses pornography through abstract terminology. A circular piece of glass, from which a smaller circle has been removed with surgical precision, intersects a horizontal wooden beam resting on the gallery floor. One side of the glass is covered in a purplish-pink-stained cloth, invoking connotations of blood, bruising, and other bodily excretions—"sex." The alternate side is sheathed in sooty black canvas—"violence." A second piece of glass, cut to the hole's dimensions, obstructs the orifice of the purple face. As the viewer physically shifts between vantage points, the work's appearance changes: from the front and back, the fabric adds an illusion of weight and substance which dissolves when seen from the side. Light is alternately absorbed by the fabric and reflected by the glass, manifesting the duality characteristic of his work: interior/exterior, public/private, masculine/feminine.

Forming, Hill's 2007 exhibition at Bortolami in New York, takes a darker, more brutal tone with works created from concrete, stone, steel, glass, and stained cloth, anchored by the large, imposing title piece. Referencing the debut single of the Los Angeles hardcore punk band The Germs, the title has multiple meanings, acknowledging Hill's debt to music as well as his preoccupation with tumors and other growths. The title piece, *Forming* (2007), is composed of a 5-by-10-foot granite trapezoid bisected by a 7-foot steel square. Perilously set in a narrow groove in the steel, a 6-foot circle of glass covered on one side with magenta-dyed fabric and on the other with black canvas evokes an apocalyptic scene—a mottled, deep purple sun setting behind a looming mountain. There is little tolerance for movement between these weighty elements, lending a precarious feel to the substantial structure. Hill has dripped fabric dye down one side of the granite and the steel, and its chemical composition deteriorates the surface of these stoic materials. While they are not stained, they decay. This erosion is reminiscent of Hill's frequent use of beet and berry juices as dyes. Organic stains react unpredictably and with volatility, creating a dynamic relationship between materials. On a larger scale, his sculpture itself is vulnerable, underscoring the temporal nature of Hill's antimonument as it reminds us of the frailty of the human body and our own mortality. **S.G.**

WILLIAM E. JONES

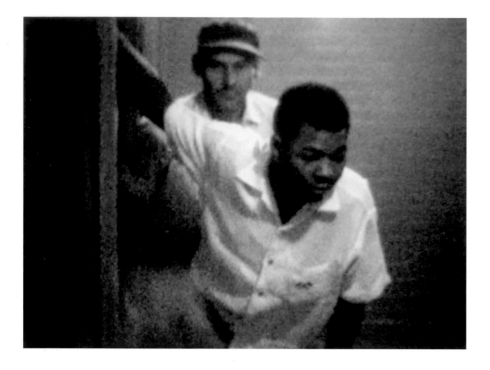

Born 1962 in Canton, Ohio; lives in Los Angeles, California Filmmaker William E. Jones edits together sequences from vintage 1970s and 1980s gay porn to create a discursive arena in which to consider the desires implicit in sexual imagery. His short films are at once explorations of the complexities of homosexual identity and nostalgic recollections of an erstwhile gay culture drastically altered since the onset of AIDS. For the most part editing out hard-core scenes, Jones allows his pieces to focus on the language of body movement and even landscape as sites for subtler fantasy and romanticism.

Earlier works, like his 2004 music documentary *Is It Really So Strange?*, contextualize Jones's more pornographic, cinematically experimental pieces as highly specific fascinations with fetish and style in popular culture. Formally, his shorts retain some of the camp qualities inherent to the films they were cut from, with awkwardly staged situations, bad acting, and diverse sexual settings. In this they're akin to Jack Smith's and George Kuchar's filmic experiments. For more recent works, however, Jones has downplayed the camp aspect by showing found footage without soundtrack or splicing in ironic audio alternatives to lend layers of cultural reference to footage rooted firmly in a specific time and place.

V. O. (2006), whose title puns on *voice-over* and *version originale*, is a montage of vignettes taken from various films re-presented with French, English, Finnish, German, Portuguese, and Spanish dialogue, English subtitles, and classical music from movie soundtracks including *Delivery Boys, Der Tod der Maria Malibran,*

and *Amor de Perdição*. Each segment highlights interactions between men that symbolize their desires for physical contact. *V. O.* opens with a pizza deliveryman hypnotized into sexual reverie by a Victrola playing a recording that suggests, "You are an extraordinary factory of natural medication." In the fourth section, footage of a man delving into a masturbatory prison and boot-licking fantasy parallels Jean Genet's *Un chant d'amour* (1950) by concurrently presenting an interview with Genet. Poetic text sets a historical precedent for each segment, offering the potential for a deeper, more sympathetic understanding of pornography's content.

Tearoom (1962/2007) takes a comparable thematic approach to fetishism, though it is rooted in the real rather than the imagined. The grainy color found footage of sexual interactions between men in a public restroom was shot by a hidden camera as part of a 1962 police sting to be used as evidence supporting sodomy charges. Other than moving the last reel to the beginning of the film, Jones left the footage unedited. Presented in long, visually similar sequences without soundtrack and punctuated by blank white screens, the men's actions begin neutrally and become increasingly risqué. The footage slowly builds up to the impassioned crescendo more typical of traditional porn; tightly edited shots of men masturbating and having sex underpin the film's voyeuristic nature. The silence of *Tearoom* metaphorically reiterates the suspicion and secrecy these men are forced to endure, elucidating, as in all of Jones's films, an omnipresent struggle for freedom through subversion. **T.D.**

Stills from *Tearoom*, 1962/2007. 16mm film transferred to video, color, silent; 56 min. Collection of the artist

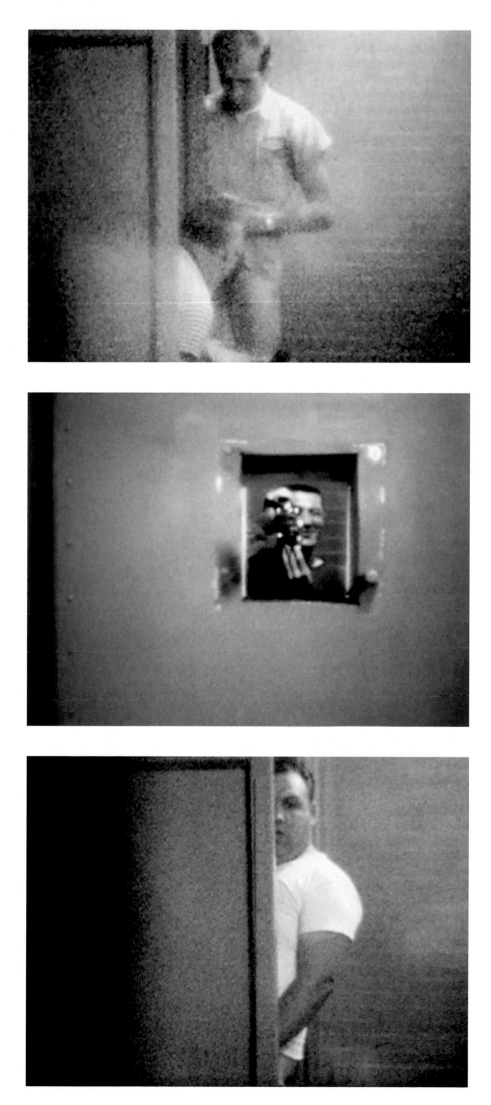

Witchcraft, 1995. Oil on canvas, 16 x 12 in. (40.6 x 30.5 cm). Private collection

The Egerton House hotel, London—tea time, 2007. Water-soluble oil on canvas, 12 x 9 in. (30.5 x 22.9 cm). Holzer Family Collection

Ruffian, an Arabian horse at the side street near the bazaar, Marrakesh, 2006. Water-soluble oil on canvas, 8 x 10 in. (20.3 x 25.4 cm). Collection of Charlotte and Bill Ford

Born 1957 in Philadelphia, Pennsylvania; lives in Philadelphia, Pennsylvania Best known for the deconstructed, so-dubbed "Scatter" installations she pioneered in the late 1980s, Karen Kilimnik has more recently alighted on painting-based mise-en-scènes replete with diminutive, loosely rendered canvases and related props. In *The Debonair General's Tent* (2006), a Napoleonic campaign tent furnished with a desk, maps, and a phalanx of toy soldiers is positioned alongside a suite of Théodore Géricault–inspired paintings. Like her earlier work, Kilimnik's new projects evidence a lush, quasi-fictive world where august artistic references (e.g., Jean-Baptiste Oudry, George Stubbs, and Sir Henry Raeburn) brush shoulders with contemporary news and cultural icons including Keith Richards, Kate Moss, and Leonardo DiCaprio (especially memorable as Kilimnik's louche *Prince Charming* [1998]).

Fog machines and minutely chosen decor and furniture likewise abet a through-the-looking-glass experience where, moored in the particularities of specific contexts, nothing is what it seems. As Kilimnik states: "Being so inspired by fairy tales, mysteries, books, TV shows, and ballets, et cetera, I like to make up characters myself as if I'm a playwright." Her mode of appropriation thus involves possession as much as fantasy.

Mediation predicated on distance is explicit in *The Hellfire Club Episode of the Avengers* (1989), which pays homage to an infamous 1966 episode (banned by U.S. censors) of the British spy show with an installation of black-and-white photocopies, photographs, and a soundtrack sampling harpsichord music, the *Avengers* theme, Madonna, and the Pet Shop Boys.

As seen in the recent work shown in her 2007 survey at the Institute of Contemporary Art in Philadelphia, Kilimnik's period sensibilities have become even more striking. *the bluebird in the folly* (2006) is a coyly graceful garden pavilion seemingly plucked from Marie Antoinette's Versailles—except that it harbors a video of Thumbelina-like ballerinas alighting on trees amid verdant woodland scenery. Such eighteenth-century fantasies of escapism played out by aristocrats on palace grounds give way to an investigation of eighteenth-century salon display strategies in *The Red Room* (2007): inside a nondescript, freestanding white cube placed in a corner of the gallery is a richly appointed red brocade chamber on whose walls fifty of the artist's paintings hang cheek by jowl. In this matryoshka-like exhibition within an exhibition, Kilimnik makes explicit her operative use of the gallery as a frame—and as an ersatz if dream factory–worthy facade. **S.H.**

the Matterhorn at dusk, 2007. Water-soluble oil on canvas, 20 x 16 in. (50.8 cm x 40.6 cm). Collection of Nina and Frank Moore

ALICE KÖNITZ

Maquette for *Raffle Sculpture*, 2007. Melamine board and metallic paper, 6¾ x 4⅝ x 5 in. (17.1 x 11.7 x 12.7 cm). Collection of the artist

Born 1970 in Essen, Germany; lives in Los Angeles, California Alice Könitz's sculptures riff on mid-twentieth-century modernist furniture and public art, while her installations of drawings, films, collages, and homemade magazines contextualize her monolithic geometric forms as both a celebration and a critique of design vernacular. Built from such inexpensive, readily available materials as construction paper, felt, lauan, cardboard, and plastic, and cobbled together with little more than a glue gun, Könitz's sculptures offer a hand-made intimacy absent in the high modernist forms they emulate. Rather they recall that mid-twentieth-century utopian vision of design's ability to facilitate social change on an individual level. Like the diverse work of Charles and Ray Eames, Könitz's practice erases boundaries between art and design, though her nonfunctional con-structions operate more clearly as models illustrating how modernist design tenets have become clichéd in their translation to the tacky signs and sculptures erected in mini-malls and skyscraper courtyards. Using materi-als that allow for a more spontaneous, process-oriented studio practice, she presents a conflicted appreciation for this kitsch beauty that is underpinned by a yearning for a reinvigorated approach to modernist formalism.

This desire was visually stated in earlier works by Könitz's linking of modernist aesthetics to the meta-physical. In her video *Light Communication* (2004), actors in primitive, geometric masks wade through a canyon swimming hole, using sunlight bounced off mirror shards and Mylar props to parody the New Age notion of communicating with light. The meandering titles of recent exhibitions such as *Beautiful Ornaments as Shadows, Crashed Down and a Video of Flickering Light in a 70s Office Tower* reinforce Könitz's affinity for offsetting the rigorous formalism of her sculptures with dream-derived language and text puzzles.

In the last few years, Könitz's dual interest in interior and exterior design has logically manifested both inside and outside the gallery space. Gatelike interactive works such as *Mall Sculpture* (2006) and *Yet Untitled* (2003) are modular constructions of hexagons recalling Buckminster Fuller's geodesic structures. Resembling a detangled, tortured Möbius strip, the angular, Mylar-covered *Logo for the Encounter Group* (2006) conjures an imagined corporate power. *Office Plant* (2006) dangles precariously from the ceiling like an Alexander Calder mobile. These works take on additional ironic weight alongside the site-specific installation *Public Sculpture* (2006), for which the artist installed a large-scale sculpture and Mylar wall piece at a California Donuts store. Könitz's photographs doc-ument public reaction as several customers, apparently unimpressed by her interventions, use the sculpture as a table.

Könitz's work documents the years in which mod-ernism in Los Angeles became grossly detached from its intellectual roots. Reintroducing these forms and design motifs as a visual language, Könitz uses the same denigrated idioms to provoke a new consideration of the art that surrounds us. **T.D.**

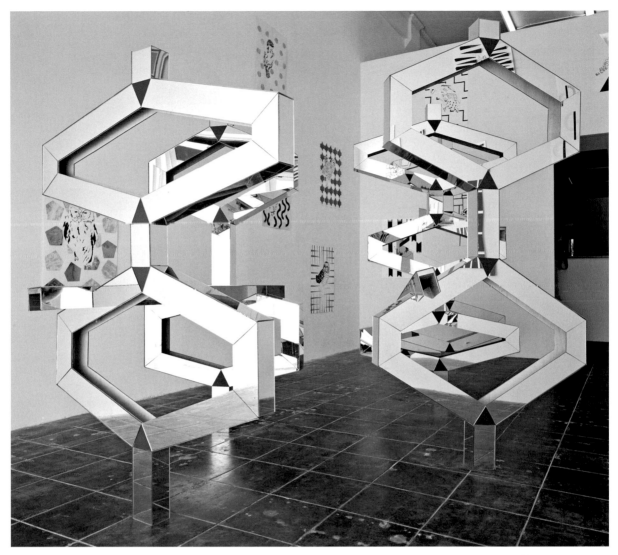

Yet Untitled, 2003. Wood, plexiglass, and paper, dimensions variable, approximately 96 x 144 x 84 in. (243.8 x 365.8 x 213.4 cm). Collection of Ken Freed

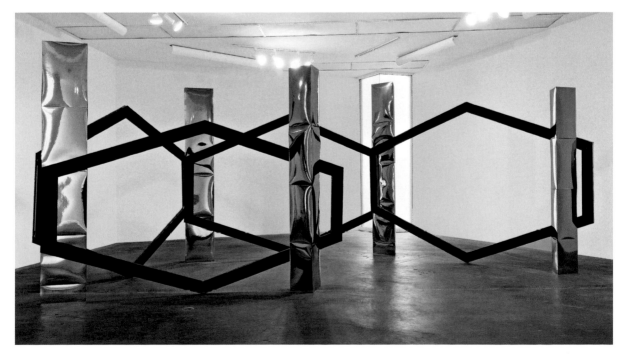

Mall Sculpture, 2006. Melamine board, metallic paper, and felt, 84 x 96 x 192 in. (213.4 x 243.8 x 487.7 cm). Collection of the artist

Untitled, 2006. Silver dye bleach print (Ilfochrome) mounted on aluminum in wooden frame, 19⅜ x 23⅛ in. (49.2 x 58.7 cm). Collection of the artist

LOUISE LAWLER

Born 1947 in Bronxville, New York; lives in New York, New York Louise Lawler's mostly photographic work collapses a variety of art-world positions, including artist, curator, photo editor, dealer, graphic designer, critic, and publisher, raising open-ended questions about the place, value, meaning, and use of art. Poignantly expanding upon the legacy of institutional critique initiated by an earlier generation of Conceptual artists, including Marcel Broodthaers, Daniel Buren, Hans Haacke, and Michael Asher, Lawler puts a frame around the contexts that define art and the audience's relationship to it. Aiming her self-reflexive lens primarily at art's institutions—museums, galleries, auction houses, private collections, art fairs, art storage, and other post-studio contexts—her "pictures present information about the 'reception' of artworks," the artist reports matter-of-factly. But Lawler's closely cropped photographs also frame specific ambiguities, too, including art's relationship to the inchoate economies of desire, exchange, prestige, gender, and power.

Not the way you remembered (Venice) (2006) and *Not the way you remembered (Flavin)* (2007) each point to the placement and exhibition of artworks in changing display contexts. The similar titling of these works bears witness to Lawler's ongoing interest in the spaces between—of the nuances of interstitial spaces, including gaps in memory. Along with other works including *Hoof* (2006), Lawler created *Not the way you remembered (Venice)* for the exhibition *Sequence One: Painting and Sculpture from the François Pinault Collection* (2006–07); rather than contributing discrete artworks, these photographs were taken of the exhibition's early installation process in Venice (*Hoof* and *Not the way you remembered [Venice]* depict fragments of works by Damien Hirst and Rudolf Stingel, respectively). "Not the way you remembered" may refer to the mega-collector and Christie's auction house owner François Pinault's displacement of the old aesthetic regime in the recent Venice installation—a difference relating to power that Lawler's title seems to candidly acknowledge. Open-ended as ever, however, Lawler's "you" also points toward the shifting audience, establishing yet another series of mnemonic intervals, of spaces between a work, context, and memory. As with *Not the way you remembered (Flavin)*, a photograph of works by Dan Flavin that were installed elsewhere, the artist insists upon the viewer's co-conspiratorial role in making sense of specific yet changing receptions of art.

Ultimately, Lawler's self-reflexive photographs about the endless parades of artistic display point toward the regeneration of surplus meanings produced in the spaces between artworks and exhibition frames. Marking the apparatus of the art system, Lawler's knowing work is at once critical and in on the game. **T.A.**

SPIKE LEE

Born 1957 in Atlanta, Georgia; lives in New York, New York In the spring of 1986, a young American filmmaker presented his debut feature at the Cannes Film Festival: a low-budget, black-and-white production entitled *She's Gotta Have It*. Set in the Fort Greene district of Brooklyn, a bohemian enclave of African-American sophisticates, it told of a graphic designer conflicted by the attention of three male suitors and her inability to commit to any of them. *She's Gotta Have It* introduced a new voice to American film and announced the driving preoccupation of its twenty-nine-year-old writer-director, Spike Lee, with the divisive forces in contemporary life.

In each of his celebrated narrative films, Lee confronts various forms of antagonism head on: racial (*Do the Right Thing [1989]*), sexual (*She Hate Me [2004]*), or both (*Jungle Fever [1991]*); creative (*Mo' Better Blues [1990]*); ideological (*Malcolm X [1992]*); and fraternal (*Get on the Bus [1996]*). His interest in dialectic oppositions is reflected in his artistic practice, which alternates between dramatic narrative and documentary, film and video, independent movies and studio productions, theatrical features and television programs. In 2006, Lee released one of his most commercially successful films, the lean, star-studded Hollywood heist thriller *Inside Man*, as well as one of the most acclaimed works of his career, an expansive television documentary on Hurricane Katrina broadcast on HBO. Sprawling, exhaustive, and furious, *When the Levees Broke: A Requiem in Four Acts* memorializes New Orleans before, during, and after the devastation wrought in 2005 by natural forces and human neglect. Using the spontaneous rhythms and associative leaps of jazz music, Lee orchestrates an immense amount of material (interviews, archival footage, photographs, news reports) over four hours of sustained intensity. Both a historically vital document and an emotionally overwhelming experience, *When the Levees Broke* is the culmination of Lee's formal and ethical concerns—but only the beginning, hopes the filmmaker, of a proper reckoning with this great national tragedy. "One of the things I hope this documentary does is remind Americans that New Orleans is not over with," Lee has said. "Americans have very, very short attention spans," he continues. "And, I'll admit there was eventually a thing called Katrina fatigue. But if you go to New Orleans, only one-fourth of the population is there. People are still not home. So hopefully this documentary will bring this fiasco, this travesty, back to the attention of the American people." **N.L.**

Spike Lee in the aftermath of Hurricane Katrina during the production of *When the Levees Broke: A Requiem in Four Acts*, 2006

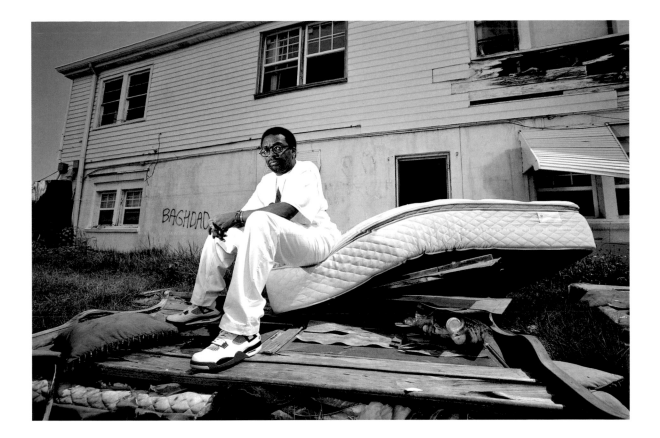

Born 1947 in Hazleton, Pennsylvania; lives in Santa Fe, New Mexico, and New York, New York Deploying a wide range of media including photography, painting, and bronze, Sherrie Levine's work raises questions about art's relationship to originality, authorship, and authenticity. Since the late 1970s, much of her practice has been posited as an explicit, secondary return to prior works by mostly male modern masters, notably in her early photographs including *After Walker Evans* (1981), for example, created by rephotographing a familiar picture by Walker Evans reproduced in an exhibition catalogue.

Levine's *After Stieglitz* (2007) consists of eighteen digitized and pixilated photographic prints after American photographer Alfred Stieglitz's *Equivalents* series from the 1920s and 1930s; his analogue images of clouds were said to be abstract correlatives of the photographer's own experiences and feelings. In Levine's recent return, however, the artist transmogrifies Stieglitz's otherwise straight images, abstracting and digitizing them further—depersonalizing or repersonalizing them, depending on the viewer's perspective. Like most of her work, *After Stieglitz* can be understood as a hall of mirrors—a series of pictures within pictures.

A related series, *After Cézanne* (2007), is a suite of eighteen pixilated photographic prints that transforms Paul Cézanne's painted and fractured nineteenth-century vision of the natural world including trees and rocks into a colorful, digitized matrix abstraction peculiar to our own twenty-first-century way of seeing. In both series, Levine reproblematizes the terms of nature and culture, original and copy, leaving behind abstract ghosts of earlier pictures. "I want to put a picture on top of a picture," Levine says. "This makes for times when both disappear and other times when they're both visible. That vibration is basically what the work's about for me—that space in the middle where there's no picture, but emptiness."

Levine's *Makonde Body Masks* (2007) is a set of polished bronze works cast after ritualistic masks belonging to the Makonde from southeastern Tanzania, and hung as a horizontal series of repeating forms. In their original cultural context, the female body masks were intended to represent a young pregnant woman and were worn by male masqueraders together with matching female face masks during initiation rites (the latter included songs and dance instructing youths in roles of gender and sexuality). Recast by Levine in bronze and presented as presumably expensive luxury art objects, the artist raises questions about the relationship between the ritual and exhibition functions of masks and the different roles and cultural significance that replication plays within each. **T.A.**

Caribou Skull, 2006 (artist's proof). Cast bronze, 54 x 31½ x 25 in. (137.2 x 80 x 63.5 cm). Collection of the artist
opposite: *After Stieglitz*, 2007 (details). Eighteen inkjet prints, 19 x 13 in. (48.3 x 33 cm) each. Collection of the artist

CHARLES LONG

Untitled, from the series *Poem of the River*, 2005. Chromogenic print, 11 x 14 in. (27.9 x 35.6 cm). Collection of the artist

Born 1958 in Long Branch, New Jersey; lives in Los Angeles, California Charles Long's interest in opposing formal and metaphysical forces informs a complex sculptural lexicon marked by radical stylistic shifts that are difficult to categorize. Incorporating an extraordinarily rich range of media, his process-based sculptures continuously show the artist's struggle to connect the cosmos to the physical world, inside space to outside, through what the artist describes as the "implosion or explosion" of materials. Though visually the organically shaped sculptures recall the modernist works of Constantin Brancusi, Isamu Noguchi, or Theodore Roszak, their nonrepresentational ambiguity encourages surrealistic interpretive free associations.

The Amorphous Body Study Center (1995), a collaborative project with British pop group Stereolab, and Long's 1997 Whitney Biennial contribution, epitomizes his colorful, blobby, biomorphic sculptures of the 1990s. Over the past ten years, this anthropomorphic style has mutated into white, gray, and pastel-colored sculptures that are now nearly devoid of Pop references, while still wittily limning the space between abstraction and figuration. Two recent exhibitions at Tanya Bonakdar Gallery in New York and Brown University's David Winton Bell Gallery demonstrated how Long has elaborated personal life experiences to comment on the human condition and the artist's ever-evolving definitions of beauty.

Since relocating from New York, Long has mined the Los Angeles River both for materials and as a source of rich meanings. *Poem of the River* (2005) is a steel armature covered with plaster-coated debris collected from the river basin. Placed upside-down as it dried, its frozen drips of plaster emulate the detritus clinging to river basin trees in the poststorm ruination following heavy rains. *Agnes Martin Kippenberger* (2005) is a conflated homage to two artists representative in Long's mind of control versus chaos: from a metal base, several copper poles—"rational supporting elements"—protrude upward to hold skull-like forms cast from cement mixed with riverbed sediment. At Brown University in 2005, these haunted, postapocalyptic works were exhibited with sculptures incorporating bare lightbulbs that enhanced the spectral atmosphere through shadow while emphasizing dynamic shapes and textures.

Also created from scavenged river junk and silt, papier-mâché, and plaster over steel armatures, the sculptures in Long's 2007 exhibition *knowirds* at Tanya Bonakdar Gallery are his most abject and apparition-like works to date. Reminiscent of Alberto Giacometti's frail figures, these pieces are modeled after the great blue heron excrement that streaks the concrete river embankment. Long sees his tall, desiccated ghosts as harbingers of death that paradoxically assert the resilience of life through their inclusion of every imaginable type of refuse. All untitled, these pieces were exhibited alongside framed albumen photographs of the heron droppings to which they allude. Here, Long has arrived at forms that are as concise as his notion that making artwork is both treacherous and life affirming. **T.D.**

opposite: *Untitled*, 2006. Papier-mâché, plaster, steel, synthetic polymer, river sediment, and debris, 144 x 72 x 7 in. (365.8 x 182.9 x 17.8 cm). Collection of the artist

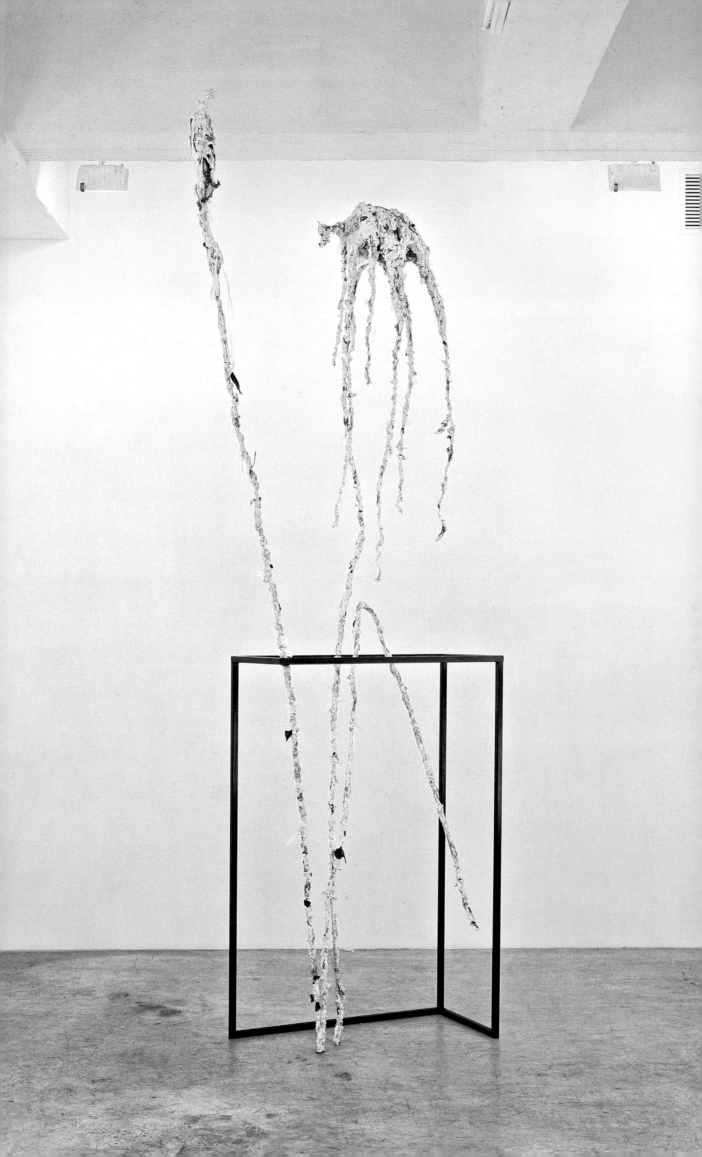

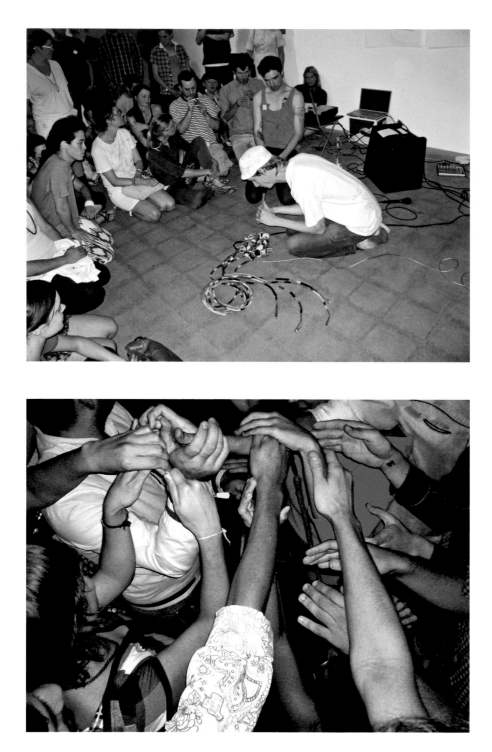

top: *Make a Baby*, 2005– . Performance, David Kordansky Gallery, Los Angeles, July 7, 2006
bottom: *Make a Baby*, 2005– . Performance, El Otro, Guadalajara, Mexico, June 30, 2007

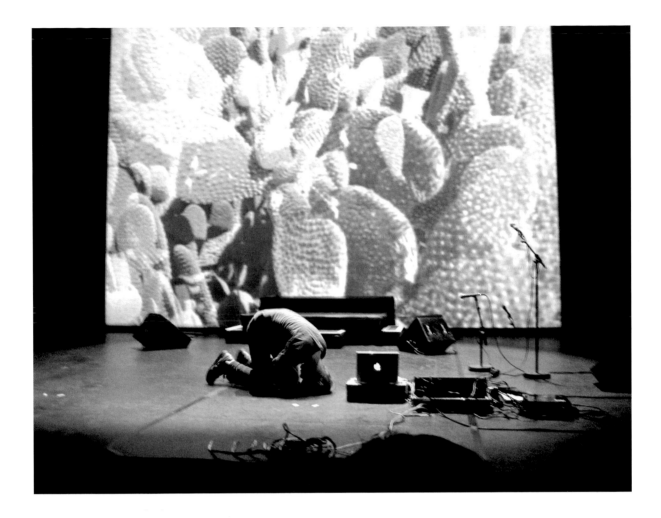

Luke Fischbeck: Born 1978 in San Francisco, California; lives in Los Angeles, California Luke Fischbeck recruits guest musicians and audience members to participate in Lucky Dragons, his communal music experiment linking sound to video, dance, and interactive technology. Embodying the current resurgence in creating psychedelic art as a message of peace, performances of Lucky Dragons promote friendship and solidarity through media typically categorized as nonemotional and isolating—computers, digital instruments, and homemade electronic devices. Fischbeck's improvisational approach to making music reflects life's unpredictable beauty in songs he has described as "nature jams." Borrowing thematically but not sonically from the acoustic-folk, protest song tradition, his ambient electronic pieces incorporate sounds ranging from gritty urban field recordings to sampled MIDI versions of medieval flutes, Inuit vocal games, and songs recorded inside the base of a redwood tree.

Having recorded five albums as limited edition CD-Rs, Fischbeck now divides his time between touring and posting music on his interactive website. The ongoing *Hawks and Sparrows* (2003–), originally released as CD-Rs individually packaged with "the first flowers of spring," has evolved into a free-download project. Its eighteen tracks are based on field recordings taken at four antiwar gatherings from which he removed all language-based rhetoric, leaving processed samples of "pauses, whistles and yells, drums, sirens, helicopters, electric hums, boom boxes" and more. The unexpectedly musical results range from meditational, harmonic loops of sound to crackling distortion that recalls music played through blown speakers.

Live, Fischbeck breaks down the barrier between audience and band by conducting his concerts as workshop-style situations. "Complement Song" (2006) implores audience members to compliment each other. The *Make a Baby* project (2005–) generates sound based on skin-to-skin contact: via conductive sensors knit into tapestries or handheld tubes and wired to his computer, Fischbeck "meaningfully interprets" frequencies sent through participants' physical interaction into a series of digital feedback loops. As audience members surround Fischbeck or hold hands to stay connected, determining the crowd's visual organization, he also distills these signals into animated representations of human motion that appear on a screen as colorful moving patterns. Microcosmic realizations of the artist's stated desire for a world "free of irony," the sincerely cultivated, loving environments Lucky Dragons creates with every project empower the individual, reminding listeners of our ability to effect change in other social arenas. **T.D.**

Desert Walkers, 2006– . Performance, Centre Georges Pompidou, Paris, October 21, 2006

top: *The House America Built*, 2004 (installation view, The Project, New York, 2004). Wood, rolled asphalt roofing, and wall paint (Martha Stewart Signature), dimensions variable. Orange County Museum of Art, Newport Beach, California; Museum purchase with funds provided through prior gift of Lois Outerbridge

bottom: *Divine Violence*, 2007 (installation view, The Project, New York, 2007). Automotive paint on wooden panels, 121 parts, 24 x 36 in. (61 x 91.4 cm) each, overall dimensions variable. Collection of the artist

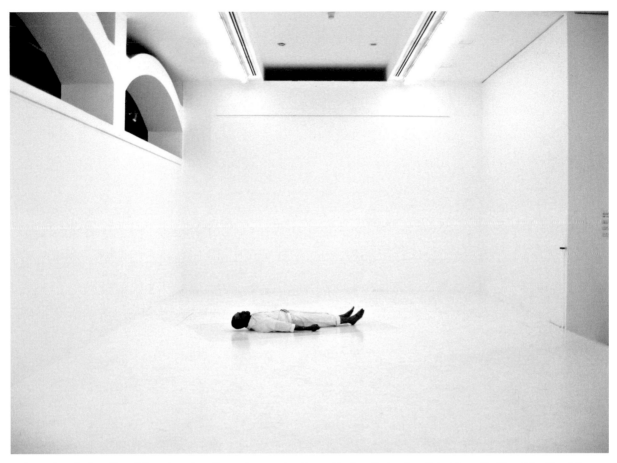

Call Me Ishmael, The Fully Enlightened Earth Radiates Disaster Triumphant, 2006 (installation view, United States Pavilion, Cairo Biennial, 2006–07). Computer-controlled animatronic sculptural installation, dimensions variable. Collection of the artist

Born 1957 in Los Angeles, California; lives in Los Angeles, California Fifteen years after his indelible first appearance in the Whitney Biennial in 1993, Daniel Joseph Martinez continues to create work that unapologetically probes uncomfortable issues of personal and collective identity, seeking out threadbare spots in the fabric of conventional wisdom. A strategic provocateur with a keen intelligence and a wicked sense of humor, Martinez deploys the full range of available media in his practice, having used at various times (and in various combinations) text, image, sculpture, video, and performance to construct his uniquely tough-minded brand of aesthetic inquiry.

The artist's works over the last few years vividly demonstrate both his methods and fascinations. *The House America Built* (2004), for example, staged an improbable, mordant collision between Unabomber Ted Kaczynski and design maven Martha Stewart (with an added touch of Gordon Matta-Clark's anarchitecture), in the form of a wooden cabin that filled the space at his New York gallery, The Project. Painted in deliberately tasteful Stewartesque pastels, the looming structure—riven from bottom to top by a widening slice evoking Matta-Clark's famous house cut, *Splitting*, of 1974—was in fact a reimagining of the Montana dwelling where Kaczynski penned his infamous manifesto.

If *House* looks outward to test whether a spiffy new coat of commerce might camouflage the fractured social architecture of the American democratic landscape, Martinez's ongoing project featuring his own body as a site of contention and disturbance brings questions about appearance and reality into strikingly personal focus. Commencing with a series of self-portrait photographs from 2000, the artist began opening himself up to viewers literally, using sophisticated makeup techniques to produce startling images such as the trio that constitute *More Human Than Human, Self-Portrait #9, Fifth Attempt to Clone Mental Disorder or How One Philosophizes with a Hammer* in which Martinez appears to reach inside his stomach and draw out his bloody entrails. A recent series of animatronic self-portraits—including *Call Me Ishmael, The Fully Enlightened Earth Radiates Disaster Triumphant*, an installation for the Official United States Pavilion of the 2006 Cairo Biennial in which a robot version of the artist convulsed in a paroxysmal seizure whenever viewers came near—constitutes an elaboration of Martinez's abiding interest in interrogating both artistic transparency and audience complicity.

Complicity is also a watchword for his newest work, *Divine Violence*, 2007— first shown late last year at The Project in New York. The work takes its name from Walter Benjamin's coinage for a form of violence that functions as pure means, with knowable ends. The installation of 121 panels, painted in automotive goldflake and each bearing the name of an organization around the world attempting to affect politics through violent means, is part of a larger ongoing project whose open-ended mix of theory, politics, and research is representative of Martinez's entire practice. **J.K.**

COREY McCORKLE

Born 1969 in La Crosse, Wisconsin; lives in New York, New York Corey McCorkle's interest in civic infrastructure and recent utopias informs a far-ranging body of work that includes architectural interventions, installations, and the production of sculptures, photographs, and films. Like the recent design orientation evidenced by Jorge Pardo and Angela Bulloch, McCorkle's practice responds to and acts on its environment: In *Eleven Eleven (Graft)* (2001), he grafted wood veneers from all over the world onto fluorescent tubes that, when lit, emit a warmly variegated glow. For *23.5* (2005) he excised and reinserted parquet floorboards to match the angle of Earth's axis at its most extreme. Drawing from his predominantly nature-inflected sensibility, marked by organic motifs, Art Nouveau–inspired patterns, and New Age points of reference, his work offers a unique acknowledgment of humanity's imperfect (and increasingly commercially mediated) quest for enlightenment. In the potentially transcendent social spaces he creates, McCorkle—hedging our bets—"promises promise," in the words of fellow artist Mungo Thomson.

The related projects *New Life Expo* (1998) and *For Greater Velocity Towards Grace* (1997–2002) mime the self-actualization industry, presenting circular groupings of seats for holding the lotus position—what he humorously calls "orthopedic aids for the cosmically inclined." The artist's tongue-in-cheek description of his work coexists with a disarming sincerity. McCorkle made the forty photographs that comprise the looped slide projection *Middle of Nowhere* (2002) while a resident of Auroville, a community in southern India created as a universal township and nondenominational meditative space based on a principle of "divine anarchy." In its dedication to the transformation of consciousness and sustainable living, the town is comparable to Findhorn, a Scottish eco-village that is the subject of *Untitled (Findhorn Pastoral)* (2002), an installation of inkjet-print images of verdant gardens and, tattooed on the gallery walls, a wing motif taken from the site's entrance.

More recently, McCorkle has shifted from examinations of utopian communities to studies of abandoned constructions. A dilapidated zoo on the fringe of Istanbul stands in for the region's misplaced optimism regarding urban planning in *Bestiaire* (2007), a short, oddly affecting video featuring the feral dogs who freely roam the deserted site once intended to domesticate wild creatures. As a modern fable of the inevitably ruinous course of empire, *Bestiaire* offers a sobering counterpoint to the promises of Auroville and Findhorn—but McCorkle's point might be that nostalgia is better than regret. **S.H.**

Crystal Chain Letter Complex (Dark Episode), 2005 (installation view, Kunsthalle Bern, 2005). 240 opaque blown-glass panels, 348 x 246 in. (884 x 625 cm) overall. Collection of the artist

Stills from *Bestiaire*, 2007. Digital video, color, sound; 6:40 min. Collection of the artist

RODNEY McMILLIAN

Born 1969 in Columbia, South Carolina; lives in Los Angeles, California Reflecting his diverse interest in the boundaries demarcating class, economic status, culture, and their relationship to the physicality of the human body, Rodney McMillian's mixed-genre practice both incorporates and challenges the notion of art as social and historical critique. Aesthetically, McMillian pits light against dark, while his materials—a palette of primarily black, dark blue, and gray paint on raw, unprimed canvas—eloquently symbolize the often opposing cultural forces underlying the delineations he studies. The battered and discarded mattresses, filing cabinets, wood paneling, chairs, bookshelves, and other postconsumer objects that his installations present elicit comparisons of domesticity, education, and race. Recently his sculptures have begun to formally mimic his unstretched paintings, which drape loosely in gallery corners, trail sewn appendages, or unravel onto the floor to highlight their textile nature. The three-dimensional quality of McMillian's paintings recalls Eva Hesse's work, though their quick, linear brushstrokes evoke the subliminal emotive release inherent to Abstract Expressionism.

Just as his paintings illustrate the artist's active, inquisitive process, McMillian's installations increasingly allude to his live performances, which recontextualize political moments neglected by history books. In *Untitled (Unknown)* (2006), shown in *Ordinary Culture* at Minneapolis's Walker Art Center in 2006, approximately fifty columns, wrapped in gray fabric and ranging in height from 1 to 11 feet, slouched like architectural ruins or sheepish devotees behind a chipped bust of an anonymous everyman. McMillian described his practice to that exhibition's curator as "interrogating history as a fixed interpretation and using it almost like a readymade to evaluate its position from the past." His displays of found busts depicting great men of politics have inspired events in which, dressed in a suit, he recites speeches they gave, reincarnating these powerful figures even while he chides their elitist positions. In 2006 McMillian delivered Lyndon B. Johnson's 1964 "Great Society" speech at Bard College's Center for Curatorial Studies, Annandale-on-Hudson, New York, during the opening of *Uncertain States of America* and again that year for his solo exhibition *Odes* at Susanne Vielmetter Los Angeles Projects.

McMillian's paintings have recently become more informed by their current surroundings, complicating his sense of the past. For *Odes*, in sunny Southern California, McMillian's *Untitled (Sky)* (2006) was filled with swirled pours of blue and white latex, sold by the square foot on a sliding scale to parallel the American dream against the backdrop of real estate investment. *Untitled (flag painting)* (2007), McMillian's take on this American symbol, is a loosely hung red canvas accentuated by two drippy horizontal white stripes and a red stuffed-canvas blob sagging below it. As McMillian continues to explicate present moments, his work comments on the lugubrious underbellies implicit to each cultural progression and movement. **T.D.**

Untitled, 2007. Vinyl and thread, approximately 114 x 156 x 48 in. (290 x 396 x 122 cm). Collection of the artist

Untitled (Unknown), 2006 (detail). Mixed-media columns and plaster bust, dimensions variable. Collection of Giovanni Springmeier

Still from *epic* (working title), 2008. Video projection, color, sound; 7:20 min. Collection of the artists

Still from *not a matter of if but when: brief records of a time when expectations were repeatedly raised and lowered and people grew exhausted from never knowing if the moment was at hand or was still to come*, 2006. Video projection, color, sound; 32 min. Collection of the artists

Still from *We will live to see these things, or, five pictures of what may come to pass*, 2007. Video projection, color, sound; 47 min. Collection of the artists

Julia Meltzer: Born 1968 in Hollywood, California; lives in Los Angeles, California. David Thorne: Born 1960 in Boston, Massachusetts; lives in Los Angeles, California Los Angeles–based Julia Meltzer and David Thorne produce installations, photographs, and videos that raise questions about the uses of documents and their social, political, and affective impact. Formerly working under the moniker The Speculative Archive, the artists' collaborative activities from 1999 to 2003 examined the intersection of state secrecy, memory, and history. Newer works address the use of documents—ranging from images and texts to objects, people, and even physical structures—"to project and claim visions of the future," according to the artists.

Two recent videos, nominally proposed as "documentaries," were shot while the pair was living in politically volatile Damascus, Syria. *Not a matter of if but when* (2006), a 32-minute work featuring Syrian performer Rami Farah, is a series of stirring monologues about peace, friendship, hate, vengeance, retribution, and transcendence. The 47-minute *We will live to see these things, or, five pictures of what may come to pass* (2007), similarly divided into distinct segments, chronicles a long-delayed building project in downtown Damascus, the hope for a perfect leader, an interview with a dissident intellectual, young girls at a Qur'an school, and "an imagining of the world made anew," in the artists' words. The sum of these distinct vantages, which include different stylistic techniques of observa-

tion, creates a kaleidoscope of "different perspective(s) on what might come to pass in a place where people live between the competing forces of a repressive regime, a growing conservative Islamic movement, and intense pressure from the United States," they explain.

Both works emerged out of the artists' research on notions of preemption developed by the Bush administration in 2002—the idea of taking present military action based on future predictions determined by inchoate, immanent, or speculative evidence. Each "documentary" turns on its head the usefulness of documents, and the viewer encounters palpable uncertainty: What is fact and what is fiction? What is scripted and what is not? And most ominously—and with piercing affect—what is to come? Interspersing a sometimes straightforward interview style with other deliberately ambiguous, fictionalized, and even fatuous treatments, these videos depart decisively from typical documentaries about the Middle East, being "informative without necessarily 'providing information,'" as Thorne notes. With this reversal, these "documentaries" attain a powerfully aesthetic, anti-instrumental dimension, leaving the viewer, in poet Theodore Roethke's words, to "think by feeling." At the same time, the works remain harrowing records of a particular time and place, examining and performing the present moment's political crisis—also a crisis of representation—and raising serious questions about how visions of the future manifest their destiny. **T.A.**

JENNIFER MONTGOMERY

Born 1961 in New York, New York; lives in Chicago, Illinois "Kodachrome/ They give us those nice bright colors, they give us the greens of summer/ makes you think all the world's a sunny day." Thus did Paul Simon, in his 1973 song "Kodachrome," sing the praises of Eastman Kodak's legendary line of color reversal film stocks. Introduced in 1935, Kodachrome quickly became the industry standard for professional color photography; thirty years later it was used as film stock for the company's newly introduced Super 8 film, beloved by four decades of avant-garde filmmakers for its chromatic intensity and affordability.

Jennifer Montgomery belongs to the dwindling but impassioned tribe of contemporary Super 8 devotees, having used it for a series of lyrical, personal short films: *Home Avenue* (1989), *Age 12: Love with a Little L* (1990), and *I, a Lamb* (1992). In the recent feature *Threads of Belonging* (2003), she presents Super 8 as a form of art therapy for residents of a fictional community. Her latest work, *Notes on the Death of Kodachrome* (1990–2006), reflects on the discontinuation of Kodachrome, announced in 2005, and with it the further endangerment of Super 8 film. For Montgomery, the loss of the much-loved film stock opens up larger issues of memory, loss, and reclamation of personal histories as well as the broader historical forces that have shaped our lives.

The work is divided into five distinct sections introduced with a title card specifying time and place.

Labeled "1986 / San Francisco / a prophecy," part one consists of a short in which Montgomery, naked, smears her own menstrual blood on a strip of film; the section ends with the limpid, dancing abstraction created by this tinted celluloid. Part two opens in New York, 2005, as Montgomery pays a visit to the writer Joe Westmoreland, an old friend who once borrowed, and now returns, an old projector. In Los Angeles, filmmaker Lisa Cholodenko admits to leaving behind a sound viewer belonging to Montgomery when she moved from New York; part three ends with the purchase of a replacement from a local vintage camera shop. Following this, part four records its unpacking in Montgomery's Chicago apartment. In the final section, Montgomery travels to the Portland home of Todd Haynes, a former classmate at Brown University who once borrowed her Super 8 camera to shoot his infamous underground film *Superstar: The Karen Carpenter Story* (1987). As they reminisce, Haynes reflects on the strange feelings of panic at the loss of "cultural objects that we've used and expressed ourselves through and that reflect history," while Montgomery describes the connection to her Super 8 camera as being "like an extension of my body." Montgomery says the impetus for her project stems from a dream she once had and always wanted to film. The work concludes with the re-creation of this dream—a final, bittersweet visit with one of Montgomery's old friends, Kodachrome. **N.L.**

Stills from *Notes on the Death of Kodachrome*, 1990–2006. Video, color, sound; 80 min. Collection of the artist

Installation view, *Olivier Mosset*, Ecole régionale des beaux-arts de Rennes, France, 2007

Born 1944 in Bern, Switzerland; lives in Tucson, Arizona For the last four decades, Olivier Mosset has remained committed to questioning painting as a historical object by, somewhat paradoxically, continuing to paint. Through his affiliation with the B.M.P.T., a group of conceptually driven painters formed in Paris in the 1960s, Mosset and his peers—Daniel Buren, Michel Parmentier, and Niele Toroni (their initials reflected in their collective acronym)—sought to democratize art through radical procedures of deskilling. They also deftly deconstructed such modernist shibboleths as the primacy of authorship and the value of originality by signing each other's works and repeating a specific compositional device across multiple grounds: while Buren became well-known for keeping to stripes, Mosset focused on the circle, which he painted in some two hundred iterations between 1966 and 1974.

Since that time, Mosset has turned to monochrome works on shaped canvases that more or less implicitly comment on circuits of production and exchange (stars standing in for revolutionary aspirations, or dollar signs representing, well, dollar signs). He has also explored other formats and materials of abstract painting involving more traditional oil and acrylic, as well as industrial plastic. Mosset alternately culls forms from the land-

scape as found abstractions and anchors paintings back to it, site- and architecturally specifically: He drew from the antitank traps dotting Europe's roadsides for the *Toblerones* (1994–2007), massive yet ephemeral Minimalism-inspired sculptures produced in ice. His shimmering *Golden Shower* (2007) transformed the lowered garage door of SculptureCenter in Queens, New York, into an improbably beautiful wash of yellow paint.

Collaboration, too, remains a constant in Mosset's practice, whether in the form of the Radical Painting Group (with Joseph Marioni and Marcia Hafif) in the late 1970s or more recent partnerships with Cady Noland, in 2004, and "Indian Larry" Desmedt, a motorcycle mechanic and stunt rider whose flame-licked customized bikes were shown alongside the artist's paintings in 2007 at Spencer Brownstone Gallery in New York. Mosset's sweeping red arcs shown there can be read equally as pure geometric shapes, references to Ellsworth Kelly, or giant smiles; adjacent brilliant yellow orbs solicit a comparable latitude of interpretation, leaving one with the suspicion that reflexivity—on the part of the maker and viewer alike—is Mosset's point. Curator Robert Nickas once described Mosset's early work as "pictures . . . of painting itself." This argument seems just as apt now. **S.H.**

opposite top: *Untitled*, 2007. Polyurethane sprayed on canvas, 48 x 48 in. (121.9 x 121.9 cm). Collection of Stefano Pult
opposite bottom: *Untitled*, 2007. Polyurethane sprayed on canvas, 48 x 48 in. (121.9 x 121.9 cm). Collection of Stefano Pult

MATT MULLICAN

Untitled (Models for the Cosmology), 2006. Cast pewter and steel, multiple parts, 16¾ x 16¾ x 6⅛ in. (42.5 x 42.5 x 15.6 cm) each. Collection of the artist

Born 1951 in Santa Monica, California; lives in New York, New York Matt Mullican's art takes form as drawing, sculpture, video, painting, electronic media, and installation, but his contribution to the 2008 Whitney Biennial might be best approached under the loose rubric of performance art. Since the late 1970s he has used hypnosis in his work, and the process both informs and helps elucidate his practice, which explores the different ways we experience the subjective through media. In Mullican's performances, which have recently taken place in settings arranged to resemble a studio and a home, his trance state can last several hours and encompass a range of behavior from the banal to the startling. Treating his psyche as a found object, he might pour himself coffee, pace the floor, grunt, sing, chant phrases (from curses to declarations about how he's feeling), and—most tellingly—draw or paint in black acrylic ink on supports including large pieces of paper, bedsheets, and the wall itself.

While Mullican's performances call up 1960s and 1970s predecessors such as Bruce Nauman or Joseph Beuys, the graphic meandering and biomorphic whorls in his drawings of the past decade hark back to Surrealist experiments with frottage and automatic writing. These abstract geometric forms are combined with more representational, repetitive imagery: grids of letters and numbers, transcriptions of song lyrics, and childlike pictures. Mullican has long been interested in the intersection of public sign systems with personal semiotics, and in the early 1970s began producing a series of charts illustrating a fictive cosmology. Arrays of pictographic symbols that seemed to denote physical, biological, epistemological, and belief systems, the charts were executed on canvas and as sculpture and diffused in formats such as printed media and public installation. Encountering them with expectations of legibility and comprehensibility, viewers found instead diagrams of a nonsystemic, idiosyncratic universe distinctly the artist's own.

Installations of Mullican's work often feature grids of his drawings hung side by side on makeshift walls in tightly packed rooms or corridors. These are spaces in which it seems possible to lose oneself, which, in a sense, the artist has done to create them. The predicate of his experiences under hypnosis is an ageless, genderless figure he calls "that person." As he emerges in the work, "that person" busies himself with everyday routines but has his eye on the big issues; a statement in one drawing reads, "I love to work for Truth and Beauty." Mullican's work of the past three decades stands as an extended, and often profound, meditation on the notion of artistic subjectivity, and on the limits—and unexpected benefits—of distancing the ego from the creative self. **L.T.**

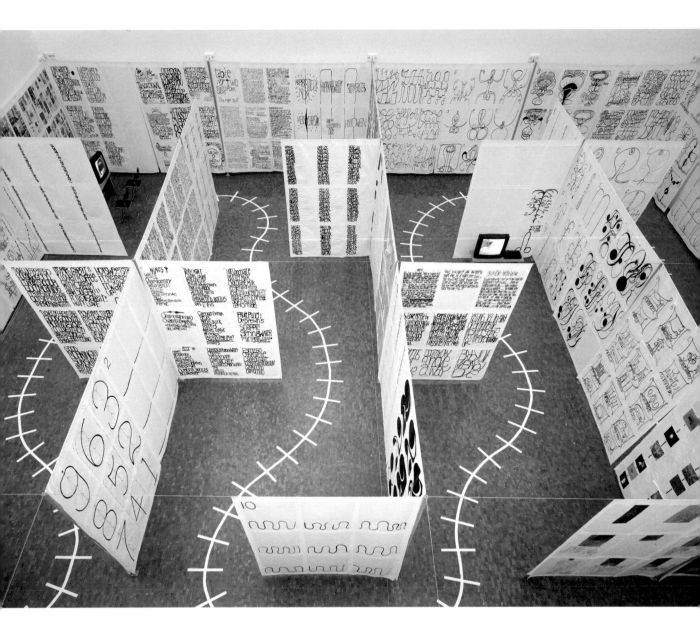

top: Installation view, *DC: Matt Mullican: Learning from That Person's Work*, Museum Ludwig, Cologne, 2005
bottom: *Untitled (Ellipses and Balls)*, 2003. Felt-tip marker on glass, wire, and wooden table, dimensions variable. Collection of the artist

NEIGHBORHOOD PUBLIC RADIO (NPR)

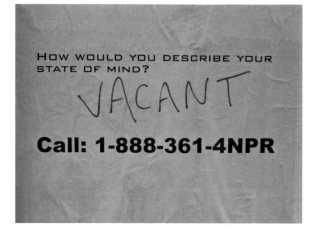

State of Mind Stations—Mission Neighborhood Poster, 2007 (detail). Poster, 36 x 24 in. (91.4 x 61 cm). Collection of the artists

Founded 2004 in Oakland, California Neighborhood Public Radio is a guerilla radio broadcast group who share their moniker, NPR, with the station they critique through community-based, noncommercial programming. Setting up temporary booths to stream content onto the internet, or using low-power portable FM transmitters, NPR's nomadic team—anchored by artists Linda Arnejo, Whiz Biddlecombe, Jon Brumit, Lee Montgomery, Katina Papson, and Michael Trigilio—broadcasts live shows from galleries, residences, and neighborhood points of interest. Parodying National Public Radio in particular, Neighborhood Public Radio believes corporate sponsorship of ostensibly public stations compromises freedom of speech and isolates communities through cultural homogenization.

To celebrate geographic individuality, NPR constructs programmatic narratives with community members' voices rather than through journalistic reporting. Local musicians, visual artists, activists, journalists, and residents are invited to participate in this unlicensed, grassroots activity whose simple, affordably produced "snapshots" of the neighborhood provide inspiration as an alternative programming model. By enabling listeners to control contact with the artist through the turn of a dial or to copy NPR's media format, NPR also engages in a form of interactive art. Myriad northern California groups including Negativeland on KPFA, San Francisco Liberation Radio, and Freak Radio Santa Cruz have influenced NPR's audio experiments, though NPR's notion of collectivity can be traced back through the lineage of Surrealism to artist collectives like Art & Language.

NPR's technology-based practice is tempered by hosting transmitter building workshops and interventions requiring physical action or collaboration by listeners. From November 2006 to June 2007, NPR aired a series of programs called *Radio Cartography* from San Francisco's Southern Exposure gallery, which was converted into a makeshift radio station. On the second Saturday of each month, for 4-hour intervals, NPR broadcast interviews and locally generated performances related to themes such as "Relocation," "Packaging," "Indecency," and "Madness." *Radio Cartography* also encompassed three other programs: *State of Mind Stations*, *Talking Homes*, and *Alternate Soundtrack Tours*.

Alternate Soundtrack City Tours (2007) led listeners on narrated audio tours of San Francisco's Mission District. Once a month, NPR provided handheld radios for hearing "orchestrated meditations" on sites located on easily navigated routes. Interference, varying degrees of reception, and environmental factors contributed to the sonic experience of shows like "Out of Bounds," about the strength of radio signals, or "Woodward's Gardens," which reconstructed the noise components of a former zoo/amusement park on a now completely altered city block. Repurposing transmitters designed to advertise real estate amenities to driving passersby, *Talking Homes* (2007) implemented door-to-door sales methods to engage participants.

For *State of Mind Stations* (2007), NPR solicited community members to call in and describe their momentary emotional conditions, illustrating how every aspect of humanity instructs personal politics. NPR's motto, "If it's in the neighborhood and it makes noise, we hope to put it on the air," is as much a statement of their agenda as it is a call to notice the democratic nature of community action. **T.D.**

Neighborhood Public Radio—Neighborhood Outreach, On-the-Street Interviews, 2007. Mission District, San Francisco, April 8, 2007

Neighborhood Public Radio—Transmitter Building Workshop, 2007. Southern Exposure, San Francisco, January 27, 2007

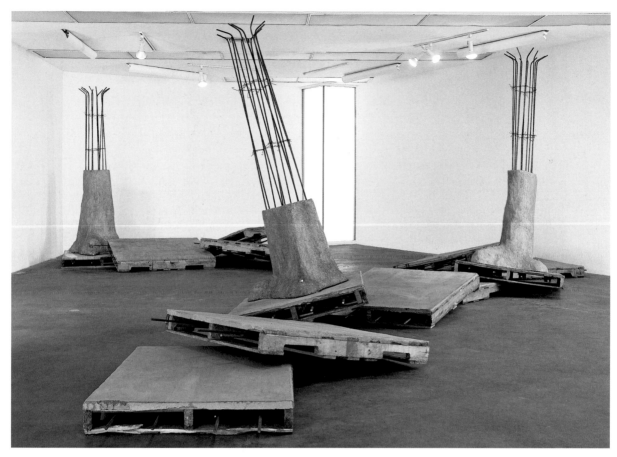

Infracted Expansion (I cannot tell a lie, lightning struck down the first one and my father chopped down the second), 2007. Eight wooden pallets, bonding cement, wire mesh, burlap, and rebar, dimensions variable. Collection of the artist

Born 1974 in Oceanside, California; lives in Los Angeles, California Ruben Ochoa's monumental use of building materials in sculpture, photography, and public interventions deconstructs a construction-worker aesthetic by investigating urban locations under contention. Cataloguing places of social and economic transactions as sites for documentation or site-specific installations, he presents a finely tuned vision of Los Angeles as a city socially, economically, and geographically described by its freeways and street curbs. Beyond its formal references to civil engineering, Ochoa's work critiques class boundaries determined by these borders in his rejection of traditionally exclusionary exhibition styles. Relocating industrial or outdoor materials such as cement, rebar, pallets, and dirt into the gallery and displaying artworks in unlikely areas throughout the city, he juxtaposes refinement with grit, as did Walter De Maria and environmental sculptors like Edward Kienholz. Increasingly Ochoa studies areas where nature buttresses itself against annihilation, a cultural metaphor lending hope and vivacity to his work.

Ochoa's conceptual arguments extend into large socioeconomic arenas. For several years he installed other artists' works in his mobile exhibition space, *CLASS: C* (2001–05), converted from his family's tortilla delivery van. One part of three in his 2006 show at Los Angeles's LAXART, *Extracted* (2006) filled the gallery with what appeared to be a massive concrete slab heaped with dirt; intrepid viewers discovered that the installation was chicken wire thinly covered with soil and cement. A disruptive reminder of the raw chaos outside, this work indicates the artist's deepening concern with sculpture as architecture and with architecture as a reflection of its surrounding culture. In *Fwy Wall Extraction* (2006–07) Ochoa applied wallpaper to a section of wall on the Interstate 10 freeway (chosen because it surrounds, separates, and disrupts culturally diverse populations) depicting a photo-realistic cross section of the landscape that might exist behind the cement.

In his 2007 exhibition *A Recurring Amalgamation* at Susanne Vielmetter Los Angeles Projects, Ochoa explored collisions between the natural and manufactured within the exhibition space, though landscape photographs lining the walls reminded viewers to search for art outside the white cube. In *Infracted Expansion* (2007) freeway column–tree trunk hybrids were installed atop cement-crusted pallets jutting from the floor like icebergs. A cast-concrete pallet called *Lean Back* (2007) reclined against one wall. Nearby a suite of chromogenic prints catalogued ficus trees whose roots have defiantly busted through the sidewalk. Nonnative to Los Angeles, here their exuberance might symbolize the city's immigrant community. *Kissed in the 90011* (2007), in which a curb and the ficus growing from it are both colored by the same carelessly applied swath of red paint, harks back to Ochoa's appreciation of human intervention. In this image the artist's formal interests seamlessly coincide with unexpected environmental discoveries to unearth art in his urban daily experience. **T.D.**

opposite: *If I had a rebar for every time someone tried to mold me*, 2007. Rebar, annealed wire ties, and dobie blocks, 122 x 198 x 222 in. (284.5 x 502.9 x 563.9 cm). Collection of the artist

DJ OLIVE

DJ Olive. Performance, Flynn Center for the Performing Arts, Burlington, Vermont, March 18, 2007

Born 1961 in Boston, Massachusetts; lives in New York, New York DJ Olive the Audio Janitor (Gregor Asch) applies his skills as a DJ and turntablist to create atmospheric multimedia events that broaden conventional definitions of listening to music. Delivering both danceable bass-heavy sets and quieter, ambient soundscapes to large audiences in clubs, warehouses, and music festivals, Olive's musical aesthetic features layered and looped urban noises reflecting the chaotic character of his Brooklyn, New York, home base. He uses computers and turntables to appropriate and combine incongruous audio clips—ranging from street sounds to previously recorded world music, drum 'n' bass, hip-hop, and dub—into songs that contain trance-like, melodic, groovy logics.

As a musician who composes, produces, distributes, and performs his collaged sound projects, Olive sees his events, which incorporate visual elements such as light shows and video screenings, as "voyages" that are at once performance art and positive, community-building political actions. His projects unfold on massive scale, transcending the typical club environment by harnessing the transformative powers of sound through colossal—and in at least one work literally global—takeovers. In

1997, as part of their opera *Quark Soup*, Olive's collective Multipolyomni offered participants *The Solar Drama*: a view of the sun perpetually rising, broadcast live from 127 consecutive locations during one of Earth's rotations, as seventy-seven performers and artists hosted a gigantic sound installation.

Olive's visionary approach to entertaining developed during the 1990s as he pioneered an electronic music scene centered around what is now called roof music. For the 2002 Whitney Biennial, Olive organized *Roof Music: Sunrise on a Rooftop in Brooklyn*, a sound installation that sought the cultural unification of all participants. Complementing the throbbing dance music, he alternately held "sleeping pill" events—quiet, sonically ambient sleepovers—to promote relaxation. Olive has written a new sleeping pill composition for the 2008 Biennial, to be played inside an installation offering viewers a cozy space to close their eyes and kick up their feet. Equating these soft, soothing sounds with medicinal healing, he seeks to provide comfort and stress relief to his audience. Though his complex sampling still reflects a tension implicit to city dwelling, Olive's music grows more hypnotic as he becomes increasingly interested in uniting people. **T.D.**

DJ Olive. Performance, Pollack Hall, Schulich School of Music at McGill University, Montreal, Quebec, June 12, 2007

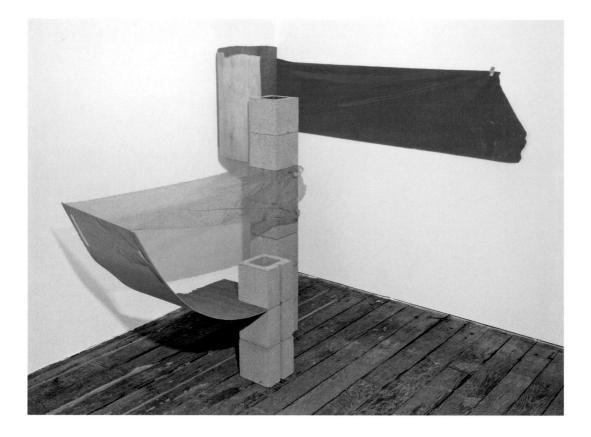

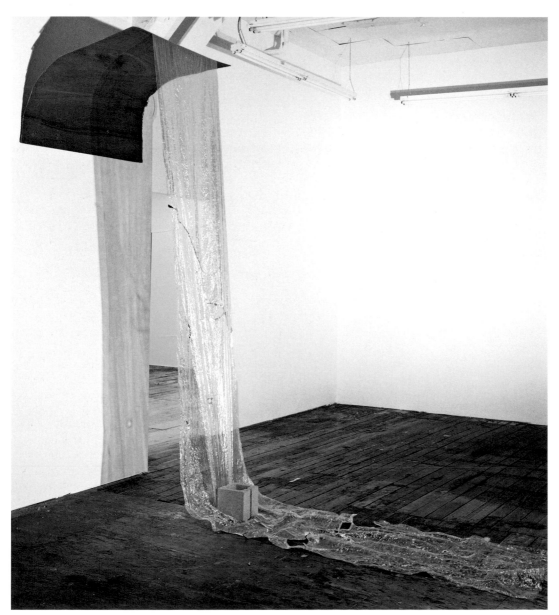

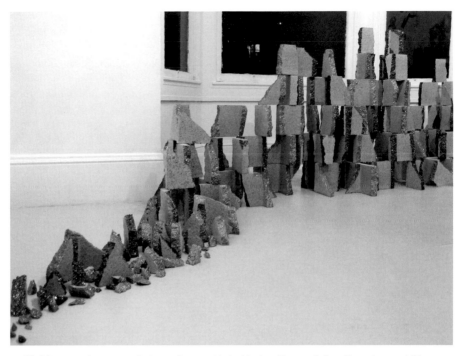

untitled (ten years later or maybe just one), 2005. Cinder blocks, glitter, and glue, dimensions variable.
Collection of Ellen Kern

Born 1976 in Stuart, Florida; lives in San Francisco, California Mitzi Pederson explores the formal qualities of abstract sculpture, juxtaposing such disparate materials as cinder blocks, plywood, plastic, cellophane, silver leaf, and aluminum tape in carefully balanced constructions that challenge the viewer to directly engage with the materiality of the work. Her sensitive use of specific media results in visually compelling works drawing on the legacy of modernist sculpture from Constantin Brancusi's attention to wood and stone surfaces to Donald Judd's use of industrial materials.

In *yellow and orange* (2006) a tall mast of cinder blocks supports a construction of thin, bowed wood paneling and shimmering orange cellophane. Extending from the tower, the cellophane is drawn taut by a sheet of wood that, anchored between two blocks of a second, shorter column, in turn bends and yields to the pull of the plastic. The thin, tacky cellophane emphasizes both the heft of the cement and the strength of the arced wood, but by withstanding the strain of the forces acting on it, the diaphanous strip proves improbably strong and resilient. As she draws our attention to the properties of these simple, everyday materials, Pederson illustrates the tensions between them as well as their collaboration. Hinting at her early training in architecture, she often utilizes the gallery infrastructure in her work. Here another strip of bowed plywood is secured between the corner of the gallery and the cinder stack, while a second sheet of plastic extends along the wall. The design relies on the inherent qualities of each component and its environment, the elements engaging in a tenuous interdependency as they reach equilibrium. This implicit interaction and movement imbues the work with its disarming impermanence.

The precarious balance of her constructions is central to Pederson's practice. In *untitled (ten years later or maybe just one)* (2005) the arrangement of coarsely chipped cinder blocks—smaller, solitary fragments leading to larger, stacked pieces—is reminiscent of craggy mountainscapes or historical ruins. Placed without mortar to adhere the blocks, the work is at once transitory and enduring. Pederson has overlaid the exposed, rough edges of the broken blocks with dark gray glitter, visually offsetting the weight of the material and its connotation of building construction. The sparkling fragments take on an organic, crystalline appearance that transforms the banal building material into a timeless, otherworldly substance. Elegantly negotiating and balancing the properties of her materials, Pederson creates subtle, enigmatic sculptures that resonate with an allusive ambiguity. **S.G.**

opposite top: *yellow and orange*, 2006. Cinder blocks, cellophane, and wood, 64 x 72 x 80 in. (162.6 x 182.9 x 203.2 cm). Collection of the artist
opposite bottom: *untitled*, 2006. Cinder block, cellophane, and wood, dimensions variable. Collection of the artist

KEMBRA PFAHLER / THE VOLUPTUOUS HORROR OF KAREN BLACK

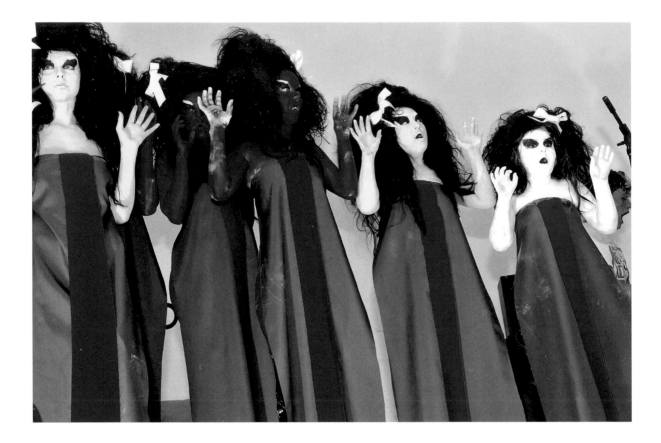

Kembra Pfahler: Born 1961 in Hermosa Beach, California; lives in New York, New York. The Voluptuous Horror of Karen Black: Formed 1990 in New York, New York, by Kembra Pfahler and Samoa Kembra Pfahler is the woman behind The Voluptuous Horror of Karen Black, a theatrical rock group that links a hideous monster aesthetic to a dark, hysterical feminine archetype. Named in honor of cult horror film heroine Karen Black, Pfahler's band performs heavy-bottomed punk-metal songs amid elaborate hand-constructed sets where she engages an animalistic, fetishistic practice of acting out transgressive physical feats. Pfahler's stage persona has been described as a dominant "lady devil" who relishes destroying notions of female beauty rooted in purity and innocence. Wearing a teased black bouffant wig with blacked-out teeth, black stiletto boots, and black underwear, her nude body painted blue, pink, or yellow, Pfahler heads a team of ladies appointed in similar campy glamour while male band members including her ex-husband, Samoa, maintain masculine rockabilly stylings. Pfahler and Samoa formed The Voluptuous Horror in 1990 after ten years of making Super 8 horror films and visual and performance art that they felt would benefit from a musical soundtrack, looking to Viennese Actionists Hermann Nitsch, Otto Mühl, and Rudolf Schwarzkogler as original influences. Rebelling against a degraded, polluted world, Pfahler developed an "anti-naturalism" platform on which to promote VHOKB reflecting their desire to reveal the attraction of repulsion.

The Voluptuous Horror of Karen Black fashion their props and sets from low-tech, readily accessible materials under the rubric of Pfahler's theory of Availablism, creating structural items and costumes such as ladybug and flower head uniforms as visual accompaniments to their songs. For *Chopsley* (1996), an oversize animal trap controlled by a female band member snaps open and shut on Pfahler as she sings about a "rabid bikini model." In a 2006 performance at New York's Deitch Projects, *The Sound of Magic*, band members danced with Mylar-covered boards shaped like giant razor blades and shark heads before a backdrop of starkly striped paintings. Members Pfahler, Samoa, Adam Cardone, Magal, Adam Pfahler, Dave Weston, and Karen Black Girls Bijoux Altamirano, Alice Moy, Anne Hanavan, Jackie Rivera, Laure Leber, and Armen Ra writhe and jump throughout these ritualized ceremonies-cum-rock shows.

Recently Pfahler has directed her interests in bodily transformation to curatorial practice. In *Womanizer* (2007), also at Deitch Projects, she co-curated a show that demonstrated an "evolution beyond gender" by showing works by women seeking to explode the dualism inherent to male/female opposition. Pfahler exhibited a suite of photographs in which, dressed only in thigh-high lace-up boots and blue body paint, she mimes fornicating with a skeleton symbolizing her recently deceased boyfriend. Conflating horror, death, and female sexuality, Pfahler and VHOKB tantalize the viewer by exemplifying an abhorrent sublime, terrible as it is irresistible. **T.D.**

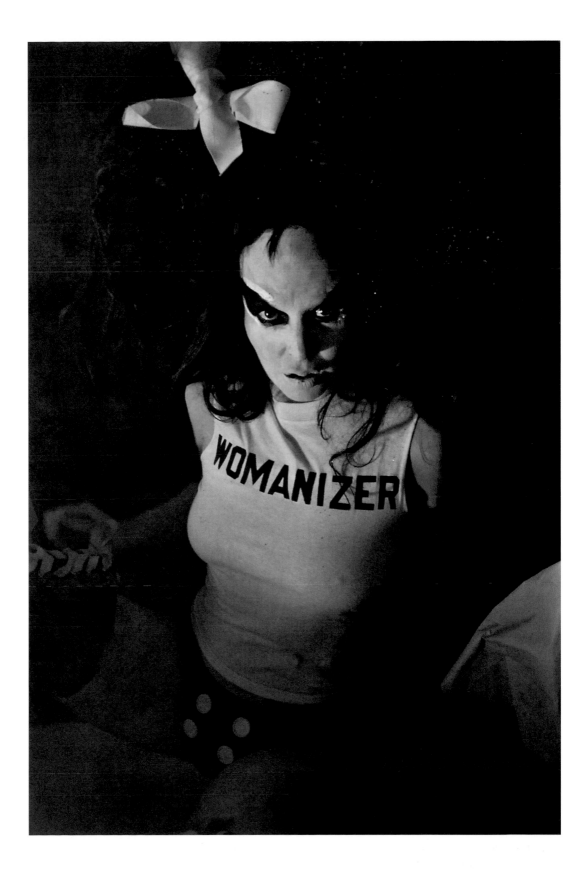

Kembra at Home, 2007. Chromogenic print, 14 x 11 in. (35.6 x 27.9 cm). Collection of the artist
opposite: *The Voluptuous Horror of Karen Black, Womanizer Banquet Performance, Deitch Projects, New York, January 5, 2006.*
Chromogenic print, 11 x 14 in. (27.9 x 35.6 cm). Collection of the artist and Deitch Projects, New York

top: *Untitled*, 2007. Bird's eye maple, butternut walnut, and plastic, 168 x 216 x ⅛ in. (426.7 x 548.6 x .3 cm). Collection of the artist
bottom: *Gold Keys*, 2007. UV-cured inkjet print on aluminum-polyethylene composite, three parts, 22 x 66 x ⅛ in. (55.9 x 167.6 x .3 cm) overall.
Collection of the artist

Dispersion, 2002– . Text, materials variable, dimensions variable
(pictured: staple-bound paper booklet, 2002; collection of the artist)

Born 1973 in East Jerusalem, Israel; lives in New York, New York Through paintings, sculpture, video, and media work, Seth Price underlines the production strategies, dissemination modes, and valuation patterns that art most typically occupies or assumes. His appropriative work, which often comprises what he terms the "redistribution" of pirated materials such as music and published texts and the circulation of archival footage and data culled from the internet, disrupts the operations of commodity culture and the information systems on which its ingratiating fluidity depends. While his practice evades rhetorical summation and aesthetic synthesis alike—effectively becoming mimetic of its profligate situation—the artist's interest in the mobility of form suggests a common denominator. The music compilations that make up the series *Title Variable* (2001–), for instance, reference episodes in recent music history, including video-game soundtracks and hip-hop. Released in various formats, Price's mixes have been delivered online and through bookstores and museums, accompanied by the artist's essays on each music form.

Ranging from vacuum-formed bomber jackets to 16-millimeter projections of rolling waves, Price's employ of interchangeable and nonspecific supports focuses on seeking out operations, allowing his work to avoid ossification as fixed images. One tactic involves collaborative performances with the art and publishing collective Continuous Project, formed in 2003 with Bettina Funcke, Wade Guyton, and Joseph Logan. That

year they made and distributed photocopied facsimiles of the first issues of the art magazines *Avalanche* (Fall 1970), for *Continuous Project #1*, and *Eau de Cologne* (1985), for *Continuous Project #4*. The collective also stages multihour readings of interviews and panel discussions—sometimes institutionally repressed—between artists, curators, critics, and dealers, inviting the audience's participation. As much historical reenactment as instantiation of presentist social space, Continuous Project's lectures draw attention to ways in which the content of such events are inextricable from their design.

Format likewise proves a crux in Price's recent two-dimensional, wall-bound works including *Gold Keys* (2007): disembodied hands passing keys to each other float on golden-metallic grounds, generic icons culled from real estate and other advertisements as well as other media sources, yet given a treatment more typical of archival photographs. *Untitled* (2007) recycles digital images illustrating various human interactions. In this portrayal of one person feeding another, Price has excised the figures themselves, leaving only the negative interval between them; other works in the series depict a couple kissing and a man with his hand on a boy's shoulder. Perhaps plucked from a commercial or shareholder prospectus, each vignette denies specificity even as it is fetishized through its transmutation into luxurious materials at a grand scale, leaving the narrative ambiguously open—and ready to be consumed, repurposed, and discarded anew. **S.H.**

STEPHEN PRINA

Born 1954 in Galesburg, Illinois; lives in Cambridge, Massachusetts, and Los Angeles, California With canny clairvoyance, Stephen Prina makes art based on a self-conscious relationship to the past, present, and future. Using a variety of media, his work addresses the afterlife of artworks in art's distribution channels: its institutions, its market, and its historiography. These shifting sites of art's post-studio reception—frequently beyond the discharge of artists' intentions—take center stage in Prina's production. Prina has also released music through popular-music channels under his own name and as part of the band The Red Krayola.

The Second Sentence of Everything I Read Is You: Mourning Sex, 2005–07 (installation 2007), the second piece in a projected series of five, combines Prina's musical interests with installation—areas of work the artist has kept separate during the last two and a half decades. "Conceived as a traveling spectacle—a mini-Broadway-musical-on-the-road or circus," the installation is a mobile, blue-carpeted listening lounge, its exhibition crates doubling as viewing benches padded with cushions covered in a thick coat of matching blue paint. An incomplete grid of eight speakers on one wall amplifies Prina's pop guitar textures, while a single separate and spotlighted speaker on another wall dramatically emphasizes the presence of the lonely, perhaps romantic vocal track: "The second sentence/Of everything I read is you/You're probably the first person to

get/Viewers to put part of a work/In their mouths and suck on it/Oral gratification." The lyrics are mouthed alone by Prina but are appropriated mostly from public testimonials by contributors—including Julie Ault and Tim Rollins—to a recent Felix Gonzalez-Torres monograph, whose muted blue cover reappears in the blue of Prina's installation. Also marked across the gallery wall is the message ". . . things Felix forgot to tell us. . . ."

Prina's monologue/dialogue refers to the tension between public and private recollections of artist Felix Gonzalez-Torres (1957–1996), whose piles of wrapped candies in gallery and museum contexts (probably alluded to in the lyrics above) were freely given to, and eaten by, viewers. Gonzalez-Torres's generous artistic approach also dispensed with art's characteristic commodity relations—systemic realities about which his romantic approach remains mute.

In his installation, Prina puts a frame around personal and public eulogies, but also around the relationship between artistic intentions and the afterlife of objects. This gap, this deferred reception, is marked with change and loss: "The carpeting in [this] traveling work," the artist notes, "is not replaced or steam cleaned but allowed to accrue social residue across its pastel surface; any shipping scars to the crates will [also] remain." Even the purest intentions fall away, the artist implies, and eventually, all that remains is a memory. And you can't put your arms around a memory. **T.A.**

The Second Sentence of Everything I Read Is You: The Queen Mary, 1979–2006 (detail). Synthetic polymer and synthetic polymer enamel on linen, synthetic polymer on plywood, synthetic polymer enamel on wall, nine Boston Acoustics DSi265 Speakers, Alesis ADAT-HD24 XR Digital Hard Disk Recorder, five Samson Servo 200 power amplifiers, Monster Cable Pro 3500 power conditioner, Duratran print on SignsByWeb SL light box, ETC Source 4 Jr. spotlight, and FLOR carpet, approximately 365 x 194 in. (927 x 493 cm). Collection of the artist

The Second Sentence of Everything I Read Is You: Mourning Sex, 2005–07 (installation view, Galerie Gisela Capitain, Cologne, 2007). Synthetic polymer and synthetic polymer enamel on linen, synthetic polymer on plywood, synthetic polymer enamel on wall, nine Boston Acoustics DSi265 Speakers, Alesis ADAT-HD24 XR Digital Hard Disk Recorder, five Samson Servo 200 power amplifiers, Duratran print on EFRA Lichtwerbung, ETC Source 4 Jr. spotlight, and FLOR carpet, approximately 489 x 240 in. (1,242 x 610 cm). Collection of the artist

ADAM PUTNAM

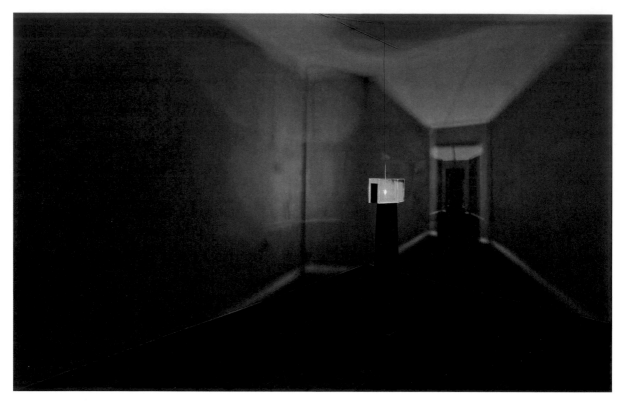

Green Hallway (Magic Lantern), 2007. Mixed media, dimensions variable. Astrup Fearnley Museet for Moderne Kunst, Oslo

Born 1973 in New York, New York; lives in New York, New York Adam Putnam's recent light installations explore the psychoperceptual dimensions of space with ingenuity and humor. *"Sundial" (Eclipse)* (2007) is a case in point. The sculpture consists of two obelisk-shaped forms, one of wood and the other a mirror, placed upright on the floor. Light from a hooded lamp placed a few feet away bounces off the mirror onto a wall, where its obelisk-shaped reflection falls directly on the shadow cast by the wooden figure. In this dramatic duel between light and dark neither side wins. "Shadow and light cancel each other out," observes the artist, who says he was "trying to make a shape completely disappear, an eclipsed image."

Putnam acknowledges that the obelisk may remind viewers of the Washington Monument in DC, but he is less concerned with politics than with the ineffable quality of space. This is evident in the *Magic Lantern* installations he has been producing since 2004, named after the protocinematic theatrical device that uses an oil lamp and painted slides to project images. In Putnam's versions, a low-wattage bulb is suspended inside a transparent boxlike container resting on a pedestal. The light passing through the structure's internal supports and sides limns a ghostly illusionistic architectural image on the walls. Pieces of opaque tape affixed to the container's surface cast shadows that appear as phantom doors and other architectural details. By installing

mirrors inside, as he does for his Biennial piece, *Green Hallway (Magic Lantern)* (2007), Putnam is able to multiply the illuminations, creating illusionistic architectural spaces on the surrounding walls. "These are small, virtual rooms, and you project yourself into them imagining yourself into the space," he says.

Earlier in his career, Putnam enacted Bruce Nauman-esque performances in which he strapped himself into a corner or contorted his large frame into a bookcase. "There's always been a weird, flat-footed play with the body becoming architecture and following that to its logical—either funny or perverse—conclusion," he says. He has made black-and-white self-portrait photographs in which he appears shirtless with a sneaker taped to his cheek, or on all fours wearing his pants on his head and arms. According to the artist, these grainy, amateurish pictures of absurd acts pay homage to the Conceptual art of the 1970s.

Increasingly, Putnam is allowing space itself to be the protagonist. For the video projection *The Way Out* (2005), he shot a model of a three-walled room, then removed the back wall and fit the diorama snugly around a computer screen on which he displayed the original video and reshot the setup, repeating the process to create an endless recession of rooms. With captivating artifice, Putnam's multidisciplinary inquiry into the imaging of space challenges the eye and teases the mind. **J.E.K.**

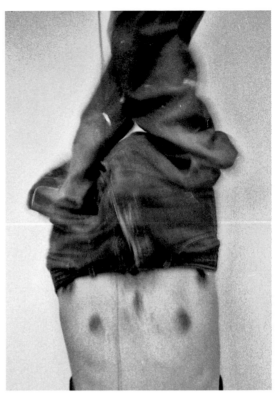

Untitled (Flying Buttress), 2007. Mixed media on paper, 28 x 22 in. (71.1 x 55.9 cm). Private collection

Untitled (5), 2007. Gelatin silver print, 14 x 11 in. (35.6 x 27.9 cm). Collection of the artist

Untitled (4), 2007. Gelatin silver print, 11 x 14 in. (27.9 x 35.6 cm). Collection of the artist

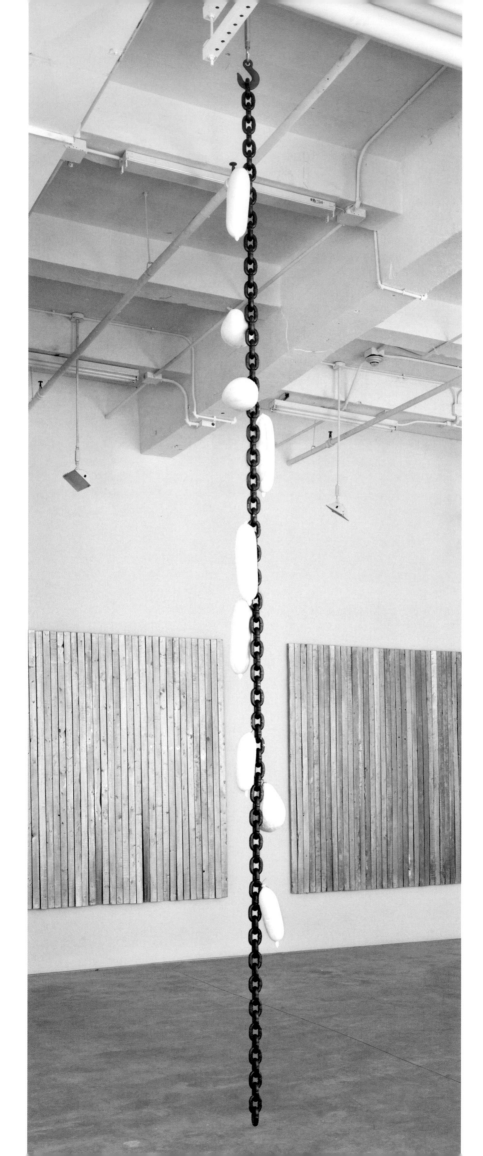

Installation view, *Bread & Balloons*, Harris Lieberman, New York, 2007

Born 1970 in Pasadena, California; lives in New York, New York Through photographs, sculptures, and installations, conceptual artist Michael Queenland examines the implications of faith and collectivity. His work centers on nonconforming figures from Henry David Thoreau to "Unabomber" Ted Kaczynski and groups including the Sabbathday Lake Shakers and the Seventh-day Adventists to rethink radical American belief systems, a subject of personal consequence for the artist. *Untitled (Derelict Cult Compound)* (2005) and the *Untitled (Radical since 1774)* series (2005) in particular are inspired by, as he recalls, "revisiting and reevaluating my own personal experience of going to Davidian meetings as a child with my father in Los Angeles and the experience of watching the Waco incident unfold on TV and in newspapers as an adult no longer tied to that community or any particular religion."

Much of Queenland's work, often composed of unadorned materials hewing to a reduced palette and deployed in sophisticated juxtapositions, treads a fine line, at once insisting upon sensible, material fact and the ineffable meaning that exceeds it. A visual pun on mundane and spiritual illumination, *Candle Piece* (2004) consists of a lit candle in a brass holder fitted with a superfluous extension cord plugged into the wall. *Standing Brooms until All or None Fall Over* (2002) offers, in his words, a kind of "impoverished magic," as a dozen found flat brooms alight, unsupported, on their bristles in a Minimalist-inspired grid, a clique of anthropomorphized apparitional figures that tumble down one by one during the course of exhibition.

Queenland employs chance by using animals as well, incorporating arachnids into *Trap* (2004) and cats in *Meant Every Other Way* (2007). In the former sculpture, a tabletop infrastructure of chopsticks buttresses cobwebs ensnaring Styrofoam peanuts. Like the broomsticks in his 2002 installation, they seem to hover magically in midair, but here Queenland references Puritan theologian Jonathan Edwards's fire-and-brimstone image of man as a spider dangling by a slender thread over the flames of damnation. Conviction and its stakes is a leitmotif for the artist, further emerging in *Bread & Balloons*, a 2007 solo show in New York whose title slyly refigures Juvenal's "bread and circuses." Operating from the position that we now experience not a surfeit but a dearth of fervor, Queenland admits that while violence often attends promise, impassioned thinking still trumps the false assurances of cultural and political palliatives. **S.H.**

opposite: *Abnormal Ladder*, 2007. Steel chain, plaster, wire, and wax, 168 x 12 x 12 in. (426.7 x 30.5 x 30.5 cm). Collection of the artist

The Grand Machine/THEAREOLA, 2002 (installation views, MUMOK/Museum Moderner Kunst Stiftung Ludwig Wien, Vienna, 2002). Mixed media, dimensions variable. Private collection

Born 1965 in Newcastle, California; died 2006 in Los Angeles, California Jason Rhoades's belief in the relentless revision of form and the continuity of ideas is epitomized by his series of exhibitions collectively known as the *Black Pussy* project. His often interactive, sculptural installations require viewers to navigate through and around vast collections of objects configured in disorienting mazes or solid masses. While at first glance the large-scale works can appear arbitrarily installed, the texts, photographic albums, and material lists often included in the installations as documentation of his voracious artmaking processes reveal a precise methodology and, albeit quirky, logic. Visually oversaturated with bright, psychedelic color, his decadent, often sexualized, displays challenge definitions of vulgarity, at the same time confronting the excesses of contemporary consumer culture. Rhoades's constructions are activated by the invented histories dictated by the artist, though his works are also subject to chance inherent in the unpredictable behavior of participant-viewers.

The Black Pussy . . . and the Pagan Idol Workshop (2005) at London's Hauser & Wirth, and *Black Pussy* (2006), first at Rhoades's Los Angeles studio and then New York's David Zwirner, constitute the closing chapter in a trilogy of work featuring, among myriad objects, neon "pussy word" signs, as part of the artist's ongoing creation of a cross-cultural compendium of synonyms for female genitalia. The first work in the series, *Meccatuna* (2003) at David Zwirner, thematically introduced Rhoades's baroque investigation into the history of Islam as a mode of questioning ideas of idolatry within a materialist, celebrity-obsessed American culture. In lieu of his original plan to send a live tuna on a pilgrimage to Mecca, Rhoades presented canned tuna with documentation of its presence in the holy city alongside a scaled Lego replica of the Ka'bah, fiberglass donkeys, two hundred neon pussy word signs, and his self-manufactured building material, PeaRoeFoam. This substance, made of light green dried peas, "virgin" Styrofoam beads, and bright red salmon eggs bonded in white adhesive, was packaged in replicated 1970s Ivory Snow soapboxes bearing an advertising image of the then soon-to-be porn star Marilyn Chambers, giving the invented material a feminine connotation at once maternal and sexualized.

Rhoades's orgiastic, elaborately interwoven exhibitions obscure any clear artist intention by overloading the viewer with information and multivalent imagery. Simultaneously, the sheer volume of objects displayed creates repetition through overlapped metaphors and constructs an abstract statement grander than one installation could achieve. These works purposely avoid finite conclusions, instead offering circuitous maps of the artist's probing preoccupation with faith, sexuality, consumerism, the creative process, the conditions under which art is possible, and the role of the artist in transgressing all boundaries. Rhoades's installations serve as frenetic, oblique, yet fiercely eloquent visual evidence of his thoughts. **T.D.**

RY ROCKLEN

Born 1978 in Los Angeles, California; lives in Los Angeles, California Ry Rocklen's sculptures paradoxically reflect at once a respect for the Duchampian sculptural tradition and an anarchic rebellion against art historical constraints. Collecting cast-off objects from the streets, dumps, or thrift stores, he doctors and assembles them into readymade sculptures charged with an eccentric delicacy that gives them a second, more "poetic" life. Rocklen strategically capitalizes on the viewer's mental and emotional associations, as Robert Rauschenberg did for his Combines, by selecting objects as much for their cultural connotations as their form. At times employing a wry sense of humor to balance his stringent editing techniques, Rocklen treats manufactured items, like toys, food packaging, furniture remnants, and construction materials, with a spontaneity he traces back to his youth and the development of the creative process through pretend play. This sense of play is reenacted in Rocklen's process-based studio practice, as he sifts through and rearranges society's leftovers.

Visual puns dominated Rocklen's earlier work, transforming his exhibitions into nonverbal comedic performances activated by the personas meticulously infused into each of his sculptures. *10,000 Year Wait* (2005) features a chair whose legs levitate "magically" inside four wineglasses (the punch line is that the chair is crafted of Styrofoam, floating in the water-filled glasses). *The Harborer* (2005), a pair of crutches entangled in a black fishing net and shoved into yellow rubber boots filled with cast-resin "ice," evokes the story of a sea captain whose adventures at sea went sorely awry. In *Juice Box Living* (2005), eighteen juice boxes arranged on the gallery floor spew rainbow "juice" arcs of painted wire. While narratives unfold like bizarre one-liners, Rocklen's sculptures also deal ingeniously with formal issues such as weight, mass, and scale, often pitting giant against minuscule, or heavy against feather-light, recalling Tom Friedman's Postminimalist works in which forms are determined by their materials.

The recent works in *Just Us*, Rocklen's 2007 exhibition at Los Angeles's Black Dragon Society, display a more refined sensitivity to his objects' unique features that reveals his increasing interest in objects as pure form and in releasing what he calls their "soul residue." A baggie tied to a stick propped against a wall as if abandoned by a hobo, *The Surrenderer* (2007) prompts a story about the mystic serendipity required to realize the piece. In *Treaty* (2007), a Christmas tree has been "mummified" in bright white two-part epoxy putty, accentuating a dainty green string tied around the trunk. Hanging from a cord encircling the gallery, *Health Medallion* (2007) dangles like a yo-yo or hypnotizing charm over the doorjamb. Each piece's meditative simplicity contributes to an ambience simultaneously serene and absurd. Rocklen's move toward creating sculptures in which "nothing becomes what it isn't" distills the essence of his materials, resulting in works that, while less and less figurative, become ever more true to the objects he reveres. **T.D.**

Treaty, 2007. Tree, stretch tie, and two-part epoxy putty, 40 x 65 x 36½ in. (101.6 x 165.1 x 92.7 cm). Private collection

Rollin' on 23's, 2007. Glasses, pressure-treated wood, concrete, and water, 23 x 144 x 23 in. (58.4 x 365.8 x 58.4 cm). Private collection

Where I Need the Most Cheering Up, 2005. Blinking neon sign mounted in plexiglass vitrine, 20 x 40¾ x 3 in. (50.8 x 103.5 x 7.6 cm). Collection of the artist

Born 1975 in Miami, Florida; lives in Miami, Florida
Pointedly subverting the concept of an artist's retrospective, Bert Rodriguez's 2000 debut solo exhibition, *Bert Rodriguez: A Pre-Career Retrospective* at the Miami-Dade Community College's Centre Gallery, offered childhood drawings, video, and objects in a portrait of a developing artist. In the tradition of Joseph Beuys, Rodriguez's conceptual practice relies heavily on process and performance; here he questioned relationships between art, the artist, the viewer, and the market. *Childhood Companion* (1993), a toilet brush presented on a pedestal, is accompanied by a caption indicating: "This is Rodriguez's first and only unadulterated ready-made object." Referencing the subject of Marcel Duchamp's *Fountain* (1917), Rodriguez pays homage to the revolutionary readymade that initiated appropriation art while highlighting the irony that Duchamp's signed urinal is now a valuable object, coveted by collectors.

The artist performed *A Bedtime Story Read by Bert Rodriguez* during 2006 Art Basel Miami Beach. One evening, under a large advertising billboard announcing the event, he installed a simple lamp and armchair on the flatbed of a borrowed pickup and read his childhood book *Five Chinese Brothers*. Rodriguez recalls that his parents did not often read to him as a child, although he loved books. His narrative allowed children in his hometown to fall asleep to the whispers of his story, and acquired added poignancy in drawing attention to the importance of a childhood ritual not part of his own memory. Executed amid the opulence of Art Basel, Rodriguez's bedtime tale became all the more compelling set against the art fair's glitz and consumerism.

For his 2007 *Advertising Works!* Rodriguez orchestrated the design, installation, and sale of approximately thirty-five advertisements at Fredric Snitzer Gallery in Miami. By receiving compensation for these billboards—inviting the commercial world of advertising into the gallery—he drastically altered the dynamic of an exhibition space typically used to showcase artists. He signed these banners and sold them as his own art, making money on the front and back ends of the project and adding an additional layer of complication to the work.

Rodriguez strives to alleviate the concerns of Armory passersby for the 2008 Whitney Biennial, conducting free therapeutic sessions inside a large white cube installed in the middle of an ornate room and assigning "patients" artwork projects as remedies for their problems. A muffled version of these discussions audible outside his "office" suggests a ghostlike presence that reflects and intensifies the Armory's haunting ambience. Operating largely outside traditional commercial art practices, and with shrewd yet playful wit, Rodriguez's multifarious practice educates, amuses, perplexes, and enriches his audience while quietly commenting on the contemporary art world. **S.G.**

The End, 2001– (installation view, Bass Museum of Art, Miami Beach, 2001). Vinyl lettering on elevator doors, CD and player with remote, five speakers, and light with motion sensor, dimensions variable. Collection of the artist

MARINA ROSENFELD

Still from *WHITE LINES*, 2005. Super 8 film transferred to video with digital animation, color, silent; 30 min.

Born 1968 in New York, New York; lives in New York, New York Marina Rosenfeld's composed musical performances deconstruct the notion that visual and sonic artistic practices are separate by placing equal conceptual importance on every aspect of her orchestrated situations. Like other experimental artist-musicians, including Christian Marclay, Yoko Ono, and Laurie Anderson, Rosenfeld's avant-garde work challenges accepted musical norms. Rosenfeld's concerns lie particularly in a clean sensory aesthetic that deemphasizes attention on the individual to highlight the dynamic relationship between the performers, orchestra, audience, and the music itself. This methodical approach to live music performance is integral to her efforts to define a sound that encompasses, but is not limited to, femininity.

Rosenfeld's sonic palette varies widely, though her interest in music's potential to level social inequalities underlies her compositional and visual arrangements. Created for the 2002 Whitney Biennial, *Delusional Situation* (2002) featured a multispeaker installation of a recording based on the artist's live performance as a turntablist spinning "dub plates"—handmade acetate records—of prior live performances, metaphorically recycling sound. An artist who creates, directs, and participates in her experimental orchestras, Rosenfeld also recruits untrained musicians as a way to multiply improvisational elements in her practice and to highlight the social interaction inherent to music-making. A row of seventeen women used nail polish bottles to play floor-bound electric guitars in *sheer frost orchestra* (1994–), recalling early punk bands the Slits and Ut, whose experimental use of instruments became feminist statements. For the 2005 Tate Modern performance of *emotional orchestra* (2003), female participants costumed in street clothes accented by single silver sleeves bowed a variety of stringed instruments; their actions were cued by a form of graphic notation realized by Rosenfeld as an animation in which a pair of large white stripes of fluctuating width and opacity bisect Super 8 footage of pastoral scenes.

For *Teenage Lontano* (2008), her sound installation and performance for the 2008 Whitney Biennial, Rosenfeld has recorded a choir of twenty teenagers "covering" György Ligeti's modernist piece *Lontano* (1967), to be heard through mp3 players and headphones. By juxtaposing a high modern composition and the teen-vocal sound associated with pop music, Rosenfeld argues that variant musical languages share common aural territory. To make the initial recording, each singer accompanied an individualized audio score, creating complex tone clusters that Rosenfeld has renegotiated into a larger composition of pop song–length segments. Certain sections are rich with choral harmony, while others dissipate into abstract, isolated sound fragments punctuated by cello, percussion, bass, and electronics reminiscent of early modern analog synthesizer sounds. Listening to *Teenage Lontano* evokes space-age, multilayered imagery that counterbalances the austere "stage" dominated by twenty headphones placed on twenty aligned microphone stands. As in Rosenfeld's other installations, here individual elements, though radically different or in apparent opposition, are forged into a transformative encounter that urges its audience to use as many senses as possible as they experience it. **T.D.**

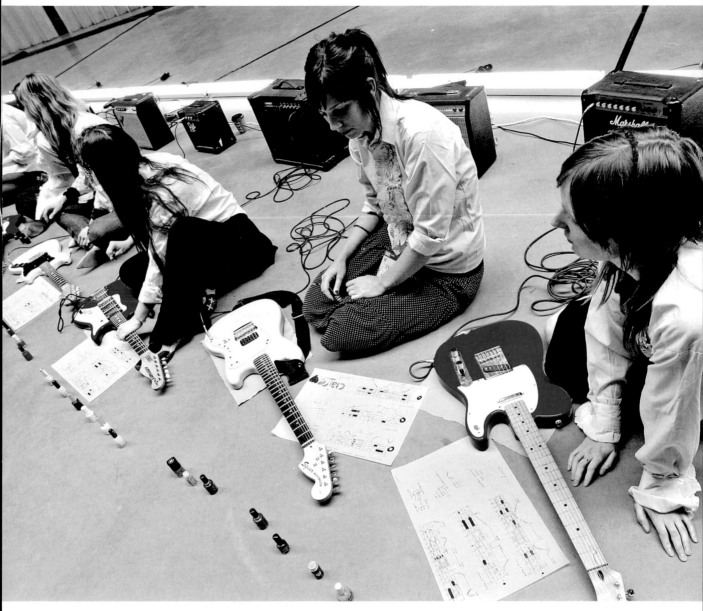

sheer frost orchestra, 1994– . Performance, Tate Modern, London, May 28, 2006

emotional orchestra, 2003. Performance, Deitch Projects off-site, New York, December 3, 2003

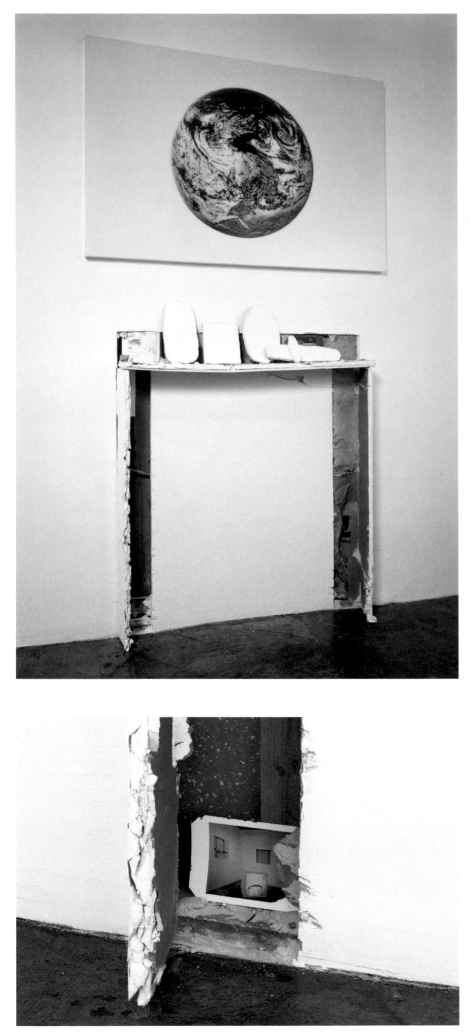

top: *Mantle*, 2007. Incised drywall, mounted and framed inkjet print, and monochrome dye diffusion transfer print (Polaroid), dimensions variable. Collection of the artist
bottom: *Mantle*, 2007 (detail)

214

Installation view, *Nothin Fuckin Matters*, Cherry and Martin, Los Angeles, 2007; from left: *White Goddess*, 2007; *Sad Sack*, 2007; *Gran-Abertura #2*, 2007; *White Goddess 3 Wall*, 2007

Born 1975 in Chicago, Illinois; lives in Los Angeles, California Amanda Ross-Ho gathers together apparently mismatched media, including found objects, photographs, drawings, sculptures, paintings, and video clips, into installations driven by her urge to imbue these groupings of impersonal materials with individual identities. At the same time, the assemblages reflect sociopolitical and formal concerns that range from renegotiating definitions of high art versus craft to exploring the dimensional tension between sculpture and photography. Ross-Ho's installations are typically deployed around slabs of drywall used either as free-standing partitions or raw sculptural elements leaning against the gallery walls. Against these architectural stages and backdrops, her collages and found objects—arranged according to various organizing principles—become contextual clues that reveal their materiality both literally, as accumulated detritus, and figuratively, as mass translated through the language of sculpture.

Inquisitive viewers can discover hidden portions of the work, placed behind or inside her more evident structures. While these groupings bear resemblance to Scatter art assemblages, any sense of clutter is precluded by the clean white Sheetrock walls that function as sorting apparatuses or sculptural "file folders." In the installation *gran-abertura* (2006) at Western Exhibitions in Chicago, a tripartite wall concealed one such collection: Ross-Ho stacked photographic collages of decorative household objects, spray-painted wreaths and baskets, and wineglasses along with items utilized in installation (a wooden palette, a dirty paint bucket), organizing the components by subject matter while obliterating boundaries between two and three dimen-sions. The imposing drywall was pierced by holes carved in a doily pattern (a recurring motif in her work), allowing light to filter in and half illuminate the objects.

Ross-Ho's use of positive and negative space recalls the work of Gordon Matta-Clark or Rachel Whiteread, though Ross-Ho's emphasis on collaged visual imagery obviates the temptation to discuss her work in purely sculptural terms. She also operates within the tradition of Conceptual artists, such as Matt Mullican, who invent idiosyncratic lexicons from existing symbols. In her 2007 exhibition *Nothin Fuckin Matters* at Los Angeles's Cherry and Martin gallery, Ross-Ho complicated her use of positive/negative and inside/outside space by using scale to point out how meaning is determined by content rather than by size. *Sad Sack* (2007), a gigantic drop-cloth tote bag slouched against the wall like a Claes Oldenburg soft sculpture, is filled with remnants of previous works as a grossly enlarged monument to artmaking. The faux fireplace *Mantle* (2007), carved roughly from drywall and decorated with drywall left-overs from other pieces, sits under a photograph of Earth that amplifies the sculptural object instead of the planet. Unifying the installation were cut-canvas macramé paintings mounted on drywall fragments and another knotwork pattern incised into drywall, comparing labor practices between Ross-Ho's tracings and paintings and the textiles they replicate.

Ross-Ho invents puzzles out of non sequiturs to seek congruence in seemingly incongruous situations, whether visual or spatial. Her work inhabits those interstitial spaces between understanding and confusion, adding mysterious allure to her installations' overall effect. **T.D.**

MIKA ROTTENBERG

Born 1976 in Buenos Aires, Argentina; lives in New York, New York Video installation artist Mika Rottenberg envisions the female body as a microcosm of larger societal issues such as labor and class inequities. In her short films, women cast for their notable physical features and talents perform perfunctory factory-line duties, manufacturing inane items worth less than the labor required to make them. Her homemade machinery and decor are functional but crudely constructed. These contraptions, operating by pedal, conveyor belt, paddle, rubber band, or string, are reminiscent of Peter Fischli and David Weiss's kinetic props, though the human interaction in her works adds a carnivalesque element to Rottenberg's environments, the physical comedy implicit in her narratives recalling Eleanor Antin's filmed performances. The bright colors of Rottenberg's self-contained sets don't disguise the close quarters in which her characters work or mitigate the sense of claustrophobia induced by a dead-end job. A blue-collar work ethic is conjured through the women's uniforms, ranging from diner-waitress dresses to jogging suits. Her cast often use several body parts at once, reminding the viewer of the feminine capacity for multitasking while it suggests an ironic futility in her sweatshop-like situations.

Three previous videos established Rottenberg's unique narrative approach, in which action is compressed into layers of illogical activity. In *Tropical Breeze* (2004), a woman in the back of a truck chews gum, wraps it in a tissue picked from a pile with her toes, and sends it on a clothesline to the profusely sweating driver, who dabs each tissue with perspiration to ferry it back for packaging and sale as a "moist tissue wipe." Rottenberg's installations often physically echo her videos: *Tropical Breeze* was screened inside a crate-like box mimicking a big rig's trailer. *Mary's Cherries* (2005) showcases a trio of obese ladies pedaling bikes who, through a magical process of clay kneading and fingernail clipping, transform acrylic fingernails into maraschino cherries. In *Dough* (2006), one woman smells flowers to provoke hay-fever tears while another mashes a foot-powered bellows into foul-scented air that wafts onto dough, which rises as the moisture and air hit it. Dripping beads of sweat, women's grunting, and booming machinery dominate the audio, while close-ups of the women's bodies and faces highlight their resignation to an abstruse cause.

Rottenberg's newest film, *Cheese* (2007), conflates farm-girl imagery with the fairy tale "Rapunzel" into a story loosely based on the Sutherland Sisters, renowned for their extremely long hair. Floating through a pastoral yet mazelike setting of raw wooden debris cobbled together into a benign shantytown, six longhaired women in flowing white nightgowns "milk" their locks and the goats they live with to generate cheese. Shots of animals crowded in pens and the sisters' bunk bed–cluttered room visually compare the women to their ruminant allies. As nurturing caretakers, these women represent maternal aspects of Mother Nature. Here Rottenberg investigates feminine magic, the ability to "grow things out of the body" as she says, as the ultimate, wondrous physical mystery. **T.D.**

Stills from *Cheese*, 2007. Digital video, color, sound; approximately 12 min. Collection of the artist

HEATHER ROWE

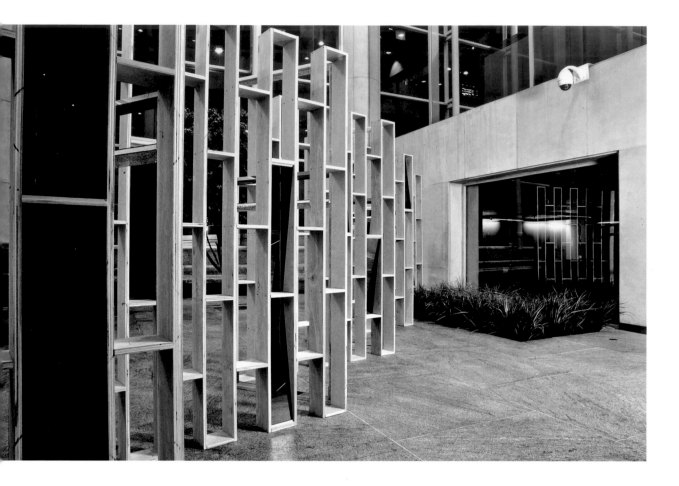

Born 1970 in New Haven, Connecticut; lives in New York, New York One might initially mistake Heather Rowe's *Entrance (for some sites in dispute)* (2007) for an unfinished part of the room in which it is installed: the series of plywood posts, manufacturer's marks visible, could be faced in plasterboard and serve as the foundation or support for a wall. But discordant details soon emerge: shards of mirror wedged between Sheetrock painted bright crimson, fragments of white molding nestled into the lower ends of the wooden frames. Straddling the fault lines of sculpture, architecture, and installation, Rowe's work fails to slot comfortably into any one of these categories and finds its force instead in the friction between media and the spaces they occupy.

Rowe's materials are the raw supplies and castoffs of architecture—drywall, 2x4 beams, wood, and metal—which she combines with more decorative elements including ornamental frames, expanses of shag carpet, mirrors, wallpaper, and molding. Her forms evoke walls, windows, doors, and passageways, their emphasis on interstitial space traceable to 1960s and 1970s

precedents such as Bruce Nauman's corridor installations, Gordon Matta-Clark's building cuts, and Robert Smithson's mirror displacements. Yet the animating tension in Rowe's work, tugging between public and private, is resolutely contemporary: negotiating one of her sculptures, in part as a result of its mirrored components, necessitates not only adjusting one's sense of surround but also one's awareness of others.

This awareness is not always comfortable; Rowe's seemingly intuitive gift for balance and proportion is punctuated occasionally by hints of menace. *The Stationmaster's Wife* (2005) comprises a found metal door, a one-way mirror, a set of windowlike casings, silver insulation, and, jutting out from the oddly exquisite arrangement, the fanciful frame and legs of a coffee table. From the top of the structure, however, hang two blades of mirrored glass. Their sharp points, like the eye-level shard in *Green Desert* (2006) and the cragged mirror edges in various of Rowe's sculptures, complicate the work's formal harmony and extend a subtle, yet nagging, proposition: that the impulse to turn the inside outside is always accompanied by a degree of risk. **L.T.**

Screen (for the rooms behind), 2007 (installation view, Whitney Museum of American Art at Altria, New York, 2007). Wood, mirror, linoleum tiles, ceiling tiles, metal studs, drywall, grass, and artificial grass, approximately 96 x 420 x 50 in. (244 x 1,067 x 127 cm). Collection of the artist

Green Desert, 2006. Wooden floorboards, glass, mirrors, drywall, found frames, and shag carpet, 67 x 248 x 88 in. (170.2 x 629.9 x 223.5 cm). Collection of the artist

EDUARDO SARABIA

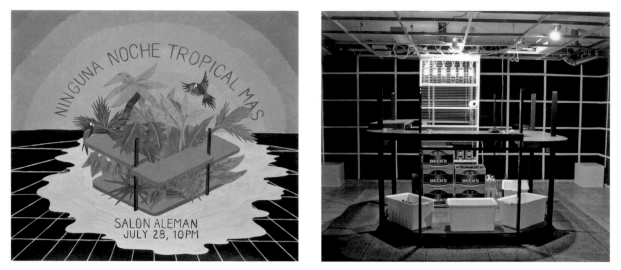

left: *Ninguna Noche Tropical Mas*, 2007. Synthetic polymer on paper, 16½ x 19 in. (41.9 x 48.3 cm). Collection of the artist
right: Installation view, *Salon Aleman*, unitednationsplaza, Berlin, 2006–08

Born 1976 in Los Angeles, California; lives in Los Angeles, California, Guadalajara, Mexico, and Berlin, Germany As the creator of fake evidence for his staged, semifictional events, Eduardo Sarabia places himself within a tradition of contemporary artists who mine culture for their performance-based satire. In the postmodern, mixed-media mode of Cameron Jamie, Sarabia invents scenarios that he participates in and creates documentation for, commemorating the event's unfolding. Handcrafted ceramic objects, drawings, paintings, photographs, and sculptures transform the exhibition space into a site for storytelling where viewers must suspend disbelief to enter the artist's fantastic, romanticized realm. These theatrical situations revolve around Sarabia's Latino heritage, which he both honors and mocks through his investigation of Mexican cultural clichés about drug smuggling, banditry, and the import/export of tawdry contraband.

Sarabia's love of Mexican folklore is implicit in the creation of his own personalized mythologies. At New York's I-20 Gallery in 2003, he presented documentation from a real-life expedition he launched outside Mazatlán to hunt for Pancho Villa's gold, following in his grandfather's footsteps. In a 2006 show at I-20 Gallery, Sarabia further pushed his interest in evidence and its exhibition by removing the performative aspect of his project, leaving only the materials confiscated at the fictional bust of an international ceramics smuggling ring. A large chromogenic print, *Puerto Vallarta* (2004), reveals Sarabia dressed as a smuggler deboarding a private plane with his girlfriend, pet tiger, and crates that, innocuously labeled "avocados," "karaoke system," and "bananas," imply a less innocent cargo. An installation titled *A Thin Line between Love and Hate* (2005) juxtaposed shipping boxes screenprinted with benign phrases and pictures describing the produce ostensibly inside ("Maizena," "Producto de Colima") and the containers' "real" contents—blue-and-white Chinese-styled vases bearing imagery of pinup girls, marijuana leaves, rifles, and skulls. Replacing site-specific engagement, the installation implied that reality is determined by its physical artifacts.

Through the fall of 2006 and the following spring and summer, Sarabia engaged an entirely different "reality" by hosting *Salon Aleman*, a sporadically open bar at local seminar/residency program unitednationsplaza in Berlin. This series of parties, at which patrons drank the artist's Sarabia tequila, played on the stereotype of Latinos as cantina dwellers while reminding attendees that third-world poverty, exemplified by rural agave farming and the tequila it produces, is exacerbated by the first-world market economy. By encouraging an "unproductive" endeavor as he promoted his own product, he also more eloquently questioned art's market value. Sarabia's narrative concepts, defined by the tangible and intangible, contain a hearty dose of humor and absurdity that both lighten his political messages and reinforce the importance of understanding the physical and human consequences of economic forces. **T.D.**

opposite top: *Stolen Vase 8*, 2006. Hand-painted ceramic vase and synthetic polymer on wood, dimensions variable. Collection of the artist
opposite bottom: *Babylon Bar*, 2006. Handmade ceramic tiles and rosewood, 48 x 48 x 48 in. (121.9 x 121.9 x 121.9 cm). Collection of the artist

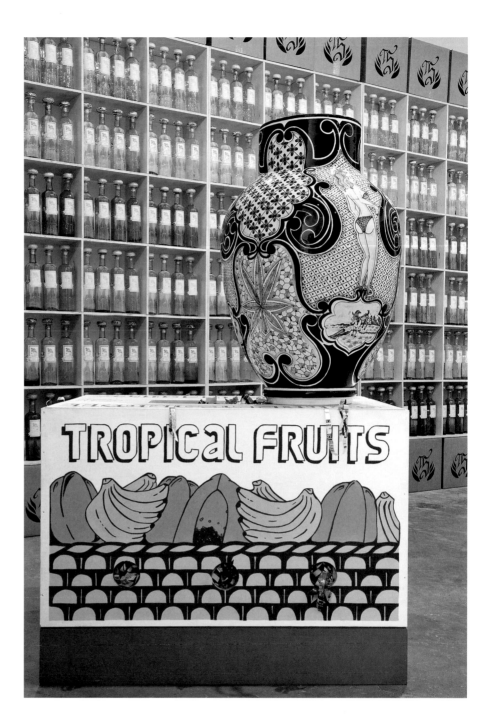

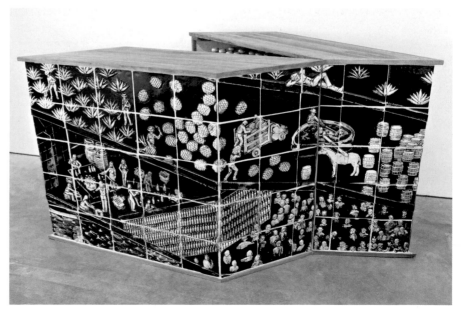

MELANIE SCHIFF

Born 1977 in Chicago, Illinois; lives in Chicago, Illinois Melanie Schiff's photographs utilize formal elements of two of the medium's most ubiquitous types, the still life and the self-portrait. The artist's keen feel for mise-en-scène, her eye for the low-key lyricism of the everyday, and her easy sense of humor imbue the quotidian subject matter she favors with uncommon lightness and poignancy.

Schiff was strongly influenced by feminist performance artist Carolee Schneemann, and her vivid, bodily mode of self-portraiture frequently bears the traces of kindred spirits like Ana Mendieta and Valie Export—in *Mud Reclining* (2006), the artist depicts herself as a muck-covered odalisque stretching languorously in a tropical landscape, evoking both the former's *Siluetas* and the latter's *Body Configurations* series—or Hannah Wilke, whose body appliqués are jokily reconceived as a pair of raspberry pasties in *boobberry* (2003). Schiff's still lifes exhibit a similar lightness of touch, conjuring the incidental poetry of the twenty-something apartment share or the backyard summer barbecue: the play of light through a stack of CD jewel boxes (*Untitled (cases)*, 2005); a sunset sinking behind a spent bottle of Jack Daniel's (*Emergency*, 2006); a Technicolor arc hovering

in a geyser of playfully spit water (*Rainbow*, 2006). The apparently casual composition and laid-back ambience of these carefully constructed images sometimes suggest the lo-fi aesthetic milieu of shoe-gazer bands, and the connection between the artist's deft photographic *sprezzatura* and a certain dressed-down, alt-rock pensiveness is a conscious element of Schiff's approach, both in terms of individual images and in the strategic way she orchestrates resonant relationships between them in the context of her installations. "You hear a sad song and you feel like it's your experience," she has observed, "and I wanted to make art like that, to make photos like that."

In her recent works, Schiff has both extended and added nuance to her investigations of photographic states of mind. Images like *Studio* of 2006—shot in a theatrically disheveled, light-filled apartment above a well-known recording studio—explore the ineffable ambiences of inspiration and creation. Meanwhile, in *Water Birth* (2007), Schiff presents a slyly disjunctive domestic setting—a huge house plant crowds a bathtub, bathed in the glow from a slanted skylight—nicely representative of her attempts to strike resonant notes with simple tools, to produce her own idiosyncratic brand of magical photographic realism. **J.K.**

Untitled (prism), 2005. Digital chromogenic print, 30¾ x 35 in. (78.1 x 88.9 cm). Collection of the artist
opposite: *Untitled (bottles)*, 2005. Digital chromogenic print, 45 x 35 in. (114.3 x 88.9 cm). Collection of the artist

AMIE SIEGEL

Born 1974 in Chicago, Illinois; lives in New York, New York, and Berlin, Germany Amie Siegel's conceptual films and multichannel installations have been described as "uncanny reflections on absence, historical disorientation, and nostalgia." Recent works examine her adoptive country Germany, and its complex history provides rich material for Siegel's investigation of issues concerning cultural memory, identity, and the cinematic portrayal of place. *Berlin Remake* (2005) is a double projection that juxtaposes scenes from East German state films with Siegel's refilming of the found footage, replicating the original camera movements in the same locations—as Siegel describes it, "performing" the earlier film scenes as if they were musical scores. The collision of past and present blurs fiction and documentary to question assumptions about the fixity of time and place.

Rather than incorporating the rapid cutting typical of today's commercial movies, Siegel composes with long segments that require the viewer to make broad associative connections. "I have been at war with montage as cinema's main mode of expression and have been in search of other more accumulative and architectural modes of structuring film," she says. The technique is particularly absorbing in her 2003 feature-length film *Empathy*, in which a character's loss of identity is evoked through disparate episodes. Interviews with therapists about the role of voyeurism and desire in their practice accompany staged therapy sessions. The therapists also appear in real-life social situations with a patient and the filmmaker, further breaking down the boundaries between private and public life, filmmaking and psychoanalysis. A parodic section of the film about Freud's influence on modernist architecture and design adds a theoretical layer, exemplifying Siegel's belief that "abstract or philosophical ideas [should] have commerce with the quotidian."

Siegel studied American avant-garde film, but she is drawn to the "conceptual, Marxist, and politicized" mode of European artists including Jean-Luc Godard, Alexander Kluge, Chantal Akerman, and Hans Haacke, as well as Americans such as Yvonne Rainer and Susan Hiller. Siegel's affinity with their work is evident in her feature-length film *ЯGG/DDR* (2008). Like *Empathy*, the film is a mosaic of interviews and incidents that gradually connect, allowing issues of history, state control, personal identity, and memory to emerge. A man walking across streets and fields as if on a tightrope is a recurring motif—an apt metaphor for the East-West divide. The camera moves through derelict East German buildings and records a man throwing Stasi-style electronic equipment from a moving truck; East German emulators of American Indian culture explain that their hobby began as a clandestine cry for freedom from Soviet oppression. The sociocultural theme is complicated, however, by a former East German mother who reminisces about her family's more comfortable life before reunification. The ruminating psychological and intellectual content of Siegel's works posits that everything is subject to shifting interpretation. **J.E.K.**

Stills from *ЯGG/DDR*, 2008. Super 16 film and high-definition video transferred to high-definition video, color, sound; running time undetermined. Collection of the artist

The Day before Yesterday and the Day after Tomorrow, 2007. Drywall, house paint, and plaster, dimensions variable. Collection of the artist

Born 1962 in Philadelphia, Pennsylvania; lives in New York, New York Lisa Sigal's practice lies at the intersection of painting, sculpture, installation, and architecture; at once integral and site-dependent, her painted constructions insinuate themselves into the physical and theoretical fabric of the built environment. The complex relationship between the illusionistic spaces of painting and the physical presence of sculpture stands at the core of her work.

The loss of a long-time studio in 2003 was a signal event in her work's evolution toward a more ambiguous physicality. "When I was evicted," she wrote recently, "I dismantled the walls and took them with me. I brought my sheetrock walls, painted with images of an urban landscape, and leaned them against a sheetrock wall that had been built in a gallery. . . . A dismantled wall with a painting on it leaned against a sheetrock surface that I was painting: where was the line between illusion and material?" In Sigal's work this line is always strategically indeterminate. In pieces like *Ramshackle*, executed at Artists Space in New York in 2003, or *On the Rooftop*, Sigal's contribution to the Brooklyn Museum's 2004 *Open House* exhibition, her carefully orchestrated interventions appear to be simultaneously coalescing and coming apart at the seams—bits of Sheetrock, featuring painted passages that both suggest intentional representational imagery and mimic casual traces of construction activity, lean against, jut out from, and pile up in front of the existing wall.

This tension between chance and control, between structure and chaos, is continued in Sigal's recent works. Her ambitious *A House of Many Mansions*, created at the Aldrich Contemporary Art Museum in Ridgefield, Connecticut, in 2005, features a painted silhouette of a large estate home on which she created flowing sequences of painted drywall and plywood like something from a shantytown, disrupting both the formal space of the underlying rendering and the notion of grand comfort that it conveyed. Her newest pieces, which incorporate both appropriated and fabricated wallpaper, as well as various found notes, photographs, and other objects, are descended from a series of what Sigal calls *Tent Paintings*—folded Sheetrock panels that similarly recall marginal forms of shelter. In these latest pieces, the wallpaper allows for further freedom and refinement in the artist's forms, as well as increasingly rich admixtures of interior and exterior, public and private, the social and the domestic. **J.K.**

A House of Many Mansions, 2005 (installation view, The Aldrich Contemporary Art Museum, Ridgefield, Connecticut, 2005–06). Drywall, house paint, cardboard, and adhesive, dimensions variable. Collection of the artist

GRETCHEN SKOGERSON

Born 1970 in Teaneck, New Jersey; lives in New York, New York Neatly centered in a wide-screen frame, silent against the ambient drone of passing traffic, a pale rectangle of light hangs suspended in darkness. Four long fluorescent lightbulbs horizontally stacked at a slight diagonal pulse with erratic, hypnotic rhythm; a fifth has gone out, disrupting the symmetry. Next, a single bulb appears, positioned at the same angle, and a sudden swell of primitive dance beats rises on the soundtrack, quickly dispelled by the barking of a dog. More fluorescent lights follow, in varying arrangements and states of disrepair—these are the opening images of *DRIVE THRU* (2006).

If the new, almost 20-minute video by Gretchen Skogerson suggests a Dan Flavin sculpture gone to seed, the title she gives to her ongoing project of experimental shorts, *The American Disaster Series*, evokes the *Death and Disaster* paintings of another sixties icon, Andy Warhol. While the nature of the calamity in *DRIVE THRU* is never specified, more than pretty lights come into view as the artist widens the early, abstract perspective of her shots. Fragments of words enter the frame, collaged alongside the fluorescent tubes: "LA," "EN," "Ra Jewelers," "BIKES." The work is "a landscape of incomplete signs," as Skogerson has described it, in a very literal

sense, documenting bits and pieces of signage from strip malls, gas stations, fast-food restaurants, and small businesses. Pulling back her perspective even farther, the tip of a palm tree sways against the night sky, cars zip by on nocturnal errands, and ghostly human figures emerge and retreat into the shadows. The soundtrack, meanwhile, continues its peculiar mix of natural and manufactured noises, unifying the images and strengthening the sense that a specific geographic region—desolate, urban, working class, temperate—is being contemplated.

Skogerson's "talking mirror" installation *PS* (2005) anticipates the reflective, circumspect nature of this later work: beckoned by an electronic voice whispering "psst," viewers are invited to close proximity with their own reflection, upon which the mirror discloses a secret. *DRIVE THRU* is likewise predicated on a reticent disclosure, albeit one revealed by the gradual widening of perspective: the video comprises images captured on the tattered streets of Miami in the wake of Hurricane Ivan in 2004. Without identifying this source material, *DRIVE THRU* examines the aesthetic paradoxes of disaster in terms at once local and universal, specific and abstract, finding structure within ruin, Minimalism in the mundane, elegance in the shattered, and light in the dark. **N.L.**

Stills from *DRIVE THRU*, 2006. High-definition video, color, sound; 19:40 min. Collection of the artist

Stills from *Portal Excursion*, 2005–07. Digital video, color, sound; 10:05 min. Collection of the artist

Class Portrait, Spring 2003. Chromogenic print, 13 x 10 in. (33 x 25.4 cm). Collection of the artist

Class Portrait, Spring 2002. Chromogenic print, 13 x 10 in. (33 x 25.4 cm). Collection of the artist

Born 1951 in Chicago, Illinois; lives in Austin, Texas, and New York, New York Performance and video/installation artist Michael Smith inhabits his alter ego, Mike, in comedic portrayals of a man struggling to succeed in a technologically sophisticated world. Live or on-screen, Mike is a nerdy underdog whose sense of isolation translates into satirical physical comedy reminiscent of filmmakers Jacques Tati and Buster Keaton, while his conveyed interior mental space pays homage to playwright Richard Foreman. Smith's approach to illustrating Mike's peculiar worldview, however, was developed in dialogue with burgeoning 1970s and 1980s performance artists such as Mike Kelley and stand-up comedians like Andy Kaufman.

Though embodying a character of such fundamental blandness, Smith's performances and videos are lively, humorous, and brief—a reaction to what he has called the "endurance performances" characteristic of New York's 1970s performance art renaissance. Taking cues from sitcoms and other television formats such as music videos, commercial advertisements, and game shows, his videos place Mike in a world once-removed from reality to accentuate his slow, quizzical mannerisms. His idiosyncrasies—including fetishistic obsessions with disco dancing and personalized clothing and accessories—manifest as eccentric overcompensation for Mike's confusions about navigating the complexities of daily life and human connection. In early videos *Secret Horror* (1980), *Down in the Rec Room* (1979/1981), and *Outstanding Young Men of America* (1996), Mike plans parties with pathetic results including a "Disco

Inferno" solo boogie. Deep-seated insecurities are conflated with pop cultural references, colliding into nonsensical, hallucinatory scenarios.

In Smith's recent works, Mike takes a more proactive approach to both aging and technology. *Portal Excursion* (2005–07) is a 10-minute piece that harks back to *Mus-co* (1997, made with director Joshua White) in the corny corporate lingo Mike adopts to underscore his determination to become successful. In *Portal Excursion*, Mike's life story unfolds as a journey into "self-learning" composed of online trade school courses, video lectures, and other dubious educational modes. Shots of Mike typing on his laptop in various drab rooms are accompanied by Smith's explanation of the computer's capacity to increase the speed of education. This earnest narration is sweetened and contradicted by Red Krayola member Charlie Abel's folksy accordion playing as part of his and Mayo Thompson's composed soundtrack.

Included in the 2008 Biennial are Smith's *Class Portraits* (1999–), taken at Sears each semester as mementos of his teaching experiences meant to gauge the artist's aging process by comparing the students' perpetual youth to his own increasing maturity. More than simple portraits, these photographs, with their generic department-store backdrops, offer a sincere glimpse into the artist's personal life through ironic visual language while seamlessly fusing Smith's identity with Mike's. As Smith eradicates lines between real and theatrical personas, he presents a character whose awkwardness is at once abnormal and expected of the stereotypical American man. **T.D.**

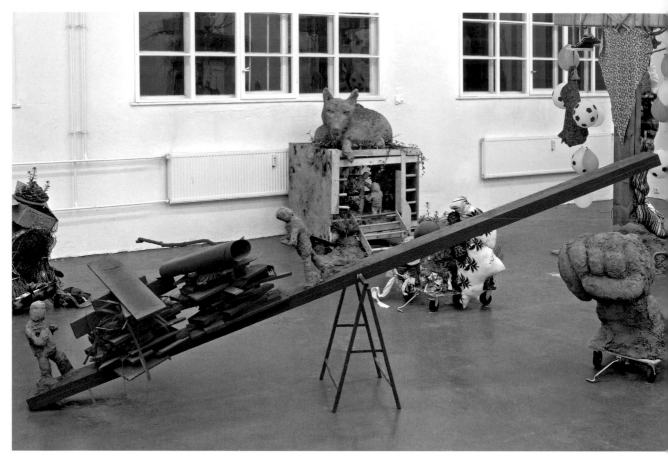

Two, 2007. Concrete, wire mesh, wood, and latex paint, approximately 55 x 157 x 45 in. (140 x 399 x 114 cm). Collection of the artist

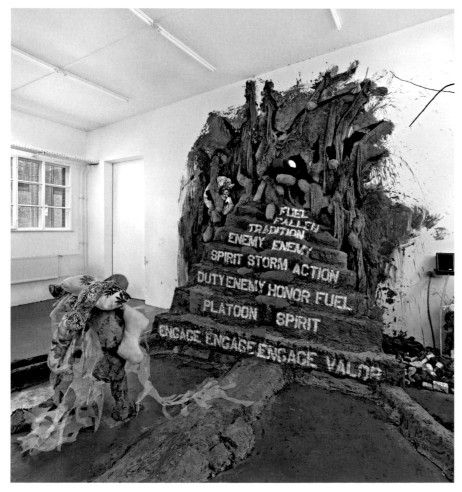

One, 2007. Bricks, wood, concrete, enamel, stuffed tarp, and wire mesh, approximately 157 x 102 x 60 in. (399 x 259 x 152 cm). Collection of the artist

Born 1976 in Corsica, France; lives in New York, New York Based on narratives of environmental collapse, sexual dysfunction, religious or moral decay, and physical disorientation, Agathe Snow's work simultaneously invokes netherworlds of decrepit horror and suggestions for rescue, celebration, and survival. Her installations typically include one or two large-scale sculptures designating her chosen mode of abjection, accompanied by smaller pieces as remnant treasuries of debris offering hope that today's detritus may someday become a precious, valued resource. Inhabiting the gallery space while she creates and exhibits her pieces, Snow accumulates and subjects found objects to a selective refining process, linking the artifacts to anecdotes injected with narrative clues pointing to the alternative lifestyle she leads to generate her work. During her exhibitions she often hosts live events to bring her sculpture's invented tales to life. These narratives are outlined in cryptic textual remarks she pens to accompany each piece or in expository exhibition titles, such as *No Need to Worry, the Apocalypse Has Already Happened . . . when it couldn't get any worse, it just got a little better* (2007).

In that show, at New York's James Fuentes LLC, Snow built a figurative rendition of a beached whale's skeleton out of chicken wire, cotton padding, duct tape, painted tarp, foam core, and steel mesh. As part of the artist's fantasy in which Manhattan has been destroyed by flood, *The Whale* (2007) offered viewers a cavelike refuge. Small piles of common domestic items such as rolls of toilet paper, flowers, goggles, kitchen utensils, and antiquated electronic circuitry were condensed into delicate altars dusted with sand, soil, and gold flakes, as objects affiliated with a previous, antediluvian existence. To set an apocalyptic mood, Snow started her opening in a desolate area under the Brooklyn Bridge, then led her audience on foot, as a processional, to the gallery.

Snow's recent solo show *I Don't Know, But I've Been Told, Eskimo Pussy Is Mighty Cold* (2007), at Peres Projects Berlin, included a dazzling variety of colorful materials gathered in Berlin flea markets mixed among earthier hand-molded works. Two large pieces both titled *One* (2007), constructed of painted tarps, bricks, wood, concrete, enamel, and stuffed cloth, one bearing a militaristic text inciting rebellion, sat like mud-encrusted termite mounds on either side of the gallery. Between them, balloons and soccer balls were slung over three enormous crucifixes, which stood in the gallery's center to create an eerie, abandoned setting. Tenuous relationships between materials encourage viewers to draw their own narrative conclusions, though all of Snow's installations convey a sense of ravaged emotion, as though the artist were making her work in a hurricane's eye. **T.D.**

Opening event for *No Need to Worry, the Apocalypse Has Already Happened . . . when it couldn't get any worse, it just got a little better*, 2007. East River Promenade, New York, New York, March 11, 2007

FRANCES STARK

Born 1967 in Newport Beach, California; lives in Los Angeles, California Since the 1960s many American artists have incorporated text into their work, but for Frances Stark language is not so much an aspect of her production as it is an essential and symbiotic other half: her earliest career intention was to become a writer, and she remains one as much as she is a visual artist. "There is a fight in my work," she notes, but this is a struggle that profits both sides. Her published writing, ranging from quasi-autobiographical narrative musings to aphoristic essays, is marked throughout by a keen visual acuity, while her art presses language into service as medium and subject.

Perhaps not surprisingly, the recurrent motifs of Stark's work evoke writing and the activities that often accompany it—from cutting, copying, repeating, and citing to the quotidian realities of sitting at a desk and reading the mail—as do her materials: carbon paper and rice paper, ink, and linen tape. Fragments of language, from blocks of repeated typewritten letters to passages by writers including Emily Dickinson, Henry Miller, and Robert Musil, are arranged on white paper fields in both abstract patterns and recognizable forms including furniture, flowers, and animals. *In and In* (2005) features dozens of strips of junk mail spliced together and "stacked" in two zigzagging towers as if piled atop

a desk: it is a conflation of art space and work space whose subtle allusion to the increasing corporatism of the art world is tempered by its intricate polychromatic delicacy.

Stark draws on Conceptual art and Minimalism as key sources. Certain of her works recall the spare poetics of Carl Andre; one project, *The Unspeakable Compromise of the Portable Work of Art* (1998–2002), engages a 1971 essay by Daniel Buren. While other affinities occasionally surface—to predecessors as diverse as concrete poet Tom Phillips and high-Cubist-era Pablo Picasso— the sociopolitical imperatives of the 1960s and 1970s underpin much of her work. Stark's birds and flowers are not simply signifiers of production and inspiration: they are traditional markers of the female. The projected PowerPoint work *STRUCTURES THAT FIT MY OPENING AND OTHER PARTS CONSIDERED IN RELATION TO THEIR WHOLE* (2006) similarly reveals her sensitivity to the exigencies of her position as a contemporary woman artist and writer. An epigrammatic collage of her own writings and excerpts from others, its dry boardroom format enlivened by intermittent bursts of sound, color photographs of her home, and images of her art, the work is a moving, personal rumination on "what kind of 'liberation' I—as a woman, artist, teacher, mother, ex-wife—am really after." **L.T.**

STRUCTURES THAT FIT MY OPENING AND OTHER PARTS CONSIDERED IN RELATION TO THEIR WHOLE, 2006 (installation view, De Appel, Amsterdam, 2006). Projection (PowerPoint), color, sound; approximately 25 min., looped. Collection of the artist
opposite: *Subtraction*, 2007. Ink on paper inlaid with printed matter, 92 x 80 in. (233.7 x 203.2 cm). Private collection

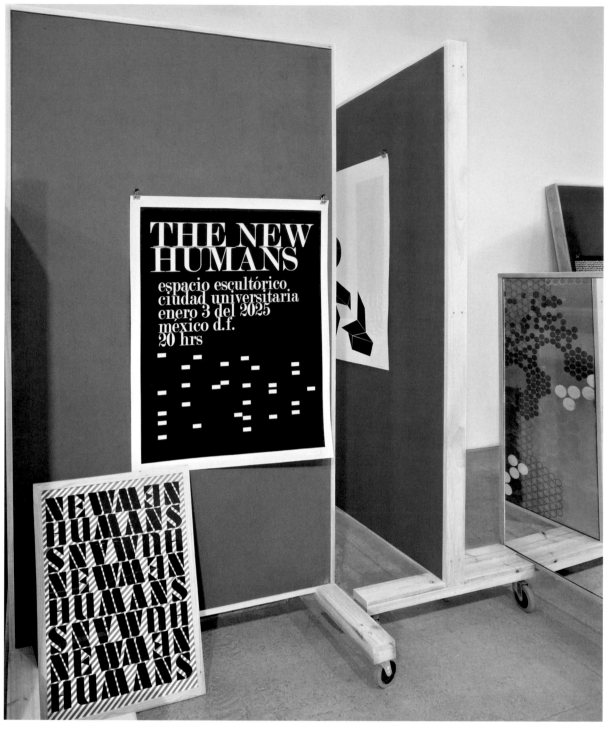

Installation view, *Disassociate*, Elizabeth Dee Gallery, New York, 2007; from left: *As Is*, 2007; *Free We Said*, 2007

Installation view, *Disassociate*, Elizabeth Dee Gallery, New York, 2007

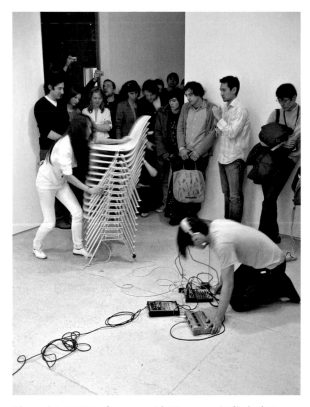

Disassociate, 2007. Performance with Vito Acconci, Elizabeth Dee Gallery, New York, February 24, 2007

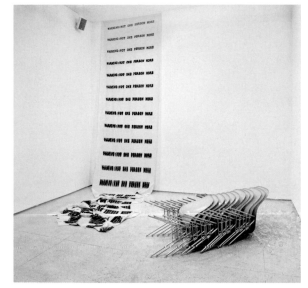

Installation view, *Disassociate*, Elizabeth Dee Gallery, New York, 2007

Mika Tajima: Born 1975 in Los Angeles, California; lives in New York, New York. Howie Chen: Born 1976 in Cincinnati, Ohio; lives in New York, New York

New Humans, a collaborative founded by Mika Tajima with Howie Chen, explores the intersecting strata of sound, installation, and performance within the context of Tajima's visual art practice. The elements making up Tajima's projects slip from foreground sculptures to background props, staging markers, and functional structures, their status in continual transition and production. Challenging the audience's expectations of sculpture as a static presence, Tajima combines multimedia installations with serial performance elements by New Humans including sonically spare noise music grounded in Minimal composition and evoking a post–John Cage mayhem. A constantly changing roster of collaborators from different disciplines contributes to a relentless layering of visual and aural textures, creating a discordant dialogue.

Appropriately, the web of collaboration is itself frequently the subject and object of New Humans' cacophonous sonic, optical, and material mash-ups. The two New Humans performances that punctuated *Disassociate* (2007), an installation by Tajima at Elizabeth Dee Gallery in New York, were created in collaboration with poet-artist-architect Vito Acconci and violinist C. Spencer Yeh. This multilayered work responds structurally to *Sympathy for the Devil* (1968), Jean-Luc Godard's close-up film documenting the Rolling Stones' fractious,

collaborative open studio sessions recorded just prior to the moment when the band's first leader, Brian Jones, went absent from the group (and drowned shortly thereafter). Using the film as a reference point, Tajima notes, the installation and performances reflected the process of working together, with all of its contradictions, takes, trials, errors, and transparency of production.

The installation of sound-baffled modular cubicles in which New Humans performed—instruments included drums, bass, violin, and Acconci's visceral, poetic voicing—was constructed as what Tajima calls essentially "double-sided paintings on wheels." These screenprinted and roller-painted works, depicting diagrams for various modular structures (geometric manuals for stacking chairs and fractured schemata for building champagne glass towers), doubled as bulletin boards papered with related graphic work by Tajima and three invited artists joining the collaborative mix.

Giving visual and aural structure to the serial elements of their collaborative creation, New Humans' time-based performances culminate, like Godard's film, in a structure of dissolution: in the collaboration with Yeh, Tajima hurls a stack of 1960s-era Eames chairs into a tower of glass champagne flutes, simultaneously creating an instrument and sound from the obliteration as the glass smashes to the floor. It is this problematizing of expectations and formalisms through destruction and transformations that is the heart of the continuing project. **T.A.**

JAVIER TÉLLEZ

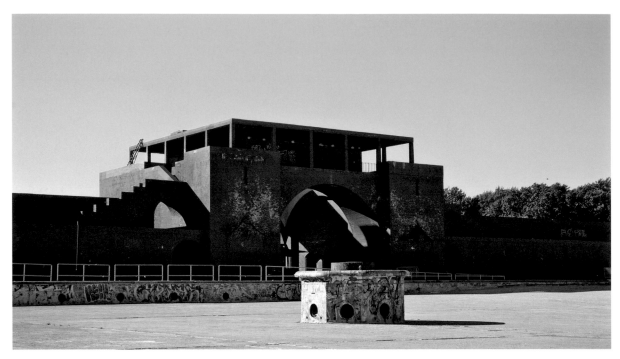

Production still from *Letter on the Blind, For the Use of Those Who See*, 2007. Super 16 film transferred to high-definition video, color, sound; approximately 35 min. Collection of the artist

Born 1969 in Valencia, Venezuela; lives in New York, New York Video installation artist Javier Téllez's films combine documentary with fictionalized narratives to question definitions of normality and pathology. Collaborating with institutionalized patients living with mental illness to rewrite classic stories or invent their own, he creates what he calls a cinematic "passport to allow those outside to be inside" by renegotiating sociocultural barriers. This approach to using art as a voice for the marginalized positions itself within the tradition of art therapy, though Téllez attempts to "cure" viewers of false assumptions, rather than the patients of their disorders. Circus tents and other props provide ironic references to historically carnivalesque exploitations of abnormality, epitomized in director Tod Browning's films. In contrast, Téllez's projects assert the individualism and competence of his actors and emphasize their human dignity by engaging their creativity on sophisticated intellectual levels. Working intimately with his casts, Téllez blurs distinctions between artist and patient to consider the arbitrary boundaries of reality, reason, and insanity.

Made for inSite_05 in San Diego, California, and Tijuana, Mexico, *One Flew Over the Void (Bala Perdida)* (2005) documents Téllez's "self-organized circus" of patients from Mexicali's CESAM mental health center, who, wearing animal masks and carrying handmade signs, walked in protest against general views on mental illness in today's society. The procession culminated at the site of a performance in which human cannonball David Smith was shot over the Mexico-U.S. border to critique current immigration policy. Combining two disparate political concerns, Téllez's film takes issue with larger notions of exclusion. Bright color footage of patients marching and playing horns, interspersed with shots of Smith's audience, suggest humor and celebration as healing alternatives to isolation, segregation, and racism. In the last sequence, entitled "Circus Performers," participants remove their masks for individual facial close-ups, the pleasure they experienced from the event obvious.

Téllez's 16mm film *Letter on the Blind, For the Use of Those Who See* (2007), made for the 2008 Whitney Biennial, extends his interest in otherness into the realm of the physically disabled. The artist re-created the Indian parable "The Blind Men and the Elephant," filming six blind people as they touch different parts of a live elephant and editing their "moments of tactile recognition" to coincide with their descriptions of what they feel. Shot inside Brooklyn's disused McCarren Park swimming pool, this piece contemporizes the ancient narrative's lesson that every being experiences the same thing in a unique way. His desire to encourage broad, compassionate thinking is reiterated by his employment of the strange architecture. By offering linguistic and visual space for the eloquent expressions of those typically relegated to silence, Téllez diminishes our differences as a means to transformation. **T.D.**

opposite: Stills from *One Flew Over the Void (Bala Perdida)*, 2005. Video, color, sound; 11:30 min. Collection of the artist

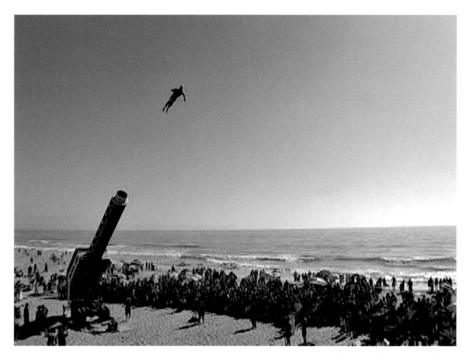

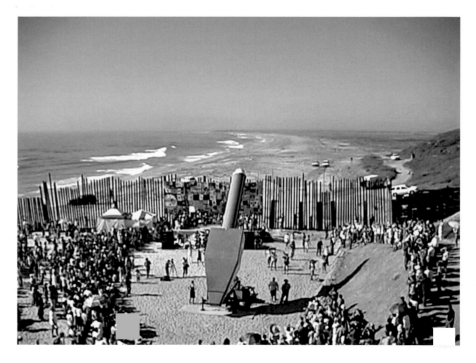

top: *Sets of Color from Robho to Storage*, 2006 (detail). Twenty-five offset lithographs, 58 x 42 in. (147.3 x 106.7 cm) each, overall dimensions variable. Private collection

bottom: Installation view, *Quelques Aspects de l'Art Bourgeois: La Non-Intervention (Certain Aspects of Bourgeois Art: Non-Intervention)*, Andrew Kreps Gallery, New York, 2006–07

Born 1975 in Baton Rouge, Louisiana; lives in New York, New York From the brushstroke, minutely controlled, to the expansive market context in which artworks are disseminated, Cheyney Thompson's paintings, photographs, and installations investigate the contemporary landscape of invention and distribution. His 2006–07 show at Andrew Kreps Gallery in New York offered a systematic exploration of this network. Entitled *Quelques Aspects de l'Art Bourgeois: La Non-Intervention (Certain Aspects of Bourgeois Art: Non-Intervention)*, Thompson's installation comprised multiple parts: a series of twenty-five color offset lithographs depicting the gallery's art storage bay, clustered in five quintets; four large abstract grayscale oil paintings derived from blurred photocopies; and eight lightweight folding tables on which were displayed sixteen imageless photographic prints progressing from white to black. A viewer following the diagonal path of the tables would traverse the gallery to be led to the storage bay pictured in the lithographs, completing the narrative circuit.

Thompson's works commonly employ these tables as pedestals or neutral presentational devices, as in *Table of Blood and Guts* (2002) and *Table Displaying Gifts from the Landlord and Working Papers* (2006). This efficiently mutable form suggests a relation to the portable economy of the street even as it serves as an organizing frame for the objects it shows off. Questioning protocols of exhibition as much as techniques of production and their contingent modes of reception in the space of the gallery, Thompson assumes the history, practice, and circulation of painting as his subject.

Thompson's strategy of flagging the conventions of display was also evident in an earlier exhibition at Andrew Kreps, *1998* (2004). There he thwarted rather than abetted them, however: Thompson hung more than 130 trompe l'oeil paintings of bricks, 2x4 wooden planks, and other building supplies Salon-style in a room, anchored by a sandbag-and-faux-wood blockade. *Barricade Blocking the Position for an Ideal Point of View* (2004) impeded viewing the installation from the "best" perspective—where the multiple vanishing points converged—undermining the ostensible contract between viewer and work. This early work's active impediment of a unified spectatorial vantage point has led the artist to investigate, in his words, "a variegated relationship between painting—a practice whose ossified discursive and speculative value I want to mark with its various economic and technical support systems—and the contradictions of discursive engagements that subsist largely outside the site of display, but which are value-producing sites nonetheless." Most recently, Thompson has comaintained a space on Ludlow Street in New York to be used for panel discussions, lectures, exhibitions, and as the editorial center for *Scorched Earth*, a magazine he edits with artists Gareth James and Sam Lewitt. Thompson's makeshift architecture, multipurposed storefronts, and nomadic tables alike attest to his interest in provisional—but no less real—sites of crisis and contestation. **s.h.**

Untitled, 2006. Oil on canvas, 84 x 72 in. (213.4 x 182.9 cm). Private collection

top: *Wind Chime*, 1999 (installation view, Margo Leavin Gallery, Los Angeles, 2000). Medium density overlay plywood, copper, and monofilament, 26 x 7 x 7 in. (66 x 17.8 x 17.8 cm). Collection of the artist

bottom: *The True Artist Helps the World by Revealing Mystic Truths (12-Step)*, 1999 (installation view, Auckland Art Gallery, New Zealand, 2007). Vinyl lettering on holographic vinyl, 3 x 36 in. (7.6 x 91.4 cm). Collection of the artist

Still from *Silent Film of a Tree Falling in the Forest*, 2005–06. 16mm film, color, silent; 7:10 min. Collection of the artist

Born 1969 in Woodland, California; lives in Los Angeles, California, and Berlin, Germany In the words of artist Margaret Morgan, Mungo Thomson is a "polymorphous, bastard conceptualist"—a designation hard to improve on, given the artist's promiscuously wideranging art. By turns deadpan and caustically sly—he has manufactured Styrofoam antenna balls emblazoned with John Baldessari's bearded visage and bumper stickers bearing Bruce Nauman's doxa "The True Artist Helps the World by Revealing Mystic Truths"—Thomson's inherently conversational practice both gamely Pop-ifies its often antiaesthetic historical precedents and resituates that generation's thought experiments in the social realm.

Across the many media Thomson exploits, a common denominator might be his interest in backgrounds, whether material (canvas or gallery wall) or historical, and his suggestion that they are not as empty as they may seem, particularly when amplified by his intercessions. In the DVD projection *The American Desert (for Chuck Jones)* (2002), for instance, Thomson compiled a chronological archive of backdrops from the Looney Tunes Road Runner cartoons that Jones created. Protagonists and narratives excised, the desert scenes mimic landscape painting; yet, the work has also become a de facto tribute to Jones, who died shortly after Thomson completed it, as well as a meditation on experiential mediation when screened outdoors at Andrea Zittel's A–Z West in Joshua Tree, California, that year.

In the white cube, Thomson's interventions pressure their containers by rendering them visible in the absence of other work. *Wind Chime* (1999), a handmade chorus of wood and copper that responds to movement, fills the space with only the possibility of sound when the air is still. Building on this for the 2008 Whitney Biennial, *Coat Check Chimes* (2008) involves replacing the Museum's coat-check hangers with custom-fabricated "tuned" metal hangers that—although peripheral to the galleries—bracket the viewer's experience of the show.

Like aural renderings of Robert Smithson's Site and non-Site pieces, *The Bootleg Series* (2003–04) are ambient recordings Thomson made of gallery exhibition openings and then installed in other galleries, filling the spaces with persistent, intangible chatter dislocated in place and time. The premise of *not* seeing the event structures *Silent Film of a Tree Falling in the Forest* (2005–06), a 16-millimeter film of trees falling, punctuated by blank intervals of white. Here and elsewhere, Thomson neither wholly directs nor abdicates responsibility. As he notes to Adam Carr in *Uovo*, describing *John Connelly Presents 2002–2005* (2005), a giant inflatable bounce house based on the New York gallery's architecture and erected at London's 2005 Frieze Art Fair: "There's stuff there to chew on—to do with the work being empty until it was filled by the viewer . . . and the gallery and the fair and all the business being a kind of romper room, and also how it *looks* and how it *functions*—but you can also take or leave that stuff and just bounce." **S.H.**

LESLIE THORNTON

Born 1951 in Oak Ridge, Tennessee; lives in New York, New York Leslie Thornton's short films combine original and archival footage, video and still images, and digital media in their investigation of the collision (and collusion) of these modes. The play that she exercises between abstract and referential imagery allows her to address moral and ethical issues as they pertain to events and as they relate to the role of art and media. By editing together controversial or transgressive material, she creates discursive cinematic spaces in which to consider humanity's inexplicable behaviors, as do fellow avant-garde filmmakers Chris Marker and Chantal Akerman. Yet Thornton's signature inclusion of sublimely beautiful footage pitted against the tragic lends her oeuvre what she describes in an interview in *Afterimage* as an "ambiguity of intentions" inspired by a favorite film, Luis Buñuel's *Land without Bread (Tierra sin pan; Las Hurdes)* (c. 1932).

Thornton's employment of footage relating to Hiroshima and the atomic age, elucidating her preoccupation with anxiety, trauma, and culpability, derives in part from her grandfather's and her father's roles in developing the atomic bomb and from her up-close childhood experience of the Cold War. Thornton's artworks often examine the ways technological advancements, from warfare to commercial media, dominate American and global culture. Included in the 1995 Whitney Biennial was a portion of her sixteen-episode epic *Peggy and Fred in Hell* (1985–2007), which integrates film, video,

and installation "environments" to focus on two children traversing an apocalyptic terrain. That work's episodic methodology is reflected in her current work in progress, *Let Me Count the Ways* (2004–).

Let Me Count the Ways is at present composed of five short segments compressed into a 22-minute exploration of the lead-up to, the confusion about, and the aftereffects of the Hiroshima bombing. The title simultaneously references the countdown to the dropping of the bomb and suggests anticipation. *Minus 10* juxtaposes footage of the artist's father in Los Alamos and on the way to Tinian Island with an interview with a woman in Japanese about the bombing. *Minus 9* aligns an American nurse's eyewitness account of the bombing and its aftermath with aerial landscape shots blocked by a blinking blue circle which could represent a mutant sun, an eye, planet Earth, an afterimage, or the inverted "rising sun" of Japanese national symbolism. *Minus 8* and *Minus 7* show excerpts from a documentary, *The Growth of Plants* (c. 1950), overlaid by running text describing radiation-induced botanical mutations. *Minus 6* explores current American war policies and ethics contrasted against the histrionics of Adolf Hitler; as the dictator gesticulates on-screen, women's voices recite a diatribe by Joseph Goebbels. In recalling past histories of warfare, Thornton's current work urges the reexamination of contemporary politics, and artistic practice, by building delicately balanced emotional and narrative arguments. **T.D.**

Stills from *Let Me Count the Ways 10 . . . 9 . . . 8 . . . 7 . . . 6*, 2004– . Video, color, sound; 22 min. Collection of the artist

"The hospitals around Hiroshima
were so crowded in the first weeks
after the bombing, and their staffs
were so variable, depending on the
unpredictable arrival of outside
help, that patients had to be con-
stantly shifted fr

Dad observes the bomb drop
on Hiroshima, August 6, 1945

and wild flowers were in bloom among
the city's bones. The bomb had not
only left the underground organs of
the plants intact, it had s

PHOEBE WASHBURN

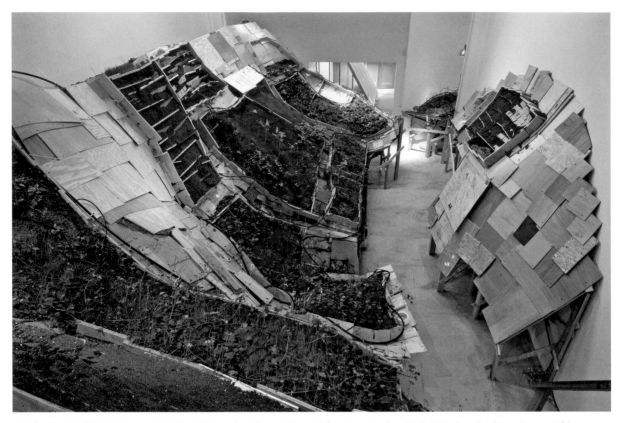

It Makes for My Billionaire Status, 2005 (installation view, Kantor/Feuer Gallery, Los Angeles, 2005). Mixed media, dimensions variable. Collection of the artist

Born 1973 in Poughkeepsie, New York; lives in New York, New York Phoebe Washburn recycles discarded industrial materials in large-scale installations that transform exhibition spaces into visually compelling architectural environments. Washburn's favored materials are cardboard boxes and wood that she scavenges from Dumpsters, sidewalks, and businesses near her Brooklyn studio and Lower Manhattan home. She cuts the material into roughly uniform pieces that she ships to galleries and then assembles into loosely designed constructions, sometimes incorporating items found on-site as well.

For *Vacational Trappings and Wildlife Worries* (2007), a recent piece shown at the Institute of Contemporary Art at the University of Pennsylvania in Philadelphia, she converted a sloping ramp into a walk-through tunnel with walls composed of scraps of wood screwed together in an overlapping, shinglelike patchwork that suggested a rustic shack. Windowlike openings contained fish tanks and a small pond with water plants, alluding to the natural world outside.

Like artists such as Nancy Rubins, Vik Muniz, and Sarah Sze, Washburn composes her pieces with items from the world of manufacturing, and this choice seems to comment on the profusion and waste of consumer culture. But she says her recycling of refuse is not an ecological act: "A lot of my working process involves skimming off of other industries, but my decision to collect and repurpose materials was not born out of trying to make a statement at all." She explains that her compulsion to accumulate discarded materials to feed her art is motivated by "greed" rather than notions of conservation. Yet her work continues to resonate with ideas about economy and sustainability.

For the Deutsche Guggenheim in Berlin she created *Regulated Fool's Milk Meadow* (2007), a mechanized factory for the production of its own grass sod. Within a crude ovoid wooden structure, a computerized conveyor belt moved eighty-five rectangular planter boxes of grass through watering, drying, and grow light stations, simulating ideal growing conditions. Each week, gardeners transferred mature sod from the factory's conveyor loop to the sloping roof, where the grass eventually wilted and died. "People read it as a sad gesture about the cycle of life and death, and that surprised me a bit because initially the grass was just an excuse to have a factory," Washburn explains. "The sculpture is the industry producing its own parts, and the cycle of production and waste is right there in the gallery." She aspires to make an installation that is a kind of "organism" that consumes its by-products and regenerates.

Though she modestly describes her handmade installations as "clumsy, labored, slow-growing events" and refers to her factories and mini-ecosystems as "anti-industrious" and "irrational," they have an elegance of form that captivates viewers with their raw beauty, while providing a "green" critique of design and industry.
J.E.K.

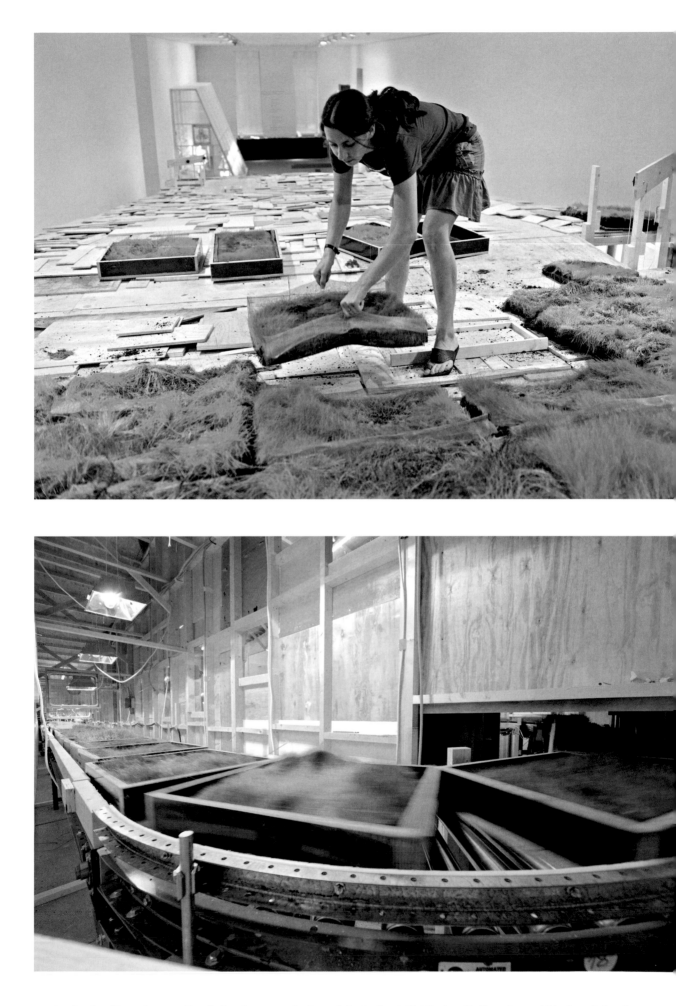

Regulated Fool's Milk Meadow, 2007 (installation views, Deutsche Guggenheim, Berlin, 2007). Mixed media, dimensions variable. Commissioned by the Deutsche Bank in consultation with the Solomon R. Guggenheim Foundation for the Deutsche Guggenheim

Born 1951 in Hartford, Connecticut; lives in Los Angeles, California James Welling has long engaged a mediated—or in his own words, a "ventriloquist"—photographic practice that frequently takes photographic norms or the representational field itself as its subject. In the early 1980s Welling was situated alongside appropriation artists including Sherrie Levine, Richard Prince, and Cindy Sherman; they all eschewed claims of verist documentation (and the fantasy of transparency that subtends it) and modernist aesthetic autonomy in favor of deconstructive criticality. Perhaps best known for his early nonreferential studio photographs of such mundane materials as phyllo dough and aluminum foil, however, Welling—unlike his peers—has long investigated the possibilities of abstraction. The exposed chromogenic paper *Degradés* (1985–2008) recall Color Field painting; his *Hexachromes* (2005) render uncanny everyday spaces through aurora borealis–like eruptions of color.

An even more apt characterization of Welling's practice might be that, as Rosalind Krauss contends, his photographs hold "the referent at bay, creating as much delay as possible between seeing the image and understanding what it was *of*." Written in 1989 vis-à-vis his early works, this argument is equally relevant to the artist's recent projects, including the *Quadrilaterals* (2006) and *War* (2005) series, both generated using Maya graphics software to create fields of shattered abstract shapes in which spatial confusions and perceptual ambiguities predominate. And while content is clear in his *Glass House* photographs (2007–08) of architect Philip Johnson's renowned Connecticut home, the manner of one's apprehension of it is not: using colored gels and lens flares, Welling physically intercedes in his visual images to create effects such as turning the green grass red (effects more typically rendered digitally today).

So too in Welling's photogram series *Torsos* (2005–08) do complexities manifest. He cut screening, of the same type used for windows, to follow bodily contours and placed them on chromogenic paper before exposing them. Folded, curled, and billowing up from the paper ground, the wavy-edged mesh scraps produce lushly variegated passages while also revealing an obdurate materiality through their density, thickness, and permeability to light. Without being hostile to photography, Welling nonetheless has obviated traditional models of pictorialism. Tactility is privileged above opticality, as he turns away from perspective and optics to reground the medium in its fundamental bases of touch, pressure, and weight. (As has often been noted, *photography* literally means "drawing with light" and is not etymologically related to any mechanical means.) To cite Welling in a 2003 *Artforum* interview: "In retrospect, I see that there's no escape from the history of photography." **S.H.**

Glass House, 2007. Chromogenic print, 30 x 37 in. (76.2 x 94 cm). Collection of the artist
opposite: *Torso 3*, 2008. Chromogenic print, 57½ x 47 in. (146.1 x 119.4 cm). Collection of the artist

MARIO YBARRA JR.

Born 1973 in Los Angeles, California; lives in Los Angeles, California In his installations and community-based projects, Mario Ybarra Jr. reimagines the possibilities of "contemporary art that is filtered through a Mexican-American experience in Los Angeles," as he told the *LA Times*. While refusing to discount social or political context, Ybarra remains skeptical about the concept of Chicano identity, a position owing as much to the politicized dockworkers of his native Wilmington neighborhood as to such artists as Rubén Ortiz-Torres and Daniel Joseph Martinez. Indeed, the work of this "cholo aestheticist and inveterate jester," in the words of critic Andrew Berardini, frequently considers the exigencies—and perverse oddities—of cultural translations and the appropriative acts they presuppose. *Brown and Proud* (2006) melds Diego Rivera's civic frescoes with inner-city graffiti art, juxtaposing the Mexican revolutionary Emiliano Zapata with *Star Wars* character Chewbacca in a large-scale mural emblazoned with slogans ("POR VIDA"/"FOR LIFE"), frenetic tags, and the requisite badass, bikini-clad model.

At the Serpentine Gallery in London's Kensington Gardens, Ybarra and his partner, Karla Diaz, created a makeshift ornithological club for *The Peacock Doesn't See Its Own Ass/Let's Twitch Again: Operation Bird Watching in London* (2006). Stuffed birds, found objects, museum artifacts, and corporate designs constituted a sort of anthropological excursion into local "birdlife" on the model of Marcel Broodthaers's ersatz *Musée d'Art Moderne, Département des Aigles* (1968). For the 2008 Whitney Biennial, Ybarra realizes *The Scarface Museum* (2008), exhibiting memorabilia related to the movie from the collection of his friend Angel Montes Jr. *The Scarface Museum* is an outgrowth of a 2005 performance entitled *For All I Know He Had My Friend Angel Killed*, in which the artist read from a particularly brutal scene in the screenplay. An homage to Ybarra's friend, to whom Al Pacino's character represented a model of success, both works reflect on the story of the fictional gangster–drug dealer as one (admittedly flawed) embodiment of the American Dream.

Ybarra's art is perhaps most notable for combining critical and institutional recognition with its deep-rooted connection to the social spaces to which it so often refers. The workshop-collective *Slanguage* (2002–05) and *DSN: Do Something New* (2007), a project for which local teenagers collaborated in producing T-shirts and other artwork and in recording auxiliary members' oral histories, demonstrate Ybarra's commitments. In 2005 Ybarra and Diaz won a competition held by artist Annie Shaw enabling them to convert a barbershop-cum-project space into a small art gallery. Their New Chinatown Barbershop was reproduced at scale for exhibition at *Fair Exchange* at the 2006 Los Angeles County Fair and the following year at the Tate Modern in London, where it returned to its roots, as it were, as the stage for a haircutting competition. **S.H.**

The New Chinatown Barbershop, 2006 (installation view, Los Angeles County Fair, 2006). Mixed media, dimensions variable. Collection of the artist

Installation views, *Latitude*, LA Artcore, Los Angeles, 2007

WORKS IN THE EXHIBITION

Dimensions are in inches followed by centimeters; height precedes width precedes depth.

A bullet (•) indicates works installed in the Seventh Regiment Armory Building, Park Avenue Armory, New York.

Works in the Exhibition as of December 14, 2007; a complete list is available at whitney.org.

RITA ACKERMANN
Not yet titled, 2008
Plexiglass, aluminum, wood, vinyl, synthetic leather, leather, linen, rope, soil, paper, oil, synthetic polymer, charcoal, graphite, ink, and spray paint
Dimensions variable
Collection of the artist

RITA ACKERMANN AND AGATHE SNOW
•Abbat-Jour, 2008
Performance; Seventh Regiment Armory Building

NATALIA ALMADA
Al Otro Lado (To the Other Side), 2005
Digital video, color, sound; 66 min.
Collection of the artist

EDGAR ARCENEAUX
The Alchemy of Comedy . . . Stupid, 2006
Nine-channel video installation: four projections and five 36-in. (91.4-cm) flat-screen monitors, cardboard, and wood
Dimensions variable
Collection of the artist

FIA BACKSTRÖM
"Let's Decorate, and Let's Do It Professionally!", 2008
Mixed media
Dimensions variable
Collection of the artist

JOHN BALDESSARI
Arms & Legs (Specif. Elbows & Knees), Etc.: Arm and Plaid Jacket (Green), 2007
Three-dimensional digital archival print with polycarbonate resin and synthetic polymer, mounted
59¾ x 90 (151.8 x 228.6)
Private collection

Arms & Legs (Specif. Elbows & Knees), Etc.: Elbow (Blue) with Desk, 2007
Three-dimensional digital archival print with polycarbonate resin and synthetic polymer, mounted
59¾ x 98¾ (151.8 x 250.8)
Private collection

Noses & Ears, Etc. (Part Four): Head (Section) with Nose and Ear. No. 2, 2007
Three-dimensional archival inkjet prints on mounted and shaped canvas, with synthetic polymer on wall
60 x 144 x 6 (152.4 x 365.8 x 15.2)
Private collection

ROBERT BECHTLE
Crossing Arkansas Street—Early Morning, 2002
Oil on linen
37⅛ x 67⅛ (94.3 x 170.5)
Private collection

20th and Mississippi—Night, 2005
Oil on canvas
37¼ x 67¼ (94.6 x 170.8)
Private collection

Six Houses on Mound Street, 2006
Oil on canvas
36 x 66 (91.4 x 167.6)
Private collection

WALEAD BESHTY
Travel Picture Fog [Tschaikowskistrasse 17 in multiple exposures* (LAXFRATHF/TXLCPHSEALAX) March 27–April 3, 2006], 2006–08
Chromogenic print
87 x 49 (221 x 124.5)
Collection of the artist

*Contax G-2, L-3 Communications eXaminer 3DX 6000, and InVision Technologies CTX 5000

Travel Picture Granite [Tschaikowskistrasse 17 in multiple exposures* (LAXFRATHF/TXLCPHSEALAX) March 27–April 3, 2006], 2006–08
Chromogenic print
87 x 49 (221 x 124.5)
Collection of the artist

*Contax G-2, L-3 Communications eXaminer 3DX 6000, and InVision Technologies CTX 5000

Travel Picture Meadow [Tschaikowskistrasse 17 in multiple exposures* (LAXFRATHF/TXLCPHSEALAX) March 27–April 3, 2006], 2006–08
Chromogenic print
87 x 49 (221 x 124.5)
Collection of the artist

*Contax G-2, L-3 Communications eXaminer 3DX 6000, and InVision Technologies CTX 5000

Travel Picture Mist [Tschaikowskistrasse 17 in multiple exposures* (LAXFRATHF/TXLCPHSEALAX) March 27–April 3, 2006], 2006–08
Chromogenic print
87 x 49 (221 x 124.5)
Collection of the artist

*Contax G-2, L-3 Communications eXaminer 3DX 6000, and InVision Technologies CTX 5000

Travel Picture Rose [Tschaikowskistrasse 17 in multiple exposures* (LAXFRATHF/TXLCPHSEALAX) March 27–April 3, 2006], 2006–08
Chromogenic print
87 x 49 (221 x 124.5)
Collection of the artist

*Contax G-2, L-3 Communications eXaminer 3DX 6000, and InVision Technologies CTX 5000

*Travel Picture Sunset [Tschaikowskistrasse 17 in multiple
exposures* (LAXFRATHF/TXLCPHSEALAX)
March 27–April 3, 2006], 2006–08*
Chromogenic print
87 x 49 (221 x 124.5)
Collection of the artist

**Contax G-2, L-3 Communications eXaminer 3DX 6000,
and InVision Technologies CTX 5000*

*Travel Picture Violet [Tschaikowskistrasse 17 in multiple
exposures* (LAXFRATHF/TXLCPHSEALAX) March
27–April 3, 2006], 2006–08*
Chromogenic print
87 x 49 (221 x 124.5)
Collection of the artist

**Contax G-2, L-3 Communications eXaminer 3DX 6000,
and InVision Technologies CTX 5000*

*•After the Ends and Before the Beginning: Yet Another
24-hr Cold War Slumber Party (1959–1989), 2006–08*
Two 24-hour film programs; Seventh Regiment Armory
Building

A Large Glass (Leviathan), 2008
Triple-paned mirrored glass
Dimensions variable
Collection of the artist

CAROL BOVE

*The Night Sky over New York, October 21, 2007,
9 p.m.*, 2007
Bronze rods, wire, and expanded metal
146 x 192 x 96 (370.8 x 487.7 x 243.8)
Collection of the artist

Untitled, 2007
Cast concrete and cinder blocks
150 x 94 x 8 (381 x 238.8 x 20.3)
Collection of the artist

Untitled, 2007
Cast concrete and steel
98 x 48 x 3 (248.9 x 121.9 x 7.6)
Collection of the artist

Navel of Sati, 2007–08
Framed found photograph and glass shelf
Dimensions variable
Collection of the artist

Untitled, 2008
Driftwood and steel
84 x 144 x 156 (213.4 x 365.8 x 396.2)
Collection of the artist

JOE BRADLEY

Not yet titled, 2007–08
Installation: vinyl on wood, multiple parts
Dimensions variable
Collection of the artist

MATTHEW BRANNON

An Actor's Actor, 2008
Letterpress print
22 x 16 (55.9 x 40.6)
Collection of the artist

*And when the credits come on you leave the theatre
before they turn on the lights.*, 2008
Screenprint
38 x 29 (96.5 x 73.7)
Collection of the artist

Consideration & Passing Enthusiasm, 2008
Sound-canceling devices and ink on paper
Dimensions variable
Collection of the artist

Don't Repeat This, 2008
Letterpress print
22 x 16 (55.9 x 40.6)
Collection of the artist

Grey Poupon, 2008
Letterpress print
22 x 16 (55.9 x 40.6)
Collection of the artist

•The last page in a very long novel., 2008
Event: words on a page, ink on paper, and hours in the
dark; Seventh Regiment Armory Building

My Mistake, 2008
Letterpress print
22 x 16 (55.9 x 40.6)
Collection of the artist

Non-stop to London, 2008
Letterpress print
38 x 29 (96.5 x 73.7)
Collection of the artist

Not Necessary, 2008
Letterpress print
22 x 16 (55.9 x 40.6)
Collection of the artist

Poodle, 2008
Words on a page, ink on paper, wood, brass, and plastic
8½ x 20 x 8½ (21.6 x 50.8 x 21.6)
Collection of the artist

The Price of Admission, 2008
Letterpress print
22 x 16 (55.9 x 40.6)
Collection of the artist

The question is a compliment., 2008
Vinyl, enamel, and screenprint on fabric
132 x 240 x 5 (335.3 x 609.6 x 12.7)
Collection of the artist

Room Service, 2008
Letterpress print
22 x 16 (55.9 x 40.6)
Collection of the artist

Rough Trade, 2008
Letterpress print
22 x 16 (55.9 x 40.6)
Collection of the artist

R.S.V.P., 2008
Letterpress print
22 x 16 (55.9 x 40.6)
Collection of the artist

Size Queen, 2008
Letterpress print
22 x 16 (55.9 x 40.6)
Collection of the artist

Sore Throat, 2008
Letterpress print
22 x 16 (55.9 x 40.6)
Collection of the artist

BOZIDAR BRAZDA
•*Our Hour/Radioff*, 2008
Mixed-media installation
Dimensions variable
Collection of the artist

OLAF BREUNING
Home 2, 2007
High-definition video, color, sound; 30 min.
Collection of the artist

•Not yet titled, 2008
Gelatin silver print
Approximately 48 x 60 (122 x 152)
Collection of the artist

JEDEDIAH CAESAR
Helium Brick aka Summer Snow, 2006
Resin, pigment, polystyrene, and wood
45 x 112 x 51 (114.3 x 284.5 x 129.5)
The Blanton Museum of Art, The University of Texas
at Austin; gift of Jeanne and Michael Klein, 2007

Dry Stock, 2007
Urethane resin, polyester resin, pigment, aluminum,
titanium, wood, and mixed media
Dimensions variable
Collection of the artist

Untitled, 2007
Mixed media
30 x 25 x 38 (76.2 x 63.5 x 96.5)
Collection of the artist

WILLIAM CORDOVA
*The House that Frank Lloyd Wright built for
Fred Hampton and Mark Clark*, 2007
Wood and suspended drawing
307⅛ x 212⅝ x 98⁷⁄₁₆ (780.1 x 540.1 x 250)
Collection of the artist

WILLIAM CORDOVA AND LESLIE HEWITT
•*I Wish It Were True*, 2004–
Screening and installation
Dimensions variable
Collection of the artists

DEXTER SINISTER
•*True Mirror*, 2008
Mixed media, multiple parts
Collection of the artists

HARRY DODGE AND STANYA KAHN
Can't Swallow It, Can't Spit It Out, 2006
Digital video, color, sound; 26 min.
Collection of the artists

SHANNON EBNER
Involuntary Sculpture, 2006
Wooden box with casters and wheels, corrugated
cardboard, rebar, water-based house paint, and gesso
34½ x 79½ x 44 (87.6 x 201.9 x 111.8)
Collection of the artist

STRIKE, 2007
540 chromogenic prints
7½ x 5¾ (19.1 x 14.6) each, approximately 150 x 155¼
(381 x 394.5) overall
Collection of the artist

GARDAR EIDE EINARSSON
•*Black Brooks Brothers Suit (Sic Semper Tyrannis)*, 2008
Found suit, framed
Dimensions variable
Collection of the artist

Blue Target, 2008
Inkjet print on plywood
78¾ x 48 (200 x 122)
Collection of the artist

Greetings to Thieves, Male and Female, 2008
Synthetic polymer on shaped canvas
71⅝ x 71⅝ (182 x 182)
Collection of the artist

No Hanging Out, 2008
Chromogenic print
11¹³⁄₁₆ x 15¾ (30 x 40)
Collection of the artist

untitled (X), 2008
Mixed media
Dimensions variable
Collection of the artist

Violators Will Be Prosecuted, 2008
Chromogenic print
11¹³⁄₁₆ x 15¾ (30 x 40)
Collection of the artist

We Take Better Care of Your Car, 2008
Chromogenic print
11¹³⁄₁₆ x 15¾ (30 x 40)
Collection of the artist

ROE ETHRIDGE
Marc, 2005
Chromogenic print
40 x 31 (101.6 x 78.7)
Collection of the artist

Camilla, 2007
Chromogenic print
32 x 24 (81.3 x 61)
Collection of the artist

Gateway Boats, Mumbai, 2007
Chromogenic print
60 x 40 (152.4 x 101.6)
Collection of the artist

Pitch Pines and Sunset, Wellfleet, 2007
Chromogenic print
40 x 50 (101.6 x 127)
Collection of the artist

KEVIN JEROME EVERSON
Emergency Needs, 2007
16mm film, color, sound; 7 min.
Collection of the artist

OMER FAST
The Casting, 2007
Four-channel video installation, color, sound; 14 min.
Collection of the artist

ROBERT FENZ
Crossings, 2006–07
16mm film, color, sound and silent; 10 min.
Collection of the artist

COCO FUSCO
Operation Atropos, 2006
Video, color, sound; 59 min.
Collection of the artist

• *A Room of One's Own: Women and Power in the New America*, 2006–
Performance; Seventh Regiment Armory Building

GANG GANG DANCE
• *Untitled*, 2008
Performance; Seventh Regiment Armory Building

Untitled, 2008
Performance; Whitney Museum of American Art

• Not yet titled, 2008
Mixed-media installation
Dimensions variable
Collection of the artists

AMY GRANAT AND DREW HEITZLER
T.S.O.Y.W., 2007
Two-channel projection, 16mm film transferred to digital video, color, sound; 200 min.
Collection of the artists

AMY GRANAT, DREW HEITZLER, AND OLIVIER MOSSET
• *T.S.O.Y.W.*, 2008
Screening and performance; Seventh Regiment Armory Building

RASHAWN GRIFFIN
Not yet titled, 2008
Fabric, pockets, wood, foam, concrete, ink, paper, collage, and string
Dimensions variable
Collection of the artist

• Not yet titled, 2008
Mixed media with live audio feed
Dimensions variable
Collection of the artist

ADLER GUERRIER
untitled (BLCK—We wear the mask), 2007–08
Mixed-media installation
Dimensions variable
Collection of the artist

MK GUTH
• *Ties of Protection and Safekeeping*, 2007–08
Braided fabric and artificial hair
Dimensions variable
Collection of the artist

FRITZ HAEG
Animal Estates Regional Model Homes #1: New York, NY, 2008
Mixed-media installations
Dimensions variable
Collection of the artist

Animal Scores: Whitney Museum Movements, 2008
Movement phrases choreographed for twelve spaces in the Whitney Museum of American Art

Sundown Schoolhouse: Manhattan Animal Lessons, 2008
Series of workshops and seminars in a mobile geodesic tent

RACHEL HARRISON
The Second Voyage, 2007
Fifty-seven archival inkjet prints
16 x 11½ (40.6 x 29.2) each
Collection of the artist

Not yet titled, 2008
Mixed media
Dimensions variable
Collection of the artist

ELLEN HARVEY
• *The Inevitable Failure of Restoration*, 2008
Looped video, flat-screen monitor, gold frame, and wall label
Dimensions variable
Collection of the artist

Museum of Failure: Collection of Impossible Subjects
& Invisible Self-Portrait in My Studio, 2008
Rear-illuminated hand-engraved plexiglass mirrors,
aluminum frame, and fluorescent lights
144 x 96 x 12 (365.8 x 243.8 x 30.5)
Oil on six wooden panels
96 x 144 (243.8 x 365.8)
Collection of the artist

•*100 Biennial Visitors Immortalized*, 2008
Performance; Seventh Regiment Armory Building

MARY HEILMANN
Not yet titled, 2008
Oil on canvas
30 x 56 (76.2 x 142.2)
Collection of the artist

Not yet titled, 2008
Oil on canvas
30 x 56 (76.2 x 142.2)
Collection of the artist

LESLIE HEWITT
Make It Plain (1 of 5), 2006
Digital chromogenic print in custom ash-wood
frame, unglazed
60 x 84 (152.4 x 213.4)
Collection of the artist

Make It Plain (3 of 5), 2006
Digital chromogenic print in custom ash-wood
frame, unglazed
60 x 84 (152.4 x 213.4)
Collection of the artist

Make It Plain (5 of 5), 2006
Digital chromogenic print in custom ash-wood
frame, unglazed
60 x 84 (152.4 x 213.4)
Collection of the artist

PATRICK HILL
Between, Beneath, Through, Against, 2007
Wood, glass, granite, concrete, canvas, dye, ink,
and bleach
67 x 79 x 79 (170.2 x 200.7 x 200.7)
Collection of the artist

Cutter, 2007
Steel, concrete, glass, wood, canvas, dye, and glue
72 x 27 x 33 (182.9 x 68.6 x 83.8)
Collection of the artist

WILLIAM E. JONES
Tearoom, 1962/2007
16mm film transferred to video, color, silent; 56 min.
Collection of the artist

KAREN KILIMNIK
Not yet titled, 2008
Installation: water-soluble oil on canvas, carpet,
and chandelier
Dimensions variable
Collection of the artist

ALICE KÖNITZ
Chairs (working title), 2008
Foam core board, two parts
48 x 48 x 36 (121.9 x 121.9 x 91.4) each
Collection of the artist

Ghost (working title), 2008
Polycarbonate panel and plaster
52 x 48 x 36 (132.1 x 121.9 x 91.4)
Collection of the artist

Magazine (working title), 2008
Inkjet prints
11 x 8 (27.9 x 20.3) each
Collection of the artist

Poster (working title), 2008
Paper
60 x 40 (152.4 x 101.6)
Collection of the artist

Raffle Sculpture (working title), 2008
Wood, plexiglass, metallic paper, and synthetic leather
61½ x 78 x 44 (156.2 x 198.1 x 111.8)
Collection of the artist

Table (working title), 2008
Wood and metallic paper
32 x 33 x 32 (81.3 x 83.8 x 81.3)
Collection of the artist

LOUISE LAWLER
Not yet titled, multiple works, 2008
Photographs mounted on aluminum in wooden frames
Dimensions variable
Collection of the artist

SPIKE LEE
When the Levees Broke: A Requiem in Four Acts, 2006
Video, color, sound; 255 min.

SHERRIE LEVINE
After Stieglitz, 2007
Eighteen inkjet prints
19 x 13 (48.3 x 33) each
Collection of the artist

Body Mask: 1–12, 2007–08
High-polish bronze, six of twelve parts exhibited
23 x 9 x 8 (58.4 x 22.9 x 20.3) each
Collection of the artist

CHARLES LONG
Untitled, 2007
Papier-mâché, plaster, steel, synthetic polymer,
river sediment, and debris
102 x 31 x 22 (259.1 x 78.7 x 55.9)
Collection of the artist

Untitled, 2007
Papier-mâché, plaster, steel, synthetic polymer,
river sediment, and debris
105 x 39 x 29 (266.7 x 99.1 x 73.7)
Collection of the artist

Untitled, 2007
Papier-mâché, plaster, steel, synthetic polymer,
river sediment, and debris
105 x 39 x 29 (266.7 x 99.1 x 73.7)
Collection of the artist

Untitled, 2007
Papier-mâché, plaster, steel, synthetic polymer,
river sediment, and debris
41 x 78½ x 23 (104.1 x 199.4 x 58.4)
Private collection

Not yet titled, 2007–08
Unique albumen prints
Dimensions variable
Collection of the artist

Untitled, 2008
Papier-mâché, plaster, steel, synthetic polymer,
river sediment, and debris
138 x 30 x 30 (350.5 x 76.2 x 76.2)
Private collection

LUCKY DRAGONS
•*Make a Baby*, 2005–
Performance; Seventh Regiment Armory Building

•*Sexy Proposal with Sarah Rara*, 2006
Video projection, color, sound; 7 min.
Collection of the artists

Desert Walkers, 2006–
Performance and video projection, color, sound; 9 min.
Collection of the artists

Morning Ritual with Sarah Rara, 2007
Video projection, color, sound; 2:50 min.
Collection of the artists

•*Congratulations*, 2008
Laser prints
36 x 18 (91.4 x 45.7)
Collection of the artists

DANIEL JOSEPH MARTINEZ
Divine Violence, 2007
Automotive paint on wooden panels
24 x 36 (61 x 91.4) each, overall dimensions variable
Collection of the artist

COREY McCORKLE
Not yet titled, 2008
Video, color, sound; approximately 10 min.
Collection of the artist

RODNEY McMILLIAN
Untitled, 2007
Vinyl, thread, and mixed media
Dimensions variable
Collection of the artist

JULIA MELTZER AND DAVID THORNE
*not a matter of if but when: brief records of a time when
expectations were repeatedly raised and lowered and
people grew exhausted from never knowing if the moment
was at hand or was still to come*, 2006
Video projection, color, sound; 32 min.
Collection of the artists

epic (working title), 2008
Video projection, color, sound; 7:20 min.
Collection of the artists

JENNIFER MONTGOMERY
Notes on the Death of Kodachrome, 1990–2006
Video, color, sound; 80 min.
Collection of the artist

OLIVIER MOSSET
Untitled, 2007
Polyurethane sprayed on canvas, nine parts
48 x 48 (121.9 x 121.9) each
Collection of the artist

Untitled, 2007
Polyurethane sprayed on canvas
120 x 120 (304.8 x 304.8)
Collection of the artist

Untitled, 2007
Polyurethane sprayed on canvas
120 x 120 (304.8 x 304.8)
Collection of the artist

MATT MULLICAN
Untitled (Ellipses and Balls), 2003
Felt-tip marker on glass, wire, and wooden table
Dimensions variable
Collection of the artist

Untitled (Learning from That Person's Work), 2005
Mixed-media installation
Dimensions variable
Collection of the artist

Untitled (Models for the Cosmology), 2006
Cast pewter and steel, multiple parts
16¾ x 16¾ x 6⅛ (42.5 x 42.5 x 15.6) each
Collection of the artist

•Not yet titled, 2008
Performance; Seventh Regiment Armory Building

NEIGHBORHOOD PUBLIC RADIO (NPR)
American Life, 2008
Interactive broadcast project

RUBEN OCHOA
*Infracted Expansion (I cannot tell a lie, lightning
struck down the first one and my father chopped down
the second)*, 2007
Eight wooden pallets, bonding cement, wire mesh,
burlap, and rebar
Dimensions variable
Collection of the artist

• *This Is for Fighting, This Is for Fun*, 2008
Performance; Seventh Regiment Armory Building

DJ OLIVE
• *Sleep*, 2001
CD; 57 min.

• *Buoy*, 2004
CD; 61 min.

• *Triage*, 2008
CD; approximately 60 min.

• *Triage*, 2008
Mixed-media installation
Dimensions variable
Collection of the artist

MITZI PEDERSON
untitled (ten years later or maybe just one), 2005
Cinder blocks, glitter, and glue
Dimensions variable
Collection of Ellen Kern

untitled, 2006
Cinder block, cellophane, and wood
Dimensions variable
Collection of the artist

KEMBRA PFAHLER
• *New York, New York, New York "Actresstocracy"*, 2008
Mixed-media installation
Dimensions variable
Collection of the artist

KEMBRA PFAHLER / THE VOLUPTUOUS HORROR OF KAREN BLACK
• *Actresstocracy*, 2008
Performance; Seventh Regiment Armory Building

SETH PRICE
Untitled, 2008
Bird's eye maple, butternut walnut, and plastic
Dimensions variable
Collection of the artist

Not yet titled, 2008
UV-cured inkjet print on aluminum-polyethylene
composite, multiple parts
Dimensions variable
Collection of the artist

STEPHEN PRINA
The Second Sentence of Everything I Read Is You:
The Queen Mary, 1979–2006
Synthetic polymer and synthetic polymer enamel on
linen, synthetic polymer on plywood, synthetic polymer
enamel on wall, nine Boston Acoustics DSi265
Speakers, Alesis ADAT-HD24 XR Digital Hard Disk
Recorder, five Samson Servo 200 power amplifiers,
Monster Cable Pro 3500 power conditioner, Duratran
print on SignsByWeb SL light box, ETC Source 4 Jr.
spotlight, and FLOR carpet
Approximately 365 x 194 (927 x 493)
Collection of the artist

• Not yet titled, 2008
Performance; Seventh Regiment Armory Building

ADAM PUTNAM
"Green Hallway II" (Magic Lantern), 2007
Mixed-media installation
Dimensions variable
Collection of the artist

"Untitled" (Crypt), 2007
Mixed media on paper
Approximately 22 x 30 (56 x 76)
Collection of the artist

"Untitled" (Four Corners), 2007
Four gelatin silver prints
16 x 20 (40.6 x 50.8) each
Collection of the artist

"Untitled" (Persian Entry), 2007
Mixed media on paper
Approximately 22 x 30 (56 x 76)
Private collection

MICHAEL QUEENLAND
Animal Stack 1, 2007
Plaster, plastic, resin, paint, metal, rubber, string,
and wood
Dimensions variable
Collection of the artist

Animal Stack 2, 2007
Plaster, plastic, resin, paint, metal, rubber, string,
and wood
Dimensions variable
Collection of the artist

Animal Stack 3, 2007
Plaster, plastic, resin, paint, metal, rubber, string,
and wood
Dimensions variable
Collection of the artist

Animal Stack 4, 2007
Plaster, plastic, resin, paint, metal, rubber, string,
and wood
Dimensions variable
Collection of the artist

Animal Stack 5, 2007
Plaster, plastic, resin, paint, metal, rubber, string,
and wood
Dimensions variable
Collection of the artist

Animal Stack 6, 2007
Plaster, plastic, resin, paint, metal, rubber, string,
and wood
Dimensions variable
Collection of the artist

Midnight Curse, 2007
Plastic chain, wax, candles, metal hardware, and powder from fire extinguisher
Dimensions variable
Collection of the artist

Untitled (Balloons), 2007
Offset print with paint in painted wooden frame
Approximately 40 x 50 (102 x 127)
Collection of the artist

Untitled (Model—4 x 4), 2007
Wood and aluminum pigment
48 x 48 (121.9 x 121.9)
Collection of the artist

Untitled (Reese's Hershey's KitKat), 2007
Offset print and adhesive
Dimensions variable
Collection of the artist

JASON RHOADES
The Grand Machine/THEAREOLA, 2002
Mixed media
Dimensions variable
Private collection

RY ROCKLEN
Blue Arc (working title), 2007
Found photographs, metal, silicone, papier-mâché, and silver leaf
44 x 66 x 21 (111.8 x 167.6 x 53.3)
Collection of the artist

Refuge, 2007
Box spring, screen, thread, and nails
73½ x 37 x 7½ (186.7 x 94 x 19.1)
Collection of Paul Monroe

Rock Balance (working title), 2007
Cardboard, epoxy, metal, wood, foam, and resin
Approximately 48 x 16 x 12 (122 x 41 x 30)
Collection of the artist

Sunday Spire, 2007
Wind sock, metal, epoxy, papier-mâché, and sand
90 x 13 x 13 (228.6 x 33 x 33)
Collection of the artist

BERT RODRIGUEZ
The End, 2001–
Vinyl lettering on elevator doors, CD and player with remote control, five speakers, and light with motion sensor
Dimensions variable
Collection of the artist

•*In the Beginning . . .*, 2008
Mixed-media installation with performance; Seventh Regiment Armory Building

MARINA ROSENFELD
•*Teenage Lontano*, 2008
Performance; Seventh Regiment Armory Building

•*Teenage Lontano/16 Channels*, 2008
Mixed-media installation
Dimensions variable
Collection of the artist

AMANDA ROSS-HO
Camera 1, 2007
Laser print
48 x 48 (121.9 x 121.9)
Collection of the artist

Camera 2, 2007
Laser print
52 x 41 (132.1 x 104.1)
Collection of the artist

Inbox, 2007
Mixed media
48 x 96 x 78 (121.9 x 243.8 x 198.1)
Collection of the artist

Knot, 2007
Laser print
28 x 28 (71.1 x 71.1)
Collection of the artist

White Goddess #12 (Namesake), 2007
Synthetic polymer on canvas drop cloth, wooden paneling, and latex
144 x 84 x 24 (365.8 x 213.4 x 61)
Collection of the artist

Perforation, 2008
Site-specific installation
144 x 288 x 288 (365.8 x 731.5 x 731.5)
Collection of the artist

Untitled Still Life (XXL), 2008
Drywall, latex, collage, linen tape, thumbtacks, imitation-gold chain, and paper
48 x 96 (121.9 x 243.8)
Collection of the artist

MIKA ROTTENBERG
Cheese, 2007–08
Mixed-media installation with multichannel video installation, color, sound; approximately 12 min.
Collection of the artist

HEATHER ROWE
3 Walls, 2008
Plywood, drywall, aluminum, glass, mirror, and molding
Dimensions variable
Collection of the artist

EDUARDO SARABIA
•*Salon Aleman*, 2006–08
Site-specific installation
Collection of the artist

The Gift, 2008
Mixed-media installation
Dimensions variable
Collection of the artist

MELANIE SCHIFF
Studio, 2006
Digital chromogenic print
50 x 36 (127 x 91.4)
Collection of the artist

Cannon Falls (Cobain Room), 2007
Digital chromogenic print, two parts
40 x 50 (101.6 x 127) each, 40 x 105 (101.6 x
266.7) overall
Collection of the artist

Reflecting Pool, 2007
Digital chromogenic print
50 x 60 (127 x 152.4)
Collection of the artist

Water Birth, 2007
Digital chromogenic print
50 x 40 (127 x 101.6)
Collection of the artist

AMIE SIEGEL
ЯДД/DDR, 2008
Super 16 film and high-definition video transferred
to high-definition video, color, sound; running time
undetermined
Collection of the artist

LISA SIGAL
*The Day before Yesterday and the Day after
Tomorrow*, 2008
Drywall, house paint, paper, and plaster
Dimensions variable
Collection of the artist

•*Not yet titled*, 2008
House paint on wall
Dimensions variable
Collection of the artist

GRETCHEN SKOGERSON
DRIVE THRU, 2006
High-definition video, color, sound; 19:40 min.
Collection of the artist

•*Not yet titled*, 2008
Neon tubes
Dimensions variable
Collection of the artist

MICHAEL SMITH
Class Portraits, 1999–
Chromogenic prints
13 x 10 (33 x 25.4) each
Collection of the artist

Portal Excursion, 2005–07
Digital video, color, sound; 10:05 min.
Collection of the artist

•*A Day with Mike*, 2008
Performance; Seventh Regiment Armory Building

AGATHE SNOW
•*Stamina: Gloria et Patria*, 2008
Performance; Seventh Regiment Armory Building

•*Not yet titled*, 2008
Performance; Seventh Regiment Armory Building

FRANCES STARK
*STRUCTURES THAT FIT MY OPENING AND
OTHER PARTS CONSIDERED IN RELATION TO
THEIR WHOLE*, 2006
Projection (PowerPoint), color, sound; approximately
25 min., looped
Collection of the artist

Subtraction, 2007
Ink on paper inlaid with found printed matter
92 x 80 (233.7 x 203.2)
Private collection

MIKA TAJIMA / NEW HUMANS
Accessory 1, 2007
Medium-density fiberboard, plastic laminate,
screenprint, vinyl, mirror, glass, and wood
48 x 24 x 30 (121.9 x 61 x 76.2)
Collection of the artist

Accessory 2, 2007
Medium-density fiberboard, plastic laminate,
screenprint, vinyl, mirror, glass, and wood
48 x 24 x 30 (121.9 x 61 x 76.2)
Collection of the artist

Accessory 3, 2007
Medium-density fiberboard, plastic laminate,
screenprint, vinyl, mirror, glass, and wood
48 x 24 x 30 (121.9 x 61 x 76.2)
Collection of the artist

Accessory 4, 2007
Medium-density fiberboard, plastic laminate,
screenprint, vinyl, mirror, glass, and wood
48 x 24 x 30 (121.9 x 61 x 76.2)
Collection of the artist

Appearance (Against Type) 1, 2008
Medium-density fiberboard, screenprint, wood,
and polished aluminum
72 x 84 x 4 (183 x 213 x 10.2)
Collection of the artist

Appearance (Against Type) 2, 2008
Medium-density fiberboard, screenprint, wood,
and polished aluminum
72 x 84 x 4 (183 x 213 x 10.2)
Collection of the artist

Appearance (Against Type) 3, 2008
Medium-density fiberboard, screenprint, wood,
and polished aluminum
72 x 84 x 4 (183 x 213 x 10.2)
Collection of the artist

Halfway There (then going dark), 2008
Medium-density fiberboard and enamel, two parts
Approximately 20 x 84 x 3 (51 x 213 x 8) each
Collection of the artist

Holding Your Breath (taking the long way), 2008
Video, color, sound; approximately 20 min.
Collection of the artist

• *Untitled*, 2008
Videotaped performance with *Appearance (Against Type) 4* and *Appearance (Against Type) 5* on stage;
Seventh Regiment Armory Building
Collection of the artists

JAVIER TÉLLEZ
Letter on the Blind, For the Use of Those Who See, 2007
Super 16 film transferred to high-definition video, color, sound; approximately 35 min.
Collection of the artist

CHEYNEY THOMPSON
Not yet titled, 2008
Mixed-media installation
Dimensions variable
Collection of the artist

MUNGO THOMSON
• *Silent Film of a Tree Falling in the Forest*, 2005–06
16mm film, color, silent; 7:10 min.
Collection of the artist

Coat Check Chimes, 2008
Nickel-plated brass
7 x 16½ x ½ (17.8 x 41.9 x 1.3) each
Collection of the artist

LESLIE THORNTON
Let Me Count the Ways 10 . . . 9 . . . 8 . . . 7 . . . 6, 2004–
Video, color, sound; 22 min.
Collection of the artist

PHOEBE WASHBURN
Not yet titled, 2008
Mixed-media installation
Dimensions variable
Collection of the artist

JAMES WELLING
Glass House, 2008
Chromogenic print
30 x 37 (76.2 x 94)
Collection of the artist

Glass House, 2008
Chromogenic print
30 x 37 (76.2 x 94)
Collection of the artist

Torso 7, 2008
Chromogenic print
57½ x 47 (146.1 x 119.4)
Collection of the artist

Torso 9, 2008
Chromogenic print
57½ x 47 (146.1 x 119.4)
Collection of the artist

Torso 14, 2008
Chromogenic print
57½ x 47 (146.1 x 119.4)
Collection of the artist

MARIO YBARRA JR.
• *The Scarface Museum*, 2008
Mixed-media installation
Dimensions variable
Collection of the artist

REPRODUCTION CREDITS

All artworks are © the artist.

Unless otherwise indicated, images are courtesy the artist and/or the owner. The following applies to images for which additional acknowledgment is due:

Rita Ackermann: courtesy Andrea Rosen Gallery, New York (90, top); courtesy Andrea Rosen Gallery and HOTEL, London (90, bottom); courtesy Andrea Rosen Gallery and Galerie Peter Kilchmann, Zurich (91). Edgar Arceneaux: courtesy Susanne Vielmetter Los Angeles Projects (94–95). John Baldessari: courtesy Marian Goodman Gallery, New York and Paris (98–99). Robert Bechtle: courtesy Gladstone Gallery, New York (100–01). Carol Bove: courtesy Maccarone, New York (104); courtesy Galerie Georg Kargl, Vienna (105). Joe Bradley: courtesy Peres Projects, Los Angeles and Berlin (106–07). Matthew Brannon: courtesy Friedrich Petzel Gallery, New York (108). Bozidar Brazda: courtesy The Kitchen, New York (110, bottom); courtesy Bortolami, New York (111). Jedediah Caesar: courtesy Susanne Vielmetter Los Angeles Projects (114); courtesy D'Amelio Terras, New York (115). William Cordova: courtesy Arndt & Partner, Berlin and Zurich (116). Shannon Ebner: courtesy Wallspace, New York (123). Gardar Eide Einarsson: courtesy Team Gallery, New York (124–25). Omer Fast: courtesy Postmasters Gallery, New York, gb agency, Paris, and Arratia, Beer, Berlin (131). MK Guth: courtesy Elizabeth Leach Gallery, Portland, Oregon (144–45). Rachel Harrison: courtesy Greene Naftali, New York (148–49). Mary Heilmann: courtesy 303 Gallery, New York (152–53). Patrick Hill: courtesy Bortolami, New York (156); courtesy David Kordansky Gallery, Los Angeles (157). William E. Jones: courtesy David Kordansky Gallery, Los Angeles (158–59). Karen Kilimnik: courtesy 303 Gallery, New York, Galerie Eva Presenhuber, Zurich, and Monika Sprüth Philomene Magers, London, Cologne, and Munich (160–61). Alice Könitz: courtesy Susanne Vielmetter Los Angeles Projects (163). Louise Lawler: courtesy Metro Pictures, New York (164). Sherrie Levine: courtesy Paula Cooper Gallery, New York (168–69). Charles Long: courtesy Tanya Bonakdar Gallery, New York (170–71). Daniel Joseph Martinez: courtesy The Project, New York (174–75). Corey McCorkle: courtesy Maccarone, New York (176–77). Rodney McMillian: courtesy Susanne Vielmetter Los Angeles Projects (178–79). Olivier Mosset: courtesy Angstrom Gallery, Los Angeles (184); courtesy Galerie Andrea Caratsch, Zurich, and Galerie Les filles du calvaire, Paris (185). Matt Mullican: courtesy Tracy Williams, Ltd., New York, and Mai 36 Galerie, Zurich (186); courtesy Tracy Williams, Ltd. (187, top); courtesy Tracy Williams, Ltd., and ProjecteSD, Barcelona (187, bottom). Neighborhood Public Radio (NPR): courtesy Southern Exposure, San Francisco, and Valencia Street neighbors (188, left); courtesy a day of Neighborhood Radio at the local café, Creative Commons, 2007 (188, right); courtesy Michael Trigilio and a San Francisco Mission District neighbor (189, top); courtesy Southern Exposure (189, bottom). Ruben Ochoa: courtesy Susanne Vielmetter Los Angeles Projects (190–91). DJ Olive: courtesy Oxingale Records, Montreal (192–93). Mitzi Pederson: courtesy Ratio 3, San Francisco (194–95). Kembra Pfahler: courtesy Deitch Projects, New York (196–97). Seth Price: courtesy Friedrich Petzel Gallery, New York (198–99). Stephen Prina: courtesy Friedrich Petzel Gallery, New York (200); courtesy Galerie Gisela Capitain, Cologne (201). Adam Putnam: courtesy Taxter & Spengemann, New York (202–03). Michael Queenland: courtesy Harris Lieberman, New York (204–05). Jason Rhoades: courtesy Estate of Jason Rhoades, Hauser & Wirth, London and Zurich, and David Zwirner, New York (206–07). Ry Rocklen: courtesy Black Dragon Society, Los Angeles (208–09). Bert Rodriguez: courtesy Fredric Snitzer Gallery, Miami (210–11). Amanda Ross-Ho: courtesy Cherry and Martin, Los Angeles (214–15). Heather Rowe: courtesy D'Amelio Terras (218–19). Eduardo Sarabia: courtesy I-20 Gallery, New York (221). Melanie Schiff: courtesy Kavi Gupta Gallery, Chicago (222–23). Michael Smith: *Portal Excursion* edited and co-directed by Joe Zane, music by Mayo Thompson and Charlie Abel, executive producer Larissa Harris, produced by the Center for Advanced Visual Studies at the Massachusetts Institute of Technology, Cambridge, courtesy Electronic Arts Intermix, New York (230); courtesy Christine Burgin Gallery, New York, and Dunn and Brown Contemporary, Dallas (231). Agathe Snow: courtesy Peres Projects, Los Angeles and Berlin (232); courtesy James Fuentes LLC, New York (233). Mika Tajima/New Humans: courtesy Elizabeth Dee Gallery, New York (236–37). Javier Téllez: commissioned by Creative Time, New York, as part of *Six Actions for New York City*, co-produced by Galerie Peter Kilchmann, Zurich, courtesy Galerie Peter Kilchmann (238); produced by InSite_05, courtesy Galerie Peter Kilchmann (239). Cheyney Thompson: courtesy Andrew Kreps Gallery, New York (240–41). Phoebe Washburn: courtesy Zach Feuer Gallery, New York (246); courtesy Deutsche Guggenheim, Berlin (247). James Welling: courtesy David Zwirner, New York (248–49). Mario Ybarra Jr.: courtesy Anna Helwing Gallery, Los Angeles (250–51)

PHOTOGRAPHY CREDITS

Rita Ackermann: 90, top. Julieta Aranda: 220. Fia Backström: 97. John Berens: 152, bottom. Tina Brotherton: 118. A. Burger: 149. Christopher Burke: 153. Chuy Chavez: 92. Gordon Christmas: 156. Cleverson: 238. William Cordova: 117. Distributed History: 199. Erma Estwick: 174, top. Claire Evans: 173. Brian Forrest: 242, top. Daniel Francesc: 187, bottom. Jennifer French: 242, bottom. Hans George Gaul: 106. Bret Gustafson: 140. Fritz Haeg: 146. George Hirose: 218. Moisés Horta: 172, bottom. David Horvitz: 172, top. Forrest Kelley: 188–89. Alice Könitz: 162. Larry Lamay: 108, 198. Kristy Leibowitz: 196–97. John Lucas: 250–51. Jason Mandella: 96, top. Daniel Joseph Martinez: 174, bottom–175. Paul McGuirk: 226, top. André Morin: 185. Jaimé Campbell Morton: 192. Frederik Nilsen: 157. Cheryl O'Brien: 109. Gene Ogami: 94–95, 163, 179, 208–09, 246. Taidgh O'Neill: 147. Tom Powel: 104, 204–05, 236–37, right. Andres Ramirez: 226, bottom. David Regen: 100–01. Adam Reich: 219. Bert Rodriguez: 210–11. Marina Rosenfeld: 213. Tim Saltarelli: 237, left. Mathias Schormann: 247. Sears Portrait Studio: 231. Frances Stark: 234. Althea Thauberger: 243. Nicholas Trikonis: 131. Jeremy Tusz: 193. Charlie Varley: 167. Jean Vong: 148. Robert Wedemeyer: 178, 190–91, 214–15, 235. Elizabeth Wendelbo: 96, bottom. Joshua M. White: 107. Carl Whittier: 221, bottom. Mark Woods: 202–03, top left. Mario Ybarra Jr.: 251, top

NOTES ON THE CONTRIBUTORS

HENRIETTE HULDISCH is assistant curator at the Whitney Museum of American Art, a position she has held since 2004. She was a co-curator of *Full House: Views of the Whitney's Collection at 75* and previously curated the retrospective of films by Robert Beavers and the exhibition *Small: The Object in Film, Video, and Slide Installation*, with the work of Sol LeWitt, Jonathan Monk, and Michael Snow, among others. She has worked on several Biennials since first joining the Whitney in 2001 and recently oversaw the installation of *Summer of Love: Art of the Psychedelic Era* (2007). Huldisch's publications include essays and interviews in *Artforum, North Drive Press,* and *Collecting the New: New Museums and Contemporary Art*, as well as numerous Whitney publications.

SHAMIM M. MOMIN is associate curator at the Whitney Museum of American Art and has been branch director and curator of the Whitney Museum at Altria since October 2000. Momin was a co-curator of the 2004 Whitney Biennial and has curated numerous exhibitions for the Whitney Museum, including *Terence Koh* (2007), *Mark Grotjahn* (2006–07), *Raymond Pettibon* (2005–06), and *Banks Violette: Untitled* (2005). Momin's exhibitions at Altria have included projects with artists such as Andrea Zittel, Rob Fischer, Sue de Beer, Mark Bradford, and Ellen Harvey. In addition to her Whitney exhibition publications, Momin has contributed essays to numerous other monograph collections, art periodicals, and exhibition catalogues, most recently as an author for the Phaidon *Ice Cream* series.

REBECCA SOLNIT is a writer, historian, and activist. Her books include *A Book of Migrations: Some Passages in Ireland* (1997), *As Eve Said to the Serpent: On Landscape, Gender, and Art* (2001), *Wanderlust: A History of Walking* (2001), *River of Shadows: Eadweard Muybridge and the Technological Wild West* (2003), *A Field Guide to Getting Lost* (2006), and most recently, *Storming the Gates of Paradise* (2007). In 2003, she received the prestigious Lannan Literary Award.

WHITNEY MUSEUM OF AMERICAN ART

WHITNEY MUSEUM OF AMERICAN ART

STAFF

Jay Abu-Hamda
Stephanie Adams
Leslie Adato
Noreen Ahmad
Alanna Albert
Adrienne Alston
Ronnie Altilo
Martha Alvarez-
 LaRose
Jeff Anderson
Callie Angell
Marilou U. Aquino
Rachel Arteaga
Bernadette Baker
John Balestrieri
Wendy Barbee-Lowell
Justine Benith
Harry Benjamin
Jeffrey Bergstrom
Caitlin Bermingham
Lana Bittman
Hillary Blass
Richard Bloes
Leigh Brawer
Amanda Brody
Barbara Brusic
Douglas Burnham
Ron Burrell
Garfield Burton
Elsworth Busano
Pablo Caines
Bridget Carmichael
Gary Carrion-
 Murayari
Howie Chen
Ivy Chokwe
Ramon Cintron
Ron Clark
Melissa Cohen
Kim Conaty
Arthur Conway
Jessica Copperman
Heather Cox
Claire Cuno
Sakura Cusie
Donna De Salvo
Anthony DeMercurio
Neeti Desai
Eduardo Diaz
Eva Diaz
Lauren DiLoreto
Gerald Dodson
Erin Dooley
Elizabeth Dowd

Delano Dunn
Anita Duquette
Bridget Elias
Alvin Eubanks
Altamont Fairclough
Jessa Farkas
Jeanette Fischer
Rich Flood
Carter Foster
Samuel Franks
Murlin Frederick
Annie French
Donald Garlington
Larissa Gentile
Stacey Goergen
Jennie Goldstein
Emily Grillo
Peter Guss
Kate Hahm
Kiowa Hammons
Barbara Haskell
K. Michael Hays
Matthew Heffernan
Dina Helal
Claire Henry
Tove Hermanson
Carlos Hernandez
Ann Holcomb
Nicholas S. Holmes
Tracy Hook
Abigail Hoover
Brooke Horne
Marisa Horowitz
Kat Howard
Henriette Huldisch
Wycliffe Husbands
Chrissie Iles
Carlos Jacobo
Kate Johnson
Diana Kamin
Amanda Kesner
Chris Ketchie
David Kiehl
Rebecca King
Anna Knoell
Tom Kraft
Emily Krell
Margaret Krug
Tina Kukielski
Diana Lada
Diana Lee
Sang Soo Lee
Kristin Leipert
Monica Leon

Vickie Leung
Jeffrey Levine
David Little
Kelley Loftus
Sarah Lookofsky
Elizabeth Lovero
George Lowhar
Carol Mancusi-Ungaro
Gemma Mangione
Olivia Mansfield
Julia McKenzie
Julie McKim
Sandra Meadows
Graham Miles
Sarah Milestone
Dana Miller
David Miller
Ashley Mohr
Shamim M. Momin
Matt Moon
Kate Morotti
Victor Moscoso
Allidah Muller
Colin Newton
Sasha Nicholas
Carlos Noboa
Kisha Noel
Thomas Nunes
Brianna O'Brien
Nelson Ortiz
Carolyn Padwa
Christiane Paul
Angelo Pikoulas
Dana Pinckney
Berit Potter
Kathryn Potts
Linda Priest
Vincent Punch
Stina Puotinen
Christy Putnam
Jessica Ragusa
Jeremiah Reeves
Maggie Ress
Emanuel Riley
Felix Rivera
Jeffrey Robinson
Georgianna Rodriguez
Gina Rogak
Justin Romeo
Joshua Rosenblatt
Amy Roth
Carol Rusk
Doris Sabater
Angelina Salerno

Karla Salguero
Rafael Santiago
Galina Sapozhnikova
Lynn Schatz
Gretchen Scott
Julie Seigel
David Selimoski
Hadley Seward
Erin Silva
Matt Skopek
G. R. Smith
Joel Snyder
Michele Snyder
Stephen Soba
Jessica Sonders
Barbi Spieler
Carrie Springer
Chrystie Stade
Mark Steigelman
Minerva Stella
Nicole Stiffle
Hillary Strong
Emilie Sullivan
Elisabeth Sussman
Mary Anne Talotta
Kean Tan
Ellen Tepfer
Phyllis Thorpe
Kristin Todd
Robert Tofolo
James Tomasello
Limor Tomer
Alexis Tragos
Beth Turk
Lindsay Turley
Ray Vega
Snigdha Verma
Eric Vermilion
Jessica Vodofsky
Tiffany Webber
Cecil Weekes
Adam D. Weinberg
Margie Weinstein
Allison Weisberg
Alexandra Wheeler
John Williams
Natalie Williams
Nicholas Wise
Rachel de W. Wixom
Sarah Zilinski
Alan Zipkin

As of December 1, 2007

THE *2008 BIENNIAL EXHIBITION* WAS CURATED BY HENRIETTE HULDISCH AND SHAMIM M. MOMIN, WITH THE ASSISTANCE OF KIM CONATY, BIENNIAL COORDINATOR; STACEY GOERGEN, CURATORIAL ASSISTANT; DIANA KAMIN, BIENNIAL ASSISTANT; AND ELIZABETH LOVERO, GALLERY/CURATORIAL ASSISTANT.

THIS PUBLICATION WAS PRODUCED UNDER THE SUPERVISION OF THE PUBLICATIONS DEPARTMENT AT THE WHITNEY MUSEUM OF AMERICAN ART, NEW YORK: RACHEL DE W. WIXOM, HEAD OF PUBLICATIONS; BETH TURK, ASSISTANT EDITOR; VICKIE LEUNG, PRODUCTION MANAGER; ANITA DUQUETTE, MANAGER, RIGHTS AND REPRODUCTIONS; BERIT POTTER, RIGHTS AND REPRODUCTIONS ASSISTANT; JESSA FARKAS, RIGHTS AND REPRODUCTIONS ASSISTANT; AND ANNA KNOELL, GRAPHIC DESIGN.

PROJECT DIRECTOR: MARY DELMONICO / OFFSITE: PUBLICATIONS, PLANNING, PROJECTS
CATALOGUE DESIGN: MIKO McGINTY ASSISTED BY RITA JULES
EDITORS: THEA HETZNER, LYNN SCRABIS, AND DALE TUCKER
PROOFREADER: RICHARD G. GALLIN

TEXTS ON THE INDIVIDUAL ARTISTS WERE WRITTEN BY TODD ALDEN (T.A.), TRINIE DALTON (T.D.), STACEY GOERGEN (S.G.), SUZANNE HUDSON (S.H.), JEFFREY KASTNER (J.K.), JASON EDWARD KAUFMAN (J.E.K.), NATHAN LEE (N.L.), AND LISA TURVEY (L.T.).

PRINTING AND BINDING: CONTI TIPOCOLOR, ITALY

THE BOOK IS TYPESET IN CASLON'S EGYPTIAN BY MIKO McGINTY AND MERCURY TEXT BY HOEFLER & FRERE-JONES, AND IS PRINTED ON 150 GSM PERIGORD.

1
1
1
1
drawing the line
newest new
1
1
negotiations
1
obsessive behavior
anti-master
1
dropout program
1
lack of emotion
realization
flat
~~inversion of a new flatness~~
cult of the beautiful
drone
dispelling the infinite
linear thinking
peak performance
applied spirituality
above
wire
~~a ring a tiger~~
not all there
crossed again
build up and fade out
thin line between love and hate
intro
prelude to violence
difference
country home
flatliner
~~crossed out~~
associations and organizations
1
~~all out ageing~~

2
2
2
2
2
so out of it
electric youth
hall of mirrors
upper
last stand
thousand plateaus
patching things up
~~in lieu of focus~~
coordination
valium holiday
~~mental abstraction~~
superstructure
this is no escape
self-help
waves
sequence of events
easy listening
tremolo
ghost hunting and physics
2
accelerated learning
sliding scale
here
archaic revival
multiplier
2
moment to moment
one thing to the next
irrational thoughts
proliferation act
absent
repetition
principles of style
crystal method
non-fiction
~~free university~~
pack mentality
complexity is no guarantee of quality
2

3
3
3
3
limited engagement
electric death
3
invasive procedure
3
~~always already~~
no chance
3
3
side effects
3
undifferentiated taste
self-sabotage
points
unreflected life
gray scale
fuzz
broken mirror
geometric growth
standard
other countries, institutions and people
razor blades
from memory
force of habit
no room
opaque
3
all your ruins
awkward weapon
3
different types of exterior
~~like a asteroid staff~~
3
virtually any shape or line repeated often enough will produce a
pattern of some sort
beyond help
3

2
4
4
4
redacted
gone
not dead
~~crossword puzzle~~
downer
jumping to conclusions
it is over
code of silence
ghost writer
extreme makeover
irreconcilable differences
altered beast
sickest and illest
not sure
~~over again~~
round about way of doing things
no pure form
reference point
consequences
afterlife
~~your common sense~~
shadow song
substitute teacher
~~promotional behaviour~~
naked in your dream
personas and sub personalities
not all there (reprise)
wrong form
not a song
silent protest
lowest of the low
4
parallel universe
ulterior motive
last form
leave of absence
4

Recorded and engineered by Sean Maffucci
at Junkyard Audio Salvage, Brooklyn, New York
Mastering by Paul Gold at Brooklynphono, New York
Cover design: Mika Tajima
Liner/poster design: José León Cerrillo
http://www.newhumansnyc.com

1.performed by Howie Chen (guitar), Mika Tajima (bass), Eric Tsai (tongue drum, guitar)
2. performed by Howie Chen (guitar), Mika Tajima (bass), Eric Tsai (guitar, drums)
3. performed by Howie Chen (guitar), Mika Tajima (vocal, bass), Eric Tsai (drums)
4. performed by Danny Barria, Howie Chen, Mika Tajima, Eric Tsai

Mika Tajima / New Humans

Phoebe Washburn

0-9 : $45
An Anecdoted Topography of Chance : $20
Anthony Froshaug (2 volumes) : $80
Appendix Appendix: $40
Bauhaus : $65 (softcover) / $210 (hardcover)
CAC Interviu (inc. Francis McKee booklet) : $6
A Dark Day of Justice : $15 (both)
Detroit : no less than $6
Proposal for documenta ∞ : $1
Dot Dot Dot : $15
El ingenioso Hidalgo: $15
Erasmus is Late : $15
Exercises in Style : $15
F.R. David : $14
Frances Stark: Collected Writing : $40
Frances Stark: Collected Work : $50
Frozen Tears I / II / III : $9.99 each
Heavy Epic (LP) : $40
In Search of the Miraculous : $15
LAB Magazine : $20
Lukas & Sternberg books : $20 each
Magnetic Promenade : $30
Militant Bourgeois : $16
Minimal Poems: $20
Modern Typography : $30
Models & Constructs : $40
Morton Feldman Says : $50
Notes for an Art School : $50
Our Spot (New York) : $20
Parallel Cards : $50
PHILIP : $20
Picture a Moon, Shining in the Sky : $6
Primer (on the Future of Art School) : $15
Psychic Soviet : $16
A Season in Hell : $10
S'wich: $3 (Sandwich)
Tom Benson I / II : $20 each
The Uncertain States of America Reader : $20
Undo: $10
Unjustified Texts : $40

Handwritten notes:

In Alphabetical Order — $15

Pale Carnage — $20

Agapé $12

Doo 14, Nov 13 $30

SKETCH FOR THE FUTURE $5

Robin Cameron

FILE UNDER: ... $20

← The National — $16.
← OF WALKING IN ICE : $25.00
← WALKING ON SPLINTERS : 10 —
STUDIO + CUBE : $25.00
making the specialist smile $20.

Charles Long

Kembra Pfahler / The Voluptuous Horror of Karen Black

Corey McCorkle

Letter on the Blind, for the Use of Those Who See

Denise Crumwell
born blind.

Audio1:04:16:14 If you touch only one part of something, you are not really going to know what the whole is like. So I think those stories are kind of biased towards the blind people in it. Because they only touched one part and they related to some things they knew, which is why they thought it looks like what they felt.

Audio2:17:14:22:02 Because her body didn't feel like, let's say, her ears, like her ears felt differently than the rest of her body, so if you just felt the ears, you may think her body was soft like that. Or if you just felt the tail, you may think her whole body felt kind of ropier or something like that. But you wouldn't know the size, how big the elephant was or what the rest of her felt like, with all the little hairs on her and the wrinkles in the skin. Her skin kind of felt like it have designs on it, like different seams and wrinkles and you wouldn't know that just from feeling only one part.

Audio2:17:13:41:15 If each person only touched one part of the elephant I could see why they said what they said, like the tail felt flat like a rope or something, just touching different parts I can see what they said, because they were not able to touch the whole thing.

Audio2:17:15:46:14 If I have to rewrite the story I would ask what each one of them felt and how it felt and then put them together as a whole and then maybe that will be the elephant, with all the different descriptions it will come together as the elephant really feels like.

Javier Téllez

Edgar Arceneaux

Francis Ponge from _The Sun Placed in the Abyss_ p.63

The Sun Entitles Nature

The Sun in its own manner entitles nature. In the following manner.

It approaches it nightly, from below. Then it appears on the horizon of the text, incorporating itself, for a moment, to the first line which it then leaves immediately. A bloody moment.

Rising little by little, it then reaches the zenith, the exact position of a title, and then everything becomes exact, everything refers back to it, according to rays of similar intensity & length.

But just as soon, it declines little by little, toward the lower lefthand corner of the page, and when it crosses the last line, to plunge once again into obscurity & silence, another bloody moment occurs.

Rapidly then the shadow reaches the text, which soon becomes illegible.

Then the nocturnal outcry neverberates.

"A RARE PRIVELEGE, THIS, OF BEING AN AMERICAN"

Shannon Ebner

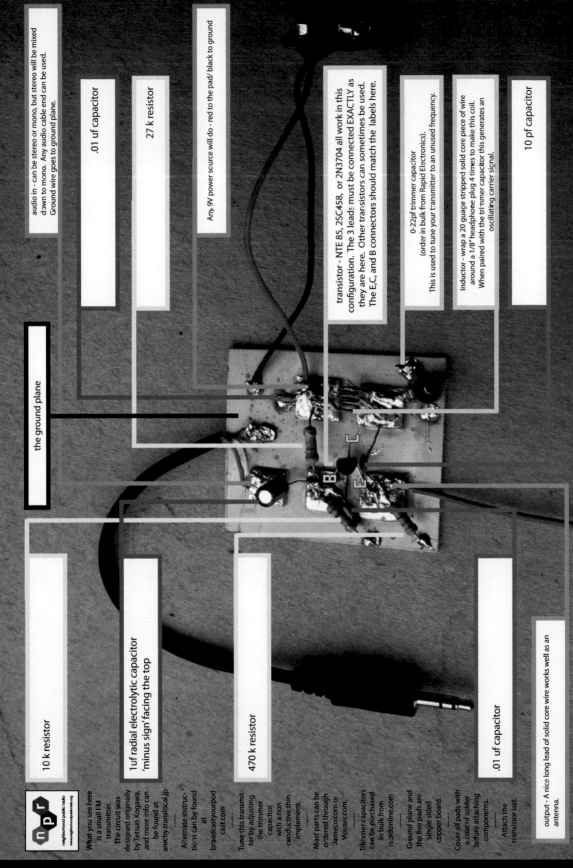

audio in - can be stereo or mono, but stereo will be mixed down to mono. Any audio cable end can be used. Ground wire goes to ground plane.

.01 uf capacitor

27 k resistor

Any 9V power source will do - red to the pad/ black to ground

transistor - NTE 85, 2SC458, or 2N3704 all work in this configuration. The 3 leads must be connected EXACTLY as they are here. Other transistors can sometimes be used. The E,C, and B connectors should match the labels here.

0-22pf trimmer capacitor (order in bulk from Rapid Electronics). This is used to tune your transmitter to an unused frequency.

Inductor - wrap a 20 guage stripped solid core piece of wire around a 1/8" headphone plug 4 times to make this coil. When paired with the trimmer capacitor this generates an oscillating carrier signal.

10 pf capacitor

the ground plane

10 k resistor

What you see here is a small FM transmitter.
The circuit was designed originally by Tetsuo Kogawa, and more info can be found at anrchy.translocal.jp
────
Alternate instructions can be found at broadcastyourpod cast.com
────
Tune this transmitter by adjusting the trimmer capacitor with a non cunductive thin implement.
────
Most parts can be ordered through Jameco.com or Mouser.com.
────
Trimmer capacitors can be purchased in bulk from rapidonline.com
────
Ground plane and the five pads are single sided copper board.
────
Cover all pads with a coat of solder before attaching components.
────
Attach the transistor last.

1uf radial electrolytic capacitor 'minus sign' facing the top

470 k resistor

.01 uf capacitor

output - A nice long lead of solid core wire works well as an antenna.

neighborhood public radio
www.neighborhoodpublicradio.org

Neighborhood Public Radio (NPR)

tiny masters

julianne

john

yyy

dennis

d.o.a

jack

minor threat

milla

sy

brazda pro's

keanu

john

leeled
palaal

daygl8's

whoomp

kate

Bozidar Brazda

FM NEWS!

(start film)

One man is dead and another hospitalized at Burrell
Memorial following a shooting late last night in the
Oldfield section of Botetourt County.

(show film)

Shot to death in the fracas was 27-year-old Spencer
L. Banks of Route One, Hollins. In fair condition at
Burrell Memorial with a bullet wound in the back is
26
24-year-old Paul Wiley. Botetourt County authorities
have arrested a third man, not identified, and charged
him with shooting Wiley. Just what touched off the
shoot-out in the predominantly negro section of the
County isn't clear, but Wiley says there was an
argument and he shot Banks. X Botetourt County Sheriff
Norman Sprinkle says Wiley confessed to him this
morning about 3:30 that he killed Banks.
Sprinkle says the third man, will be held for further
questioning in the shooting.

ON THURSDAY
DEC. 21st AT
SIX THIRTY PM
AT

fAMily

436 N. FAIRFAX

ROED ONO
BONE RATTLE (BOSTON)
LUCKY DRAGONS (

Lucky Dragons

Beer Ptg. Co., Cols., O. CD99794

Number	NAME	Age	Color	Term	CRIME	COUNTY
115818	KUHN, SAMUEL GAIL	57	W	Min. 1 / Max. 20	SODOMY	RICHLAND
115819	WALTON, EDWARD JOHN	46	W	Min. 1 / Max. 20	SODOMY	RICHLAND
115820	ALAMANTEOFF, CHRIST	32	W	Min. 1 / Max. 20	SODOMY	RICHLAND
115821	HALE, ARNELESS ROBERT	31	W	Min. 1 / Max. 20	SODOMY	RICHLAND
115822	THOMAS, FRANK JOSEPH	37	W	Min. 1 / Max. 20	SODOMY	RICHLAND

William E. Jones

Olaf Breuning

Brocchi's Cluster (AKA The Coathanger)
West Boylston - 11/6/2002
UO90 Finder Scope view

**Brocchi's
Cluster**

Brocchi's Cluster, also known as the
Coathanger, a conspicuous asterism easily seen
with binoculars in the constellation Vulpecula.

Gromada Brocchiego - Wieszak

Zasięg 9,9 mag. **Zasięg 10,9 mag.**

Klub Astronomiczny Almukantarat "Nadwarciański Gród"
Ariel Majcher, Marcin Marszałek, Anna Urbańska, Wojciech Warkocki 16 sierpnia 2002 01:48

Mungo Thomson

Amie Siegel

Vorbereitung einer Observation« (BStU: HA VIII 2049/2, Bl. 1).

Gang Gang Dance

Mario Ybarra Jr.

THERE IS
NO BECOMING
NO REVOLUTION
NO STRUGGLE
NO PATH
ALREADY YOU
ARE THE
MONARCH OF
YOUR OWN
SKIN—YOUR
INVIOLABLE FREEDOM
WAITS TO
BE COMPLETED
ONLY BY
THE LOVE
OF THE
OTHER MONARCH
A POLITICS
OF DREAMS
URGENT AS
THE
BLUE SKY

Daniel Joseph Martinez